ESOTERIC MUDRĀS OF JAPAN

ŚATA-PIṬAKA SERIES

INDO-ASIAN LITERATURES
Volume 393

Reproduced in original scripts and languages
Translated, annotated and critically evaluated by
specialists of the East and the West

Founded by
Prof. RAGHUVIRA *M.A., Ph.D., D.Litt. et Phil.*
Continued by
LOKESH CHANDRA

आचार्य—रघुवीर—समुपक्रान्तं

जम्बुद्वीप-राष्ट्राणां
(भारत-नेपाल-गान्धार-शूलिक-तुरुष्क-पारस-ताजक-भोट-चीन-मोंगोल-मञ्जु-
उदयवर्ष-सिंहल-सुवर्णभू-श्याम-कम्बुज-चम्पा-द्वीपान्तरादीनां)

एकैकेषां समस्रोतसां संस्कृति—साहित्य—समुच्चय—
सरितां सागरभूतं

शतपिटकम्

ESOTERIC MUDRĀS OF JAPAN

Mudrās of the Garbhadhātu and Vajradhātu maṇḍalas, of homa
and eighteen-step rites, and of main Buddhas and Bodhisattvas,
gods and goddesses of various sūtras and tantras

Mrs. Gauri Devi

INTERNATIONAL ACADEMY OF INDIAN CULTURE
and ADITYA PRAKASHAN, NEW DELHI

ISBN 81-86471-56-1

Published by P.K. Goel for Aditya Prakashan, F-14/65, Model Town II, Delhi – 110 009
and printed at Rajkamal Electric Press, G.T. Karnal Road, New Delhi – 110 033.

v

CONTENTS

PREFACE

Mudrās or postures of the hands have been central to the iconography and ritual of the esoteric Mantrayāna and Vajrayāna denominations of the Tantras. They accompany the mantras in rites, so that the verbal plane of the mantras and physical plane of the mudrās harmonise to interiorise the cosmic and spiritual forces. They lend efficacy and transcendance to the processes of realisation or sādhanā. The visualisation of the Divine in one's innermost being entails the epiphany of the main deity with all its attributes and mudrās. As Tantric iconography developed and ritual diversified, a large number of mudrās evolved. Three categories of hand gestures can be discerned. The first category is the *hasta* or hand-gestures of dance, which is a veritable non-verbal vocabulary to denote gods, demons, emperors, gardens, flowers, animals, seasons, child, forest, night, thunderbolt, arrow, tree, river bank, temple tower, drinking poison and so on. The second category of mudrās are the attributes of fearlessness(*abhaya*), argumentation(*vitarka*), salutation(*añjali*), earth-touching(*bhūmi-sparśa*), meditation(*dhyāna*), ecstasy(*samādhi*), turning the wheel of dharma(*dharma-cakra-pravartana*), granting boons(*varada*), wisdom-fist(*bodhyagrī*), and so on which are determinative characteristics of the various Tathāgatas and Bodhisattvas. These mudrās are relatively restricted to sculpture and painting. The third category of mudrās is concerned with the esoteric liturgies dedicated to Mahāvairocana of the Garbhadhātu and Vajradhātu systems, of Vajrasattva of the Naya-sūtra, of Rāgarāja(Aizen Myohō), and with the more general eighteen-step rite(jūhachidō) and the fire-ceremony of homa(goma).

The earliest illustrated manual of mudrās goes back to the great master Śubhākarasiṁha who lived from 637 to 735 and was responsible for translating the Mahāvairocana-sūtra into Chinese. He illustrated the deities of the Garbhadhātu-maṇḍala in which we can see the richness of mudrās. This manuscript of the Taizō-zuzō was discovered by Seigai Omura in 1897 and published in his series *Bukkyō-zuzō-shūko*. It was brought to Japan from China by Chishō Daishi in the ninth century. Śubhākarasiṁha also drew the illustrations of the first section of the Sarva-tathāgata-tattva-saṅgraha(STTS) whose Vajradhātu-maṇḍala is prevalent in the Genzu version in Japan. Its title is Ritasogyara-gobu-shingan 'meditation on the five families of the Ṛta-saṁhāra'. The Ṛta-saṁhāra is another name for the STTS. Its extant manuscript scroll is dated AD 855. It illustrates the deities with their mudrās and each deity is accompanied by its cihna-mudrā, karma-mudrā, and mahā-mudrā: all duly captioned so that correct identification is ensured. It has been edited and annotated by Lokesh Chandra in *A Ninth Century Scroll of the*

Vajradhātu-maṇḍala. This was brought to Japan from China again by Chishō Daishi. Its commentary *Rokushu-mandara-ryaku-shaku* 'short explanation of the six kinds of maṇḍalas' help us to understand the pantheon. The mudrā(body), mantra(speech), and samādhi(mind) are the three mysteries for the attainment of Enlightenment or Buddhahood through the practice of yoga and ritual.

The manuscript illustrating the mudrās of the Susiddhi-tantra, entitled Soshijji-giki-gei-in, is dated AD 864 and is the second ancient manuscript of mudrās. Its mudrās pertain to the ritual of siddhi.

As early as AD 1272, a mudrā-manual entitled Shi-dō-in-zu, appeared in the Tendai denomination in accordance with the tradition of Chishō Daishi. It contains the mudrās of four(shi) rites(dō): Garbhadhātu, Vajradhātu, homa and eighteen-step rite. A manual of this tradition has been illustrated and described in the present work. The worshipper sanctifies himself, the sanctum, and invokes the deities of infinite worlds to descend in the purified space. The ramparts of vajras and of flames prevent demoniacal forces from penetrating the precincts. He enshrines the main deity and his retinue in the temple of his heart as his whole being is concentrated in meditation. He visualises the serene symbolic presence of the dharmakāya in the incandescence of his visualisation.

The second part(pages 117–410) illustrates the mudrās of Tathāgatas, Bodhisattvas, Devas esp. Twelve Devas, Goddesses, Uṣṇīṣas, Planets, Constellations, Ṣaḍakṣara-sūtra, Rakṣā-sūtra, Ratnakūṭa-sūtra, Naya-sūtra, Vajrasattva, Pañca-guhya, various Ākāśagarbhas, Eight Mahākumāras(Dai-dōji), homas, fourteen mudrās of Acala, four seasons, Catur-mahārājika, and so on. The mudrās in this part are large and clear. They are accompanied by Sanskrit mantras in Siddham script in a racy ductus of the brush and are difficult to decipher.

In the endless details of liturgy, in the complexity of rites, the ceremony is a dramatic movement of implements and substances, acts performed and mantras recited. The hand gestures or mudrās contribute to the irresistible power of the worshipper, who transcends his physical consciousness and visualises the invisible but pervasive presence of the Divinity invoked. The words, the gestures, the sacraments transport the worshipper from the flow of samsara to the ineffable dazzle of bodhi. The mudrās attune him to mystical participation, as they do away with the blemishes purifying the physical, intellective and spiritual planes. The mudrās establish syntony between the worshipper and the Deity by redeeming physical postures of his hands into the dharmadhātu so that he is reintegrated into the innate quintessence(*sahaja*). The devotee has become one with the Buddhas (*ekakāyo 'si Buddhānāṁ*) who flock from various points of space. He has conquered awareness of his nature as a means of purification, and the epiphany has opened up the light of supreme reality.

GAURI DEVI

1. MUDRĀS OF THE FOUR RITES/*SHI-DŌ-IN-ZU*

The four Buddhist rites are called *Shi-dō* (*shi* 'four' *dō* 'rites'). They deal with instructions, doctrines and rites relating to various degrees of initiation through which the worshippers who follow and practise the teaching of esoteric Buddhism, have to pass. These degrees are four in number, each of them having its particular rites. The term Shi-dō is the collective name of the rites of these four degrees. There are two sequences of these four rites:

I. The sequence adopted by the Shingon sect, that places them in the following order: (1) *Jūhachi-dō* 'eighteen rites', so called because the ceremony of this first degree consists of eighteen *in* or mudrās. (2) *Kongō-kai* (in Sanskrit Vajradhātu). (3) *Taizō-kai* (in Sanskrit Garbhadhātu). (4) *Go-ma* (in Sanskrit homa).

II. The sequence followed by the Anafuto sect of Tendai which has been detailed in this book. It differs from the preceding by putting in the first place the rite Taizō-kai, in the second the rite Kongō-kai, in the third Go-ma and in the fourth Juhachi-dō. The Shingon sect considers it irregular and contrary to good sense. The Jūhachi-dō contains the preliminary rites, Kongō-kai the rites relating to the acquisition of the qualities of a Buddha, Taizō-kai the rites of perfection that can be attained only after one has attained the state of a Buddha, and lastly the Goma consists of ceremonial rites for the purpose of destroying evil and to assure salvation of the world. This order alone is rational.

Buddhism is divided into two great schools called Kengyō 'exoteric' doctrines and Mikkyō 'esoteric' doctrines. The Kengyō school teaches the theory of the doctrine, but it does not study the acts that are to be performed, and the degrees of wisdom that are to be acquired for becoming a Buddha. Mikkyō teaches the acts that produce the 'incarnation of Bodai' (Sanskrit *Bodhi*). These acts of incarnation constitute the teaching of San-mitsu. The San-mitsu or 'three mysteries' consist of acts of three different orders: (1) Acts of *Kuan-nen* 'meditation', i.e. meditation on the raison d'etre of the supreme Buddhist Dharma. (2) Acts of *Shin-gon* 'mantra': minutely accurate recitation of the dhāraṇīs or Sanskrit formulas that are of unlimited powers. (3) Acts of *Shi-in* 'mudrās', consisting of forming gestures with the fingers for the purpose of acquiring in this very life the quality of a Buddha. The acts by which the worshipper becomes an incarnation of Buddha consist in the working of these three mysteries. We shall deal here only with the third act of mudrās.

For being initiated into these mysteries, one has to prove his fidelity to the Buddhist Dharma and an unshakable faith in the Buddha failing which both the initiated and the

initiator are inflicted with punishment prescribed by the Buddha for violators of the mysteries. He who practises the rites according to rules laid down in a book, without submitting himself to the process of Buddhist meditation, would be violating Dharma.

The Kegon-kyō/Avataṁsaka-sūtra says: 'one is all'. This means that a single mantra has immense virtue. When we say that a mudrā contains immense virtue, it means that when a worshipper makes the mudrā, after having meditated in the prescribed manner, its miraculous effect will be produced spontaneously.

For performing the esoteric rites, it is necessary that all the elements of the rite, such as the site, the edifice, the altar, the directions, the orientation of the temple and the altar, the choice of day, the dress, the food (of the worshipper), the cult objects, the offerings, the decoration of the hall, etc. should be perfect and in conformity to the rules. The days of fasting and of not-fasting are determined by the position of the stars. Besides all these material formalities it is indispensable that the worshipper has a firm faith in Dharma. Then only may be produced the miraculous effects resulting from the performance of the esoteric rites. It should not, however, be assumed that one will be able to perform the esoteric rites merely by knowing the meaning of the mudrās.

One and the same mudrā may change signification according to the circumstances in which it is formed. Thus, for example, the mudrā of Butsu-chō 'mudrā of the face of Buddha' is the same as that of Shin-chi-mu-shō 'mudrā of producing the heart without birth' that is made on the chest, for the purpose of meditating on the doctrine of 'no-birth' and of 'no-destruction'. Many others are in the same category, because the meaning of the same mudrā varies according to the mantras/dhāraṇīs uttered by the worshipper and the meditation in which it occurs.

The word *in* 'mudrā' is taken in the meaning of a 'seal of a well decided resolution', in the same way as one fixes a seal on a solemn contract. So the mudrā is just a material formula used for affirming one's resolution to become a Buddha.

In the theory of mudrās, the right hand symbolises the 'world of Buddhas' and the left hand the 'world of human beings'. Every finger has a particular value. The thumb indicates 'infinite space, the void, the ether'. In Buddhism ether is considered to be an element and is identified with the void. The index finger symbolises the element 'air or wind'. The middle finger is the element 'fire'. The ring finger represents the element 'water'. The little finger represents the element 'earth'.

2. MUDRĀS OF THE RITE OF TAIZŌKAI/GARBHADHĀTU

The Taizōkai or 'world of form' is the counterpart of the Kongōkai or 'world of Dharma'. The beings who practise it attain the state of the Buddha but return to this world for saving other men by charity. They are 'equal' to the Buddhas and are 'one with them'.

This part of the book deals with mudrās that the worshipper makes according to certain rules, as he performs the rites before the maṇḍala of Taizōkai.

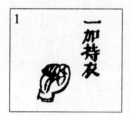

Kaji-i, Kia-chi-yi, **purification of the robes**. The worshipper forms the first mudrā before entering the temple, for purifying the 'robes of the Dharma' or sacerdotal adornments. For this he has to hold the garments with his left hand, while the right one forms the mudrā that consists of closing the fist, the thumb surrounded by the four folded fingers. The gesture so formed is called 'fist of lotus', and symbolises the bottom of the lotus flower. As the lotus that grows in the mire, rises up the mire, so that it may not at all become dirty, so the worshipper should purify his adornments soiled by contacts with men.

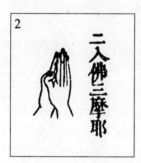

Nyu butsu sammaya, Ju-fo-san-mei ye, **to enter the samaya of the Buddha**. Samaya signifies 'convention, order, contract, engagement' and by extension 'the fundamental resolve of the Buddha, and of his disciples'. Here it implies the idea of identification with the Buddha. This gesture is made by applying the extremities of the four fingers of the two hands one against the other, extended in a manner that a little space is left between the palms, the two thumbs twisted and leaning against the base of the indexes. This mudrā, called Chō butsu fu ni 'the Buddhas and men are one' marks that the worshipper has entered the samaya of the Buddha, that is to say, that he has attained the perfection relative to the fundamental resolution. It is the desire to obtain Bodhi and to make all beings obtain it, to emancipate them from the bonds of transmigration.

Hokai sho, Fa kiai sheng, **mudrā of the production of the world of Dharma**. Called also kayen shō or mudrā of the production of the flame. According to an ancient tradition from India, the body of the fire is triangular. The mudrā of hokai shō consists in forming a

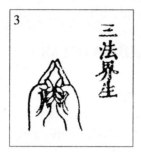

triangle by joining together the tips of the two extended index fingers, the other fingers remaining closed. It symbolises the production of the fire that is meant to destroy all that is impure in the world of Dharma, and to make this world pure and sacred. The index fingers are symbols of the air, and by extension of the wind.

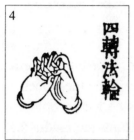

Ten hō rin, Choan fa loen, **turning the wheel of Dharma**. Turning the wheel of Dharma is the teaching of Buddhism, an expression that is generally explained as expressive of 'incessant repetition' of the fundamental doctrines of Buddhism. It is to be noted that the mudrā and the recitation of a dhāraṇī is equivalent to preaching, likewise for the merit that a worshipper derives from it and for the benefit of living beings. The word Dharma is taken here in the sense of the Dharma of Buddhism and wheel in the figurative sense. Indeed the force or the power of the preaching breaks and destroys the bad thoughts and the erroneous and malevolent judgements, 'in the same way as a wheel of iron crushes all that it runs over'. The expression 'turning and returning the wheel of Dharma' is equivalent to preaching. By forming this mudrā of turning the wheel of Dharma, while pronouncing the dhāraṇī accurately, without changing a single letter and with the prescribed intonation, and by performing this rite perfectly, the monk preaches as he wants.

The mudrā consists of joining together the back of both hands by intertwined fingers, the extremities of the thumbs touching each other.

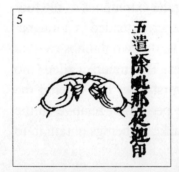

Kenjo Binayakya, Khien chu pi na ye kia, **to drive away the Binayakya**. Binayakya is the name of a very powerful deity, who rejoices in gathering obstacles. He is Gaṇeśa with the head of an elephant. He is capable of assuming different forms. He is malevolent to those who follow Buddhism, and so the worshipper has to chase him away before beginning the celebration of a ceremony. Vināyaka is one of the names of Gaṇeśa. He accumulates obstacles (particularly those of intelligence) when he is not satisfied. He is invoked in the beginning of all undertakings and of books. The Japanese Buddhists distinguish between two Gaṇeśas: the one is an incarnation of Dainichi Nyorai, constitutes a member of the Gon-rui group and is benevolent; the other belongs to the malevolent group of Zitsurui. The second one is spoken of here. He lives on Mount Binayakya-yama. According to a legend Bodhisattva

Avalokiteśvara transformed himself into a woman to seduce and to soften him.

The mudrā is made by two fists of kongō (vajra-muṣṭi) by joining together the hands with the 'finger of the wind', the thumbs are confined within the last three twisted fingers. It produces a 'violent wind', that forces the god to flee away.

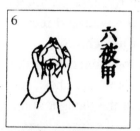

Hi kō, Pei kia, **putting on the armour**. *Hi* signifies 'to cover' and *kō* 'armour'. The god of obstacles having been chased away, the worshipper puts on an armour to become invulnerable. This is why the mudrā has the 'form of a helmet'.

It is made with the hands joined together, the last two fingers twisted and covered by the thumbs, the middle finger extended touching each other at their extremities and the index finger pressing at the back side of the middle fingers.

Another explanation of this mudrā is also given: the ring fingers and the little fingers, twisted in the interior of the hands represent the 'body of the worshipper', and the thumbs that recover them, symbolise the 'void': this signifies that there is a void around the body of the worshipper. The two middle fingers straight up appear like two 'great flames animated by the wind', that is symbolised by the index. So this mudrā signifies that the body of the worshipper is protected by the void and by a scorching flame. This makes him unapproachable and beyond the demons, who are obstacles in the course of the path of Buddhism.The eight good paths explained in the third part of the four excellent virtues, or the four paths to salvation, correspond to the states of Srotāpatti, Sakṛdāgāmin, Anāgāmin and Arhat.

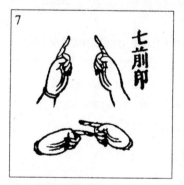

Zen in, Tshien yin, **fastening the armour**. This mudrā is a complement of the preceding: the two gestures that compose it are merely the breaking up of Hi kō. The worshipper pretends to fasten an armour with some cords. After having released the preceding mudrā, first of all he raises the index finger, the three other fingers of each of the two hands and the thumbs being twisted (in the manner shown in the first drawing) and turns them thrice one about the other (second drawing), and utters the Sanskrit mantra *On ton*. *On* signifies 'to arouse', and *ton* 'to attach, to fix'. Then he simulates attaching the cords, while repeating several times this gesture on different parts of his body, for example, at the navel, at the thigh, at the knee, at the chest, at the neck, at the face, etc.

Tō butsu zen san-ge ke, Tao fo tshien chhan hoei kie, **confession before the Buddha and**

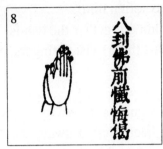

recitation of the gāthā/ke. After having put on the armour, the worshipper presents himself before the Buddha and confesses his sins. The word *san* is an abbreviation of Sanskrit *sanma* (=kṣamā?), which is explained as 'to regret, to confess one's faults'. The term *sange* is Sanskrit *san* and Chinese *ge* 'fault' and in its popular Japanese meaning is 'to repent and rectify oneself'. The ke gāthā is cited in the rite of juhachi-dō.

This mudrā is also called kongō gō shō 'junction of the hands of vajra' (vajrāñjali). It is made by taking the two folded hands to the chest, the extremities of the fingers interlaced. It symbolises the 'concentration of the thought of the worshipper on a fixed idea'.

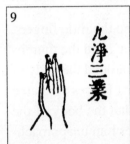

Jo san go, Tsing san ye, **purification of the three things**. This mudrā is also named *Mi be renge gashō* 'junction of the hands of lotus not folded'. It is formed by pressing the folded hands against one another in a manner that some vacant space is left between them, the fingers uniting themselves at their ends, except the middle fingers that remains a little away. This figure is called 'bud of lotus'.

By execution of this gesture, accompanied by the recitation of a dhāraṇī all the physical, mental and verbal actions are made pure: hence it is called the mudrā of the purification of three things. It is given the form of a lotus-bud, because this flower is always pure, although it is born in the midst of mire.

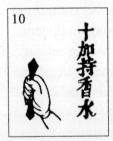

Kaji kō sui, Kia chi hiang shoei, **purification of the perfumed water**. The purpose of this mudrā is to sanctify the perfumed water kept over the altar, by means of a dōkō (one-pointed vajra) that the worshipper holds in his closed fist. The sense of the word *kaji* is 'to make a thing pure and sacred by the power of mysterious Dharmas'.

Shō jō, Shai tsing, **purification by spraying**. The rite of Shō jō consists of spraying in all directions — with a small rod of white wood, called *sanjō* — with a spray of water previously sanctified for purification all that could become impure in the temple, both a being and a thing.

The drawing given above shows the cup of sanctified water with a cover, but at this

moment of the ceremony the cover should be lifted up and kept by the side of the cup on the altar.

Kaji ku motsu, Khia chi kong wu, **purification of offerings**. Same mudrā as of Kaji kō sui, applied with a special dhāranī, for purification and for consecration of offerings kept on the altar.

Haku shō, Pho chang, **clapping**. This mudrā has two objectives: it is an instrument of praise and it serves to frighten or arouse beings. Here it is used in the second meaning that the worshipper strikes the hand for terrifying the demons and the malevolent spirits that may be hovering on the offerings. As its name indicates, it consists of striking the left hand with the right.

Tan zi, Than chi, **hurling the finger (with a noise)**. Here is another form of the idea expressed than done by the preceding mudrā. The fist is closed, the index finger is twisted and pressed with the thumb and suddenly it is made loose (as for giving a blow) then the thumb is released, comes to be supported rapidly against the middle finger and there is a light sound. Although this sound is very feeble it has the same effect as of clapping the hands.

Kō ku, Khin keu, **removing impurities**. After the demons have been scared away from the offerings, there arises the question of removing the impurities left by them. First a general purification is performed by the rite of Kaji ku motsu; the second one brings about a purification of the offerings in each of their elements.

To execute this mudrā, the worshipper twists the little finger and the thumb, making them touch each other, and with the remaining three fingers is formed the figure of a spear with three points or a trident. The two hands simultaneously make the same sign. The right hand is allowed to rest upon the right thigh, and it is the left hand aided by the recitation of the mantra of Kaji 'means of making pure' that removes the impurities deposited on the offerings.

Shō jō, Tshing tsing, **purification**. When the impurities have been removed from the offerings, a more perfect purity is added to them by sprinkling them with sanctified water.

For this the two hands make the posture of the vajra-fist (vajra-muṣṭi, no. 1). The left hand rests on the right thigh, while with the right hand the worshipper holds the rod san-jō (see mudrā 11), plunges it in the sanctified water and sprinkles it over the offerings.

Kō taku, Koang tse, **brilliant light**. The offerings having been purified and sanctified, there remains to confer upon them the quality of 'burning with a perfect colour'. For this the worshipper makes with each of his hands the symbol of the spear with three points (see mudrā 15), takes 'with the lance of the right hand the lance of the left hand' (that is to say touches his left arm with the right hand) and with this three-pointed lance of the left hand gives a magic refulgence to the offerings. The purpose of this rite is to satisfy the Buddhas by providing the offerings with the quality of 'burning with an agreeable colour, by means of the power of the 'brandishing of the lance with three points'.

Mashi ge baku, Mo scheu wai fo, **rubbing the hands and interlacing the fingers**. As the offerings are prepared, the worshipper reads the Hyō haku, 'exposition of the purpose of the ceremony'. Before reading, he rubs with the mudrā of 'interlacing of the fingers'. The rubbing of the hands symbolises the harmony, the interlacing of the fingers forms a round figure, that is of the 'full-moon', this is what

indicates that the spirit of the worshipper does not have any internal sullity, and it is 'full (of purity) like the full-moon'. Having the heart perfectly pure, the worshipper explains to the Buddhas the motifs of the rite performed by him.

Ku yō mon, Kong yang wen, **discourse of the offerings**. Ku-yō is the offering of material objects. After reading the Hyō haku, he reads a formula of offering. While reading this, the worshipper holds in his left hand a rosary, a vajra, and an incense-holder with a handle, conforming to the requirements of the rite that prescribes that the incense-holder is held in the hand during the celebration of the propitiation of the Buddha, or that the offerings are announced to them. The sense of this rite is that the incense is the messenger that carries the real intention of the worshipper to the Buddha. As regards the rosary and the dokō, they do not have any special significance here. They are shown in the figure, since the worshipper always holds them in his hands. He lays down the dokō when it is necessary to be free to form the mudrās. In the drawing, the incense-holder is substituted by a flower of the lotus, a symbol of perfume without equal.

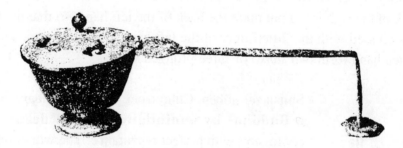

Chou-ri 'Japanese incense-holder'

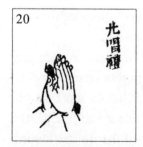

Chō rai, Chhang li, **recitation of compliments**. The names of the Buddhas (invocation mantra) are pronounced with veneration and they are thanked for their beneficial generous intervention. In this circumstance the mudrā consists simply of holding the dokō between the joined hands, as in the rite of vajrāñjali' (see mudrā 8).

Kyō gaku, King kio, **awakening**. The worshipper desiring to invite all the Buddhas to participate in the ceremony should 'arouse' them, that is, he should invite their attention.

The mudrā consists of twisting on the thumb the middle and the ring finger of each hand, raising up the index fingers and drawing hands while curving the little finger. This symbolises the grandeur and the solidity of each, with which is confirmed the firmness of the faith of the worshipper. Then, the ends of the two index-fingers are turned thrice. By virtue of this mudrā, the Buddhas of the infinite worlds are awakened.

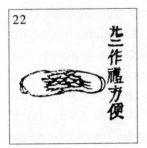

Sarai hōben, Tso li fang pien, **means (of becoming a Buddha) by the salutation (of Buddhas)**. There are nine means or types of acts that lead to the state of a Buddha: act of respect, of adoration, of confession, etc. This is called the 'path of perfection'.

For respectfully saluting the Buddhas, the worshipper forms the mudrā called *San-kō–chō*, that expresses his firm resolution not to go back. When indeed a person remains firm in his resolution to attain mahābodhi 'great enlightenment', by that he manifests his intention to honour all the Buddhas.

The mudrā is formed by turning towards the earth the interior of the open left hand, with the back of the right hand put upon the back of the left hand, so that the thumb of the right hand is crossed with the little finger of the left hand and vice versa. The other three fingers of each hand form two *sankō* or three-pronged vajras.

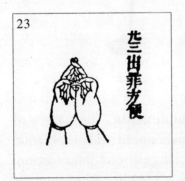

Shitsu zai hōben, Chhu tsoei fang pien, **means (of becoming a Buddha) by annihilation of evil deeds**. It is a real confession with perfect repentance. The worshipper confesses his sins and prays that they be 'exhausted', that is to say, that they be not pardoned, but that they do not remain at all, so that the effects to ensue inevitably are 'destroyed' and that the sins themselves may not be reproduced any more.

The mudrā, called Dai ye tō 'sword of great knowledge' is formed with the two open hands, the fingers raised up. The thumb and the index-finger are folded at their extremities, then the hands are brought together and joined, while making the three other fingers of 'the earth, water and fire' (little, ring and middle fingers) cross each other. This is the symbolic figure of the mystic sword. At the same time the worshipper enters into meditation on the means of destroying sins.

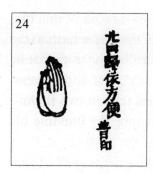

Ki-i hōben, Koei yi fang pien, **means (of becoming a Buddha) by submission**. The worshipper leaves himself entirely into the hands of the Buddhas, and expresses to them his profound gratitude and at the same time forms the mudrā of vajrāñjali' (no. 8).

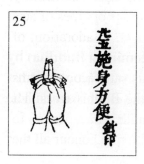

Se shin hōben, Shi shen fang pien, **means (of becoming a Buddha) by offering oneself**. By offering, or consecrating, his person to the Buddhas, the worshipper expresses his resolution to become their disciple, that is, to follow their teachings faithfully.

The mudrā of this is formed by joining the hands firmly, with all the fingers intercrossed, except the middle ones that remain straight up. The joining of hands expresses the firmness of his resolution and the middle fingers raised up symbolise the offering of his person.

Hotsu bodai shin hōben, Fa phu thi sin fang pien, **means (of becoming a Buddha) by the manifestation of the intention of bodhi**. The term bodai is Sanskrit bodhi, and signifies 'knowledge or perfect comprehension'. There are two degrees in bodhi: *ji kaku* 'understanding one's ownself' and *ta kaku* 'making others understand'. The worshipper performs the acts that would be done by a Bosatu/Bodhisattva. Hence he starts with the second stage of the rite of comprehension, the 'manifestation of the intention of bodhi'. The mudrā of 'crossing the hands of the world of the Buddhas and of the world of humans' (the right hand, symbolises the world of the Buddhas, and the left the world of beings), that the worshipper places upon his knee, signifies that the Buddhas and humanity form a single whole, and the same body. The worshipper has become a Buddha, that is to say, has been invested with the qualities of a Buddha for the duration of the ceremony. However, the Shingon sect affirms that the worshipper really becomes a Buddha, in this very life, by long practice of the rites. Strictly this rite can be celebrated

only by an absolute recluse who has been freed of mundane bonds. As a result of this rite, the worshipper causes to be born in his own self the feeling of charity that gives birth to the desire to guide all people to the state of a Buddha, by making them realise the truth that he himself has realised. We recognise here the 'fundamental vow of charity', that distinguishes a perfect Buddha from a Pratyeka-Buddha. This is called *ta kaku* 'great intention of Bodhi'.

This intention is manifested by the mudrā formed by the worshipper by crossing his open hands with their fingers interlaced, the thumbs touching one another at their extremities and the hands placed on the knees with the palms over, the gesture symbolising the idea of 'encircling (protecting, instructing) humanity continually up to the time of attaining the perfect condition of Buddha'.

Zui ki hōben, Soei hi fang pien, **means (of becoming a Buddha) by satisfaction.** Here the worshipper manifests his satisfaction and his recognition of all good by the Buddhas and the Bodhisattvas. The mudrā that he forms is that of vajrāñjali (see mudrā 8).

Kuan shō hōben, Koan tshing fang pien, **means (of becoming a Buddha) by prayer.** After having proved his gratitude for the favours of the Buddhas and Bodhisattvas, the worshipper prays to them to continue to extend their grace upon humanity. He again makes the mudrā of vajrāñjali (see mudrā 8).

Bu jō hōben, Fong tshing fang pien, **means (of becoming a Buddha) by a new prayer.** It is a more powerful and more elevated prayer. The worshipper prays instantly to the Buddhas and the Bodhisattvas to make all the beings of the ten quarters of the world attain the blissful position that they have obtained on their own. The ten quarters of the world are: east, south-east, south-west, west, north-west, north, north-east, zenith and nadir. These 'ten quarters of the world' are different from the 'ten worlds' which are habitations of beings of diverse classes, namely: the world of Buddhas, the world of Bodhisattvas, the world of gods, the world of spirits, the world of men, the

world of asuras, the world of yakṣas, the world of pretas, the world of animals, and the world of hells.

The mudrā of this rite is formed by inserting the fingers of the right hand into those of the left hand. The right index is slightly twisted for indicating the prayer, in the same manner as when one curves one's head. The worshipper makes use of the index, because this finger represents the wind, and therefore implies the idea of rapidity and of generality.

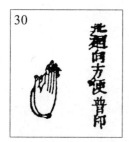

Yekō hōben, Hoei hiang fang pien, **means (of becoming a Buddha) by charity**. By charity, the worshipper renounces the merits of all the good deeds that he has done in favour of all beings. The mudrā is the vajrāñjali (mudrā no. 8).

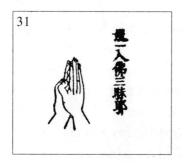

Nyu butsu sammaya, Ju fo san mei ye, **entry into the samaya of Buddha** (see mudrā no. 2).

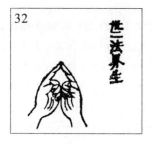

Hōkai shō, Fa kiai sheng, **production of the dharmadhātu** (see mudrā no. 3).

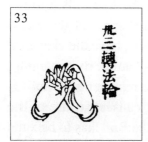

Ten hō rin, Choan fa loen, **revolving the wheel of Dharma** (see mudrā no. 4).

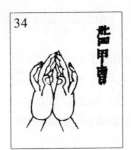

Ha chiu, Kia cheu, **putting on the armour** (mudrā nos. 5 and 6).

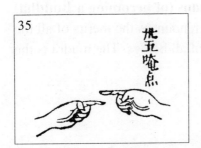

On ton, An tien, **fastening the armour** (mudrā no. 7).

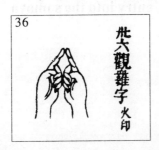

Kuan ra ji, Koan lo tseu, **meditation on the bīja Ra**. In Sanskrit the bīja RA symbolises the 'element or the body of fire'. The mudrā is the same as that of hōkai shō (mudrā no. 3) While the worshipper is meditating on the syllable RA and is pronouncing it, an (invisible) fire is produced at the vertex of the triangle (the body of fire is triangular), formed by his fingers for the purpose of scaring away all that is bad in his person.

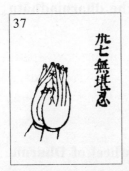

Mu kuan-nin, Wu khan jen, **impatience**. The term *mu kuan-nin* signifies 'ardent courage, impatient eagerness'. The mudrā is made by the worshipper for manifesting his extreme ardour to save beings. He forms it by joining his hands in a manner that a bit of space is left in between them. The fingers slightly cross at their extremities, the thumbs are bracketed and the ring-fingers remain free. This mudrā bears the name *mifu renge gashō* 'junction of the hands as a lotus-bud'. A little space is left between the hands to represent the lotus-bud. The lotus-bud symbolises beings who, at the bottom of their heart, have the character or nature of the Buddhas, but have not yet been able to manifest this nature. By separating the ring-fingers and by moving them to the right and to the left, one represents the movement of water (the ring-fingers symbolise the element water), that causes closure of the lotus-bud, the symbol of the worshipper who causes the qualities of the Buddhas to become

closed in all beings by the power of his faith, of the mudrā, of the mantra and of meditation.

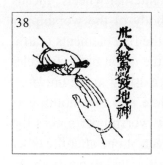

Kyō gaku ji shin, King fa ti shen, **awakening deities of the earth**. As the ceremonies concerning the purification of the interior of the temple have been performed, it is necessary to purify the earth on which the temple is constructed, up to its deepest bed, the first formality to be observed is the 'awakening' of the deities living in the depths of the earth. For this the worshipper knocks at the earth thrice with the thumb of his right hand that is fully open (posture of Śākyamuni, when he summoned the earth to bear witness), while he rests his left hand armed with the dokō (one-pronged vajra) on his left hip (which symbolises the earth).

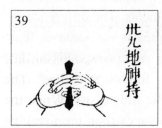

Ji shin ji, Ti shen chi, **deities of the earth and possession of the earth**. The deities of the earth are awakened. Now they are told about taking possession of their domain down to the extreme depths. For this the worshipper crosses the fingers of his hands, without joining them, holds the dokō with them, and he inclines the dokō thrice towards the earth to manifest his intention of taking this possession.

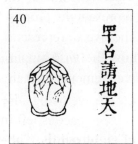

Chō-shō ji ten, Chao tshing ti thien, **invitation to the deities of the earth**. After having affirmed his resolution to take possession of the ground and the basement of the temple, the worshipper invites the deities of the earth to attend the ceremony.

He executes, for this purpose, the mudrā of the bowl (pātra-mudrā), that is made by bringing close the lightly folded hands, so as to make the figure of a bowl which he fills up by his meditation, with (invisible) flowers very much liked by the deities of the earth. He offers them these flowers and then invites them by uttering the 'dhāranī of awakening', while he raises up and lowers down his thumbs thrice, which constitutes the 'mudrā of summoning'.

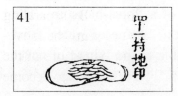

Ji chi in, Chi ti yin, **possession of the earth**. Master of the ground, the worshipper transforms it into the 'earth of kongō' (vajra-bhūmi), or sacred soil, by the mudrā called *sankō shō kongō no in* 'the mudrā of three-pronged vajra (sankō)'.

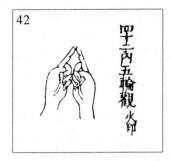

Nai gō rin kuan, Nei wu loen koan, **meditation on the five internal wheels**. The expression 'five internal wheels' means the assimilation of five parts of the body of the worshipper (loins, navel, breast, face and skull) to the five elements (earth, water, fire, air and ether). *Rin* (cakra) is the union of the five elements that contain matter and all forms existing in the universe. The wheel signifies that all is complete and that nothing is wanting (gussoku). In this situation the worshipper makes the mudrā of hōkai shō 'production of the flame' (mudrā no. 3) and directs it one after the other to the above-mentioned five parts of his body to destroy their impurities and to purify them.

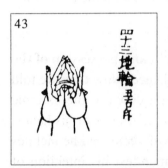

Ji rin, Ti loen, **wheel of earth**. This mudrā and the following four are meant to purify and sanctify the five parts of the body of the worshipper representing the five elements. The difference in the former and the following four mudrās is the same as that between the whole and its parts. The ji rin corresponds to the loins of the worshipper. The mudrā is formed with both the hands. The two middle and the two little fingers are raised up and they are made to touch each other at the extremities, the ring fingers are crossed and join the hands, the thumbs stand up and join each other and index fingers are raised behind the middle ones. The gesture thus formed is called *ge baku gokō* 'external intersection of five-pronged vajra', the fingers standing erect represent the prongs (kō) and the crossed ring-fingers constitute the 'external intersection'. The five *kō* represent the 'bodies of the five Buddhas'. By applying this mudrā on his hips the worshipper communicates to them the 'virtue of the element earth', first of the five elements, that in reality is the 'virtue of the solidity of the intelligence of the Buddhas'.

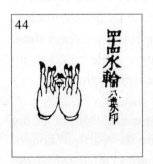

Sui rin, Shoei loen, **wheel of water, mudrā of eight petals**. The worshipper applies this mudrā over his navel for producing in it the full effect of the element water, that is, to purify by washing. For forming this mudrā he raises up all the fingers, joins together his hands by putting together the thumbs and the little fingers against one another. This produces the figure of a 'lotus-blossom'. The worshipper makes use of it, because the 'virtue of water', that cleans things that are dirty, is comparable to the 'virtue of never being sullied', possessed by the lotus.

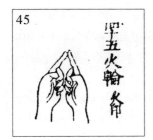

Ka rin, Ho loen, **wheel of fire**. This mudrā of fire is that of 'production of the flame' (mudrā no. 3). The worshipper uses it over his breast for purifying and consecrating it by virtue of the element fire.

Fu rin, Fong loen, **wheel of air**. This mudrā, called the 'revolving wheel of Dharma' (mudrā no. 4), is the symbol of the preaching of the Buddhist Dharma. Since this sermon is identical with the movement of the element air, it is taken to be the symbol of the element air and it is applied on the forehead which is also assimilated with the same element.

Ku rin, Khong loen, **wheel of ether or of the sky**. Here is the mudrā of the 'sword of great knowledge' (mudrā no. 23) considered as a mudrā of the 'principle of the void,' the fifth element. The worshipper applies it at the top of his head for destroying all evil forms and for generating the 'virtue of the principle of the void'. By evil forms are meant the crimes, the accidents, the diseases, and in general all that is not included in the thirtytwo noble forms, or characteristics (*lakṣaṇa*) of the Buddhas.

Ju-ni kushi ji shin in, Shi eul chi kiu tseu shen yin, **mudrā of the twelve parts of the body**. It is also called the 'mudrā of great arrows'. The arrows are represented by the middle fingers bent into the interior of the hands, where they are touched by their external surface; the arch is represented by the index and the intersected ring-fingers, by the two small fingers raised up and joining themselves at the ends and by the thumbs resting upon the index-fingers. With the mudrā of Nai go rin kuan (mudrā no. 42), the worshipper purifies the whole of his person, and with the following five mudrās he starts to clean in detail the five special parts of his body. There remains,

however, the same to be done for twelve other parts, namely: skull, ears, neck, shoulders, front of the throat, breast, navel, hips and feet. He does this by 'hurling the arrows' by this mudrā at the points where some impurities may still exist.

Hyaku ko hō, Po koang gang, **king of hundred lamps**. The 'king of hundred lamps' is the first of the qualities of a Buddha, that the worshipper, having become perfectly pure, aspires to acquire. For this he enters into meditation, applies on his face the vajrāñjali mudrā (no. 8) and utters the Sanskrit *an* (=om). If his vow is realised, miraculous flames of various colours (ordinarily five: white, red, green, yellow, blue) emanate from his face. These are miraculous flames called 'king of hundred lamps', since, just as a king is the most important person of the kingdom, so are all the fires. As regards the formula *an* (=om), it expresses the acquisition of Bodhi.

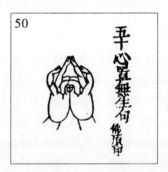

Shin chi mu shō ku, Shin chi wu sheng kiu, **making the spirit without birth, mudrā of Buddha's face**. This is the mudrā of nirvāṇa. Really the expression *mu shō* 'without birth' is an abbreviation of *mu shō mu metsu* 'without birth and without cessation', that is, the state of the spirit of the Buddhas and the same as nirvāṇa. When the worshipper applies this mudrā over his heart and utters the formula an (om), his spirit becomes the spirit of the Buddha.

The mudrā is formed thus: the hands are joined in which the last two fingers are twisted; the middle fingers are raised up and they touch one another at their tips; the index fingers, a little twisted, are supported on the external face of the middle fingers, at the second joint, at which are pressed the thumbs. The circle formed by the middle fingers represents the 'full moon surrounded by flames' (the middle fingers being the element fire), by covering them with the index-fingers (element air), the worshipper makes the fire burn with the wind. The thumbs are considered to be like the body of the worshipper, the little and ring fingers are his seat. This gesture expresses the idea that the worshipper is 'in the middle of the full-moon, surrounded by flames, in perfect possession of the spirit of the Buddha'.

By mistake this gesture is called 'the mudrā of Buddha's face'. The mudrā is very much the same, but here the sense is different.

Kyō hyō risenji, Kiong piao li jan tseu, **showing risenji on the breast**. By this rite, the

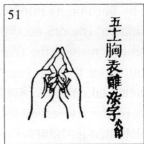

worshipper resolves to obtain the qualities of light and of brilliant colour, in addition to the spirit of the Buddha that he has acquired by the preceding rite, that is to say, he desires to flash the light of infinite intelligence of the spirit of Buddha. For doing this he applies on his heart the mudrā of the 'production of the flame' (mudrā no. 3) and pronounces the mystic syllable RA, symbolic of the element fire.

The term risenji 'word of destruction of impurities' denotes simply the Sanskrit syllable RA: because being the element fire, the character RA burns all that is impure.

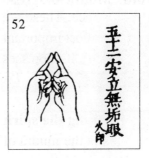

Anryu muku gen, An li wu keu yen, **purifying the eyes**. This mudrā is the same and has the same meaning as the preceding one, except that instead of being applied on the chest, the worshipper places it on his eyes. *Anryu* means 'to put, to place, to construct'. By this mudrā of fire the worshipper burns all that is impure and evil in his eyes.

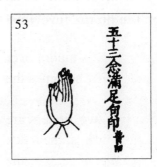

Nen man zoku kon in, Nien man tsu kiu yin, **mudrā of meditation of satisfaction**. *Nen* is the abbreviation of *kuan-nen* 'meditation'. The worshipper meditates on the happiness felt by him on having acquired the spirit of Buddha and affirms this happiness. For this he employs the mudrā of vajrāñjali, that is also called the 'general mudrā' and 'universal mudrā', since it is used every time the worshipper fixes his meditation on a single object.

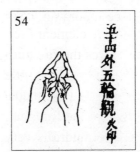

Ge go rin kuan, Wai wu loen koan, **meditation on the five external wheels. Mudrā of fire**. We have seen before how by a series of mudrās, the temple and the worshipper have acquired the requisite qualities. The ground on which the temple stands should also acquire the qualities possessed by the Buddhas, because the Avataṁsaka-sūtra says: "the plants, the trees, the countries, the earth, all may become Buddha". According to the Buddhist doctrine, all that exists in the entire universe, whether animate or inanimate, is capable of becoming Buddha, because every thing has the quality of bodhi in a virtual state. So it is necessary to purify and consecrate the ground of the temple and its hard soil, the four

elements, other than that of the earth, the contents in these terrains, by burning its impure elements with the mudrā of hōkai shō or 'production of the dharmadhātu' (mudrā no. 3). Indeed the objective of this rite is to purify and to consecrate in a general manner the five elements of earth, water, fire, air, and ether or void, while the following five rites are performed with the same intention, with respect to each of the elements taken separately. The mudrās used are the same as those that served for purification of the five elements contained in the body of the worshipper, except that the rites are celebrated in the reverse order. One begins with the element of ether and concludes with the element of earth.

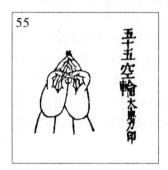

Ku rin, Khong loen, **wheel of the void**. Mudrā of great intelligence (see mudrā no. 47).

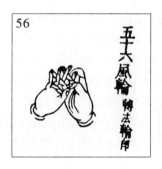

Fu rin, Fong loen, **wheel of air**. Mudrā of Ten hō rin, revolving the dharmacakra (see mudrā no. 46).

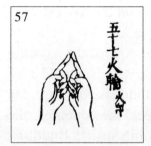

Ka rin, Ho loen, **wheel of fire**. Mudrā of fire (see mudrā no. 45).

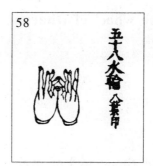

Sui rin, Shoei loen, **wheel of water**, mudrā of eight petals/aṣṭadala (see mudrā no. 44).

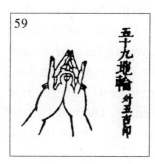

Ji rin, Ti loen, **wheel of earth**, mudrā of the vajra with fire external prongs (see mudrā no. 43).

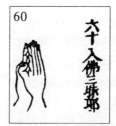

Nyu butsu sammaya, Ju fo san mei ye, **to enter into the samaya of Buddha**. By dual meditation on the internal world and on the external world, the worshipper has acquired complete possession of the spirit of the Buddha. The purpose of the actual rite is to transfer into him all the qualities of a Buddha, namely, the thirtytwo external signs of beauty (lakṣaṇa) of Śākyamuni. The relevant mudrās and the two following ones are included among those that the worshipper has to repeat every time the purpose of the rite changes to stimulate his energy at will, but when he has attained a certain degree of experience he need not repeat them.

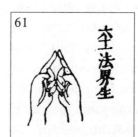

Hokai shō, Fa kiai sheng, **production of the dharmadhātu** (see mudrā no. 3).

Ten hō rin, Choan fa loen, **revolving the wheel of Dharma** (**dharmacakra-pravartana,** see mudrā no. 4).

Dai ye-to no in, Ta hoei tao yin, **mudrā of the sword of great knowledge**. We have already described and explained this mudrā, no. 23. The sword is the symbol of the intelligence of Buddha, because it cuts and destroys evil thoughts, wrong judgments and errors with the same ease as a sword cuts the thing it strikes. By applying this mudrā the worshipper manifests and renders efficacious the action of the 'virtue of knowledge'. The word virtue has the meaning of 'power' and of 'quality' at the same time. We have seen above that the worshipper has acquired perfect possession of the spirit of Buddha, but in a general manner. It should not be confused with the particular case dealt with here.

With regard to the sword, let us mention once for all, that so far as it concerns the Buddhas, it is not an instrument of killing or injuring but simply a metaphor: 'the force of intelligence compared with the cutting blade of a sword'. This holds good for the swords with which the Myō-hō (Vidyārāja) and the Ten (Devas) are armed. They are classes of superior and inferior gods, protectors of the dharmadhātu against the demons.

Hora no in, Fa lo yin, **mudrā of the conch**. This mudrā represents the marine conch called hora or conch (śaṅkha). It is made by bringing the hands close without joining them together, actually in such a manner that the three last fingers of one touch those of the other at the tips; the thumbs are lifted up and the index fingers are twisted to press the thumbs at the root of the nail; one thus forms what is called the 'opening of the conch'. In India the conch served to transmit orders in the guise of a trumpet. This is why it has become the mudrā of the sermon of the Buddha, who leads beings in the battle of salvation, in the same manner in which the conch leads the warriors into battle. By the efficacy of this mudrā, the worshipper acquires 'perfect possession of the virtue of the sermon'.

Ki shō, Ki siang, **beatitude, bliss, mudrā of eight petals (aṣṭadala lotus)**. This mudrā represents a blossomed lotus (see mudrā no. 44) and symbolises 'perfect beatitude,

the satisfaction of all desires'. The Buddhas, who possess the perfection of all virtues, may at their pleasure save the beings and satisfy all their desires, that are compared to a fully blossomed lotus, possessing in a perfect manner the perfume, colour and form, presenting all the agreeable qualities. By this mudrā the worshipper acquires 'perfect possession of beatitude without limit.'

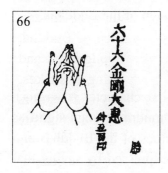

Kongō dai ye, King kang ta hoei, **great knowledge of vajra, mudrā of five external prongs**. This mudrā is the symbol of the intelligence of Buddha solid like the vajra, because there is no force that can prevail upon it — the same holds good for knowledge — in the same manner as the hardness of the vajra resists all efforts.

By purifying and consecrating his spirit by the mudrā of the five-pronged vajra, the worshipper provides a 'real solidity' to his knowledge and acquires the 'virtue of solidity of the knowledge of Buddha'.

The mudrā of dai-ye-to (mudrā no. 63) represents likewise the knowledge of Buddha, but with the sense of 'cutting force', while here it concerns 'solidity'. We should not confuse these two mudrās.

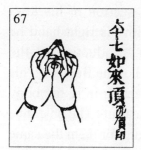

Nyorai cho, Ju lai ting, **head of Tathāgata, mudrā of the Buddha**. The purpose of this mudrā is acquisition of the face of a Buddha. The middle fingers (element fire) standing up and touching one another at the tips, represent the 'blazing halo', the index fingers (element air) standing and supported against the hind face of the middle fingers symbolise the 'activation of the flame', and the ring and little fingers twisted and the thumbs supported against them represent the 'curly hair of the Buddha'. By executing this mudrā the worshipper obtains the 'resemblance of the face (or of the head) of the Buddha'.

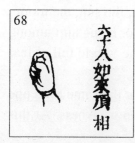

Nyorai chō so (the character so is missing), Ju lai ting, **form of the head of Tathāgata**. Here the subject is the upper part (uṣṇīṣa) of the head of the Buddhas, called *Fu ken chō sō* 'invisible form of the head', because nobody can feel it. The allusion is to a Buddhist legend, according to which Brahmā, in spite of all his efforts, could not see the head of Śākyamuni. One of the characteristic signs of the

Buddhas, it occupies the foremost rank in the ten quarters of the world. This quality of Buddha is acquired by the worshipper by taking the mudrā of the vajra–fist (vajra-muṣṭi) to his face for making himself pure and sacred.

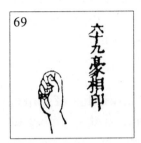

Gō sō, Hao siang yin, **resemblance of hair**. This is the tuft of white hair (ūrṇā) that the Buddhas have on their face between the two eye-brows, whence they emit the rays of light of five colours. By applying the vajra-fist/vajra-muṣṭi (no. 16) between his eye-brows, the worshipper acquires this characteristic sign of the Buddhas.

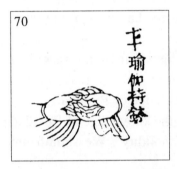

Yoga ji hachi, Yu kia chi po (the first character is wrong), **possession of the pot of yoga**. The mudrā of yoga signifies that the worshipper possesses the virtues of the Buddhas and that he is identical to them. This is expressed by saying that he possesses the pot of Buddha (pātra). The word pātra has become *hachi* in Japanese, and it is translated into Japanese as *ōryo ki* 'instrument of appropriate measure', because the pātra is the bowl which the Buddhas (who live on earth) use for measuring the quantity of rice to be received in alms, as is strictly necessary for food.

For making this mudrā, the monk completely covers with a section of his keṣa (religious robes) his open left hand and palm stretched up, then with his right hand he brings it to his thighs. Then he makes the mudrā of *hokai shō* 'production of the dharmadhātu' (mudrā no. 3), which in reality is the mudrā of the bowl of the Buddha. This mudrā contains the 'flavour of innumerable Dharmas'. When he is eating in it, the body and spirit of the worshipper experience a sensation of indescribable pleasure. The objective of his meditation is to make other living beings taste the same to procure for them the same pleasure.

Se mu i, Shi wu wei, **charity of the destruction of fear**. Fear is innate not only in human beings, but in all that has existence. Birds, animals of all species, men, the sun, the moon, the worlds, all fear continually of being oppressed by one and another, or being hurt among themselves, there is not, a moment without terror. This state is called the 'world full of fear and terror'.

The praise of others, joy, pleasure make one feel agreeable, but at the same time one has fear, one never tastes unalloyed joy. This is a natural lot of human weakness. At this

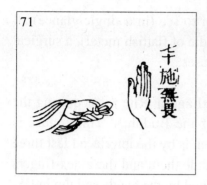

moment, the worshipper raises his self above this world of fear and reaches the world of Buddhas, where he enjoys supreme contentment, to which no other happiness can be compared. He simultaneously rises above praise and slander. He is above pleasure and pain, above joy and sorrow, attains real deliverance from all attachments. This is called the 'world of the Buddha exempt from fear'. Having entered this world without fear, the worshipper should gift this quality of being free from all fear to other beings, and this act bears the name 'charity of the destruction of fear' (See Eug. Burnouf, *Lotus de la bonne Loi*, p. 402 on the subject of the virtue of fearlessness).

The mudrā of this rite is made in this way: the worshipper takes into his left hand the edge of his robe and puts it in the region of his navel. He opens the right hand, extends the five fingers and raises up the arm in a manner that the ends of his fingers reach the top of his head. The five fingers symbolise the five elements (earth, water, fire, air and ether), representing the 'perfect state of the world of Buddha'. Thus by raising his right hand, the worshipper distributes the charity of freedom from fear to all beings, and makes them all enter, without doubt, the world of Buddha, by the force of the Dhāraṇī recited by him and with the mudrā.

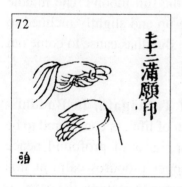

Man gan, Man yuen nin, **full desire**. This rite and the mudrā accompanying it are for obtaining the 'satisfaction of the desires of all beings'. This is the mudrā of charity. The left hand makes the same gesture as in the preceding mudrā, while the worshipper opens his right hand, extends its fingers and presents it outside, by lowering it to the height of his knees. This signifies that he satisfies all beings by giving them his right hand — symbol of the world of Buddha — all that they wish. This is why the gesture of lowering the open right hand is called the mudrā of *yogan* 'giving (satisfaction of) desires'.

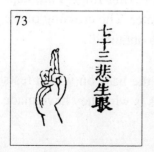

Hi shō gen, Pei sheng yen, **the eyes generate compassion**. Hi shō means 'to produce great compassion', and the eyes of the Buddhas are called the 'eyes of compassion'. This mudrā consists of extending the middle and the ring fingers, closing the other two fingers and the thumb. It expresses the idea that the worshipper sanctifies his spirit by rubbing his eyes with two fingers and makes

his eyes like those of the Buddhas, and acquires the power to see (in a single glance) all beings of the world. This mudrā represents the *kimbei* (needle of flattish metal), a surgical instrument used in ancient India for curing certain eye-diseases.

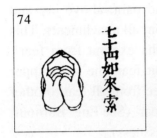

Nyorai saku, Ju lai so, cord of Tathāgata. Rite for acquiring the power of the great compassion of the Buddhas. This mudrā is formed by firmly joining the two hands by the interlaced last three fingers with the thumbs pressed inside them and the index fingers rounded about them. The circle formed by the hands and the index-fingers represents the 'cord', a symbol of the 'great compassion (mahākaruṇā) of Buddha', that embraces all beings without exception, 'as if they were bound together by a cord'. By this mudrā the worshipper acquires a perfect possession of this great virtue of compassion.

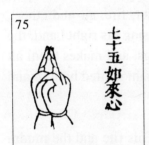

Nyorai shin, Ju lai sin, spirit of Tathāgata. The worshipper resolves to acquire the virtue of the 'great knowledge of the Buddhas', and for this he firmly joins his hands by twisting the fingers with the exception of the middle ones that stand erect and touch one another at their extremities. The joined hands represent the 'spirit of the Tathāgata, full like the full moon'. The middle fingers (element fire) remain standing up and slightly inclined to the right, symbolising the light of the great knowledge that the Buddhas cause to come out of their spirit.

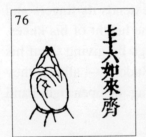

Nyorai hossō, Ju lai tshi, navel of Tathāgata. In Buddhist terminology, the navel, called the 'ocean of life', is considered to be the vital centre. For attaining the happiness of profound peace enjoyed by the Buddhas, the worshipper procures calm at this 'ocean of life' by this mudrā, or in other words acquires the navel of Tathāgata. This mudrā is almost the same as the preceding one, except that in place of the middle fingers the ring fingers are kept standing up, since like the navel they too symbolise the element water. The crossing of the fingers is the symbol of the 'unshakable solidity' of the peace thus obtained.

Nyorai koshi, Ju lai yao, hips of Tathāgata. The hips constitute the base on which rests the whole body, the most solid part of the human frame-work. This is why they have made

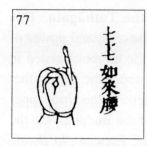

it 'the sure shelter, where the Buddha may stay in peace', while by virtue of this mudrā his body becomes the very body of the worshipper. To execute this mudrā the hands are joined as in the two preceding ones, and only the ring-finger of the right hand is raised up: it represents the worshipper who already resides in the world of Buddha. The other fingers are interlaced and represent his hips, sure and solid habitation of the Buddhas.

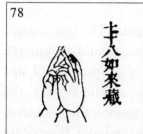

Nyorai zō, Ju lai tshang, **receptacle of the Tathāgata**. The word zō has the sense of 'containing, consisting' and the mudrā of Nyorai zō expresses the idea that the body of the worshipper contains that of the Buddha in the condition of Dharma-kāya. The Buddhas have three bodies: nirmāṇa–kāya, sambhoga-kāya and Dharma-kāya. The last is absolutely spiritual.

To form this mudrā, the hands are joined together by the crossed ring-fingers; the twisted index fingers are supported on the extremities of the thumbs, the middle and the little fingers remain standing and touching one another respectively at their ends. The middle fingers (element fire) represent the flames; the little fingers (element earth) are the errors and faults of men; the thumbs and the index represent ignorance (insufficient knowledge of Dharma). This means that by making this mudrā the worshipper destroys (lit. burns) errors and ignorance and manifests the body of knowledge of the Tathāgata.

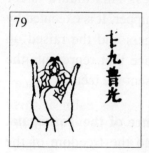

Fu kō, Phu koang, **eternal light**. This is the mudrā of the light that always evolves without being extinguished. It signifies that the light of Buddha envelops the body of the worshipper (like a coat of mail). The middle fingers (element fire) represent the 'body of light', the index fingers (element air) keeps the flame burning; the other fingers represent the body of the worshipper who, while making this gesture, meditates on the light of Buddha that envelops his body.

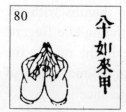

Nyorai kō, Ju lai kia, **helmet of Tathāgata**. Repetition of the mudrā of armour (kavaca-mudrā for purification and consecration): here the worshipper executes only once the kaji instead of practising it on different parts of his body. He puts on the armour of the Buddha as a protection against dangers and defilements.

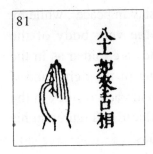

Nyorai getsu, Ju lai she siang, **tongue of the Tathāgata**. This mudrā is to help the worshipper procure possession and power of 'the tongue of the Buddha', represented by the thumbs twisted in a manner that their extremities get pressed under the eight other fingers raised and joined. Due to him the tongue of the worshipper becomes the veritable and infallible tongue of the Buddhas. On the power of the tongue of Buddha, see Burnouf, *Lotus de la Bonne Loi*, Paris 1852:234.

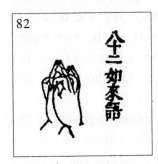

Nyorai gō, Ju lai yu, **speech of the Tathāgata**. The worshipper, in possession of the tongue of the Tathāgata, should acquire the 'veritable utterance of the Buddha'. This is the purpose of this mudrā, which is executed as follows: the middle fingers, the thumbs and the little fingers are raised up, making them touch at their tips respectively, the ring-fingers and the index fingers are twisted, leaving in between them and the thumbs a little space that represents the lips. While the worshipper sanctifies his mouth, by applying this mudrā in it, he acquires the 'miraculous power of the veritable veracious utterance of the Buddhas'.

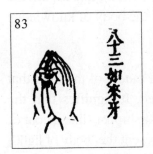

Nyorai ga, Ju lai ye, **tooth of the Tathāgata**. The two (upper) canine teeth of a Tathāgata have the virtue of transforming the strongest poisons into beneficial remedies. This mudrā is for communicating the same virtue to the worshipper. It is executed by taking the hands close, the three last fingers and the raised up thumbs, leaving between them a little space that represents the mouth. The ends of the index-fingers represent the teeth.

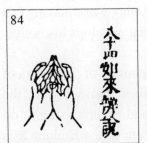

Nyorai benzetsu, Ju lai pien shoe, **eloquence of the Tathāgata**. By eloquence is understood the "ease and the freedom of the sermon of the Dharma". The mudrā is made by bringing the hands close, the last three fingers and the raised up thumbs with the index fingers placed against the back face of the middle fingers. The thumbs represent the tongue. While reciting the mantra the worshipper moves the thumbs lightly to imitate the movement of the tongue and to express symbolically the 'ease and freedom of the utterance'.

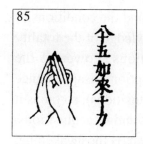

Nyorai ju riki (ṛddhi), Ju lai shi li, **ten powers of the Tathāgata**. By the ten 'infallible virtues' possessed only by the Buddhas is understood a power, that is infinite, that has no equal in the ten quarters of the world. According to the text Chō jō hossu these ten powers are:

1. 'Power of knowing the good and evil results'. Power of knowledge by virtue of which the Tathāgata is able to judge that such actions are good, and consequently produce some satisfaction, and such others are bad and so they do not bring satisfaction. (Burnouf 1852:781f: First power of the science of positions and of non-positions. Power of knowledge of the stable and of the unstable. Power of the knowledge of the just and of the unjust, of the possible and of the impossible).

2. 'Power of knowing the consequences of the actions, past, present and future.' Power of knowledge by virtue of which the Tathāgatas are able to judge without error the consequences to which living beings are subjected or will be subjected by their actions in the three lives. (Power of knowledge of the complete maturity of actions. Knowledge of complete maturity of the works. Knowledge of the degrees or stages that befall (beings) universally. Burnouf 1852:781f.

3. 'Power of knowing the capacity to be free from passions by means of various meditations.' There are profound and less profound meditations. The first are those of the Bodhisattvas, the second are those of the Arhats. This power is the power of knowledge, by virtue of which the Tathāgatas are able to know the quality and the capacity of living beings to be freed from passions by meditation. (Power of knowledge of the faith of all beings. Knowledge of the various respects. Knowledge of multiple elements and of diverse elements. Burnouf l.c.).

4. 'Power of knowing the superiority and inferiority of the spirits.' Power of the knowledge by virtue of which a Tathāgata is able to judge without being mistaken about the superiority or inferiority of the spirit of his disciples and devotees. (Power of the knowledge of multiple elements. Power of knowledge of the various regions. Knowledge of the diverse inclinations or dispositions of beings. Burnouf l.c).

5. 'Power of knowing the capacity of understanding (of Buddhist doctrines) of all beings.' Power of the knowledge by virtue of which a Tathāgata is able to judge without erring the extent upto which living beings are capable of understanding Buddhist doctrines. (Power of knowledge of him who is superior and of him who is inferior by the organs of sense. Knowledge of good and bad organs. Knowledge of diverse measures of the consequences resulting from the determinations to act in the past, present and future. Burnouf l.c.).

6. 'Power of knowing the different worlds.' Power of the knowledge by virtue of

which a Tathāgata is able to judge the homogeneity, the dissimilarity and the conditions of various societies that may exist in the ten quarters of the world. (Knowledge of the totality of contemplations, of liberations, of meditations and of acquisitions. Power of the knowledge that enters into mystic neutrality. Knowledge of the corruption, disappearance (of the obstacles) and of awakening (skill to be awakened from its acquisitions), so far as it concerns the totality of contemplations, of deliverance, of mediations and of acquisitions. Knowledge without obstacles that permits to say: here is corruption, here is the awakening, so far as it concerns the said actions, the contemplations, the salvations, the meditations and the fixed acquisitions. Burnouf l.c.).

7. "Power of knowing all the paths that lead (to salvation)." Knowledge of the stages that can be reached by men and gods of feeble intelligence and Bodhisattvas of great intelligence. (Knowledge of liberation and disappearance of corruption of evil. Knowledge of the measure of superiority or of inferiority of the organs of other creatures, of other individuals. Burnouf l.c.).

8. 'Power of seeing without obstruction with the eyes of heaven'. The heaven that is 'liberty, ease'. The eyes of heaven signifies the power by which a Tathāgata can see the ten quarters of the world without being mistaken. By virtue of this power the Tathāgata sees and judges without fail the birth and death, good and bad deeds of all beings. (Power of knowing the memory of ancient dwellings. Science that reminds of past residences. Recollection of the memory about previous dwellings. Burnouf l.c.).

9. 'Power Mu-rō of knowing the shiku-myō of all beings'. Shiku i.e. 'ancient, past' and myō 'life in the past'. Mu-rō signifies 'absence of evil ideas or of evil deeds of the spirit and of the body' since the Tathāgata is free from passion. This force, therefore, is the knowledge of sufferings, of joys, of births and of deaths of all beings and of the 'I' (Buddhas and other beings) in past existences. (Power of knowing, fallings and births. Science that knows about the transmigration of souls and about birth. Knowledge of the divine intention. Burnouf l.c.).

10. 'Power of being able to cut off for good the shiu–ki'. Shiu-ki means 'the essence of habit'; it is like the perfume that remains in the vessel in which incense has been burnt; in other words this is a fault originating from habit, whether spiritual or physical. The Tathāgata knows the method of destroying these faults of habit and of checking them from being reproduced ever. (Power of destruction of the dirt of vice. Science that knows development and decline. Burnouf l.c.).

The mudrā of this rite — formed by joining the hands with the thumbs and the little fingers, twisted and the other three fingers raised up — symbolises the 'solidity of the ten powers', and it is a simple variation of the Renge go cho 'junction of the hands of

lotus'(padmāñjali mudrā no. 9). If one employs this mudrā of padmāñjali, in place of that of kongō baku in 'solid crossing of the hands', it is because the junction of the hands of lotus represents the spirit of man, and thereby one may express the idea that the worshipper, a man like others, acquires instantaneously the powers of the Buddhas.

Nyorai nen chō, Ju lai nian chhu, **thought of the Tathāgata**. About what does a Tathāgata think? About the identity and homogeneity of all the dharmas, about the equal interest evoked in him by all beings. It is this idea that he tries to manifest in the spirit of the worshipper. For this purpose, the worshipper joins his hands, the last three fingers are raised up and the tips of his index fingers are made to touch the extremities of his thumbs; then he makes the gesture of 'hurling the index' as a spring that is protected. Such is the mudrā of the thought of the Tathāgata.

Issai hō byo dō kai gō, Yi chie fa phing teng, **inspiration of the equality and homogeneity of all dharmas**. This mudrā is meant to impress upon all beings the principle of 'equality and homogeneity of dharmas', the principle which is inculcated in the worshipper by the preceding rite. Hence it is named the 'great mudrā for the conversion of beings.'

Water and void (or ether) being of the same nature, and equal, the worshipper reunites his thumbs (element void) and his ring-fingers (element water) are twisted and the other fingers are raised up. By this gesture accompanied by the recitation of a dhāraṇī, he acquires the power to inspire other beings with this great principle of Buddhism.

Fugen bosatsu nyo ishu, Phu yen ju yi chu, **cintāmaṇi of Samantabhadra Bodhisattva**. Although the name Samantabhadra 'Universal Wisdom' is given to one particular Bodhisattva, all the Bodhisattvas are capable of becoming Samantabhadra Bodhisattvas, on the condition of possessing the virtue of Myō jen fu hen 'miracle of Universal Happiness', because Samantabhadra is the personification of this virtue. Samantabhadra has the power to overwhelm beings with joy by procuring for them all they desire. The worshipper acquires this power by this mudrā and simultaneously the status of a Bodhisattva.

The 'ball of will' is the precious stone nyo i shu, called cintāmaṇi in Sanskrit, which is endowed with the power of producing all things to satisfy beings. It is represented by the figure formed with the two hands by making them touch at their ends, the slightly twisted fingers, symbolic of the elements earth, water, and fire (little, ring and middle fingers) and the index fingers pressed over the back of the middle fingers.

Ji shi bosatsu, Tsheu shi, **bodhisattva of the love for all beings**. This Bodhisattva is Miroku (Sanskrit Maitreya, personification of maitrī 'love for all beings') characterised by his deep love for all beings. The worshipper identifies himself with Maitreya by meditating on his profound love. The mudrā that he forms by his hands coming close without joining one another, with the last three fingers touching one another at their tips and the end of twisted index fingers resting upon the extremities of the thumbs, called stūpa, symbolises the 'spirit of beings'. It signifies that though Buddha resides in the stūpa, 'the essence of the body of Buddha' permeates the spirit of beings. The main concern of Maitreya is to make all creatures know this great truth, an idea expressed by the pagoda with five stages placed in the hand.

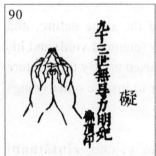

Sanze mu ge riki myo hi, San shi wu ai li ming fei (third Chinese character is wrong), **queen of the power without obstacles in three lives**. By this rite the worshipper penetrates into the 'world of the power wihout obstacles of the three lives'. The three lives are the past, the present and the future, and the power without obstacles is the power of freely exercising his will in these three lives or worlds.

Myo 'clear' (and also light), a translation of the Sanskrit dhāraṇī, expresses the idea that the dhāraṇī possesses the virtues of victory and of light'.

Hi signifies 'queen' and also 'woman'. The characteristic of woman being tenderness, the worshipper borrows from her this character for penetrating into the world of three lives, when he pronounces the dhāraṇī of the queen of the power without obstacles in the three lives. The mudrā is made in the same manner as that of the 'Face of Buddha' (mudrā no. 67).

Mu nō gai riki myo hi, Wu neng hai li ming fei, **queen of the power of invulnerability**. The palm of the open right hand rests on the palm of the left hand. By making this gesture the worshipper acquires the prerogative of becoming invulnerable and inaccessible to the

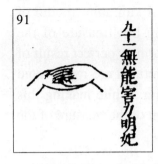

mischief of the evil spirits. Hence it is also called the mudrā of Mu nō chō jō 'to win non-stop'. It is also called the mudrā of the 'basket of books' (Tripiṭaka), because it contains the truth that 'the Buddhas and all beings constitute one and single body', the principle that is preached by the Buddhas of the ten quarters of the world, as the fundamental basis of Buddhism. Indeed it is seen that the left hand that represents beings and the right hand the symbol of the world of Buddhas are closely united in a manner that they form one body and one single mass.

When the worshipper has performed this rite, the Buddhas, the beings and his 'I' are completely equal and homogeneous and form one and the same body. All the beings being equal, nobody and nothing can injure the 'I'; nothing is superior to it. The 'I' (of the worshipper) is then the 'king of all beings and of the whole universe' and forms one and the same body with all beings and with the whole universe.

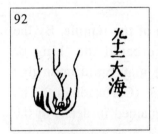

Dai kai, Ta hai, **great ocean**. Up to the present we have been dealing with the perfect possession of the virtues (or qualities) of the body and of the spirit. Now it is necessary to purify and sanctify the temple again, to transform it into 'pure land of Buddha', to invite the Buddhas and to offer them joys and pleasures. This result in obtained by the meditation of transformation or of the great ocean.

For making this mudrā, the worshipper holds his hands towards the earth, his fingers are interlaced, then he shakes a little the eight fingers (the thumbs remaining immobile) for the purpose of imitating the 'waves of waters of eight merits' constituting the great ocean. The drawing of the mudrā is not accurate.

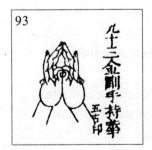

Kongō shi ji ke, Kin kang sheu chi hoa, **flowers held in the hands of vajra**. In this ocean, some lotus flowers have to be grown. This is done by the mudrā of five prongs (no. 43). The drawing alongside represents the open hands; this is an error. It should be closed when one is meditating on the 'lotus-stem'.

Ke dai, Hoa thai, **petals of flowers**. They are of the lotus flowers. The mudrā that makes

them blossom is identical with that of ju-ni kuji shin 'mudrā of twelve parts' (no. 48) and with that of rin bō 'treasure of the wheel'. It is called the mudrā of koruma (karma) 'perfect result of the works and deeds'. The stems of these lotuses are represented by the symbol of *goko* or five-pronged vajra. While making this gesture the worshipper meditates on the form of the treasure of the wheel.

Myo renge hō, Miao lien hoa wang, **king of the flower of the miraculous lotus**. The worshipper meditates on the lotus flowers with eight petals and forms the mudrā of sui rin 'wheel of water' (no. 44). This flower blossoms on the petals of the treasure of the wheel. It has a dimension that covers the dharmadhātu. Hence it is called 'king of the lotus of the world, store of flowers'. The word king expresses superiority.

Dō jō kuan, Tao chhang koan, **meditation of the temple**. By the preceding mudrā, the worshipper has created the 'king of lotus flowers'; now he meditates that he may build upon this marvellous lotus the maṇḍala of Taizō-kai (Garbhadhātu). The formula of the meditation of Dō-jō is explained in detail in the Taizō-kai shi-ki.

Dō-jō is the temple where the worshipper is, and since it is this place where the way leading to the state of Buddha is found, it is called the 'place of path'.

The objective of this meditation is to build the temple of Taizō-kai in thought. The meaning of this mudrā is that the mind of the worshipper is wholly concentrated in meditation and on one and only object.

San riki ge, San li kie, **three powers**. **Universal mudrā**. The three powers are:

1. The power of conduct, that is to say 'performance of rites'.
2. The power of thought of the protection of the Buddhas.
3. The miraculous power of the dharmadhātu.

When a man possesses these three combined powers, nothing is impossible for him in the universe. Hence it is called the 'great

power of the world of mystery'. The harmony of the power of the thought of the protection of the Buddhas and the power of the faith of the worshipper leads to the manifestation of the natural power of the dharmadhātu. Now this natural power of the dharmadhātu exists everywhere in the universe. The Buddhas and the worshipper obtain from it equal impulse. When the worshipper succeeds in balancing these three powers by his faith, he acquires the virtue of miraculous power. At this moment the mystery is performed. The gāthā of these three powers expresses this idea, in which the worshipper meditates while reciting it.

The gesture is that of the 'universal mudrā' (no. 8), that we have already described.

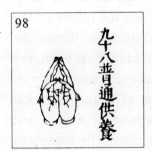

Fu-tsu ku-yō, Phu thong kong yang, **universal offering**. Fu tsu signifies 'to fill completely' (the temple or the place of the path) and ku-yō expresses the idea of decorating this temple with the offering of objects such as banners, dais, lamps, flowers, etc.

With the index fingers slightly twisted and touching one another at the ends, the worshipper meditates upon the precious ball/maṇi. Raising his thumbs he meditates on the banners and on other objects he wishes to offer. From this precious bowl he makes the offerings thus emanated and decorates the temple with them. Hence it is called the universal offering.

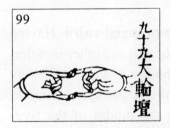

Dai rin-dan, Ta loen than, **great wheel**. The universal offering completed, the worshipper accomplishes the decoration of the temple and completes the offerings by this rite. *Dai* is the adjective 'great', rin-dan is a compound noun: *rin* wheel and *dan* 'wheel, circle, middle, centre, perfect state'; it is in reality a pleonasm.

By making with his hands two fists of vajra (vajramuṣṭi no. 16) and by twisting at their tips the index and little fingers, the worshipper accomplishes the kaji (purification and consecration) of the space of the temple and of his body. By joining together the two fists of vajra he affirms the solidity of his faith

Shu shiki kai dō, Chong se kiai tao, **tracing the limits, or a path, of different colours**. When the temple is decorated, it is necessary to determine the place that each Buddha will occupy. The worshipper determines this place by fixing the limit points with the help of gokō or five-pronged vajra. Then he joins with a line (or a stroke) the five colours (white, red, yellow, green, black or blue) or the blended colours. This operation is called shu shiki kai dō. The temple representing the world of Garbhadhātu has thirteen sections, to be

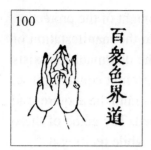

established according to the rules prescribed by Taizō-kai shiki. This mudrā is made by joining the hands in the middle of the twisted ring fingers, the thumbs being bracketed, the index fingers raised up vertically and the middle and little fingers elevated and touching one another at their extremities.

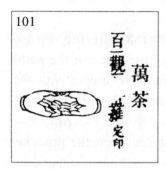

Kuan mandara, Koan wan kong lo (the character for ḍa is wrong), **meditation on the maṇḍala.** When the places of the thirteen sections have been determined and the limits drawn, the worshipper produces the image of each Buddha. First he makes the mudrā of jō 'meditation, trance' to acquire tranquility of spirit. Then he meditates upon the place of Dainichi nyorai (Mahāvairocana) who is to occupy the centre of the temple, and successively upon the places of other Buddhas. The mantra of this meditation is given in the Taizō-kai shiki. Its mudrā is made by putting on the knees the back of the hands in a manner that the fingers of the right hand encroach on the two joints upon those of the left hand, the thumbs touching one another at the tips.

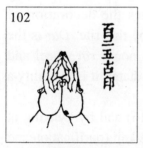

Gokō in, Wu ku yin, **mudrā of the five-pronged vajra.** Having meditated on Dainichi Nyorai (Mahāvairocana) and other Buddhas of the maṇḍala, and having created the bodies of these deities by the power of his meditation, the worshipper perfects his work, purifies and sanctifies it by executing the mudrā of the five-pronged vajra, because this mudrā represents the body of Dainichi Nyorai (Mahāvairocana) who possesses the perfect state of the five knowledges. They are:

1. Hokai tai chō chi 'principle of the knowledge of the dharmadhātu', the collection of the other four knowledges on account of which at times one speaks of only four knowledges in place of five.

2. Dai yen kyō chi 'knowledge of the great circular mirror' that enables one to see (at a single glance) all the beings that exist in the ten worlds. The ten worlds are: 1. World of the Buddha, 2. World of the Bodhisattvas, 3. World of gods, 4. World of superior spirits, 5. World of men, 6. World of inferior spirits/asuras, 7. World of demons/

rākṣasas, 8. World of hungry demons/pretas, 9. World of animals and 10. World of hells.

3. Byō dō chō chi 'knowledge that enables one to consider all beings as equal without distinction'. These two knowledges do not have as their objective any activity nor any action on another.

4. Myo kan sa chi 'knowledge of control and of judgment or of preaching'.

5. Jō chō so chi 'knowledge that one to perform all the acts perfectly': the last two knowledges have as their objective action on others.

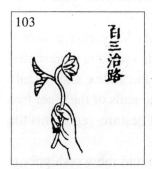

Ji rō, Chi lu, **preparation of the path**. When the maṇḍala has been built and the image of Dainichi Nyorai has been produced in the middle of the maṇḍala, the worshipper is occupied in making the Dainichi Nyorai of the other worlds come into the temple, in order that they be united and mixed up with other deities present and form with them one and single body. He performs this task with the mudrā of *preparation of the path*. As its name indicates, this mudrā has for its objective to level and clean the path by which the Buddhas will come into the temple. For this purpose, the worshipper takes into his right hand the encensoir with handle, burns the incense and lifts the encensoir to the height of his face. In the drawing the encensoir has been replaced by a lotus-flower.

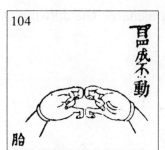

Jō fudō, Chheng pu tong (the first character is wrong), **to become or to make Fudō/Acala**. This rite consists of a series of acts represented by mudrās nos. 104–110. By virtue of them god Fudō Myohō/Acala Vidyārāja gets incarnated in the body of the worshipper to give him the power of scaring away evil spirits and to remove the obstacles that prevent the arrival of the Buddhas.

The first act is to cover the body and the person of Fudō/Acala with clothes. The worshipper does this by sanctifying his own body by applying on his chest the mudrā of Fudō ken or fists of anger.

Fudō Myoho/Acala vidyārāja (Fudō 'immobility, immutability') chief of the deities called Myohō/Vidyārāja or Tembus, transformation of the supreme Buddha Dainichi Nyorai/Mahāvairocana, is charged to fight against evil spirits and perturbing demons of the sacrifice. He is represented as a terrible figure, with two or four arms, armed with a sword and a spear, encircled by a halo of flames, sitting or standing on a rock whence shoots forth a cascade, or some time standing on a dragon.

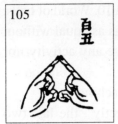

Flames of Fudō/Acala. Then he extends the index fingers from the fists of anger so that they are touched by their tips, he forms a triangle, symbol of fire, and produces in a perfect state the flames of Fudō Myoho/Acala Vidyārāja. He purifies himself by applying this mudrā on his chest, and at the same time uttering the dhāraṇī of RA. which is a Sanskrit bīja meaning 'heat, combustion' which explains how esoteric Buddhism was able to consider it as an equivalent and symbol of Agni 'fire'. Even the character by which it is written has infact received the same sacred mystic value.

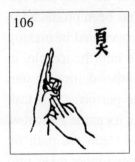

Drawing out the sword. Fudō Myohō/Acala Vidyārāja is armed with a sword for combatting the demons. This sword is represented by the right hand of the worshipper, with the index and middle fingers stretched out, the thumbs twisted on the nails of the other two last fingers. The left hand making an identical gesture, represents the sheath and is put on the left thigh.

In the drawing, the sword is at the thigh and the worshipper is preparing himself for drawing it out.

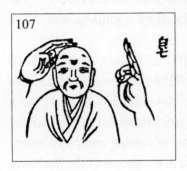

First menace. The worshipper draws out the sword, places it on his right bosom and puts the sheath on his head, making it turn around thrice. This is the first menace. The drawing is badly executed.

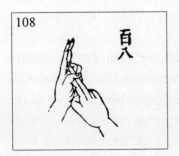

Putting back the sword into the sheath. The worshipper brings out his left hand on his left thigh and puts the sword back into the sheath.

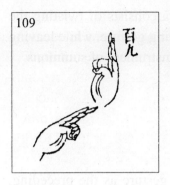

Second menace. The worshipper again draws out the sword and carries it to his right bosom. Then brandishing his sword, he purifies the temple in all its parts, from top to bottom and in the four cardinal points for the purpose of scaring away the demons. In the meantime, the left hand rests on the left bosom.

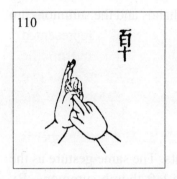

Putting back the sword into the sheath. The demons are in complete flight and the worshipper puts back the sword into the sheath.

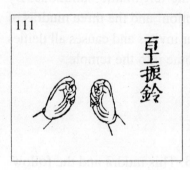

Shin rei, Chen ling, **sounding the bell**. The objective of this act is to awaken the Buddhas, the Bodhisattvas, the deities and the spirits of the ten quarters of the world, and to make them know that they are expected. For ringing the bell, the worshipper holds it in his right hand and the goko (five-pronged vajra) in the left hand and raises them upto the height of his face. The bell and the gokō are missing in the drawing.

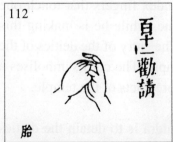

Kuan jō, Koan tshing, **receiving with willingness**. This first gesture, called mudrā of general reception of the Buddhas, Bodhisattvas, gods and spirits of the ten quarters of the world in the temple transformed (by intention) into a paradise of flowers.

The worshipper twists his fingers in the interior of his hands and moves the index of his right hand, while uttering the dhāraṇī of invitation. The movement of the index symbolises the summons.

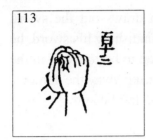

Reception of the Buddhas. This mudrā consists of twisting the fingers inside the hands, as in the preceding gesture, while leaving the thumbs free that in this case are the instrument of summons.

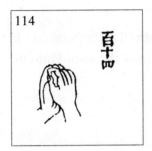

Reception of the Bodhisattvas. Same gesture as the preceding, only the left thumb is twisted inside the hands and the summons are by the right thumb.

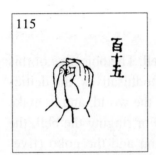

Reception of the deities and the spirits. The same gesture as the preceding, with the difference that the left thumb summons. By forming this mudrā of 'general reception' and the three mudrās of 'particular receptions', the worshipper invites and causes all deities of the ten quarters of the world to come into the temple.

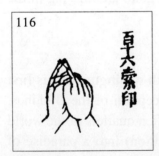

Saku in, So yin, **mudrā of the cord**. This mudrā and the following two are included in a series of rites celebrated in honour of the invited deities. The cord is made by joining together two closed hands and by raising up the index fingers that touch one another at their tips. At the same time, while he is making this gesture, the worshipper meditates on the entry of the deities of the ten quarters of the world into the temple. The cord symbolises a lien that holds the deities within the precincts of the temple.

Sa in, Soo yin, **mudrā of the chain**. The intention of this mudrā is to detain the deities for the longest possible time in the temple, while procuring for them perfect satisfaction.

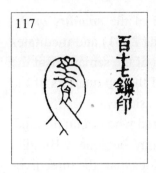

The five closed fingers of both the hands pressed against one another and twisted from the right to the left represent a chain that holds the deities morally.

Rei in, Ling yin, **mudrā of the bell**. The bell arouses the idea of joy and of contentment. But there are two types of joy: to enjoy oneself, and to make others rejoice. These two distinct nuances are certainly found here, but the principal idea is to rejoice at the arrival of the deities in the temple.

The right hand remains open and is turned towards the ground to form an angle with the arm representing the bell, and the thumbs inverted inside the hand represents the clapper of the bell.

Kenjō ju ma, Khien chhu tshong mo, **chasing away the demons who are following the invitees**. The worshipper, fearing that some demon may himself come in along with the deities of the ten quarters of the world, into the temple, where their very presence would sully the sanctity, wants to stop the entry of these mischievous beings and to terrify them he begins again the series of gestures of menace of the mudrā of Fudō Myoho/Acala Vidyārāja (mudrās 108,109, 110).

Ji sammaya, San mei ye, **manifestation of the samaya**. The Sanskrit word samaya signifies four ideas according to traditional Japanese interpretation: 1. the idea of warding off the obstacles, 2. the idea of arousing, 3. the idea of desire or of the main vow, 4. the idea of equality. Here the idea of equality is clear, that is to say, the idea that the worshipper, the deities of the mandala, that he has created and the deities of the ten quarters of the world form one and the same body. The notion of distinction between them has disappeared and does not exist any more.

For manifesting this idea, the worshipper recites the dhāraṇī of the *equality of the three*, makes the mudrā of the purification of the three acts (mudrās 2, 31) and meditates upon the principle of the equality of three. Such is the manifestation of the samaya. But the worshipper is not alone to produce this manifestation: the deities of the ten quarters of the world also do this; hence it is called 'reciprocal manifestation of the samaya'.

By this is to be understood that it is not only the souls of the dead who obtain nirvāṇa, but it is possible to attain it even during the present life. One may become a Buddha without quitting this existence. This is the meaning of the Buddhist idea that 'the three lives form one and the same whole'.

Akka, O kia, **water**. The word *akka* is Sanskrit *argha* and signifies water. On the altar of the temple of the maṇḍala, there is always a pot containing some water. The worshipper holds the pot and its stand on his two hands and raises them to the height of his face, then with his right hand he sprinkles some drops of this water and meditates on the washing that he proposes to offer to each of the deities who have come from the ten quarters of the world.

Argha is one of the eight offerings: 1. *arghya* 'excellent drinking water of a river', 2. *pādya* 'fresh water for washing the feet', 3. *puṣpa* 'flower', 4. *dhūpa* 'incense', 5. *āloka* 'lamp', 6. *gandha* 'perfumed water for anointing the body', 7. *naivedya* 'sacred food', 8. *śabda* 'cymbal or music'. Further in paragraph 136ff we again find six of these offerings beginning with drinking water. The author of our work does not differentiate between *argha* and *pādya*, and calls them by the common name akka. We are concerned here with *pādya*.

The drawing of the mudrā is not accurate. The actual mudrā consists of joining the hands in the form of a cup as shown in figure 140.

Ke za, Hoa tso, **carpet of lotus, mudrā of eight petals (aṣṭadala)**. This mudrā has already been mentioned several times (no. 44). Here its purpose is to offer to each deity, after the bath, a carpet of lotus flowers in the guise of a seat.

Zen rai ge, Shan lai kie, **welcome address, vajrāñjali**. When each deity is seated on his carpet of lotus, the worshipper thanks them and welcomes them by executing the vajrāñjali mudrā (no. 8).

Jō shō ko gō, Chhu chang kia hu pu tong, **strengthening the defences**. The maṇḍala is complete; but the worshipper, fearing the invasion of demons takes new measures of defence, that consist in repeating the mudrās of Fudō Myohō/Acala Vidyārāja (mudrās 108, 109, 110).

Jō ji go shin, Chheng shi ye shen, **persons performing the deeds**. To serve the deities present perfectly the worshipper takes the form of Kongō-satta/Vajrasattva for becoming the 'body that accomplishes the acts'. The acts are the offerings to deities, and he who prepares the offerings is called Kongō-satta. The mudrā is that of goko (five-pronged vajra), which signifies that Kongō-satta/Vajrasattva possesses the power of five knowledges/pañca-jnāna.

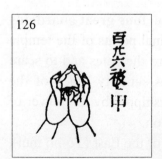

Hi kō, Pei kia, **to put on the armour (kavaca)**. See mudrā no. 6.

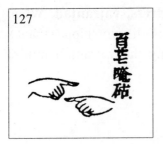

On ton, An chen, **to fasten the armour** (see mudrā no. 7). The two mudrās are made on (his own person transformed into) Kongō-satta/Vajrasattva. They fortify the faith of the worshipper and make him invulnerable to the attacks of demons.

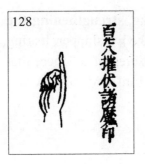

Sai fuku shō ma in, Tshoei fu chu mo yin, **mudrā of victory over demons**. This is the gesture by which Śākyamuni scared away the demons to flight at the moment of his entry into the Great Illumination (Mahābodhi) under the bodhi tree at Bodhgayā, in the kingdom of Magadha. With the help of this mudrā, the worshipper breaks and upsets all that presents obstacles to Buddhism. The index finger of the right hand remains straight up and raised to the level of his nose. It is the symbol of victory over the demons.

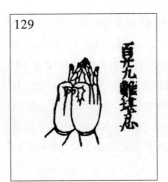

Nan kan-nin, Nan khan jen, **difficult patience**. This mudrā is the same as that of impatience (mudrā no. 37). By forming it the worshipper affirms anew the firmness of his faith in the efficacy of the rites.

Shi hō shi dai kagō, Seu fang seu ta kia hu, **four great guardians of the four directions**. At the four cardinal points of the temple stand the four great gods charged to guard the gates and to scare away the demons who would defile its sanctity. Each of the guardians is born in the spirit of the worshipper by the power of the mudrā, of the dhāraṇī and of meditation.

The first of these gods, called Hero of the East (Tō-bō mui), is created by the mudrā formed by bringing the closed hands close,

with the twisted fingers, except the index fingers that remain straight and touch one another at the extremities and represent a daṇḍa or stick. Armed with this stick, the Hero of the East remains standing at the gate.

Hoppō yie shō fu, Pe fang hoai chu pu, **Destroyer of Fear in the north**, mudrā of the sword of great knowledge. The Destroyer of Fear guards the northern gate. For emanating him, one makes the mudrā of the sword of great intelligence (no. 23). His role is to vanquish the demons by the mudrā of the sword.

Saippō nan gō buku gosha, Si fang nan kiang fu hu che, **Vanquisher of Indomitable Demons, guardian of the west**. The Vanquisher of Indomitable Demons, guards the western gate. The mudrā of the chord (no. 116) creates him. It is represented by the index fingers of the closed hands. Its effect is to bind the demons without letting them move.

Nampō mu kan-nin fugō, Nan fang wu khan jen phu hu, **Universal Guardian Without Patience in the south**. The phrase 'without patience' expresses courage and violence at the same time. The qualificative *universal* is equivalent to 'great'. The mudrā presents the hands close to each other, without being joined, and the index fingers raised up. These two fingers represent the rod, weapon of the god who guards the southern gate.

Mu no shō shu-gō, Sien wu neng sheng sheu hu yin, **invincible guardians**. There are eight deities, two placed at each gate, whose duty is to assist the guardians of the four cardinal points. For emanating them, the worshipper combines two mudrās already known: with the right hand, he makes the vajra-fist/vajra-muṣṭi' (no. 16) while extending the index, and with

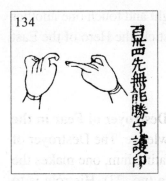

the left hand the fist of anger (no. 104). The index of the vajra-fist taken to the front of the chest of the worshipper simulates the act of knocking; this is the symbol of the rod, with which the worshipper intimidates the demons. The index and little fingers of the left hand that form the fist of anger in the manner that they are twisted to form the gesture called *ge in* or 'mudrā of the teeth' expresses that the worshipper meditates on the means to destroy the demons by biting them or by tearing them off.

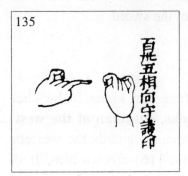

Sō kō shu-go, Siang hiang sheu hu yin, **guardians of the face**. At each gate, before the invincible guardians, are posted two other deities of a lower rank charged to lend them their strong hand. They bear the name guardians of the face. The mudrā that evokes them is the inverse of the preceding one; that is to say that the right hand makes the fist of anger and the left hand the fist of vajra.

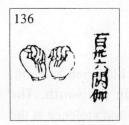

Akka (Sanskrit argha), O kia, **water**. After all the arrangements are made, either for the decoration of the temple or for assuring the guarding of its gates, the worshipper gets busy with making offerings to the invited deities. The first one is that of the akka 'sanctified water'. Its mudrā is the same as that of no. 121; only with the difference that in the first case there is an offering of bath (or of washing the feet) to the deities, while now the akka/argha is meant for quenching their thirst. In the first case we have a real pot of water; here we have just a mudrā to represent a glass that the worshipper fills with 'the perfumed water of eight qualities', by means of the mudrā, dhāraṇī and meditation.

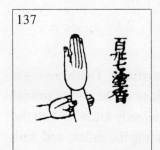

Zu kō, Thu hiang, **anointing with perfumes (gandha)**. Now the body of the deities has to be anointed with perfumes. For this the worshipper opens and raises the right hand, whose five fingers represent the world of the Buddhas, by holding it with the left hand. Then he lowers it gently, while reciting a dhāraṇī and thinking that from the tips of his five fingers springs forth a perfume that sprinkles the body of the deities.

Ke man, Hoa man (corect the second character), **garland of flowers (mālā)**. In the third place one makes an offering of a garland of flowers. The open hands represent a basket and the last three interlaced fingers a garland that the worshipper presents to each deity, while rejoicing in the felicity overwhelming his heart.

Shō kō, Shao hiang, **burning incense (dhūpa)**. The fourth offering consists of burning incense as an offering to the deities. The open hands represent the burning incense; the last three twisted fingers pressing each other at the back represent the smoke of the incense. This offering is prepared separately for each deity.

Bon jiki, Fan shi, **cooked rice (naivedya)**. For the offering of cooked rice, the worshipper joins his hands in the form of a cup, representing a bowl, that is filled supernaturally with cooked rice, by virtue of the dhāraṇī and meditation of the worshipper.

Tō myo, Teng ming, **lamp (dīpa)**. Of all the offerings the most agreeable to the deities is that of the lamp, because the light that dissipates darkness is the symbol of the knowledge of the Buddhas that dispels the darkness of ignorance and error, and removes obstacles.

It is performed in the following manner: the worshipper makes the vajra-fist/vajra-muṣṭi with his left hand that he places on his left thigh. He twists the little finger and the ring finger of his right hand, holds his thumbs on the nails of these two fingers and raises it up by twisting it with the middle finger on the back of which he presses the index. This is the mudrā of the lamp, because the middle finger (element fire) covered with the index (element air) represents the 'fire in action': this offering is prepared for each deity separately. The drawing of the mudrā is badly done.

Fu kuyō, Phu kong yang, **general or universal offering**. After the offerings are over, the

worshipper recites a dhāraṇī and explains the intention of the offering to the deities by executing the mudrā of vajrāñjali.

San, tsan, **eulogy (stotra)**. After the offerings come the praises of the power and merits of each deity. The worshipper begins with the kada/gāthā of praise of Dainichi Nyorai/Mahāvairocana that is found in Taizōkai shiki. The universal mudrā accompanies the recitation of the praise.

Shi chi san, Seu chi tsan, **eulogy of the four knowledges/catur-jñāna**. The four knowledges are: Dai yen kyō chi, Byo dō chō chi, myo kan sa chi, jō chōsa chi (see under mudrā no. 102). The eulogy is common to all deities; since the four knowledges/catur-jñāna precede the 'essential knowledge of the dharma-kāya' of Dainichi Nyorai/Mahāvairocana, and from them flow the 'sixteen knowledges' and these sixteen are the 'knowledges in infinite numbers'. The four knowledges cover all the deities endowed with infinite knowledges. By proclaiming the praise of these four knowledges, the worshipper pronounces, in fact, the praise of all the deities.

Perhaps an objection may be raised that the praise of Dainichi Nyorai will suffice, because that would be equivalent to that of the four knowledges and of all the deities. The error lies in not distinguishing between the 'essence' and the 'secondary'. From the point of view of essence the spirit of the worshipper is Dainichi/Mahāvairocana himself; therefore, the worshipper need not utter the praise of Dainichi Nyorai/Mahāvirocana. Dainichi Nyorai is the 'body of the essence', of which the four knowledges and the others are derived forms. It is natural and correct to praise the 'essence', the primary in the beginning and then their derivatives or secondary ones. It is this that is 'distinction where there is no distinction at all'.

After this eulogy naturally comes the praise of the sixteen knowledges.

Up till now the worshipper has been occupied only with the anterior offerings and he has not yet presented the posterior offerings. In the meantime the deities and the

worshipper taste the pleasure of the feast. The state of satisfaction is manifested by the mudrā of the 'meditation with the objective of becoming Buddha', and by the following mudrās.

Nyu hon-zon kuan, Ju pen tsoen koan, **meditation for becoming Buddha**. By this meditation the worshipper causes transformation of his body into that of the Buddha, who is the patron of the temple. This is one of the most important rites among those of Taizōkai/Garbhadhātu. Its mudrā is that of the 'meditation on the dharmadhātu'.

Konpon in, Ken pen yin, **mūla-mudrā of the five-pronged vajra**. This mudrā represents Dainichi Nyorai/Mahāvairocana, the primary body of all Buddhas. The middle finger of the mudrā of the five-pronged vajra represents the knowledge of the dharma-kāya and the other fingers the four knowledges/catur-jñāna. This mudrā thus represents the perfect reunion of the Five Knowledges or the Five Tathāgatas. This is called the base of Dainichi Nyorai/ Mahāvairocana.

It may be objected that Dainichi Nyorai/Mahāvairocana is the knowledge of the dharma-kāya, that the four knowledges are four Buddhas, and therefore, we do not see any reason for calling this mudrā 'Base of Mahāvairocana'. This objection has no basis, since the four knowledges are simply derived from the knowledge of the Dharma-kāya of Mahāvairocana, who contains in himself all these four knowledges. This is called the 'five knowledges of the complete body'. It is as a seed of the lotus contains in itself the elements of the leaves, of the flowers and of the fruit. The mudrā of five-pronged vajra represents the complete body of five knowledges.

To see the five knowledges in Mahāvairocana is another thing than to see them in one's ownself. They should be seen in the self so that the whole distinction between the worshipper and Mahāvairocana may disappear. When the worshipper attains this state, it may rightly be said that he is Divine, since he manifests the character of Buddha 'who has neither a beginning nor an end', and since he has attained the perfect state of mystery.

Ka ji shu, Kia chi chu, **purification of the rosary**. After the mūla-mudrā, the worshipper recites the appropriate dhāranī, and meditates on its meaning while participating in the joy

of the Buddhas. This is called nenju 'meditation of the recitation'.

The worshipper holds the rosary in both hands, kept on the table by his side, while reciting the appropriate dhāraṇī, and recites the 'gāthā of the merit of nenju'. Then holding it between the thumb and the ring finger of the right hand and between the same fingers of the left hand he utters the dhāraṇī of the purification of the rosary.

Chō nen ju, Cheng nien yong, **true meditation of recitation**. Chō nen ju (*chō* 'true', *nen* 'meditation', *ju* 'recitation of a dhāraṇī') is the condition in which the worshipper finds himself when his heart is pure; and when he meditates on the meaning of the dhāraṇī of Mahāvairocana without being distracted by other thoughts. Counting the beads of the rosary with both his thumbs and both ring fingers constitutes the mudrā of the 'sermon in opportune body', that Śākyamuni practised all his life. The mudrā of chō nen ju manifests the virtue of the 'sermon in opportune body' or of the sermon of Śākyamuni, and its objective is to identify the worshipper with Śākyamuni himself.

Guen shu, Hoan chu fa, **rule for putting back the rosary**. After having counted all the beads of the rosary, the worshipper holds it between his joined hands, and recites a gāthā and puts it again on the table.

Nyu sammaji, Ju san mo ti, **entering samādhi**. After having performed the rite of nenju, the worshipper enters into a state of samādhi. The traditional Japanese interpretation of samādhi is: 'removing obstacles, awakening, equality and fundamental vow'. It is sometimes translated by jō 'absolute tranquility', that is 'purity of spirit', when neither bad thoughts nor erroneous illusions cause any trouble. It has the little used meaning 'engagement, obligation', whence may come the significance 'fundamental vow'. The ideas of 'awakening, warding off obstacles and equality' do not exist in the Sanskrit word. The adjective

sama means 'equal, identical' and in a figurative sense 'just, virtuous'. Having attained the purity of spirit, the worshipper plunges into the meditation of the dharma-kāya of Mahā-vairocana Tathāgata. This is the condition called samādhi. The mudrā of jō (no. 101) is used.

Kon pon in, Ken pen yin, **mūla-mudrā** (no. 146).

Bu mō in, Pu mu yin, **mudrā of the mother of classes**. Having come out of the meditation of the fundamental vow of Mahāvairocana, the worshipper acquires the intelligence that enables one to see all the worlds by making the mudrā of 'mother of classes', that provides the 'five eyes,' namely: 1 the eye of flesh, 2 the eye of heaven, 3 the eye of knowledge, 4 the eye of Dharma, and 5 the eye of Buddha.

The eye of flesh is that of the ordinary person (see description in Burnouf 1852:215–216 ch.17), the heavenly eye is that of the Devas, the eye of knowledge and the eye of Dharma belong to the Bodhisattvas, and the eye of Buddha can be possessed by a person who has attained this supreme rank.

The eye of Buddha had been created by Buddha himself; his power is such that he embraces the ten quarters of the world in all their extensions and he sees across the three lives (past, present and future).

By executing the mudrā of 'five eyes', the worshipper sanctifies himself and he creates for his use the five eyes, represented by the space left in between the fingers. One of these eyes is formed by the space left free between the two little fingers, two are produced by the space between the index and the middle fingers, the remaining ones are the artificial voids created by pressing the thumbs against the index-fingers. It has been named 'mother of classes', because it is formed by the union of the five eyes that can be posessed only by the Buddhas; hence these eyes are considered as 'bearing' all the Buddhas. So they are the 'Mother', and therefore they are the Mother of all beings.

Classes means: 1. The class of the Nyorais or Tathāgatas, 2. The class of the Bosatsu or Bodhisattvas, 3. The class of En-gaku or Pratyeka-Buddhas, 4. The class of Shō-mon or

Sramanas, 5. The class of Ten or Devas, 6. The class of men, etc. In short, the diverse conditions of transmigration commonly designated by the term ten worlds.

It is here that the offerings called *posteriors* are placed. They have to be prepared according to the same rites, as in the case of preceding offerings and therefore the author of the present work Shi-dō-in-zu did not decide to make a fresh enumeration on this behalf.

Yekō hōben, Hoei yang fang pien, **means to cause to turn**. The offerings over, the worshipper performs the rite of the 'means to cause to turn' for causing to turn for the benefit of all beings the noble actions done by him upto this moment, and to make them obtain their reward, as if they had performed them themselves. For this purpose he employs the universal mudrā or the vajrāñjali (no. 8).

Hotsu gan, Fa yuen, **manifestation of desires**. The worshipper explains his desires to the deities by making the universal mudrā.

Kaji ku, Kia chi kiu, **words of purification**. By kaji ku one understands the recitation of the dhāranīs related to purification. The universal mudrā helps further. The worshipper uses it for asking the Buddhas to make him eternally pure. Though he has entered the 'mystery of the unification of his body with that of the Buddha', he is still on the way of trial, and has not attained the *fushi gi*, the 'world that can neither be imagined nor described'. Naturally this demand has to be made before the departure of the Buddhas for their respective paradises.

Che kai, Kiai kiai, **to deliver the world**. We have seen in the beginning of the ceremony that the worshipper purifies and consecrates the ground of the temple and takes possession by the mudrā of impatience (no. 37). When the ceremony is over, the worshipper returns the liberty to the ground by forming the same mudrā again, that he turns inversely while reciting an appropriate dhāranī.

Ji sammaya, Tshi shi san mei ye, **manifestation of the samaya,** see mudrā no. 120.

Rai butsu, Li fo, **salutation to the Buddhas.** The Buddhas (here the word Buddha means all the divinities) will return back to their paradises and the worshipper salutes each one of them individually by executing the universal mudrā (no. 8).

Bu zō, Fong song, **escorting back respectfully.** For seeing off the Buddhas, the worshipper makes the mudrā of 'external crossing of the fingers' (nos. 18, 75) and places a lotus flower on the table, that he holds between his two middle fingers. Then he recites the dhāraṇī of circumstance, throws the flower on the altar and vows that the Buddhas retire to their paradises, borne on this flower.

Nyu butsu sammaya, Ju fo san mei ye, **entry into the samaya of Buddha.** See mudrā no. 2.

Hōkai shō, Fa kiai sheng, **mudrā of production of the dharmadhātu.** See mudrā no. 3.

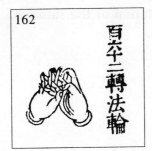

Ten hō rin, Choan fa loen, **revolving the wheel of Dharma**. See mudrā no. 4.

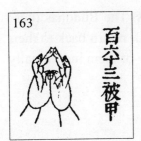

Hi kō, Pei kia**, to put on the armour again**. See mudrā no .6.

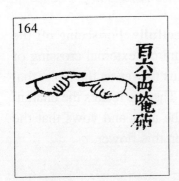

On ton, An chen, **fastening the armour**. See mudrā no. 7.

Ju sa san mitsu ji, **renewal of the three mysteries**. When the ceremony of the Garbhadhātu/Taizōkai is over and before leaving the temple, the worshipper purifies himself so that he may not be exposed to causes of sin. This rite is called 'renewal of the three mysteries', since the worshipper again makes the following three symbols.

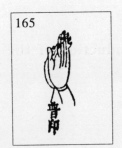

Kongō gō shō, Phu yin, **universal mudrā**. Never to forget that the essence of the Buddha is in his heart (mudrā no. 8).

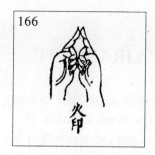

Kayen chō, Ho yin, **mudrā of fire**. To destroy the causes of sin that are in him (mudrā no. 3).

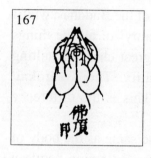

Nyorai chō, Fo ting yin, **mudrā of the head of Buddha**. So that his spirit and body endeavour to attain the state of the Buddha (mudrā no. 67).

These three mudrās are meant to prevent him from forgetting that he should always keep himself pure and be away from evil and that when he goes out of the temple, he will return to the world.

Here ends the commentary of the rite of Garbhadhātu.

3. MUDRĀS OF THE RITE OF KONGŌKAI/VAJRADHĀTU

The term Kongōkai/Vajradhātu 'world of vajra' applies to a maṇḍala, parallel to that of the Taizōkai/Garbhadhātu. The latter is the subject matter of the book entitled *Dai Birushana jun ben kaji kyō* 'Sūtra of the mystery of Mahāvairocana' and the Kongōkai is the subject matter of the book *Kongō-chō-kyō*. The principle developed in the first sūtra is that all living beings have in them the essence (or the essential body) of the Buddhas, whilst the second sūtra has the objective to demonstrate the 'perfect equality' of all the things before the knowledge of the Buddha and to manifest the spirit of great charity resulting from this knowledge that sees all on a footing of perfect equality. The Kongōkai/ Vajradhātu treats 'internal virtues' appropriate to living beings. This is the difference between the two *kai* or worlds.

But the body of the Buddha of the Taizōkai/Garbhadhātu is the same as the body of the Buddha of the Kongōkai/Vajradhātu. Knowing that there is no distinction between these two bodies and that the Taizōkai/Garbhādhatu has the objective of manifesting the 'thousand virtues of the spirit of living beings', it may be concluded that the bodies of Kongō and of Taizō are combined in the 'body of the spirit of living beings'. This is termed the 'body of the real treasure of the maṇḍalas'.

The worshipper being in possession of the virtue of the rite, who meditates on this subject, may acquire the 'mysterious power of the dharmadhātu'. Manifestation of the form of the maṇḍala of this dharmadhātu is called the 'world of divine mystery'.

All that we have said here belongs to the moral world and the real results may not be produced except in the condition that the worshipper has attained the perfection of the moral state.

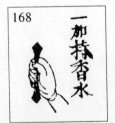

Kaji kō sui, Kia chi hiang shoei, **consecration of the perfumed water**. See mudrā no. 10.

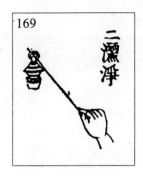 Chō jō, Chai tsing, **purification by sprinkling**. See mudrā no. 11.

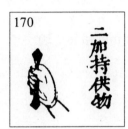 Kaji ku motsu, Kia chi kong wu, **consecration of the offerings**. See mudrā no. 12.

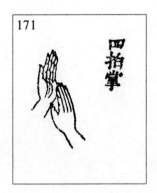 Haku chō, Pho chang, **knocking the hands**. See mudrā no. 13.

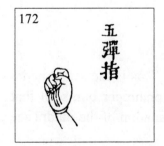 Tan zi, Tan chi, **scaring away the demons**. See mudrā no. 14.

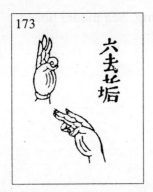

Kō ku, Khiu keu, **purification**. See mudrā no. 15.

Chō jō, Shing tsing, **purification by water**. See mudrā no. 16.

Kō taku, Koang tse, **brilliant light**. See mudrā no. 17.

Jō ji, Tsing ti, **purification of the place**. This is the same mudrā as that of *kuan Ra*. By his virtue the worshipper burns all that is impure inside the temple. For the explanation of the mudrā see no. 36.

Jō san gō, Tsing san ye, **purification of three things**. Same mudrā as no. 9, but here it is badly drawn.

Kuan butsu, Koan fo, **meditating on the Buddhas**. Seated in the temple, the worshipper meditates on the Buddhas of the ten quarters of the world, by executing the vajrāñjali mudrā. He turns his face towards the sky while he is reciting the dhāraṇī, for looking at the Buddhas.

Gniō kaku, King kio, **awakening**. The worshipper awakens the Buddhas to let them know his resolution to perform the rite. See mudrā no. 21.

Shi rai, Seu li, **four salutations**. After having awakened the Buddhas of the ten quarters of the world, the worshipper salutes the Buddhas of the four cardinal points (whence the name four salutations) by invoking them successively: the Buddha of the East, of the South, of the West and of the North. He is to meditate on each of the Buddhas, recite the appropriate dhāraṇī, and make the vajrāñjali mudrā.

Kongō ji dai in, Kin kang chi ta, **the great mudrā, of the possession of the power of vajra**. The worshipper offers to the Buddhas, whom he has saluted, the spectacle of the 'dance of vajra' that consists of three successive mudrās. It starts with that of *kongō ji dai*

in, that he raises high up to the level of his figure. This is the mudrā of *ji ji in*, that is assumed as the material symbol of the 'dance of vajra'.

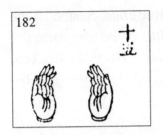

Then he opens his hands, as indicated in the figure, and again raises it up to the level of his face.

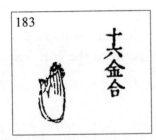

Then he lowers them to the level of his breast, again forms the vajrāñjali mudrā and raises it once again to his face for offering it to the Buddhas.

These last two mudrās are just complements of the first one. While making mudrā no. 182, the worshipper imitates the action of lowering his neck over to his breast an 'ornamented necklace of three vajras', and by mudrā no. 183 he salutes the Buddhas having thus decorated his body.

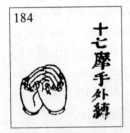

Mashi ge baku, Mo sheu wai fo, **to rub the hands and interlace the fingers**. See mudrā no. 18.

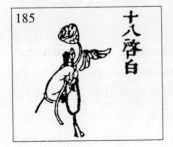

Kei byaku, Khi po, **discourse of offerings**. See mudrā no. 19.

Chō rai, Chhang li, **recitation of compliments**. See mudrā no. 20.

Chō shitsu-ji, Cheng si ti, **excellent result**. *Chō* signifies 'excellent' and *shitsu-ji* (shijji) is Sanskrit *siddhi*, that means 'result, success, accomplishment, perfection, final deliverance'. The prayer of the worshipper requests the Buddhas for their protection in order to succeed in his intentions. As regards the gesture it is the universal mudrā.

Ma ta, Mo cha, **tranquility of knowledge**. These are two Sanskrit words. *Ma* means the same as Japanese *jō* and may be translated as 'state of meditation, state of tranquility, samādhi'. *Ta* is 'knowledge'. The worshipper makes with his hands two vajra-fists (vajra-muṣṭi), applies them on his hips, meditates to place the word *ma* in his left eye and the word *ta* in his right eye, and he looks at the interior of the temple. Then, from his eyes spring forth flames that put the demons and evil spirits to flight.

Kongō baku, Kin kang fo, **external crossing of the fingers of vajra**. Manifestation of purity and generosity of the heart (shin) of the worshipper. Compare mudrā no. 18 which has the same sense, though the form differs slightly.

Kai shin, Khai sin, **opening the spirit**. The idea expressed by this mudrā is that the

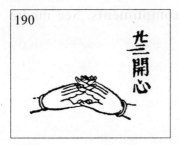

worshipper brightens the ten quarters of the world by opening his spirit. The ten fingers represent the light of the spirit. The mudrā is executed by disjoining the fingers, crossed in the preceding gesture, as shown in the drawing, and by recitation of a dhāraṇī, accompanying this movement.

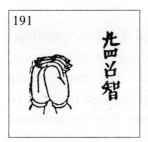

Chō chi, Chao chi, **attracting the knowledge**. Without loosening the foregoing gesture, the worshipper again forms the gesture of 'crossing of the fingers'. This gesture represents the lunar disc of his spirit, in which he — attracts by making the signal of appeal with his thumbs — the knowledge of the Buddhas that fill the ten quarters of the world. The worshipper has to be convinced that he is actually attracting these knowledges into his spirit.

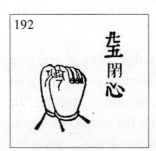

Hei shin, Pi sin, **closing the spirit**. For retaining these knowledges drawn by the foregoing mudrā, the worshipper has to enclose them in his spirit. This mudrā called *disc of the moon of the spirit* is made by tightly pressing the two fists closed with the help of intercrossed fingers: the index fingers press the thumbs to express the idea of closure.

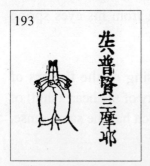

Fugen sammaya, Phu hien san mo ye, **samaya of Samantabhadra**. *Fu* signifies 'universality, totality', *gen* has the meaning of 'supreme bliss, all-pervading wisdom', in other words, fugen is the 'wisdom superior to all wisdoms', that is to say 'the state of the wisdom of the Buddha'. Here *samaya* has the meaning of union. This mudrā symbolises the identification of the body of the worshipper with that of Bodhisattva Fugen/Samantabhadra, personification of the knowledge of equality of Mahāvairocana. The straightened middle fingers raised above the joined hands represent a 'banner', symbol of the knowledge of Buddha. As the banner flies at the head of armies in a battle, so does the knowledge of equality precede all others, while Mahā-vairocana himself utilizes them all to come to help living beings.

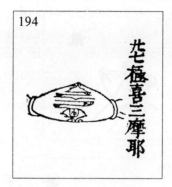

Goku ki sammaya, Ki hi san mo ye, **samaya of extreme joy**. 'Extreme joy' is the extreme love for neighbours that follows acquisition of the knowledge of equality. The samaya of extreme joy is in reality the samaya of Aizen Myohō/Rāga Vidyārāja in which the worshipper enters.

Like its form, this mudrā is the same as no. 94. Only by his meditation the worshipper transforms his coupled middle fingers into an arrow that he draws against his breast, while reciting a dhāranī, with the idea that he will break against his conscience, the egoistic teaching of Hīnayāna and will manifest the 'great resolution of converting beings'. This 'great resolution to convert beings' is the principal sermon preached by Aizen Myohō/Rāga Vidyārāja, personification of the virtue of love of Mahāvairocana.

By love is intended simultaneously, the sentiment of compassion for beings and that of supreme satisfaction realised by protecting them. To convert beings is the vow of all the Buddhas with a great heart.

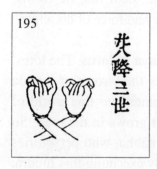

Go-san-ze, Hiang san shi, **to vanquish the three lives**. It is one of a series of samayas that follow those of Aizen Myohō/ Rāga Vidyārāja. Gosanze/Trailokyavijaya (past, present and future) is one of the five devas called Myohō/Vidyārāja. His name literally signifies 'subduer of the three lives'. There are evil spirits, demons who claim to have created the universe and, therefore, to be the directors of the three lives. They glorify themselves with this pretention and seek to violate the 'true dharma of cause and effect (karma)'. For vanquishing and taming them Mahāvairocana enters the samaya of anger. Hence the expression 'to tame the three lives'.

When he is in the samaya of Aizen Myohō/Rāga Vidyārāja, the worshipper protects living beings by 'the great heart of love', having entered the samaya of Gosanze/ Trailokyavijaya, he tames the evil spirits who have propagated and continue to propagate false views.

This mudrā is formed by the 'fists of anger' (mudrā no. 104), with the two hands crossing one another in a manner shown in the drawing. The fist of anger is doubled to give expression to the intensity of extreme anger. This is the gesture made by Gosanze/ Trailokyavijaya.

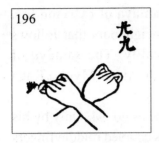

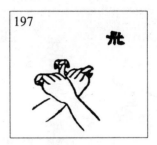

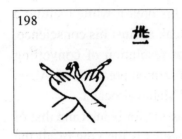

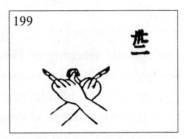

The four drawings represent the transformations that the worshipper effects in the mudrā of Gosanze/Trailokyavijaya by reciting the dhāraṇīs. The teeth that he forms, whether by crossing or by prolonging his fingers, express the intensity and force of his anger.

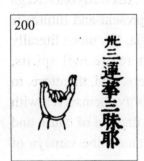

Renge sammaya, Lien hoa san mei ye, **samaya of lotus**. The lotus, taken here in a figurative sense, personifies the virtues of Amida Nyorai/Amitābha Tathāgata, because he comes into this world of misery for saving beings, like the lotus that grows in the mud. So the 'samaya of lotus' is the samaya of Amitābha, who personifies the 'virtue of sermon' of Mahāvairocana. By executing this mudrā, the worshipper enters the samaya of Amitābha.

It is made by joining the two hands with the crossed fingers, except the thumbs and the small fingers, that remain straight up, are twisted, and this figure represents a lotus with a vajra upon it: the thumbs and the little fingers symbolise the vajra, and the joined hands the lotus. Its purpose is to manifest the virtue of Amitābha. Manifesting the virtue of Amitābha is to represent him. Here this gesture is called the mudrā of Amitābha or 'mudrā of the first of the group of lotus' *Renge-bu shu*. Buddhas, Bodhisattvas, Myohō/Vidyārājas, Kongō/Vajra and Ten/Devas are divided into three groups: of the Buddha, of the lotus and of vajra. Amitābha presides over the lotus group (padma-kula).

There are several modes of forming the lotus or 'mother of the lotus' mudrā. In the Kongōkai/Vajradhātu, it is made by joining the hands, pressed by externally interlaced

fingers; in the Taizōkai/Garbhadhātu a little space is left between the hands.

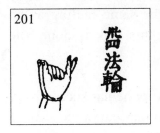

Hō rin, Fa loen, **dharmacakra**. The mudrā of the dharmacakra, derived from the foregoing from which it differs merely by twisting of the little fingers. Dharmacakra is an abbreviation of the sacred phrase 'revolving the dharmacakra' symbolic of the sermon. The worshipper lifts this mudrā to his mouth and takes it to the right thrice, while reciting a dhāraṇī. He is convinced that he possesses the virtue of the sermon of Amitābha and he further meditates to obtain the power of this Buddha. The crossed little fingers represent the 'qualities of charity and of generosity' of Amitābha Buddha and symbolise the expansion of his charity to all living beings.

Dai yoku, Ta yu, **Great Avidity**. This is Kongōsatta/Vajrasattva, who is called 'Great Avidity'. This Great Avidity is the ardent desire of Mahāvairocana to love all living beings as if they are his own children. The samaya of Kongōsatta/Vajrasattva is the manifestation of this ardent desire. For men this desire is relative, that is to say a desire, little extensive, that does not embrace all beings and hence dangerous for society. But the desire of Kongōsatta/Vajrasattva is the Great Avidity without a parallel, pervading all beings at the same time and consists in loving all like a father loves his children.

The mudrā of Great Avidity is that of the 'exterior crossing of the hands' that symbolises here the Heart of Buddha. While the worshipper is reciting the dhāraṇī (of Kongōsatta/Vajrasattva) he makes three appeals with his right thumb. He leaves a little opening between the left thumb and the index finger by which — by force of the dhāraṇī — living beings, whom he considers as his children, come to be reunited in his hands. He proposes to convert them so that all of them have one and the same idea and one and the same sentiment (of kindness and reciprocal love).

Dai raku, Ta lo, **supreme bliss**. This mudrā is the continuation and consequence of the preceding one. Indeed after his extreme avidity of love is satisfied, the worshipper enters into the state of 'supreme bliss' that results from the satisfaction of this desire.

This mudrā is almost the same as that of *Dai yoku*; the only difference is that in this the worshipper closes his hands strongly, for the purpose of retaining the beings drawn by his avidity, of converting them and of inculcating in them the same feeling as he experiences while treating them as his own children. When this task is done, the worshipper enjoys infinite happiness.

Chō zai, Chao tsoei, **summoning of crimes**. After he has successively entered the different samayas, the worshipper comes out of the samaya of Great Love, undertakes to annihilate the crimes and faults of all beings, and for this he 'summons them and unites them in his hands'.

The mudrā that he employs for this purpose is derived from the preceding one. The erection of the middle fingers does not have any particular sense, but the action of folding the index fingers thrice during the recitation of the dhāraṇī expresses the idea of holding the crimes of all living beings in his hands.

Sai zai, Tshoei tsoei, **destruction of crimes**. The mudrā to break and destroy the crimes that the worshipper holds together in his hands is made in the following manner. The worshipper takes his index fingers to their places with the intention of forming 'exterior crossings of the fingers' (mudrā no. 189), then he raises and lowers the middle finger thrice, meditating on the act of crushing and destroying the crimes held within his hands. Recitation of the dhāraṇī always precedes this act.

Jō gō chō, Tsing ye chang, **purification of acts**. This mudrā is a continuation of the preceding one, and is meant for the purification of culpable acts committed by living beings. This is the mudrā of the 'sword of great knowledge' (mudrā no. 23).

Jō bodai, Chheng phu ti, **acquisition of Bodhi**. The living beings having been purified of culpable acts committed by them, the worshipper has to develop in them the spirit of Buddha, whose essence is present in all. The production of the spirit of Buddha is called Bodai/Bodhi. The worshipper makes all living beings

acquire Bodhi. The mudrā is the same as that of the samaya of lotus (mudrā no. 200).

Baku jō in, Fo ting yin, **mudrā of the meditation of the exterior crossing of the hands**. This gesture is so called on account of its form. The worshipper places it on his knees at the moment of entry into meditation of five forms of Kongōkai/Vajradhātu. But, first he has to perform a rite for putting himself in communion with the Buddhas of the World of the Void. This rite and its dhāraṇī are explained in the Kongōkai shiki.

Go sō jō shin, Wu siang chheng, **production of five forms in one's ownself**. The mudrā is the same as the preceding: the worshipper makes it by entering into meditation of the 'production of the five forms in himself'. These 'five forms' are: (1) Tsu datsu bodai shin 'acquisition of the spirit of Bodhi or comprehension', (2) Jō kongō shin 'expansion of the spirit of vajra', (3) Chō kongō shin 'manifesting the spirit of vajra', (4) Ren kongō shin 'pressing the spirit of vajra', (5) Butsu shin yemman 'entry into the perfect state of Buddha'.

The name 'production of the five forms in oneself' is common to the five mudrās numbered 209 to 213. Their objective is to transform the body of the worshipper into the veritable body of Buddha. The mudrā 209, though bearing the general name 'production of the five forms' is particularly of the first of these forms: *tsu datsu bodai shin*.

By the meditation indicated in mudrā no. 208, the worshipper enters into communion with the Buddhas of the World of the Void. These Buddhas teach him 'the form of the spirit of Bodhi' and with this teaching he can acquire the spirit of Bodhi.

Jō renge, Shu lien hoa, **extension of the lotus**. The second of the five forms. Its mudrā is a transformation of the preceding and represents two *sankō* /three-pronged vajras. The worshipper places his left hand on his knees, and the right hand on the left, the hands and the fingers being kept in the position shown in the drawing. Then he meditates to fill with lotus the dharmadhātu of the ten quarters. Simultaneously, he recites a dhāraṇī and raises his right hand upto his face. These gestures are called *jō kongō* 'extending the vajras' and *jō renge* 'extending the lotuses', since according to the form of the mudrās, it relates to the vajra,

while according to the idea it relates to the lotus that presides over the meditation.

Jō signifies 'to extend, to lengthen' and by extension also 'to fill'. The idea affirmed in the mudrā is that the worshipper fills the ten quarters of the dharmadhātu with the lotuses of vajra, sprung forth from his spirit and transforms this world of Dharma into a world of lotus.

Chō kongō renge, Cheng kin kang lien hoa, **manifesting the lotus of vajra**. The third mudrā of the five forms is made by taking the left hand over to the right hand that is kept at the height of the face, each one of them forming a three-pronged vajra/*san-ko*. At the same time the worshipper recites a dhāranī and meditates on the reunion of all the Buddhas, of all living beings and of his own self in the world of lotus of vajra. This is called 'manifesting the lotus of vajra'.

Ren renge, Lien lien hoa, **pressing the lotuses**. The fourth mudrā consists of joining together the two mudrās of the three-pronged vajra to form the mudrā of vajrāñjali of the unblossomed lotus. The worshipper places this mudrā in front of his breast, recites the dhāranī and meditates to collect while compressing them, the 'lotuses of vajra', that fill the dharmadhātu and of putting them in his heart. It is here that we hear about 'pressing the lotuses'.

Kuan shin i honzon, Kuan shen wei pen tsoen, **meditating to become Mahāvairocana**. The mudrā of the fifth form is meant for the worshipper to acquire the perfect state of Buddha. It is made by joining the hands in the form of making a 'sword', with the upright middle fingers pressed by the index fingers. Hence it is named 'mudrā of the sword of Mahāvairocana'. It symbolises the idea that the knowledge of Mahāvairocana comparable to a 'sword with two blades' cuts (destroys) the wrong affirmative judgment and wrong negative judgment. This sword is surrounded by flames (middle fingers) made active by the wind represented by the index fingers. The knowledge of Mahāvairocana is identical with the Spirit of Buddha and 'manifesting the spirit of Buddha in perfect state' and it is for 'acquiring the perfect state of Buddha'. Having attained this state the worshipper has exhausted the meditation of the five forms and has at the same time really become Buddha, as he had resolved.

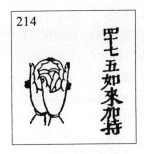

Go Nyorai kaji, Ju lai kia chi, **virtues of the Five Tathāgatas**. Having attained the perfect state of Buddha, the worshipper manifests in himself the Buddhist virtues of Five Tathāgatas. This is called *Go Nyorai kaji*. This expression is applied to the aggregate of Five Virtues, but it designates likewise the first virtue that pertains to Mahāvairocana, the first of the Tathāgatas. The mudrā employed is the same as the preceding, a symbol of Mahāvairocana.

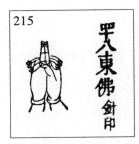

Tō butsu, Tong fo, **Buddha of the East**. The second virtue of the Five Tathāgatas is represented by the mudrā of Ashiku Nyorai/Akṣobhya, Buddha of the region of the east. It is termed the 'mudrā of the needle', because the middle fingers standing erect remind us of this object; though here it does not relate to the needle, but to a 'banner'. In the same way as in war the banner is the first of ensigns, so the Buddhas take as their first emblem the Spirit of Bodhi/Bodhicitta. As the Spirit of Bodhi is the attribute of Akṣobhya, the worshipper takes on the personality of this Buddha, who develops and makes the Spirit of Bodhi to progress in all living beings.

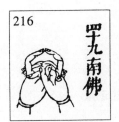

Nan butsu, Nan fo, **Buddha of the South**. The third mudrā of the Five Virtues represents Hōchō Nyorai/Ratnasambhava Tathāgata, the producer of treasures, president of the region of the south. This is likewise a derivative from the mudrā of the 'crossing of hands'. With his twisted middle fingers, the worshipper figures a hōju/mani 'precious ball, a treasure that produces all things' that is to say that Hōchō possesses all the virtues. By the power of meditation of this mudrā the worshipper takes the form of Hōchō Nyorai/Ratnasambhava Tathāgata.

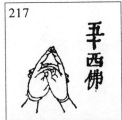

Sai butsu, Si fo, **Buddha of the West**. The Buddha of the region of the west is Amida Nyorai/Amitābha Tathāgata. This is always the primordial mudrā of 'crossing of hands' that is employed, but a figure of a 'leaf of lotus' is drawn by making the middle fingers stand erect. As already said with regard to mudrā no. 200 the lotus symbolises the sermon of Amitābha. While making this mudrā, the worshipper meditates to acquire the virtue of Amitābha.

Hoku butsu, Pe fo, **Buddha of the North**. This is Fuku-jō-ju Nyorai/Amoghasiddhi, who reigns in the region of the north. The mudrā that symbolises it is the same as that of samaya of extreme joy (mudrā no. 194) with the difference that here it represents 'a bird with feathers of gold' (Suparṇa), mount of Amoghasiddhi. The middle ones are the feet of the bird, the little fingers its head, the thumbs its tail, the index and the ring fingers its wings. While mounting this bird, the worshipper assumes love for all living beings and thus becomes this fifth Buddha in person.

Dai nichi, Ta ji, **mudrā of the sword**. See mudrā nos. 213 and 214.

Tō butsu, Tong fo, **Buddha of the East**. See mudrā no. 215.

Nan butsu, Nan fo, **Buddha of the South**. See mudrā no. 216.

Sai butsu, Si fo, **Buddha of the West**. See mudrā no. 217.

Hōku butsu, Pe fo, **Buddha of the North**. See mudrā no. 218.

These five mudrās are exactly the same as the preceding ones except the difference of name. The former ones are called 'rites of kaji' and the latter ones are called 'rites of kanchō'. The worshipper renews them for the purpose of affirming his vow and for assuring their accomplishment.

Nyorai ke man, Ju lai hoa man, **garlands of flowers for the Tathāgatas**, mudrā of Mahāvairocana (see mudrā nos. 213, 214). The worshipper once more executes the same series of five mudrās and after having 'loosened' the mudrās makes the gesture of hanging a garland of flowers from his neck, then he forms the mudrā of the 'junction of the hands of vajra' (mudrā no. 8) to present his garland of wonderful flowers to each of the Five Tathāgatas. See mudrā no. 138.

Tō butsu, Tong fo, **Buddha of the East**. See mudrā no. 214.

Nan Butsu, Nan fo, **Buddha of the South**. See mudrā no. 216.

Sai Butsu, Si fo, **Buddha of the West**. See mudrā no. 217.

Hōku Butsu, Pe fo, **Buddha of the North**. The mudra is left out in the manual. The worshipper prays with mudrā no. 218.

Nyorai hachiu, Ju lai kia cheu, **armour of Tathāgata**. See mudrā no. 34.

On ton, An tien, **fastening the armour**. This gesture is a complement of the former. It has the same meaning as mudrā 35 of the Taizōkai/Garbhadhātu.

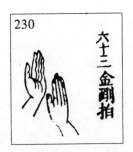

Kongō haku, Kin kang pho, **vajra-clapping**. This mudrā has the same form and the same meaning as no. 13.

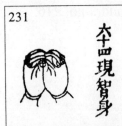

Gen chi shin, Hien chi shen, **manifesting the body of knowledge**. When he has performed meditation of the Five Tathāgatas and has driven away the demons, the worshipper takes on the body of Kongōsatta/Vajrasattva, that is to say he is transformed into Vajrasattva for the purpose of subsequently creating the maṇḍala of Kongōkai/Vajradhātu. This transformation is called *gen chi shin*. The mudrā of the external crossing of the fingers (mudrā no. 18, 189) symbolises the knowledge of the Bodhisattva.

Ken chi shin, Kien chi shen, **visualising the body of knowledge/jñāna-kāya**. The word *gen* (of the preceding mudrā) and *ken* have likewise the meaning 'to show, to manifest', but there is a difference between the two mudrās. The former has only the objective of 'manifesting the body of Kongōsatta/Vajrasattva', while here the matter relates to

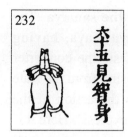

'manifesting the action of the knowledge of Bodhi'. In other words, the preceding symbol is the 'body' and the latter the 'action'.

The gesture represents the 'banner of the knowledge of Bodhi' (see mudrā no. 193).

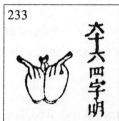

Si ji myo, Seu tseu ming, **lamp of the four words**. In possession of the 'body' and of the 'action' of Kongōsatta/Vajrasattva, the worshipper originates from this body Gosanze Myohō, the luminous king, victorious in the three lives (Trailokyavijaya Vidyārāja), that is, he subdues and reduces into servitude the demons.

The 'four words' are: *jaku, un, ban, koku*. The term *myo*, which is taken here in the sense of 'light' is simply a qualificative, representing the dhāraṇī of these four words. It expresses the sanctity of this dhāraṇī whose four words have the meaning 'light'.

The mudrā, derived from the 'fist of anger' is the same as that of Gosanze Myohō (mudrā no. 198) and necessitates four successive transformations.

First form. While pronouncing the word *jaku* the worshipper curves his little fingers.

Second form. He joins his hands back to back, the index of the right hand remains straight, he makes the sign of appeal by twisting the index fingers and pronounces the word *un*.

Third form. He twists the index fingers uttering the word *ban*.

Fourth form. He pronounces the word *koku* and again joins his hands back to back.

The mudrā of *shiji myo* is an incantation addressed to the demons so that the worshipper is able to catch them in his hands and subdue them.

Ji sammaya, Chhen san mei ye, **manifestation of the samaya**. The worshipper, transformed into Gosanze/Trailokyavijaya, having rendered the demons incapable of injuring, manifests the converter virtue of Kongōsatta/Vajrasattva or *ji sammaya*. Passing from the state of *ken chi shin* to that of *ji sammaya*, he extends the action of the 'knowledge of Bodhi'. In its real sense *ji* means 'to express'. Here it is used in the meaning of 'to show'. 'Samaya' expresses the fundamental vow of Kongōsatta/Vajrasattva and of the worshipper.

This rite consists of two mudrās: the first represents the body of Kongōsatta/Vajrasattva. The straightened middle fingers represent leaves of the lotus considered as the symbol of this Bodhisattva because they are pure as his body.

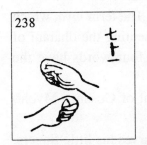

The second is the mudrā of the fist of vajra/vajramuṣṭi (no. 16), the right is supposed to hold a five-pronged vajra (gokō), and the left a bell (rei). We have used the word 'supposed', because these objects do not exist in reality, but are produced by the meditation of the worshipper. The right hand (world of the Buddhas), armed with the gokō, represents the spirits of all living beings, in which the knowledge of Buddha exists in the perfect state. The left hand (material world) shakes the little bell to dispel the illusions and errors of beings. To develop the knowledge of Buddha in the spirit of beings and to dispel their errors is the fundamental vow of Kongōsatta/Vajrasattva.

When the rite is over, the worshipper erects the maṇḍala of Kongōkai/Vajradhātu.

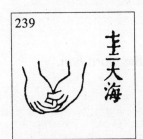

Dai kai, Ta hai, **great ocean**. The creation of the great ocean precedes that of mount Sumeru and the edification of the maṇḍala (mudrā no. 92)

Shumi sen, Siu mi shan, **mount Sumeru**. Mount Sumeru is the Myokō, the Marvellous Height. This mountain, centre of three thousand worlds, emerging out of the ocean of the preceding mudrā, is the terrain on which the maṇḍala will be built. For symbolising the height of mount Sumeru, the stoutly pressed hands are raised up.

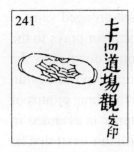

Dō jō kuan, Tao chang koan, **meditation of the temple**. The worshipper having taken mount Sumeru for his residence, constructs over its summit — by the power of his meditation — the temple of the maṇḍala and the maṇḍala itself. The mudrā employed by him is the same as no. 96.

Kongō rin, Kin kang loen, **vajra-wheel**. See mudrā no. 99.

Kei jō, Khi tshing, **solicitation**. The mudrā is the same as the preceding. The worshipper takes it to his breast, while reciting the dhāraṇī for imploring the Buddhas to return, to mount this vajra-wheel, back to the temple constructed by him. He sends this invitation in the skies of the ten quarters of the world.

Kai mon, **opening the gates**. The mudrā consists of making the 'fists of vajra' (no. 16) by twisting the little and index fingers that touch one another at the tips. While he is reciting the dhāraṇī, the worshipper meditates on the act of opening, in succession, the four gates of the temple of the maṇḍala, situated in the east, south, west and north. He represents the opening by separating the index fingers each time.

Kei byaku in, Khi po yin, **mudrā of prayer**. This mudrā consists of crossing the fingers in

a way that they form a figure of the san-kō or three-pronged vajra.

The four gates having been opened, the worshipper prays to the Buddhas of the ten quarters of the world to come down into the temple. The three vajras signify that the worshipper possesses an ardent knowledge of Bodhi. They symbolise also the three groups of Buddha, lotus and vajra. As a result, the worshipper is assumed to possess in his heart these three virtues and it is with this heart that he sincerely requests the Buddhas to come back at his invitation.

Kuan butsu kai ye, Koan fo hai hoei, **meditation on the grand reunion of the Buddhas**. After he has invited the Buddhas, the worshipper meditates on their perfect reunion. The mudrā consists of forming the vajrāñjali (no. 8), that he taken over to his breast, then he stretches out the index fingers. This is this last phase of the gesture that is represented by our drawing.

Chō nyorai shu ye ju-roku dai-bosatsu, Chu ju-lai tsi hoei shi lu ta phu-sa, **reunion of the various Tathāgatas and of the Sixteen Great Bodhisattvas**. The term chō nyorai means the Five Tathāgatas and all other Buddhas. The Sixteen Great Bodhisattvas form four groups of four personages dependant on the four Tathāgatas: Ashiku/Akṣobhya, Hōchō/Ratnasambhava, Amida/Amitābha and Fukujōju/Amoghasiddhi. They are chiefs of the innumerable Bodhisattvas they represent here.

By virtue of this mudrā and of meditation all the Buddhas and Bodhisattvas are reunited in the temple, and the worshipper recites gāthās in praise of each of them.

Shi ji myo, Seu tseu ming, **lamps of the four words**. See mudrā no. 233.

Un, see mudrā no. 234.

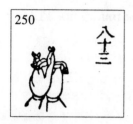

Ban, see mudrā no. 235.

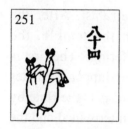

Koku, see mudrā no. 236.

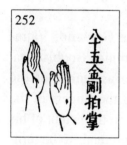

Kongō haku chō, Kin kang pho chang, **vajra-clapping**. See mudrā no. 13.

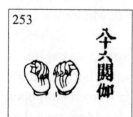

Akka (argha), O kia, **water**. See mudrā no. 121.

Ke za, Hoa tso, **carpet of flowers**. See mudrā no. 122.

Shin rei, Chen ling yin, **ringing the small bell**. See mudrā no. 118.

Ki Bosatsu, Hi phu-sa, **Bodhisattva of Joy,** Vajralāsī. After the reception of the Buddhas and Bodhisattvas in the temple, the worshipper presents them a number of agreeable offerings. The first is the offering of music. For accomplishing this the worshipper emanates a feminine Bodhisattva playing on the flute. He represents the flute by bringing near the face his joined hands with fingers intertwined and the thumbs standing erect.

Man Bosatsu, Man phu-sa, **Bodhisattva of the Garland**, Vajra-mālā. The worshipper then invokes a second feminine Bodhisattva, with a garland of flowers, an offering to the assembly of the Buddhas. The mudrā is formed by intertwining the fingers of the two hands that remain apart, and by raising them to the height of his face; then separating his hands, the worshipper pretends to be turning around (in his fingers) a garland of flowers. See Mudrā no. 138.

Ka Bosatsu, Ko phu-sa, **Bodhisattva of Song**, Vajragītā. A third feminine Bodhisattva is evoked to amuse the holy assembly with the sweetness of her voice. The mudrā is formed with open hands, first raised up to the level of the shoulders and then lowered to the level of the navel. Then the worshipper joins his hands while intertwining the fingers; then he separates them while taking them to his mouth, and on reaching there they are fully separated (cf. mudrā 277).

Bu Bosatsu, Wu phu-sa, **Bodhisattva of Dance**, Vajranṛtyā. The dance before the Buddhas is entrusted to a fourth female Bodhisattva, whom the worshipper likewise emanates by his meditation and by a mudrā executed with the two hands raised up to the level of the breast, the twisted ring fingers touching the thumbs. The worshipper turns them again and again before his breast to imitate the movement of the dance.

These four mudrās are named 'mudrās of the Bodhisattvas of the four offerings'.

Cho ko Bosatsu, Chao hiang phu-sa, **Bodhisattva of Incense**, Vajradhūpā. After evoking the four feminine Bodhisattvas, the worshipper proceeds to the offering of incense, flowers, lamps, perfumes and food. The offering of incense consists of executing a mudrā representing a cloud of incense smoke by vajrāñjali (mudrā no. 8). When the recitation of the dhāraṇī is over, the hands are separated by returning them (as shown in mudrā no. 279), the gesture that is assumed to represent the cloud of sweet smelling smoke.

Ke Bosatsu, Hoa phu-sa, **Bodhisattva of Flowers**, Vajrapuṣpā. For making this offering the worshipper holds his open hands horizontally and imitates the gesture of throwing flowers.

To Bosatsu, Teng phu-sa, **Bodhisattva of the Lamp**, Vajrālokā. The mudrā of this offering consists of joining the hands with intertwined fingers and the thumbs standing erect. The thumbs represent the 'source of light' on which the worshipper meditates to assume the flame.

Zu ko Bosatsu, Thu hiang phu-sa, **Bodhisattva of Perfume**, Vajragandhā. The mudrā of anointing with perfumes is executed by intertwining the fingers of the hands held apart.

By his meditation the worshipper causes to be produced on his body 'perfumed unguent' with which he proposes to anoint the Buddhas and the Bodhisattvas.

Bon jiki in, Fan shi yin, **mudrā of food**. The mudrā of this offering is the same as that of Fugen sammaya (no. 193). A distinction should be made between the two kinds of offerings: the offering of (real) articles and constructive offerings. The offerings enumerated above are of things, because by nature they are the same as the material objects. The offerings that are represented by a mudrā are constructive offerings.

Food is of four kinds: (1) food of touch, (2) food for consumption, (3) food for thought, (4) food of conscience. All that satisfies man by touch is the food of touch; for example, the satisfaction that one has by the touch of beautiful garments. All that nourishes the body by passing through the stomach is the food for consumption. It is called *dan jiki* (*dan* signifies 'stage, distinction, class') in Japanese, because the articles of food that fill the plates are consumed, one by one, just as one ascends a ladder. The food for thought is all that gives satisfaction by imagination, for example, while thinking of a sour fruit one has the sensation of acidity in his mouth. The food of conscience is all that satisfies the spirit and renders the conscience strong and pure.

The food of touch and that of consumption are foods of things, the food for thought and that of conscience are constructive food. The present mudrā represents the food of conscience, since the worshipper has the knowledge of Bodhi, the Buddhas are satisfied in their conscience.

Fu ku-yō, Phu kong yang, **universal offering**. After the special offerings, the worshipper proceeds to make the general offering. Its mudrā is the vajrāñjali. With his hands joined, the thumbs kept erect and the index fingers resting on the middle fingers; the worshipper forms a precious ball from which he causes banners, hangings, etc to come out in unlimited quantity. It is 'the shower of offerings'.

San, Tsan, **praises**, stotra. Recitation of gāthās in praise of the four knowledges of the Buddhas (mudrā no. 144).

Hyaku ji san, Po tseu tsan, **praise in hundred words**. The mudrā is the same as that of the sword of Dainichi/Mahāvairocana (mudrā no. 210). The worshipper praises Mahāvairocana while pronouncing a gāthā of hundred words.

Kon pon in, Ken pen yin, **mūla-mudrā**. This too is the mudrā of the sword of Dainichi Nyorai/Mahāvairocana (for explanation see 213).

Ho ju man, Phong chu man, **offering of the garland of pearls**. The worshipper makes this gesture at the time of reciting the dhāraṇī of Mahāvairocana of the Vajradhātu. The garland of pearls is simply the rosary. The worshipper perfumes the rosary, holds it with his two middle fingers and takes it to his face (see mudrā no. 147). See no. 138.

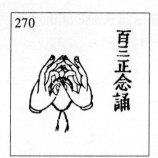

Chō nen ju, Cheng nien song, **true nenju/jāpa**. See mudrā no. 148.

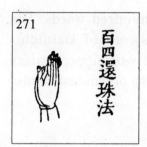

Guen chu hō, Hoan chu fa, **rule for putting back the rosary**. See mudrā no. 149.

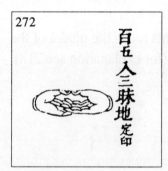

Nyu sammadi, Ju san mei ti, **entering into samādhi**. See mudrā no. 150.

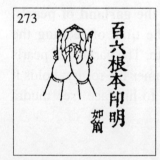

Kon pon in myō, Ken pen yin ming, **mūla-mudrā**. See mudrā no. 263. The word myō added here, indicates that the worshipper recites the dhāraṇī of Kongōsatta/Vajrasattva.

Bu mō in myō, Pu mu yin ming, **mudrā of the mother of the classes**. The same mudrā as that of 152.

Ki Bosatsu, Hi phu-sa, **Bodhisattva of Joy**, Vajralāsī. See mudrā no. 256.

Man Bosatsu, Man phu-sa, **Bodhisattva of the Garland**, Vajramālā. See mudrā no. 257. See no. 138.

Ka Bosatsu, Ko phu-sa, **Bodhisattva of Song**, Vajragītā. See mudrā no. 258.

Bu Bosatsu, Wu phu-sa, **Bodhisattva of Dance**, Vajranṛtyā. See mudrā no. 259.

Chō kō Bosatsu, Chao hiang phu-sa, **Bodhisattva of Incense**, Vajradhūpā. See mudrā no. 260.

Ke Bosatsu, Hoa phu-sa, **Bodhisattva of Flowers**, Vajrapuṣpā. See mudrā no. 261.

Tō Bosatsu, Teng phu-sa, **Bodhisattva of the Lamp**, Vajrālokā. See mudrā no. 262.

Zu kō Bosatsu, Thu hiang phu-sa, **Bodhisattva of Perfume**, Vajragandhā. See mudrā no. 263.

Bon jiki in, Fan shi yin, **mudrā of food**, naivedya. See mudrā nos. 193 and 264.

Fu ku-yō, Phu kong yang, **universal offering**. See mudrā nos. 142 and 265. These ten mudrās are identical with nos. 256–263 and correspond to a new series of offerings.

Akka, O kia, **water**, argha. See mudrā nos. 121 and 136.

Hotsu gan, Fa yuen, **manifestation of desires**. See mudrā no. 154.

Ge kai, Kiai kiai, **liberation of the world**, mudrā of Gosanze/ Trailokyavijaya. By mudrā nos. 195–199 the worshipper has entered into the samaya of Gosanze/Trailokyavijaya to chase away the demons. By forming this mudrā again, he 'loosens' the world that had been 'joined', as the Buddhas are about to depart for their respective heavens.

Bu zō, Fong song, **escorting (the Buddhas) respectfully**. See mudrā no. 159.

Chō nyorai kaji, Chu ju-lai kia chi, **kaji of several Tathāgatas**. Same mudrā and the same meaning as that of mudrā no. 214. The five Tathāgatas are considered as representing all the Buddhas.

Tō Butsu, Tong fo, **Buddha of the East**. See mudrā no. 215.

Nan Butsu, Nan fo, **Buddha of the South**. See mudrā no. 216.

Sai Butsu, Si fo, **Buddha of the West**. See mudrā no. 217.

Hōku Butsu, Pe fo, **Buddha of the North**. See mudrā no. 218.

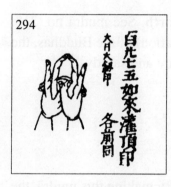

Dainichi nyorai, Wu ju-lai koan ting yin, **mudrā of the sword**. See mudrā no. 219.

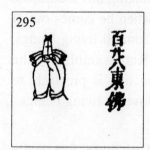

Tō Butsu, Tong fo, **Buddha of the East**. See mudrā no. 215.

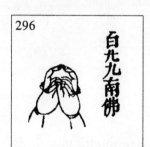

Nan Butsu, Nan fo, **Buddha of the South**. See mudrā no. 216.

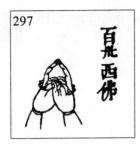

Sai Butsu, Si fo, **Buddha of the West**. See mudrā no. 217.

Hōku Butsu, Pe fo, **Buddha of the North**. See mudrā no. 218. By executing these kaji (rites of purification) of the Buddhas, the worshipper becomes more and more pure and saintly.

Hō in, Pao yin, **mudrā of treasure**. By making this mudrā, the worshipper acquires perfect purity and when he comes out of the temple, he attains respect and love from all living beings. This is the mudrā of Hōshō Nyorai/Ratnasambhava, the Buddha of the South, whose special function is precisely to bestow these two virtues of respect and love on living beings.

Nyorai hachiu, Ju-lai kia cheu, **armour of Tathāgata**. See mudrā nos. 6, 34 and 228.

On ton, An tien, **putting on the armour**. See mudrā nos. 7, 35 and 229.

Kongō haku, Pho chang, **vajra-clapping**. See mudrā nos. 13 and 230.

Si rai, Seu li, **four salutations**. See mudrā no. 180.

4. MUDRĀS OF THE RITE OF GOMA/HOMA

The meaning of the rite according to the goma/homa of Dainichikyō (goma/homa of the present world and of the future world) is as follows. The fire, purified and consecrated with holy water according to the rite of kaji/adhiṣṭhāna (mudrās 3, 10, 12, 155) is considered to be the Fire of Knowledge (or wisdom) of Buddha. With this Fire of Knowledge the worshipper destroys (burns) passions of living beings and makes them all equal to the Buddhas.

There are two goma/homa: the internal homa without form, and the external homa with form. The former is a rite with which the worshipper purifies the world with the Fire of Knowledge by establishing himself in intense samādhi, busy with the syllable *Ram* (see mudrās 51, 105). The second consists of burning in the fire pieces of wood sprinkled with special oil in accordance with numerous rules.

The goma/homa of our book belongs to this last category, called *ge goma* and is subdivided into twelve rites. It relates to the second rite of goma, called the 'cessation of evils'. These evils are of two kinds: those that come from outside (the external world), and those that come from the interior of living beings.

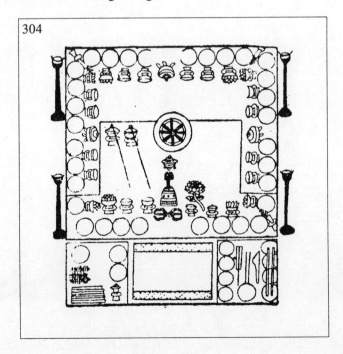

The drawing given above represents the disposition and decoration of the altar for the rite of goma/homa before the celebration of the ceremony.

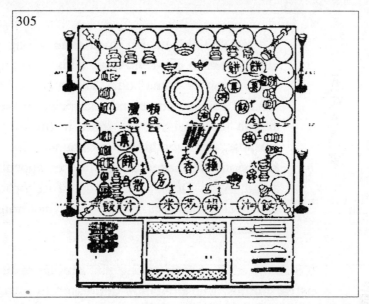

This drawing shows the arrangement of the altar during the course of the ceremony.

Although it is sub-divided into twelve rites, the goma/homa has several forms. The homa of this drawing bears the name *Roku dan siki* 'form of six phases'. At each phase of the ceremony, the worshipper puts some wood into the fire and burns some offerings. Of these six phases, the first three are meant for inviting Ka-ten (Agni) and to pray to them for removal of obstacles. The fourth is the principal goma/homa. In the fifth, offerings are made to the Buddhas, the Bodhisattvas and to superior Devas, except the principal deity. The sixth is meant to make the *Ten*/Devas of this world and the demons of the World of Dark participate in the benefits of this rite. Such in short is the rite of *Roku dan siki.*

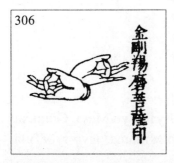

Kongō-karuma Bosatsu in, Kin kang kia mo phu-sa, **mudrā of Bodhisattva Vajrakarma.** This mudrā has to be executed before the fire is burnt. For executing it, the worshipper twists his ring fingers of the two hands by holding them with the thumbs, extends the other three fingers (that represent the five-pronged vajra or gokō) and crosses his arms. This gesture signifies that the worshipper, plunged in the samādhi of Bodhisattva Kongō-karuma/Vajra-karma, constructs the hearth and the altar of the sacrifice with the help of an instrument made of three vajras. Karuma is

the Sanskrit word karma translated by 'work, action', and Bodhisattva Kongō-karuma is the engineer who executes the works to be done in the world of the Buddhas and Bodhisattvas.

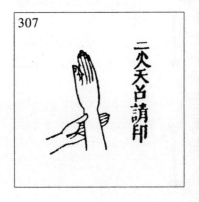

Ka-ten chō shō in, Ho thien chao tshing yin, **mudrā of invitation to Ka-ten/Agni.** This is the first act of the celebration of goma/homa, an invitation to Ka-ten/Agni, God of Fire, to come and take place in the middle of the hearth for receiving his share in the offerings. For this purpose, the worshipper pronounces the dhāraṇī of the occasion and makes the gesture of appeal with the right hand. Agni Deva is invited before proceeding to the principal goma/homa, so that he may not bring any trouble in the ceremony.

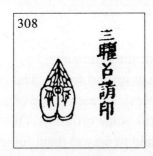

Yō-chō jō in, Yao chao tshing yin, **mudrā of invitation to the astral bodies.** The invitation addressed to astral bodies is the second phase of the ceremony. It has the same purpose and the same meaning as the preceding. The astral bodies are the seven planets (for whom the term yō-chō is applied in particular), and the twelve Kiu/Palaces or Signs of the Zodiac.

1	Sun	Nichi yōchō	Sūrya	Sun
2	Moon	Gachi	Candra	Moon
3	Fire	Ka	Maṅgala	Mars
4	Water	Sui	Budha	Mercury
5	Wood	Moku	Bṛhaspati	Jupiter
6	Metal	Kin	Śukra	Venus
7	Earth	Dō	Śani	Saturn
8	–	Ragō	Rāhu	
9	–	Keitō	Ketu	

10 Signs of the Zodiac: Hōhyō/Kumbha, Sōguiō/Mīna, Byaku-yō/Meṣa, Gōmitsu/ Vṛṣa, Nan-nyō/Kanyā, Bō-gue/Karkaṭa, Shi-shi/Siṁha, Sō-nyō/Mithuna, Hyō-ryō/Tulā, Kat-chien/Vṛścika, Ku/Dhanuṣ, Ma-katsu/Makara.

The mudrā is made by reuniting the hands in the form of a cup, the index

fingers turned against the thumbs. The thumbs are the instruments of appeal for the invitation.

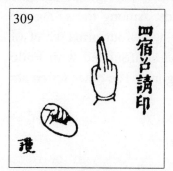

Chiku chō shō in, Su chao tshing yin, **mudrā of invitation to the constellations**. The intention of this invitation is the same as of the preceding. The word chiku designates the constellations. There are twenty-eight chiku/nakṣatras:[1] seven in the east, seven in the south, seven in the west and seven in the north. The worshipper invites them to come to take place in the hearth by reciting a dhāraṇī and by making the gesture of the sword (mudrā no. 109) with the right hand. The index and the middle fingers remain erect and they are the instruments of appeal. The left hand makes the fist of vajra and is placed on the left thigh.

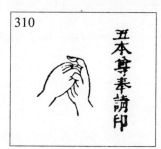

Honzon bu jō no in, Pen tsoen fong tshing yin, **mudrā of the reception of the honzon or principal deity**. This fourth act, the most important of the ceremony, has the objective of inviting Fudō Myohō/Acala Vidyārāja, the chief deity of the rite of goma, to come to take place in the middle of the hearth. At this moment the worshipper meditates on the complete destruction (combustion) of the passions of living beings. The mudrā executed here is the same as 112.

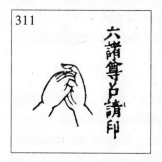

Chosson chō shō no in, Chu tsoen chao tshing yin, **mudrā of invitation to all the deities**. The deities who are invoked by this invitation form three groups: the group of Buddha, the group of Lotus and the group of Kongō/vajra. The worshipper prays them to come to take place 'in the hearth' with the intention of procuring their satisfaction resulting from the burnt-offering. The mudrā is the same as the preceding.

[1] They are 1. Kaku/Citrā, 2. Kō/Svāti, 3. Tei/Viśākhā, 4. Bō/Anurādhā, 5. Shin/Jyeṣṭhā, 6. Bi/Mūla, 7. Ki/Pūrvāṣāḍhā, 8. Tō/Uttarāṣāḍhā, 9. Gō/Abhijit, 10. Nyō/Śravaṇa, 11. Kyō/Dhaniṣṭhā, 12. Kie/Śatabhiṣā, 13. Shitsu/Pūrvā-bhādrapadā, 14. Heki/Uttara-bhādrapadā, 15. Kei/Revatī, 16. Ru/Aśvinī, 17. I/Bharaṇī, 18. Bō/Kṛttikā, 19. Hitsu/Rohiṇī, 20. Si/Mṛgaśīrṣa, 21. San/Ārdrā, 22. Sei/Punarvasu, 23. Ki/Puṣya, 24. Ryu/Āśleṣā, 25. Syō/Maghā, 26. Chō/Pūrvā-phalgunī, 27. Yō ku/Uttara-phalgunī, 28. Shin/Hasta.

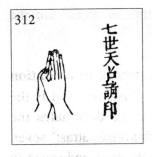

Se-ten chō shō no in, Shi thien chao tshing yin, **mudrā of invitation to deities of the world**. *Se* signifies 'life or world' and *ten* 'deva or deity', therefore the term *se-ten* signifies all the celestial deities living in different worlds. Among the *se-ten* are included Fudo Myohō/Acala Vidyārāja, with four arms, chief of the celestial deities, who should not be confounded with Fudō Myohō, the principal deity of the rite of goma. The other *se-ten* are the Twelve Devas:

Taishaku-ten	Indra	East
Ka-ten	Agni	SE
Yemma-ten	Yama	S
Rasetsu-ten	Nairṛti	SW
Sui-ten	Varuṇa	W
Fu-ten	Vāyu	NW
Bishamon-ten	Vaiśravaṇa	N
Ishana-ten	Īśāna	NE
Bon-ten	Brahmā	Zenith
Ji-ten	Pṛthivī	Nadir
Nichi-ten	Āditya	
Ga-ten	Candra	

Besides the above twelve, the *se-ten* include the nine planets, the twenty-eight constellations and other celestial deities who are dependent on him. The mudrā of this invitation consists in joining the hands and twisting the thumbs. The thumbs serve to make the gesture of appeal to the invited deities to enjoy the satisfaction that the celebration of the rite of goma/homa procures to them.

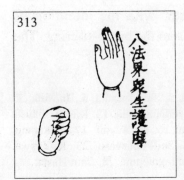

Hō kai shu jō goma, Fa kiai chong sheng hu mo, **goma/homa for all living beings of the dharmadhātu**. Dharmadhātu is the aggregate of all the worlds that exist: because the dharmas are the rules and all exist by virtue of the rules of karma. The living beings, in view here, are the miserable creatures of the dark, such as the gaki (bhūta, preta and piśāca) and the shuras/asura demons, who fill these worlds. The objective of the rite is to provide them some relief with the offerings in the fire,

and to inspire the love of Dharma in them. This is called goma/homa of all living beings of the dharmadhātu. The mudrā of this rite is the same as that of semei (no. 71). The left hand makes the 'fist of vajra' (no. 16).

Kaji bon jiki in myō, Kia chi fan chi yin ming, **mudrā of purification of rice**. By virtue of this mudrā, the worshipper procures rice for miserable beings, whom we have just mentioned. When he recites a dhāraṇī, he relaxes the index finger of his right hand, that is now pressed back by the thumb; and this produces a light sound, signal of the fact that these beings are awakened and that they have been accorded permission to partake of the rest of the offerings (mudrā no. 264).

Shumi sen hō in, Siu mi wang yin, **mudrā of Sumeru**, the king of mountains. As already mentioned above, Sumeru is also called Myō-kō 'marvellous height'. This mountain is called the King, because it is higher than all other mountains.

The elevated right hand represents Mount Sumeru (mudrā no. 240). This gesture is to distribute the remaining offerings to miserable beings living on Mount Sumeru and in its neighbourhood, who were not able to be present at the invitation of the goma/homa of all beings. It is likewise the mudrā of Se-mei (no. 71) and it may be considered to be complementary to the mudrā 313. See no. 240.

Ichi ji sui rin kuan, Yi tseu shoei loen koan, **meditation on one word on the wheel of water**. This word is Ban, essence of water. While meditating on this word and concealing it in the mudrā se-mei, the worshipper produces some 'milk' that he distributes among beings living in the World of Darkness.

5. MUDRĀS OF THE JŪHACHI-DŌ OR EIGHTEEN-STEP RITE

The name jūhachi-dō has been given to this rite on account of its having eighteen essential elements, namely:

(1) Butsu bu sammaya 'samaya of the group of Buddha'.
(2) Renge bu sammaya 'samaya of the group of Lotus'.
(3) Kongō bu sammaya 'samaya of the group of Vajra'.
(4) Ketsu gō shin 'formation of the mudrā of protection of the body'.
(5) Kyō gaku 'awakening'.
(6) Ji ketsu 'consolidation of the earth'.
(7) Kongō chō 'wall of vajra'.
(8) Dō jō kuan 'meditation of the temple'.
(9) Sō cha rō 'despatch of carts'.
(10) Sō cha rō 'prayer for getting into the cart'.
(11) Ge chō 'reception'.
(12) Jō ju ma 'pursuit of the demons'.
(13) Kongō mō 'wall of vajras'.
(14) Ka in 'wall of flames'.
(15) Nyu sammaji '(first) entry into samādhi'.
(16) Kon pon in 'mūla-mudrā'.
(17) Chō nen ju 'true nenju'.
(18) Nyu sammaji '(second) entry into samādhi'.

The whole rite is addressed to one divinity, called Honzon, the principal deity or the fundamental deity. In the rite of Taizōkai/Garbhadhātu, the honzon is Dainichi Nyorai/Mahāvairocana of the Taizōkai, in that of Kongōkai/Vajradhātu he is the Dainichi Nyorai/Mahāvairocana of Kongōkai. For the jūhachi-dō, there is no definite honzon. The selection is left to the choice of the worshipper who invokes the deities, whose functions are mostly in accord with the causes or the variable motifs of the ceremony. In all events, the honzon has only a constructive body, without any material form. So he can never be an image of wood or of stone or of earth or of bronze.

Kaji I, Kia chi yi, **purification of the robes**. See mudrā no. 1.

Jō san gō, Tsing san ye, **purification of three things**. See mudrā no. 9.

Butsu bu sammaya, Fo pu san mei ye, **samaya of the group of Buddha**. According to Esoteric Buddhism, the deities are divided into three main groups: group of Buddhas, group of Lotus (no. 200), group of Vajra.

The group of Buddhas includes all the Buddhas or Tathāgatas of the ten quarters of the world, the group of Lotus all the Bodhisattvas, and the group of Vajra all the Devas (myo-hō and Ten). They are collectively named the 'monument of the three groups'. Here we are concerned with the first group of Buddhas.

For executing the mudrā one forms the junction of the hands of the spirit, that consists in forming a sort of cup with the hands, with the little, ring and middle fingers touching one another, the thumbs pressing against the back side of the middle fingers and the thumbs pressing at the base of the index fingers. The worshipper applies at his face this mudrā, that symbolises the face of Buddha. The fingers of earth, of water and of fire (little, ring and middle fingers) represent the face of Buddha covered with curly hair. The index fingers (of the element air) represent the rays of flashing light that illuminate the face of Buddha.

Renge bu sammaya, Lien hoa pu san mei ye, **samaya of the group of Lotus**. The mudrā, container of all the virtues of all the Bodhisattvas is the same as that of the eight petals

(no. 65). Here the word virtue implies the two-fold sense of 'quality' and of 'power'. The worshipper applies it on his right shoulder.

Kongō bu sammaya, Kin kang pu san mei ye, **samaya of the group of Vajra**. This mudrā contains all the virtues of the Myohō/Vidyārāja and of the Ten/Devas and its form is the same as that of mudrā 22. The worshipper applies it over his left shoulder.

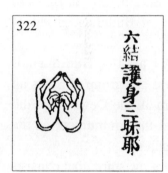

Ketsu gō shin sammaya, Kie hu shen san mei ye, **samaya of the formation of the mudrā of the protection of the body**. This mudrā is identical with the mudrā of Hi-kō (no. 6), the difference is only in its name.

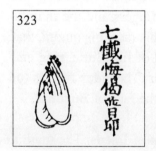

San ge ke, Chhan hoei kie phu yin, **confession and recitation of the gāthā**. See mudrā no. 8.

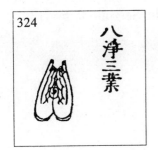

Jo-san gō, Tsing san ye, **purification of the three things**. See mudrā no. 9.

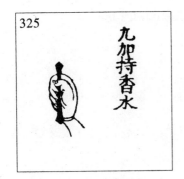

Kaji kō sui, Kia chi hiang-shoei, **consecration of the perfumed water**. See mudrā no. 10.

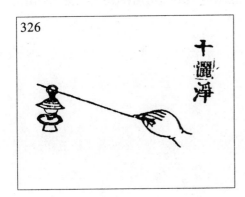

Chō jō, Chai tsing, **purification by sprinkling**. See mudrā no. 11.

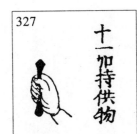

Kaji ku motsu, Kia chi kong wu, **purification of the offerings**. See mudrā no. 12.

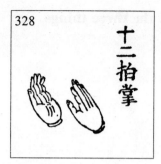

Haku chō, Pho chang, **striking the hands**. See mudrā no. 13.

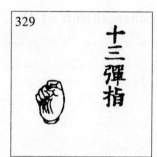

Tan zi, Tan chi, **hurling the finger**. See mudrā no. 14.

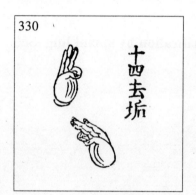

Kō ku, Khiu keu, **removing the impurities**. See mudrā no. 15.

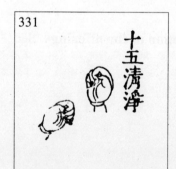

Chō jō, Tshing tsing, **purification**. See mudrā no. 16.

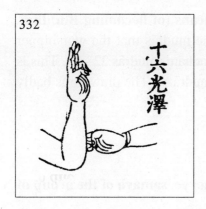

Kō taku, Koang tse, **brilliant light**. See mudrā no. 17.

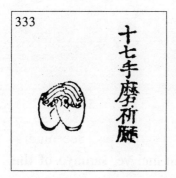

Shu ma ki gan, Sheu mo khi yuen, **prayer after rubbing the hands**. Mudrā of the same form as no. 18. It is given this name because the worshipper recites the dhāranī while crossing his fingers after having rubbed his hands.

Rei hō kon ju ku, Ling fa kie chu kiu, **vow of eternal duration of Dharma**. The mudrā is identical with no. 19. It derives its name from the fact that at this moment the worshipper takes the vow that the Dharma is of eternal duration.

Kyō gaku, King kio, **awakening**. See mudrā no. 21.

Ku hōben, Kieu fang pien, **nine means (of becoming Buddha).**
This single mudrā replaces the nine mudrās that the worshipper
makes in the rite of Taizōkai/Garbhadhātu (mudrās 22–30). This is
the universal mudrā of vajrāñjali (mudrā 8). The drawing is badly
executed.

Butsu bu sammaya, Fo pu san mei ye, **samaya of the group of
Buddha.** See mudrā no. 319.

Renge bu sammaya, Lien hoa pu san mei ye, **samaya of the
group of Lotus.** See mudrā no. 320.

Kongō bu sammaya, Kin kang pu san mei ye, **samaya of the
group of Vajra.** See mudrā no. 321.

Ketsu gō shin, Kie hu chen san mei ye, **samaya of the formation of the mudrā of the protection of the body**. See mudrā no. 322.

Ji ketsu, Ti kie, **consolidation of the ground**. This rite is to make the vajra enter into the soil of the temple to purify it and to impart it the solidity of the vajra.

The mudrā consists of crossing the ring and middle fingers, the remaining three fingers touching one another at their extremities respectively. The worshipper applies it over his breast and bends the thumbs thrice towards the earth while reciting the appropriate dhāraṇī. It is the mudrā of three-pronged vajra/san-kō. See no. 320.

Kongō chō, Kin kang lu, **wall of vajras**. The same mudrā as the preceding, but turned up. The worshipper takes it towards his left, while reciting a dhāraṇī. With this he erects walls of vajra around the temple for preventing the demons from penetrating into its compound.

Dō jō kuan, Tao chhang koan ting yin, **meditation of the temple**. See mudrā no. 96.

San riki ge, San li kie phu yin, **three powers, universal mudrā**. See mudrā no. 97.

Fu tsu ku yō, Phu thong kong yang, **universal offering**. See mudrā no. 98.

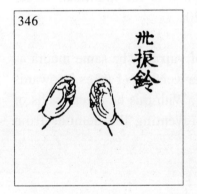

Shin rei, Chen ling, **ringing the bell**. See mudrā no. 111.

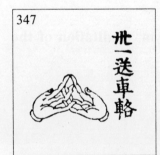

Sō cha rō, Song chhe lu, **sending the cart**. The worshipper, by virtue of his meditation and of the recitation of the dhāraṇī, sends into the paradises of the ten quarters of the world, carts meant to serve as vehicles for the Buddhas who have been invited to come into the temple prepared for them. The mudrā consists of crossing the fingers of open hands with their palms turned up, the index fingers touching one another at their tips and the thumbs resting on the base of the index fingers. The little, ring and middle fingers represent the cart. The departure of the cart is symbolised by the relaxation of the thumbs.

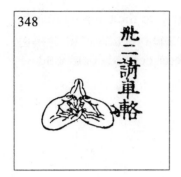

Shō cha rō, Tshing chhe lu, **reception (of the Buddhas arriving in) the carts**. Same mudrā as the preceding, but the worshipper utters the dhāranī and carries his thumbs into the interior of the hands and meditates upon the reception of the Buddhas arriving in the carts.

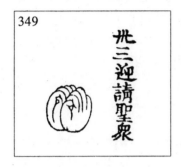

Gei shō chō shu, Ying tshing sheng chong, **reception of the Buddhas**. Mudrā identical, both in form and meaning, with the mudrā 115.

Reception of the Bodhisattvas. See mudrā no. 113.

Reception of gods and spirits. Same mudrā as no. 114. However, it should be noted that in drawing 114 the thumbs are placed outside, while here they are inside the hands.

Jō zu ma kō ku in, Chhu tshong mo khiu keu yin, **mudrā of the expulsion of the demons and of the purification of impurities**. The gesture is made with the left hand, of which the index, middle and ring fingers are straightened and represent a three-pronged vajra/sen-kō. The worshipper recites the dhāranī as well as takes the mudrā towards his right to bring about a double act of purification having two objectives: on the one hand to scare away the

demons who have attempted to penetrate into the temple after the Buddhas, Bodhisattvas and gods and on the other hand to destroy the impurities that may be found in the consecrated compound.

Ji sammaya, Chi san mei ye, **manifesting the samaya**. Executing the same gesture with his right hand, the worshipper completes and perfects the act that he has just done with his left hand. For the explanation of the term ji sammaya, see mudrā no. 120.

Kongō mō, Kin kang wang, **wall of vajras**. Once the ceremony of reception of the Buddhas, Bodhisattvas and Devas is over, the worshipper stretches forth in the space around the temple a vajra-wall for their decoration and protection. For this he reproduces mudrā no. 342 that he carries to his face while reciting a dhāraṇī.

Ka in, Ho yuen, **wall of flames**. For terrifying the evil spirits and for scaring them away from the temple, by his meditation the worshipper constructs walls of flames that surround the walls of vajra. For this he puts the back of his right hand on the palm of the left hand, thus forming a triangle representing 'the body of fire' while the separated thumbs represent the vacant space. Then he utters a dhāraṇī and takes the mudrā towards his right. Then a flame is produced that forms an enclosure around the vajra-walls.

Akka (argha), O kia, **water**. See mudrā nos. 121 and 136.

Ke-za, Hoa tso pa ye yin, **carpet of lotus**, mudrā of eight-petalled lotus (aṣṭadala). See mudrā no. 122.

Zen rai ge, Shan lai kie pha yin, **words of welcome**, vajrāñjali. See mudrā no. 123.

Ju ketsu dai kai, Chhong kie ta kiai, **double construction of the great world**. When all the deities occupy their places, the worshipper takes a new measure for protecting them by edifying the wall said to be of triple vajras. Its mudrā is formed by reuniting the hands with the crossed ring and little fingers, while he draws up the middle fingers and pushes the index fingers against their back face, the thumbs drawn up parallel to the middle fingers. When this mudrā which is the symbol of 'three great vajras' has been executed, he turns it thrice. See no. 320.

Zu kō, Thu hiang, **anointing with perfumes**. See mudrā no. 137.

Ke man, Hoa man, **garland of flowers**. See mudrā no. 138.

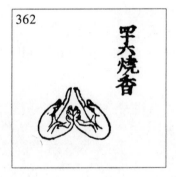

Chō kō, Chao hiang, **burning incense**. See mudrā no. 139.

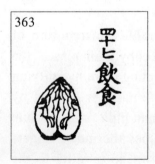

Bon jiki, Fan chi, **cooked rice**. See mudrā nos. 140, 264.

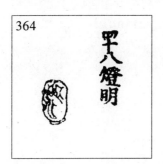

Tō myo, Teng ming, **lamp**. See mudrā no. 141.

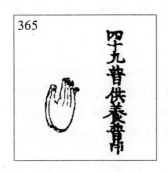

Fu kuyō, Phu kong yang phu yin, **general offering**. See mudrā no. 142.

San, Tsan, **eulogy**. See mudrā no. 143.

Shi chi san, Seu chi tsan phu, **eulogy of the four knowledges**. See mudrā no. 144.

Nyu sammaji, Ju san mo ti, **entry into samādhi**. See mudrā no. 150.

Kon pon in, Ken pen yin, **mūla-mudrā**. The meaning and the intention are the same as those of mudrā no. 146. The only difference is that the principal deity of the rite of Taizokai/ Garbhadhātu is Dainichi Nyorai/Mahāvairocana, for whom they make the gesture of the gokō or five-pronged vajra, while here the principal deity is Fudō Myohō/Acala Vidyārāja, so they make the gesture of the sword, represented by the index fingers standing up over the hands that are joined together. The sword of Fudō Myohō/Acala Vidyārāja cuts and destroys the errors of the dan-ken (doctrine of annihilation) and of the jō-ken (doctrine of permanence) and conducts living beings by the 'middle path of equality'.

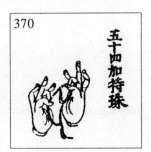

Kaji shu, Kia chi chu, **purification of the rosary**. See mudrā no. 147.

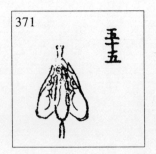

Hō ju man, Phong chu man, **offering of the garland of pearls**. See mudrā no. 269.

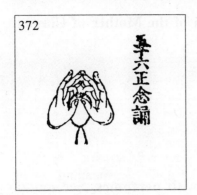

Chō nen ju, Cheng nien song, **true jāpa**. See mudrā nos. 148 and 270.

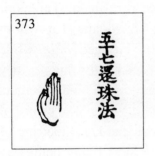

Guen shu hō, Hoan chu fa, **rite for putting back the rosary**. See mudrā no. 149.

Nyu sammaji, Ju san mo ti, **entry into samādhi**. See mudrā no. 150.

Kon pon in, Ken pen yin, **mūla-mudrā**. See mudrā no. 146.

Bu mō in myo, Pu mu yin, **mudrā of the Mother of Classes**.
See mudrā no. 152.

Zu-kō, Thu hiang, **anointing with perfumes**. See mudrā
no. 137.

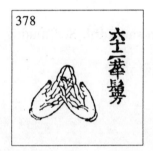

Ke man, Hoa man, **garland of flowers**. See mudrā no. 138.

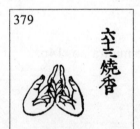

Chō kō, Chao hiang, **burning incense**. See mudrā no. 139.

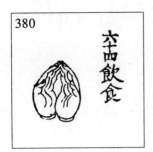

Bon jiki, Fan chi, **cooked rice**. See mudrā nos. 140, 264.

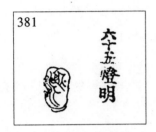

Tō myō, Teng ming, **lamp**. See mudrā no. 141.

Fu kuyō, Phu kong yang phu yin, **general offering**. See mudrā no. 142.

San, Tsan, **eulogy**. See mudrā no. 143.

Shi chi san, Seu chi tsan phu yin, **eulogy of the four knowledges**. See mudrā no. 144.

Akka (argha), O kia, **water**. See mudrā no. 136.

Shin rei, Chen ling, **ringing the bell**. See mudrā no. 111.

Yekō hōben, Hoei hiang fang pien, **means of causing to turn**. See mudrā no. 153.

Ge kai, Kiai kiai, **destruction of the enclosure**. When the ceremony of the reception is over and the Buddhas are about to retire, it is necessary to destroy the enclosure of the walls of flames built with mudrā no. 355. With this intention the worshipper again makes the same symbol, but while he is taking it to the left, he utters a dhāraṇī which the fire gets extinguished.

Bu zō, Fong song, **escorting back respectfully**. The intention is the same as governs mudrā no. 159, but in this case the worshipper utilizes mudrā no. 348 anew. By hurling his thumbs out he makes the Buddhas, the Bodhisattvas and other dieties to get back into the carts in which they had come.

Gei shō chō shu, Ying tshing cheng chong, **departure of the Buddhas**. The worshipper again forms mudrās 349 and 350 and again releases his thumbs, the gesture that makes the Buddhas and the deities depart for their respective paradises.

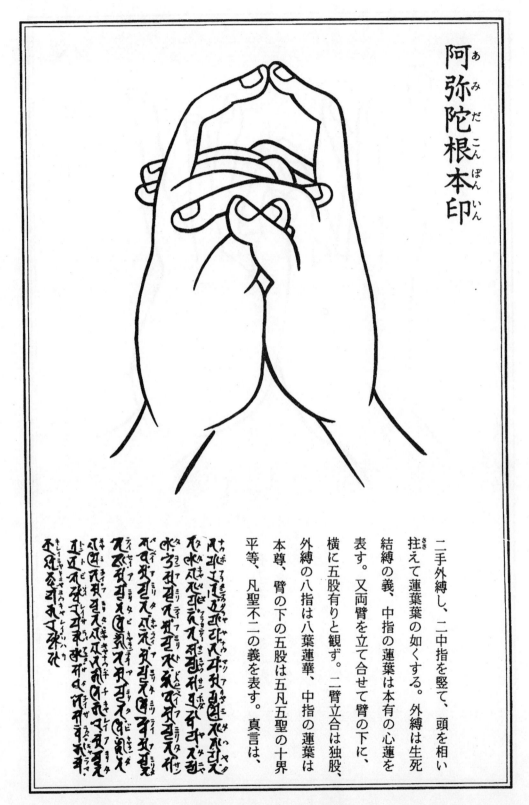

阿弥陀根本印

二手外縛し、二中指を竪て、頭を相い拄えて蓮葉の如くする。外縛は生死結縛の義、中指の蓮葉は本有の心蓮を表す。又両臂を立て合せて臂の下に、横に五股有りと観ず。二臂立合は独股、外縛の八指は八葉蓮華、中指の蓮葉は本尊、臂の下の五股は五凡五聖の十界平等、凡聖不二の義を表す。真言は、

Mūla-mudrā of Amitābha

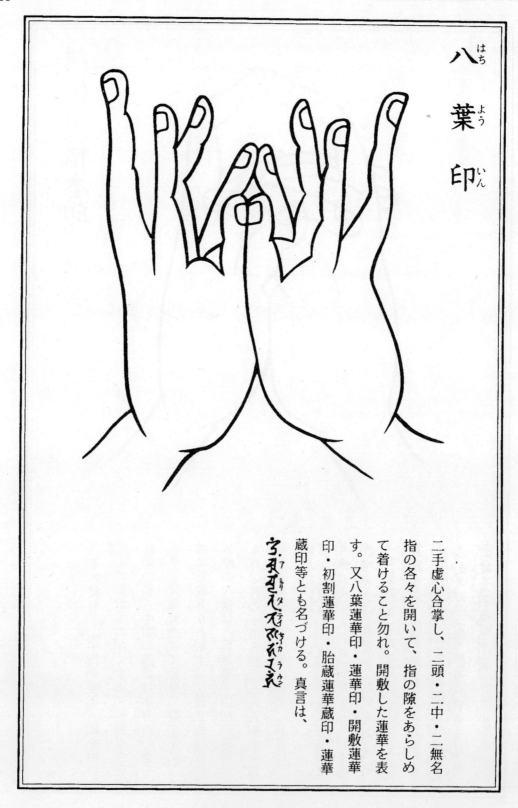

八葉印
（はち・よう・いん）

蔵印等とも名づける。真言は、
印・初割蓮華印・胎蔵蓮華蔵印・蓮華
す。又八葉蓮華蓮華印・蓮華印・開敷蓮華
て着けること勿れ。開敷した蓮華を表
指の各々を開いて、指の隙をあらしめ
二手虚心合掌し、二頭・二中・二無名

Aṣṭadala-mudrā

阿弥陀定印
<ruby>阿<rt>あ</rt></ruby><ruby>弥<rt>み</rt></ruby><ruby>陀<rt>だ</rt></ruby><ruby>定<rt>じょう</rt></ruby><ruby>印<rt>いん</rt></ruby>

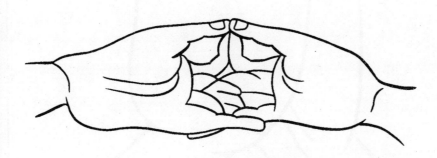

二手を相い叉え、二頭指の背を着けて中節より直く竪て、二大指を以て二頭指を捻ず。小・無名・中指の六指を相い交え、頭・大の四指の頭を相い拄えるのは、六道衆生が四智の菩提を顕得する事を表す。是れは自証の位である。

又この印を引き開けば化他門にして説法の印となる。又風・空の端を拄えて開敷の勢に作るのは、風には開花の功があり、空中の風は専ら自在の徳を具する義である。又禅・進の二度は禅定養育の義であり、仏性の心蓮を勇猛増長ならしめる為に禅・進を合して此の印を作す。真言は、

ナウマク サンマンダ ボダナン ア ミリ タ テイ ゼイ カラ ウン

Dhyāna-mudrā of Amitābha

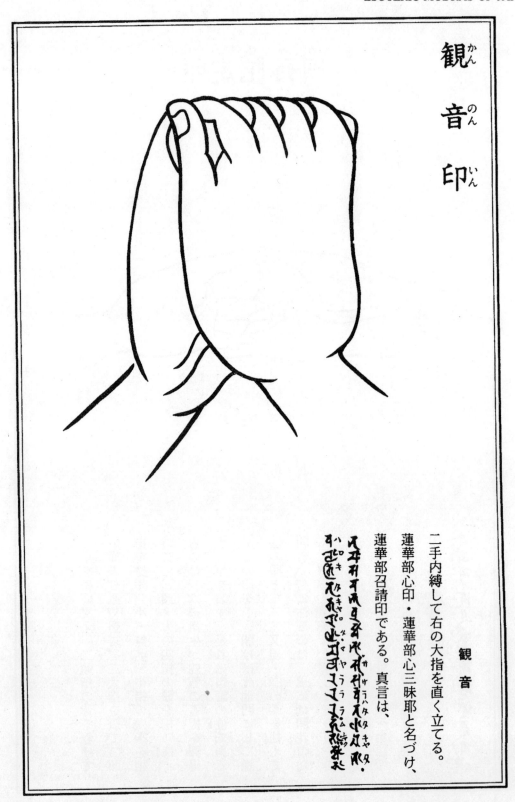

観_{かん}音_{のん}印_{いん}

観　音

二手内縛して右の大指を直く立てる。
蓮華部心印・蓮華部心三昧耶と名づけ、
蓮華部召請印である。　真言は、

Mudrā of Avalokiteśvara, one of the two acolytes of Amitābha

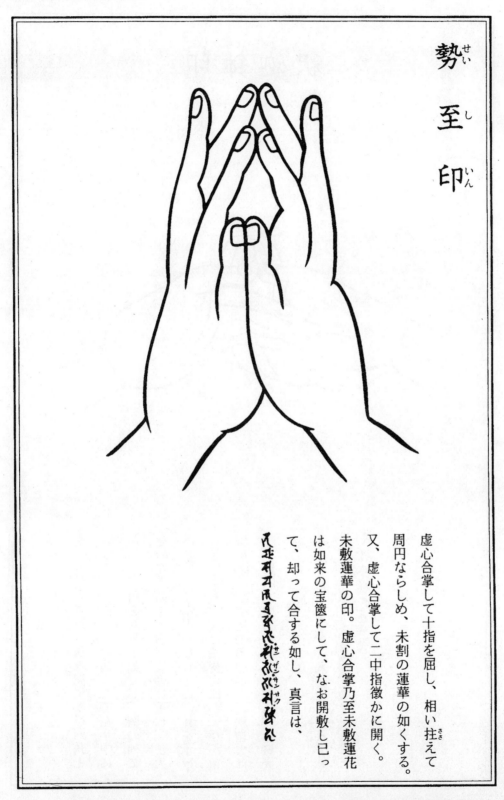

勢至印

虚心合掌して十指を屈し、相い拄えて
周円ならしめ、未割の蓮華の如くする。
又、虚心合掌して二中指徴かに開く。
未敷蓮華の印。虚心合掌乃至未敷蓮花
は如来の宝篋にして、なお開敷し已っ
て、却って合する如し、真言は、

Mudrā of Mahāsthāma-prāpta, one of the two acolytes of Amitābha

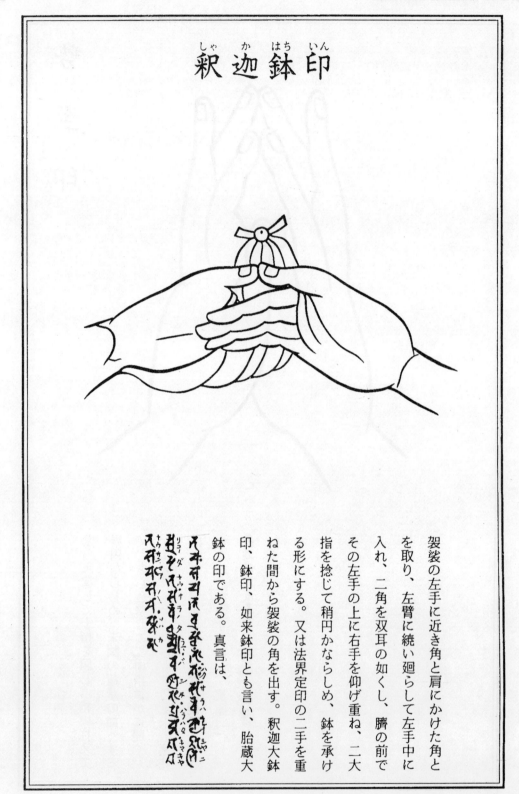

釈迦鉢印

袈裟の左手に近き角と肩にかけた角と
を取り、左臂に繞い廻らして左手中に
入れ、二角を双耳の如くし、臍の前で
その左手の上に右手を仰げ重ね、二大
指を捻じて稍円かならしめ、鉢を承け
る形にする。又は法界定印の二手を重
ねた間から袈裟の角を出す。釈迦大鉢
印、鉢印、如来鉢印とも言い、胎蔵大
鉢の印である。真言は、

Pātra-mudrā of Śākyamuni (the alms-bowl of Lord Buddha)

智吉祥印

の根本印である。真言は、
す事、とも言う。智吉祥印は釈迦如来
手）吉祥印であり、右手を吉祥印と為
るからである。又は智吉祥印は智手（右
であり、此れに依って衆生が吉祥を得
祥印とするのは、説法は後得智の作用
指を以って頭指を捻ず。説法印を智吉
を以って無名指を捻じ、応身説法は大
を報身説法の印とし、法身説法は大指
を上求、右を下化とする。或いは此れ
手を左手の上に覆せて相い著けず。左
指を舒べ散ず。左手を心前に仰げ、右
二手各々大指を以って中指を捻じ、余

Jñāna-śrī-mudrā of Śākyamuni

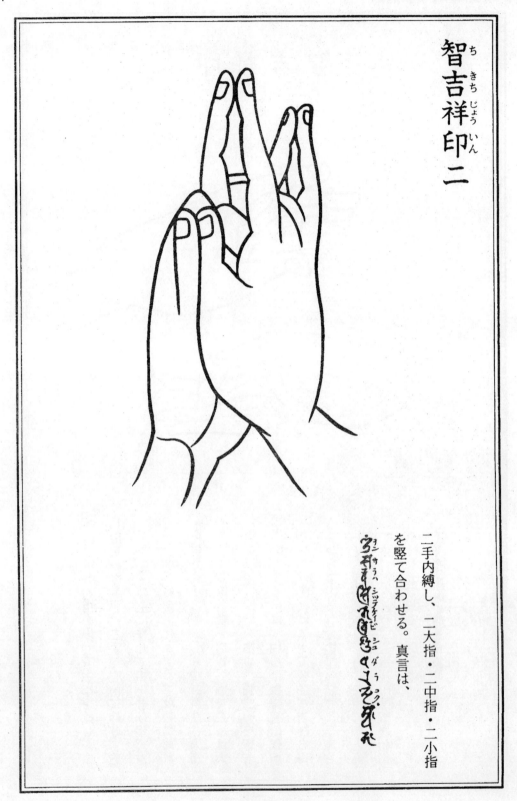

智
吉
祥
印
二

二手内縛し、二大指・二中指・二小指
を竪て合わせる。真言は、

Jñāna-śrī-mudrā of Śākyamuni, no. 2

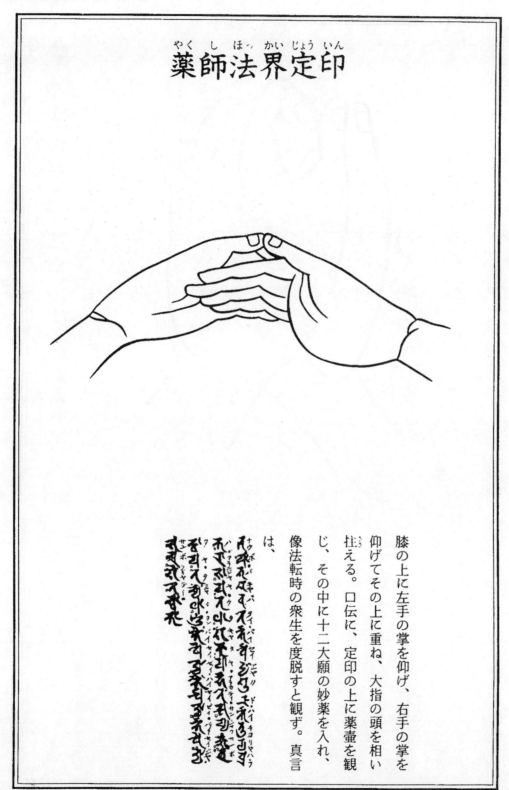

薬師法界定印

膝の上に左手の掌を仰げ、右手の掌を
仰げてその上に重ね、大指の頭を相い
拄える。口伝に、定印の上に薬壷を観
じ、その中に十二大願の妙薬を入れ、
像法転時の衆生を度脱すと観ず。真言
は、

Dharma-dhātu-dhyāna-mudrā of Bhaiṣajyaguru, the Lord of Healing

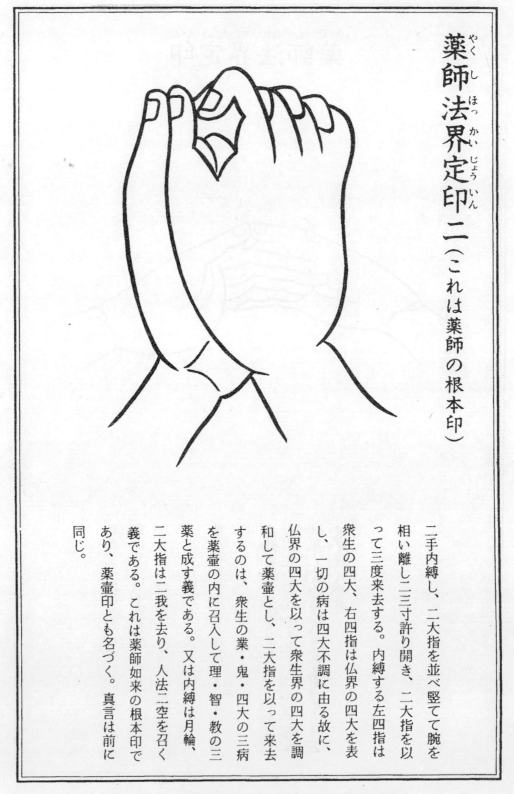

薬師法界定印二（これは薬師の根本印）

二手内縛し、二大指を並べ竪てて腕を相い離し二三寸許り開き、二大指を以って三度来去する。内縛する左四指は衆生の四大、右四指は仏界の四大を表し、一切の病は四大不調に由るが故に、仏界の四大を以って衆生界の四大を調和して薬壺とし、二大指を以って来去するのは、衆生の業・鬼・四大の三病を薬壺の内に召入して理・智・教の三薬と成す義である。又は内縛は月輪、二大指は二我を去り、人法二空を召く義である。これは薬師如来の根本印であり、薬壺印とも名づく。真言は前に同じ。

Dharma-dhātu-dhyāna-mudrā of Bhaiṣajyaguru,
the Lord of Healing, no. 2 (it is his mūla-mudrā)

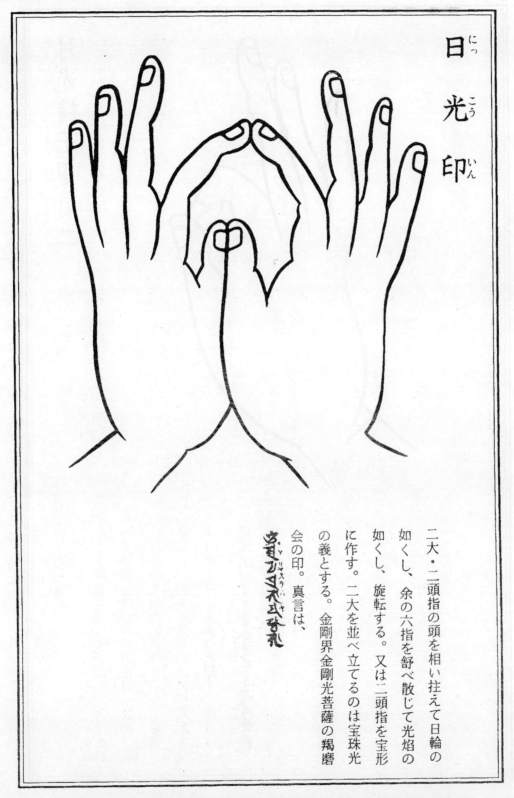

日光印

二大・二頭指の頭を相い拄えて日輪の如くし、余の六指を舒べ散じて光焰の如くし、旋転する。又は二頭指を宝形に作す。二大を並べ立てるのは宝珠光の義とする。金剛界金剛光菩薩の羯磨会の印。真言は、

Mudrā of Sūryaprabha, one of the two acolytes of Bhaiṣajyaguru

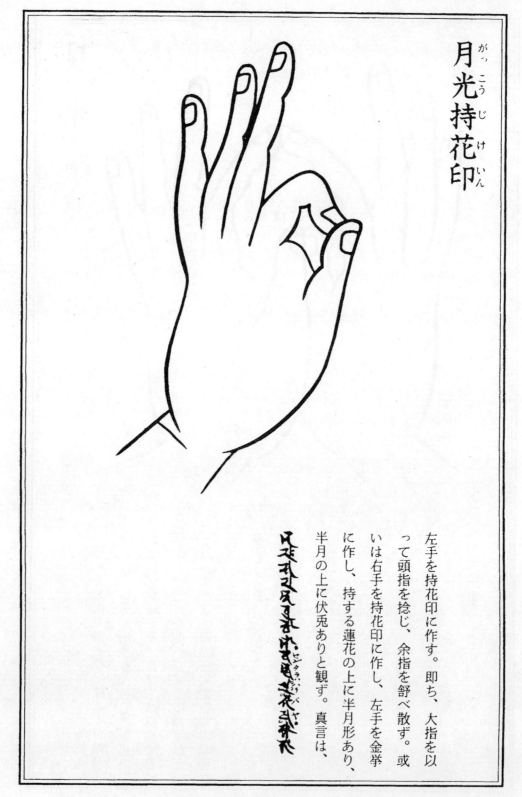

月光持花印

左手を持花印に作す。即ち、大指を以って頭指を捻じ、余指を舒べ散ず。或いは右手を持花印に作し、左手を金挙に作し、持する蓮花の上に半月形あり、半月の上に伏兎ありと観ず。真言は、

Mudrā of Candraprabha, one of the two acolytes of Bhaiṣajyaguru
(the mudrā of holding a flower)

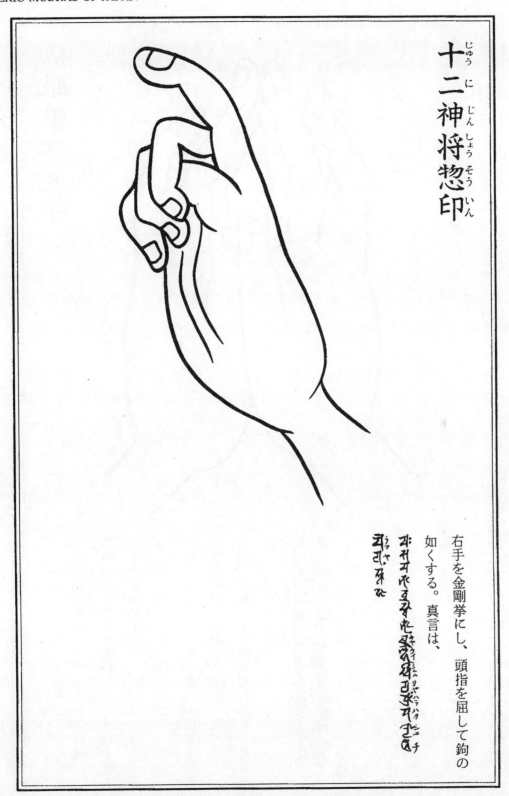

十二神将惣印

右手を金剛挙にし、頭指を屈して鉤の如くする。真言は、

Mudrā of the Twelve Spirits (Jūni Jin)

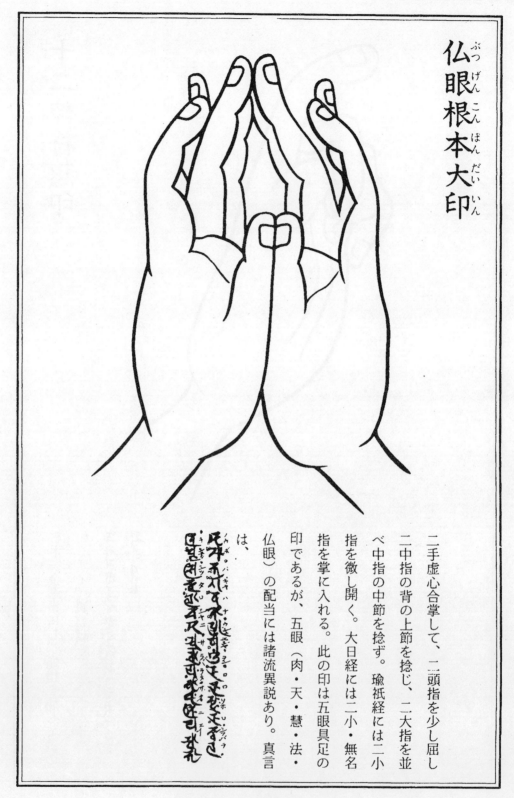

仏眼根本大印

二手虚心合掌して、二頭指を少し屈し
二中指の背の上節を捻じ、二大指を並
べ中指の中節を捻ず。瑜祇経には二小
指を微し開く。大日経には二小・無名
指を掌に入れる。此の印は五眼具足の
印であるが、五眼（肉・天・慧・法・
仏眼）の配当には諸流異説あり。真言
は、

Mūla-mahāmudrā of Locanā

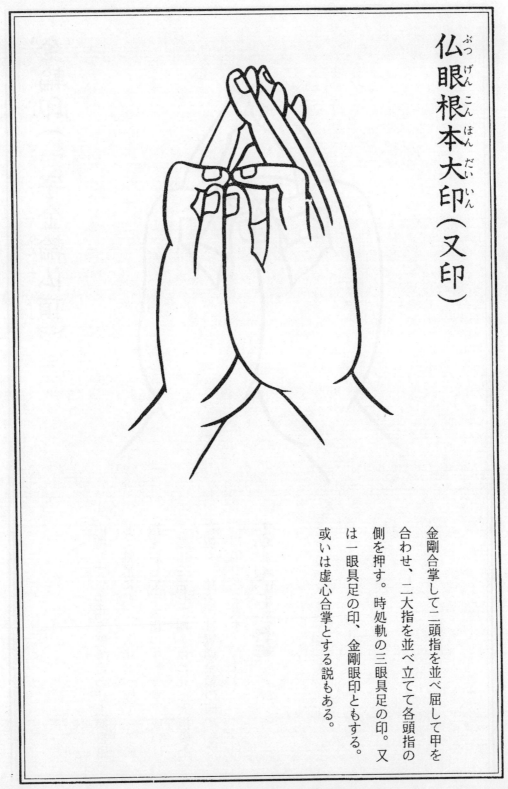

仏眼根本大印（又印）

金剛合掌して二頭指を並べ屈して甲を
合わせ、二大指を並べ立てて各頭指の
側を押す。時処軌の三眼具足の印。又
は一眼具足の印、金剛眼印ともする。
或いは虚心合掌とする説もある。

Mūla-mahāmudrā of Locanā, no. 2

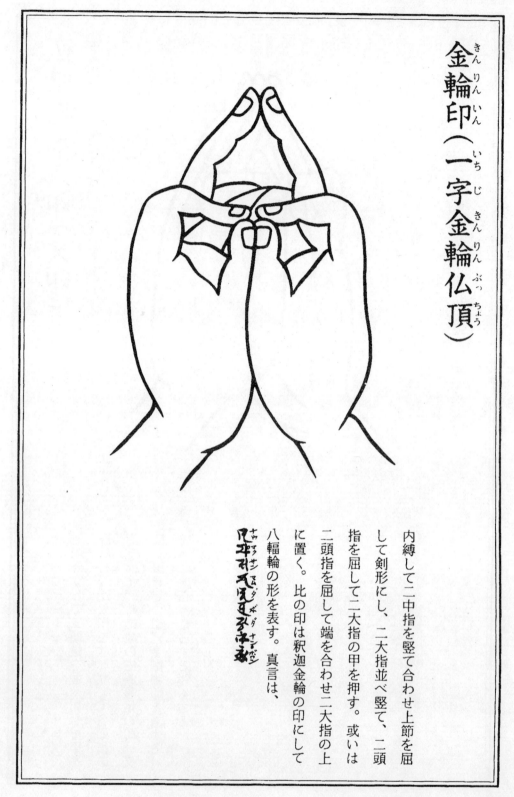

金輪印（一字金輪仏頂）

内縛して二中指を竪て合わせ上節を屈して剣形にし、二大指並べ竪て、二頭指を屈して二大指の甲を押す。或いは二頭指を屈して端を合わせ二大指の上に置く。此の印は釈迦金輪の印にして八輻輪の形を表す。真言は、

Mudrā of Ekākṣara Cakroṣṇīṣa (Cakravartin)

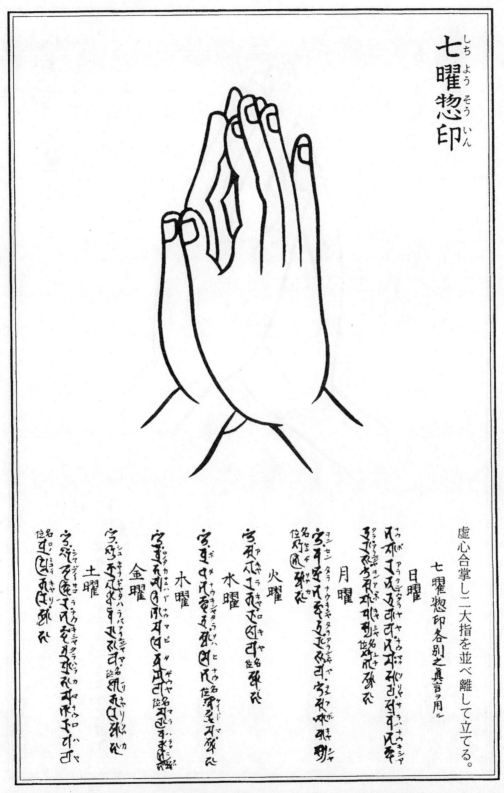

Mudrās of the Seven Planets (sapta-vāra or seven days of the week)

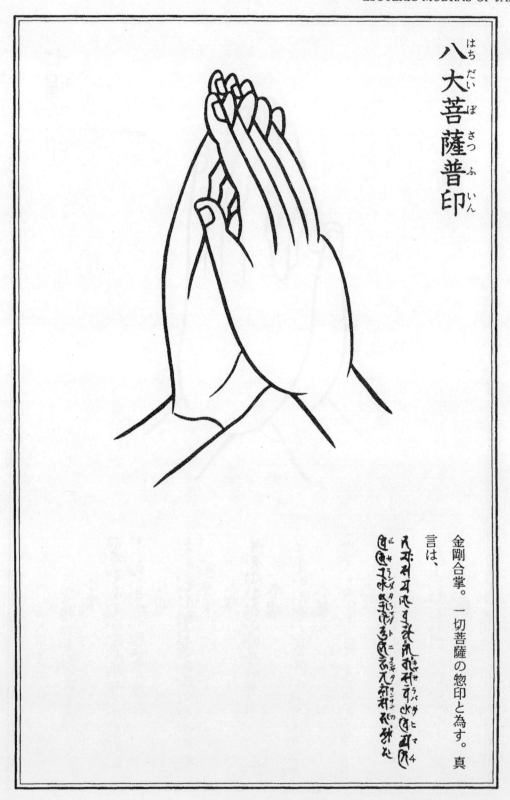

八大菩薩普印

金剛合掌。一切菩薩の惣印と為す。真言は、

General mudrā of the Eight Great Bodhisattvas (aṣṭa-mahābodhisattva)

八大明王
はち　だい　みょう　おう

二手、左を覆せ右を仰げて背を合わせ
着け、右大指を左小指に叉え、右小指
を左大指に叉え、中間の六指を手の背
に広げ着けて三股杵の如くする。護身
法五種印の一。金剛部三昧耶印、三股
金剛印、持地印、一切持金剛印と名づ
く。真言は、

General mudrā of the Eight Great Vidyārājas

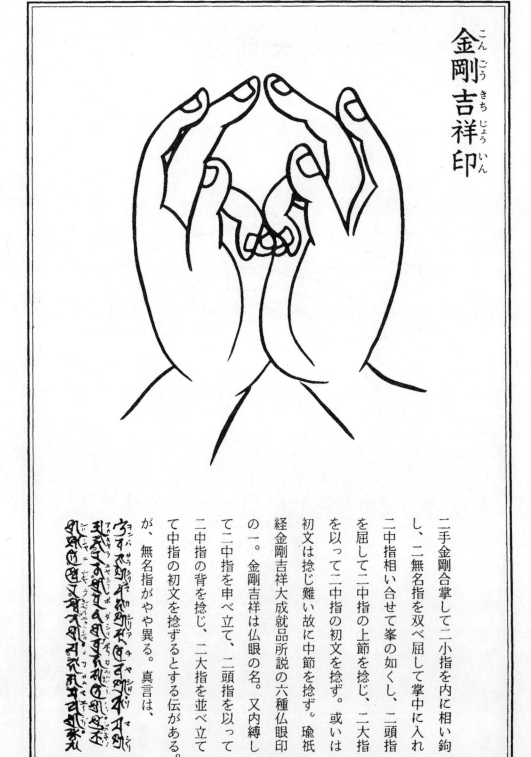

金剛吉祥印

二手金剛合掌して二小指を内に相い鉤し、二無名指を双べ屈して掌中に入れ二中指相い合せて峯の如くし、二頭指を屈して二中指の上節を捻じ、二大指を以って二中指の初文を捻ず。或いは初文は捻じ難い故に中節を捻ず。瑜祇経金剛吉祥大成就品所説の六種仏眼印の一。金剛吉祥は仏眼の名。又内縛して二中指を申べ立て、二頭指を以って二中指の背を捻じ、二大指を並べ立てて中指の初文を捻ずるとする伝がある。が、無名指がやや異る。真言は、

Vajra-śrī-mudrā

破諸宿曜印
<ruby>破<rt>は</rt></ruby><ruby>諸<rt>しょ</rt></ruby><ruby>宿<rt>しゅく</rt></ruby><ruby>曜<rt>よう</rt></ruby><ruby>印<rt>いん</rt></ruby>

内縛して、指の節を痛めて二大指を竪
てる。即ち並べ竪てた二大指を少し屈
して、二頭指の屈節の上に押し著ける。
又外縛とする説もある。二大二頭指の
間を開くと閉じるの二説あり、開くは
これを師子口と観じ、一切衆生の煩悩
不祥等を噉食すと観想する。閉じるは
己に噉食し尽して閉じる意である。故
に師子口印と名づけ、又大精進印・一
切無畏印・師子冠印・師子首印・文殊
師子口印・宝珠印・妙吉祥破諸宿曜印
・破宿曜障印・破七曜一切不祥印とも
名づける。此の印は仏部心三昧耶と同
じである。真言は、

ナン・サラ（ハ）・タラ・サムマチイ・シリテイ・
忠気千叉弃当ズ叵ぎ求充

General mudrā of the twenty-eight constellations (nakṣatra)
and nine planets (nava-graha)

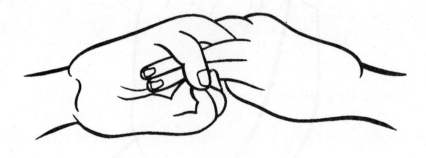

じょう じゅ いっ さい みょう いん
成就一切明印

二手各々不動剣印にし、左を仰げ、右
を覆せ、各剣を以って互いに掌中に差
し入れる。互いに掌中に入れるのは生
仏不二の義、又生仏共に月輪に住する
義を表す。此の印を諸尊の入我我入の
印に用いる。真言は、

サ・ル・ワ・ビ・ジャ・ク・ビ・ジャ
・チ・チ・キャ・ノ・リッ・ク・バ・ラ
・タッ・タッ・ギャ・タ・ク・ラ・キャ
・ギャ・ク・ラ・ギャ・ク・ムッ・タ

Sarva-vidyā-siddhi-mudrā

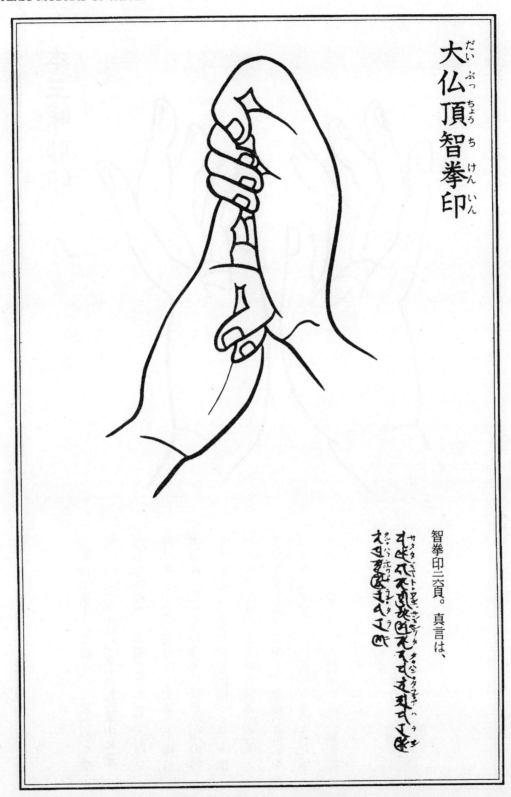

大仏頂智拳印

智拳印二六頁。真言は、

Jñāna-muṣṭi-mudrā of Mahoṣṇīṣa

本三昧耶印
<ruby>本<rt>ほん</rt></ruby><ruby>三<rt>さ</rt></ruby><ruby>昧<rt>ま</rt></ruby><ruby>耶<rt>や</rt></ruby><ruby>印<rt>いん</rt></ruby>

二手の十指を立て散じ、二掌の根を並
べ合わせる。口伝に、二手仰げ、二掌
の小指の根の方の側を合わせ、十指を
散じ伸べて面を覆う如くする。十指に
次第に、九仏頂の種子に普通仏頂の種
子を加えた十字真言を配唱する。十指
に各々十色を具して雑色無量の光明を
放って十方浄土を照し、無量の諸仏を
供養する。摂一切仏頂輪王本三昧耶印
・成就一切事業仏頂諸仏心本三昧耶印
と名づける。真言は前に同じ。

Mūla-samaya-mudrā

金輪（宝瓶印）

虚心合掌して二頭指を屈して甲を相い
着け、二大指を以って二頭指の頭を押
して弾指の如くする。　又印母を蓮華合
掌とする説あり。　瓶印・尊勝宝瓶印・
尊勝空印等とも称す。　塔印・大慧刀印
・無所不至印と同印と称するが印相に
少し異りがある。

Mudrā of Cakravartin (ratna-ghaṭa-mudrā i.e. mudrā of the jewel jar)

智拳印

二手各金剛拳にし、左の頭指を伸べ竪て、右拳の小指を以って左の頭指の第一節を握り、右の頭指の頭を右の大指の第一節に扨え着く。此の印は理智不二、生仏一如、迷悟一体等の深義を表す。又左は衆生の五大の身、右は五智五仏の宝冠にして、衆生に宝冠を被らしめる形である。又大智拳印・菩提最上契・菩提引導第一智印・能滅無明黒暗印・毘盧遮那如来大妙智印・引導無上菩提第一智印・能滅無明黒暗大光明印・大毘盧遮那如来無量福寿大妙智印・金剛拳印・大日法界印等とも名づける。金剛界一印会大日如来の結ぶ印である。真言は前に同じ。独一法身の印である。

Jñāna-muṣṭi-mudrā

勝身三昧耶印

金剛合掌し、二中指円かに立てて蓮葉の如くし、二頭指を屈して各二中指の背の上節に置く。二中・頭指は仏身の体、二小・無名指は後の光焔、二大指は結跏趺坐、二掌は日月輪、両腕は師子座を表す。頂輪王勝身三昧耶・如来勝身三昧耶と云う。真言は前に同じ。

Vara-kāya-samaya-mudrā

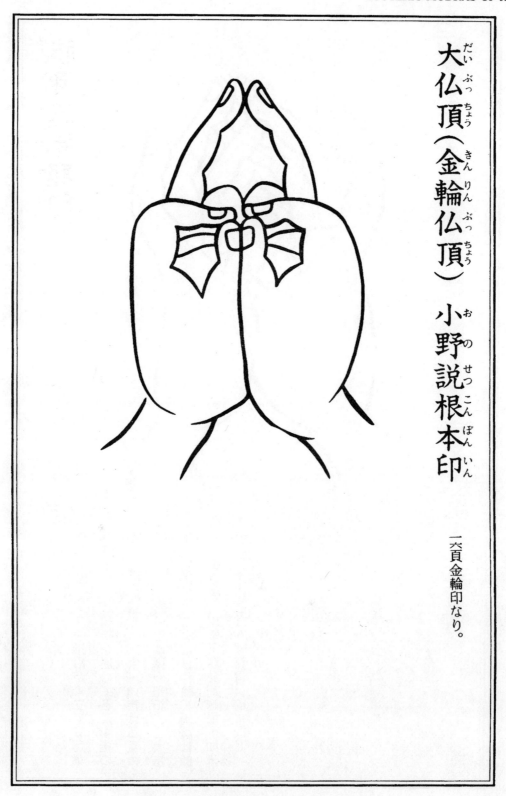

大仏頂（金輪仏頂）小野説根本印

一六頁金輪印なり。

Mūla-mudrā of Mahoṣṇīṣa (Cakroṣṇīṣa)

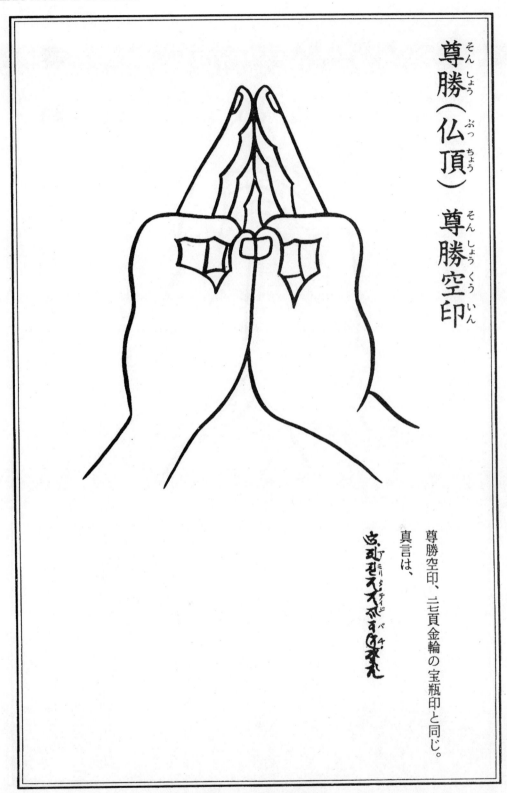

尊勝（仏頂）尊勝空印

尊勝空印、三七頁金輪の宝瓶印と同じ。
真言は、

Mudrā of Vijayoṣṇīṣa

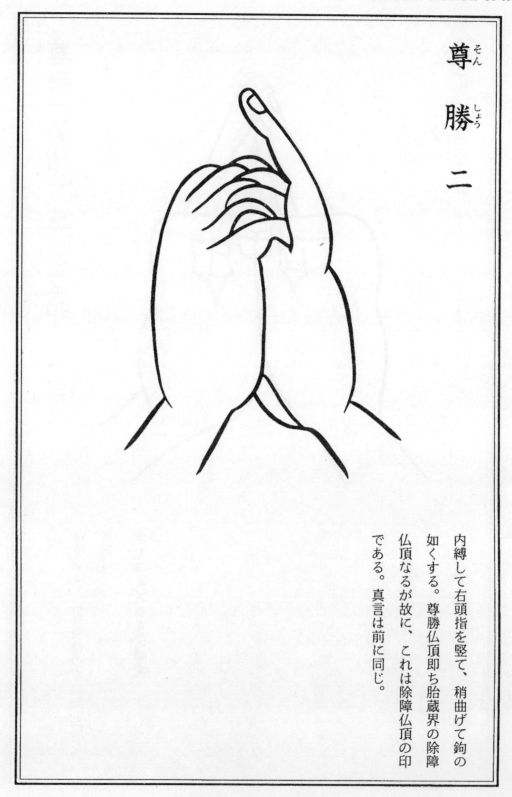

尊勝二

である。真言は前に同じ。
仏頂なるが故に、これは除障仏頂の印
仏頂即ち胎蔵界の除障
如くする。尊勝仏頂即ち胎蔵界の除障
内縛して右頭指を竪て、稍曲げて鉤の

Mudrā of Vijayoṣṇīṣa, no. 2

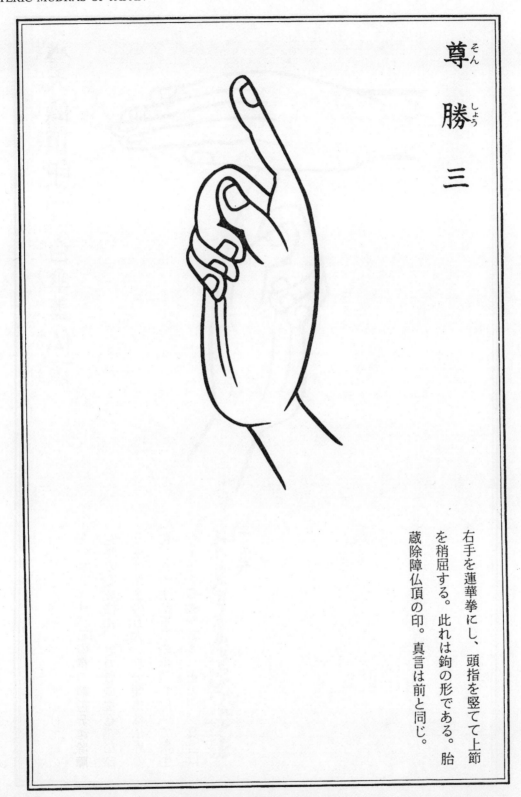

尊
勝
三

右手を蓮華拳にし、頭指を竪てて上節
を稍屈する。此れは鉤の形である。胎
蔵除障仏頂の印。真言は前と同じ。

Mudrā of Vijayoṣṇīṣa, no. 3

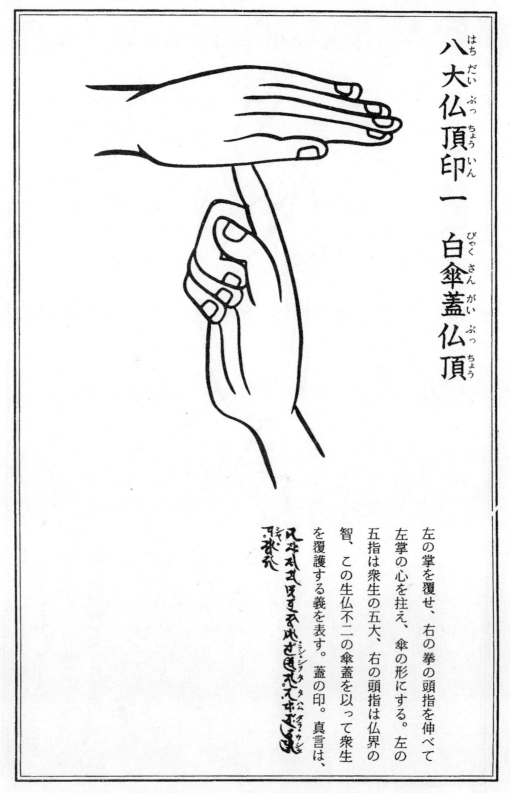

八
大
仏
頂
印
一
白
傘
蓋
仏
頂

を
覆
護
す
る
義
を
表
す
。
蓋
の
印
。
真
言
は
、

智
、
こ
の
生
仏
不
二
の
傘
蓋
を
以
っ
て
衆
生

五
指
は
衆
生
の
五
大
、
右
の
頭
指
は
仏
界
の

左
掌
の
心
を
拄
え
、
傘
の
形
に
す
る
。
左
の

左
の
掌
を
覆
せ
、
右
の
拳
の
頭
指
を
伸
べ
て

Mudrā of Sitātapatroṣṇīṣa, the first of the Eight Great Uṣṇīṣas

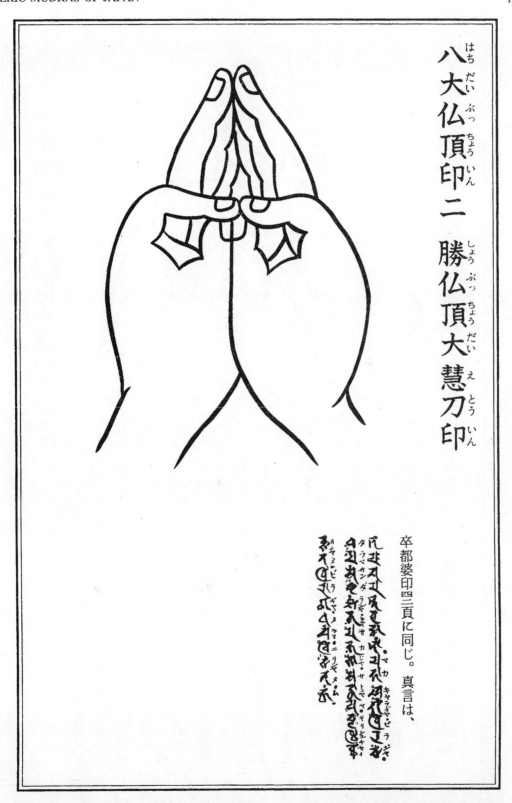

Mahā-jñāna-khaḍga-mudrā of Jayoṣṇīṣa, the second of the Eight Great Uṣṇīṣas

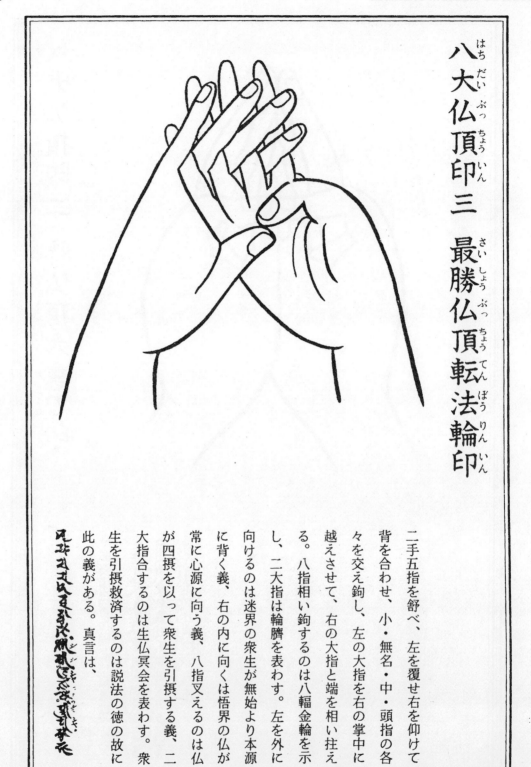

八大仏頂印三　最勝仏頂転法輪印

此の義がある。真言は、
生を引摂救済するのは説法の徳の故に
大指合するのは生仏冥会を表わす。衆
が四摂を以って衆生を引摂する義、二
常に心源に向う義、八指又えるのは仏
に背く義、右の内に向くは悟界の仏が
向けるのは迷界の衆生が無始より本源
し、二大指は輪臍を表わす。左を外に
る。八指相い鉤するのは八輻金輪を示
越えさせて、右の大指と端を相い拄え
々を交え鉤し、左の大指を右の掌中に
背を合わせ、小・無名・中・頭指の各
二手五指を舒べ、左を覆せ右を仰けて

Dharmacakra-pravartana-mudrā of Vijayoṣṇīṣa,
the third of the Eight Great Uṣṇīṣas

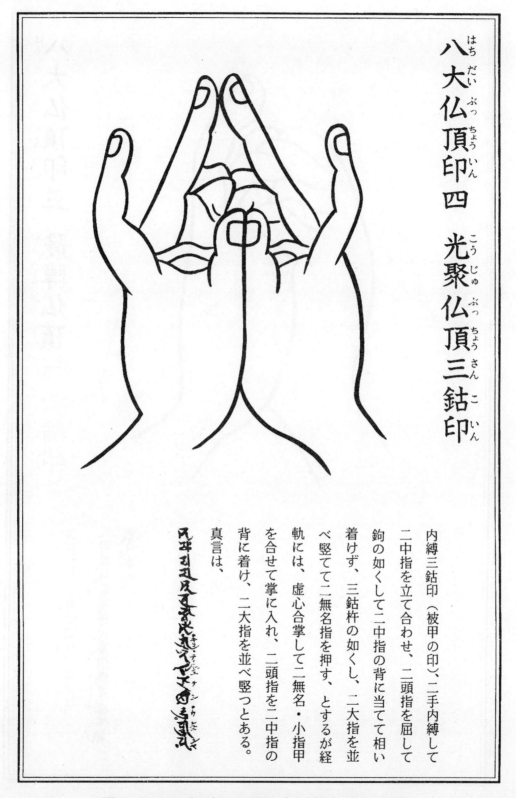

八大仏頂印四　光聚仏頂三鈷印

内縛三鈷印（被甲の印）、二手内縛して
二中指を立て合わせ、二頭指を屈して
鉤の如くして二中指の背に当てて相い
着けず、三鈷杵の如くし、二大指を並
べ竪てて二無名指を押す、とするが経
軌には、虚心合掌して二無名・小指甲
を合せて掌に入れ、二頭指を二中指の
背に着け、二大指を並べ竪つとある。
真言は、

Three-pronged vajra mudrā of the Tejo-rāśy-uṣṇīṣa,
the fourth of the Eight Great Uṣṇīṣas

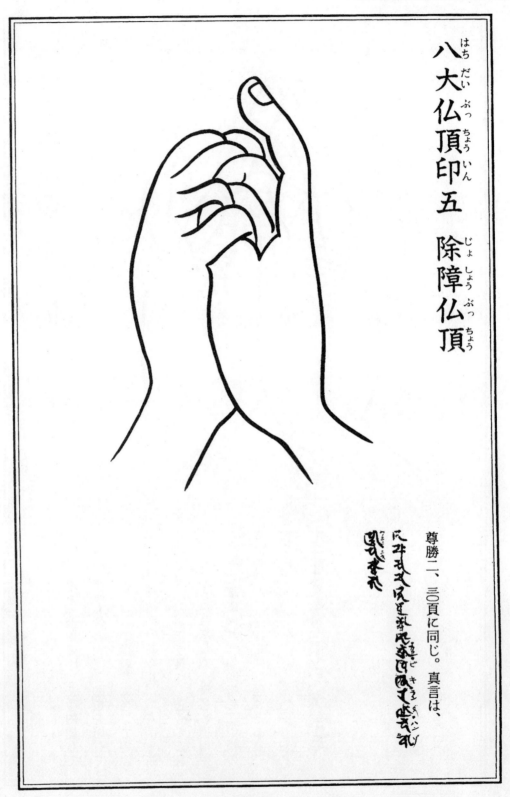

八大仏頂印五　除障仏頂

尊勝二一、三〇頁に同じ。真言は、

Mudrā of Vikiraṇoṣṇīṣa, the fifth of the Eight Great Uṣṇīṣas

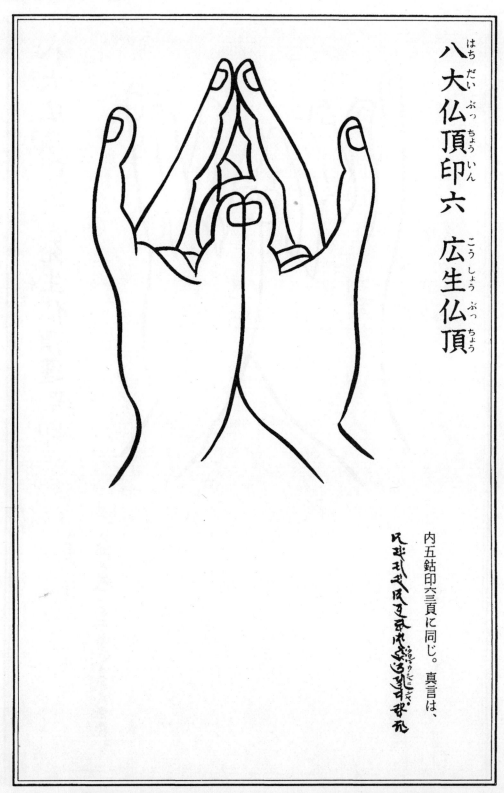

八大仏頂印六　広生仏頂

内五鈷印六三頁に同じ。真言は、

Mudrā of Mahoṣṇīṣa, the sixth of the Eight Great Uṣṇīṣas

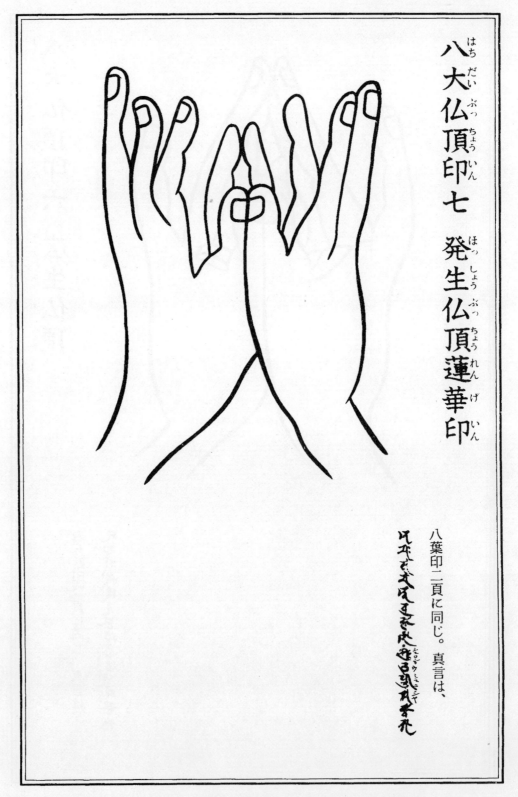

八大仏頂印七　発生仏頂蓮華印

八葉印二頁に同じ。真言は、

Padma-mudrā of Abhyudgatoṣṇīṣa, the seventh of Eight Great Uṣṇīṣas

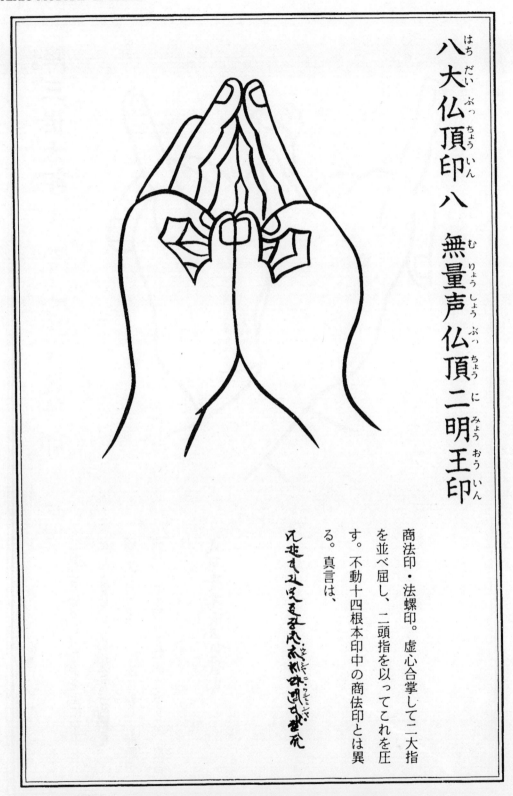

八大仏頂印八　無量声仏頂二明王印

商法印・法螺印。虚心合掌して二大指を並べ屈し、二頭指を以ってこれを圧す。不動十四根本印中の商佉印とは異る。真言は、

元弁弁ざほ支き欠兂杉咏凫凩玖貭罤凧

Śaṅkha-mudrā of Ananta-svara-ghoṣoṣṇīṣa,
the eighth of the Eight Great Uṣṇīṣas

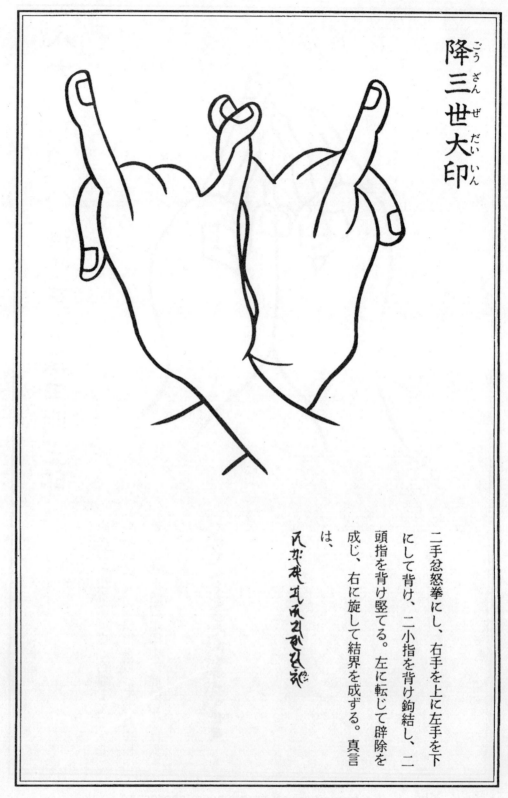

降三世大印

二手忿怒拳にし、右手を上に左手を下
にして背け、二小指を背け鉤結し、二
頭指を背け竪てる。左に転じて辟除を
成じ、右に旋して結界を成ずる。真言
は、

Mahāmudrā of Trailokyavijaya

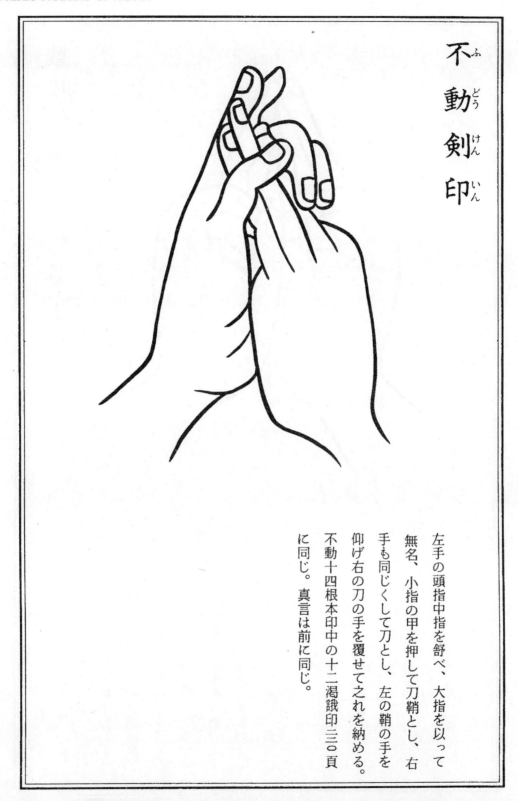

不動剣印

左手の頭指中指を舒べ、大指を以って
無名、小指の甲を押して刀鞘とし、右
手も同じくして刀とし、左の鞘の手を
仰げ右の刀の手を覆せて之れを納める。
不動十四根本印中の十二渇誐印三〇頁
に同じ。真言は前に同じ。

Khadga-mudrā of Acala (the mudrā of the sword of Acala)

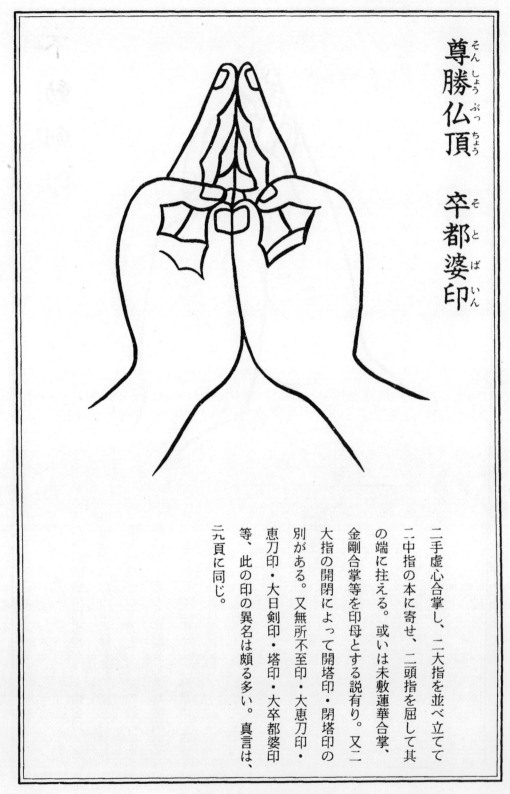

尊勝仏頂　卒都婆印

二手虚心合掌し、二大指を並べ立てて
二中指の本に寄せ、二頭指を屈して其
の端に拄える。或いは未敷蓮華合掌、
金剛合掌等を印母とする説有り。又二
大指の開閉によって開塔印・閉塔印の
別がある。又無所不至印・大恵刀印・
恵刀印・大日剣印・塔印・大卒都婆印
等、此の印の異名は頗る多い。真言は、
二九頁に同じ。

Stūpa-mudrā of Vijayoṣṇīṣa

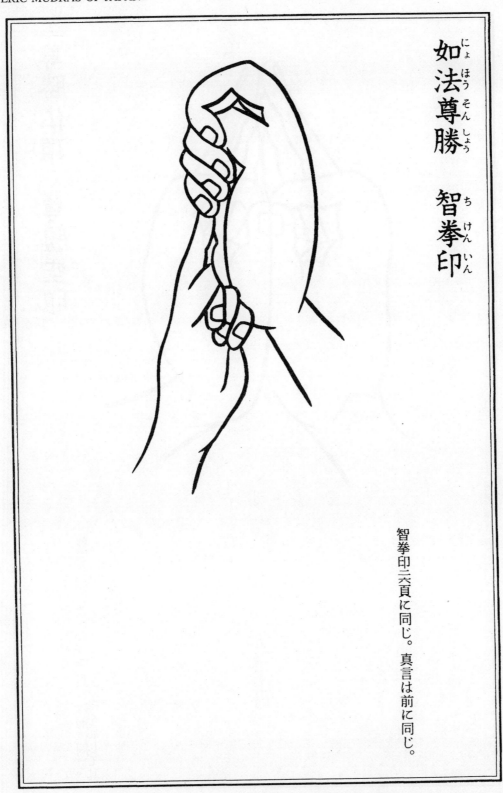

如法尊勝　智拳印

智拳印二六頁に同じ。真言は前に同じ。

Jñāna-muṣṭi-mudrā of Tathatā-dharma-vijaya

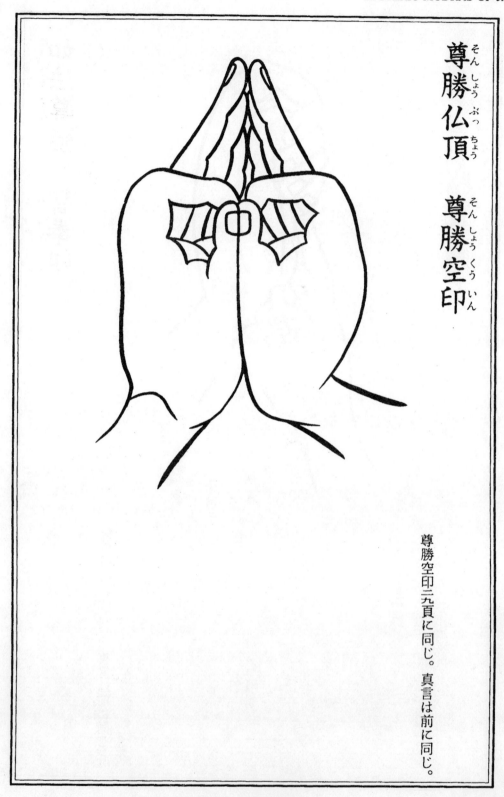

尊勝仏頂　尊勝空印

尊勝空印二九頁に同じ。真言は前に同じ。

Mudrā of Vijayoṣṇīṣa

光明真言
五色光印

左の手を金剛拳にして腰に按じ、右手
を開いて五指を舒べて外に向ける。五
指を少し離して立て、指の頭より各々
五色の光明を放ち五道の衆生の罪暗を
照破すと観じ、印を下に向けて物を打
つ勢を作して、三途極苦の扉を打破し
て受苦の衆生を極楽浄土に到らしめる
と観想する。五指は五輪・五智・五仏
等の義、小指より大指に至る五指と五
色の配列は次の如く、黄白赤黒青であ
る。真言は、

Mudrā of the five-coloured light of the Prabhāsa-mantra

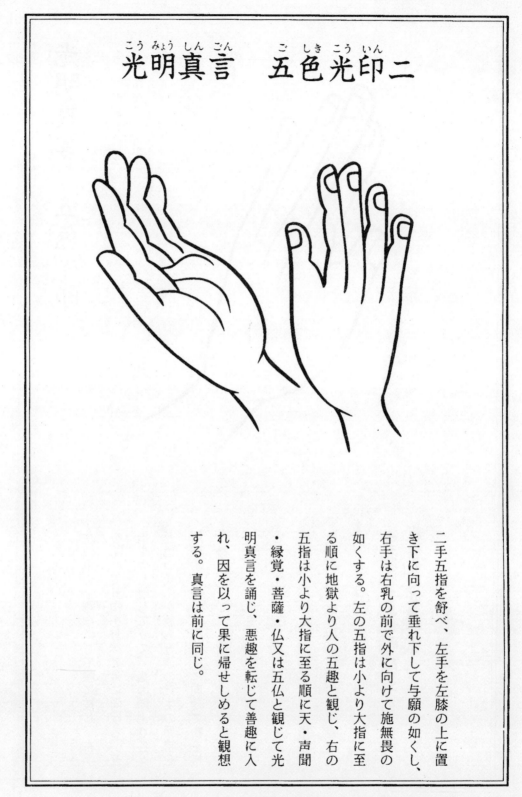

光明真言　五色光印二

する。真言は前に同じ。

れ、因を以って果に帰せしめると観想

明真言を誦じ、悪趣を転じて善趣に入

・縁覚・菩薩・仏又は五仏と観じて光

五指は小より大指に至る順に天・声聞

る順に地獄より人の五趣と観じ、右の

如くする。左の五指は小より大指に至

右手は右乳の前で外に向けて施無畏の

き下に向って垂れ下して与願の如くし、

二手五指を舒べ、左手を左膝の上に置

Mudrā of the five-coloured light of the Prabhāsa-mantra, no. 2

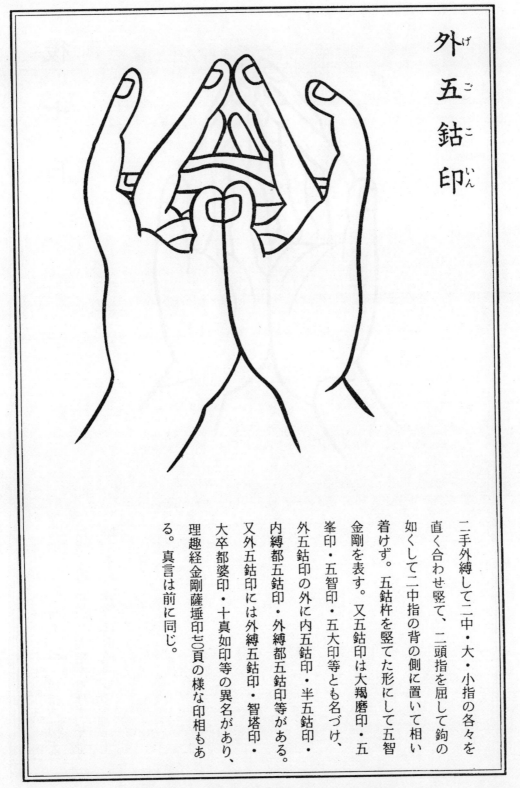

外五鈷印

^げ外 ^ご五 ^こ鈷 ^{いん}印

二手外縛して二中・大・小指の各々を
直く合わせ竪て、二頭指を屈して鉤の
如くして二中指の背の側に置いて相い
着けず。五鈷杵を竪てた形にして五智
金剛を表す。又五鈷印は大羯磨印・五
峯印・五智印・五大印等とも名づけ、
外五鈷印の外に内五鈷印・半五鈷印・
内縛都五鈷印・外縛都五鈷印等がある。
又外五鈷印には外縛五鈷印・智塔印・
大卒都婆印・十真如印等の異名があり、
理趣経金剛薩埵印七〇頁の様な印相もあ
る。真言は前に同じ。

Mudrā of the exterior five-pronged vajra

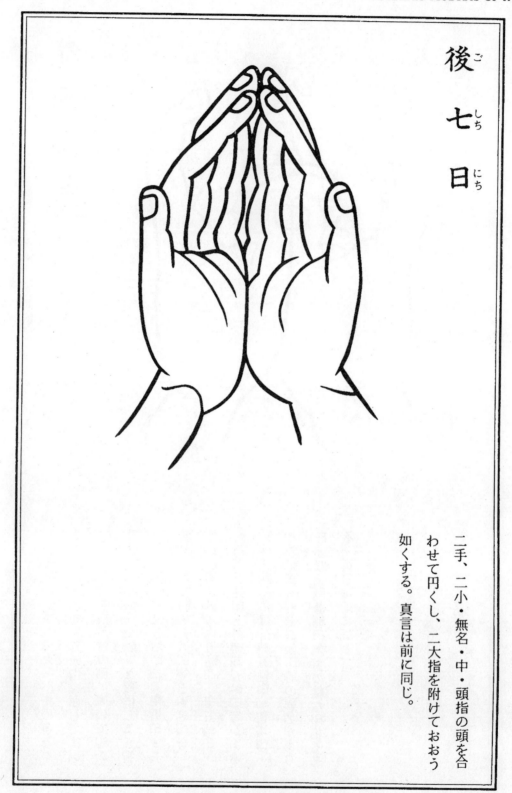

後
七
日

二手、二小・無名・中・頭指の頭を合
わせて円くし、二大指を附けておおう
如くする。真言は前に同じ。

Mudrā of the seven days

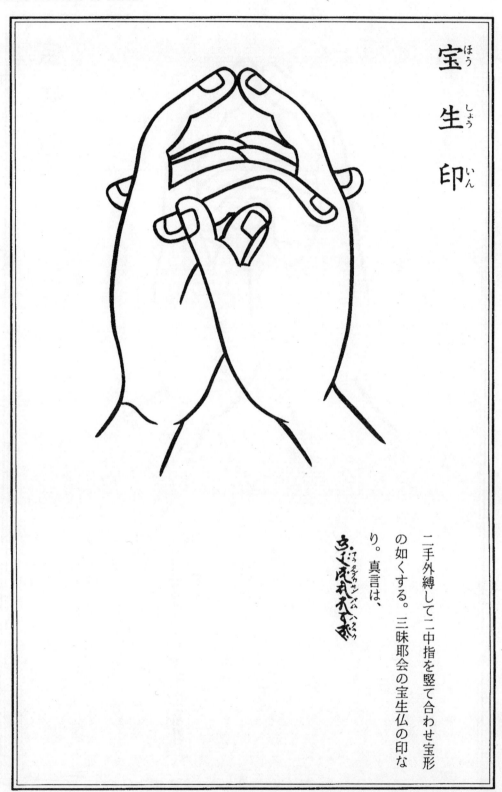

宝
生
印

ほう
しょう
いん

二手外縛して二中指を竪て合わせ宝形
の如くする。三昧耶会の宝生仏の印な
り。真言は、

Mudrā of Ratnasambhava

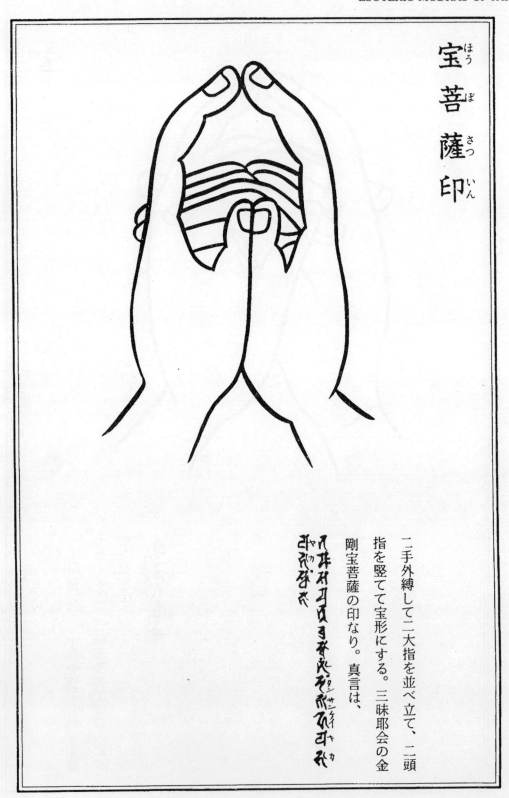

宝菩薩印

二手外縛して二大指を並べ立て、二頭
指を竪てて宝形にする。三昧耶会の金
剛宝菩薩の印なり。真言は、

Mudrā of Ratna Bodhisattva (i.e. of Vajraratna)

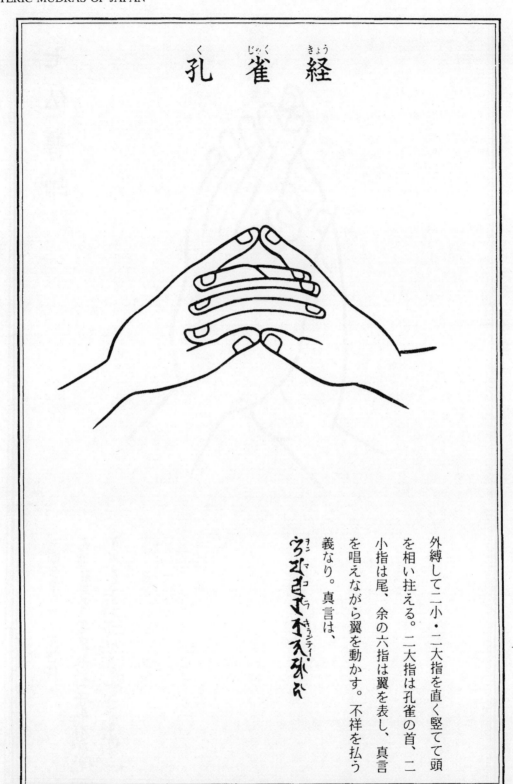

孔<ruby>雀<rt>じゃく</rt></ruby><ruby>経<rt>きょう</rt></ruby>

外縛して二小・二大指を直く竪てて頭を相い拄える。二大指は孔雀の首、二小指は尾、余の六指は翼を表し、真言を唱えながら翼を動かす。不祥を払う義なり。真言は、

Mudrā of Mahāmāyūrī

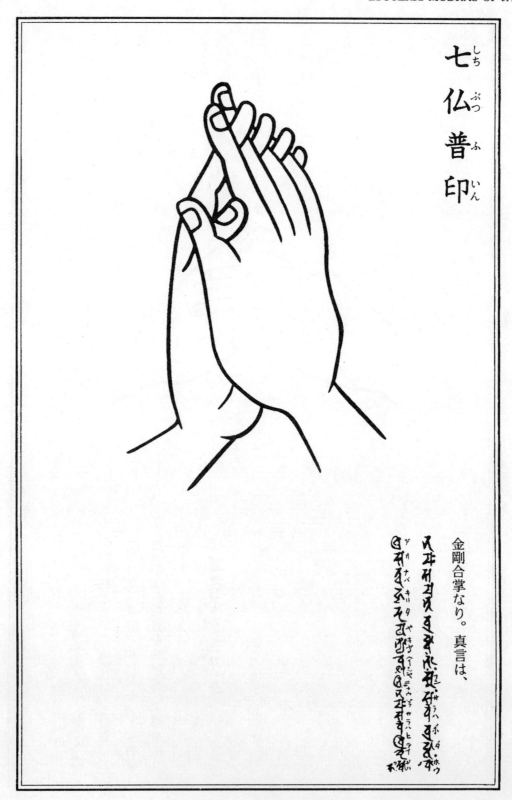

Mudrā of the Seven Buddhas

慈氏金剛掌旋転

金剛合掌をしたまま右を覆せ左を仰げ
て左に転ず。　次に左を覆せ右を仰げて
右に転ずる。　如来神通の力を以って迅
速に加持することを表す。　真言は、

Mudrā of Maitreya

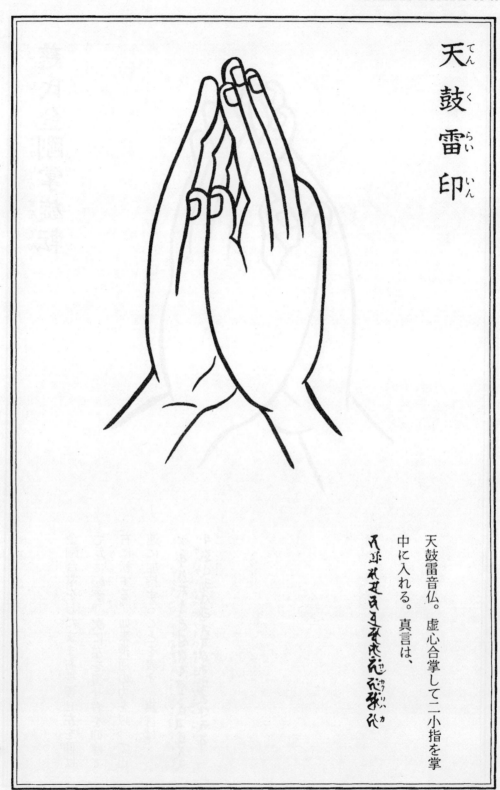

天
鼓
雷
印

天鼓雷音仏。虚心合掌して二小指を掌中に入れる。真言は、

Mudrā of Divya-dundubhi-megha-nirghoṣa

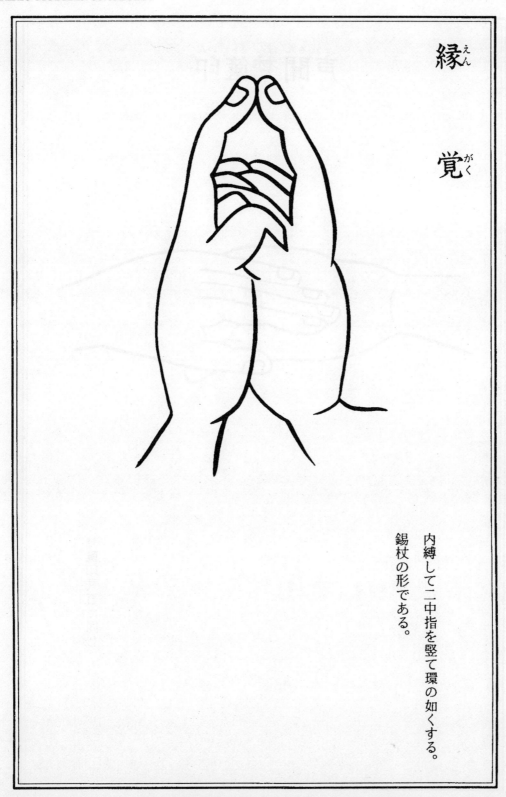

縁
<ruby>えん</ruby>

覚
<ruby>がく</ruby>

内縛して二中指を竪て環の如くする。
錫杖の形である。

Mudrā of Pratyeka-Buddha

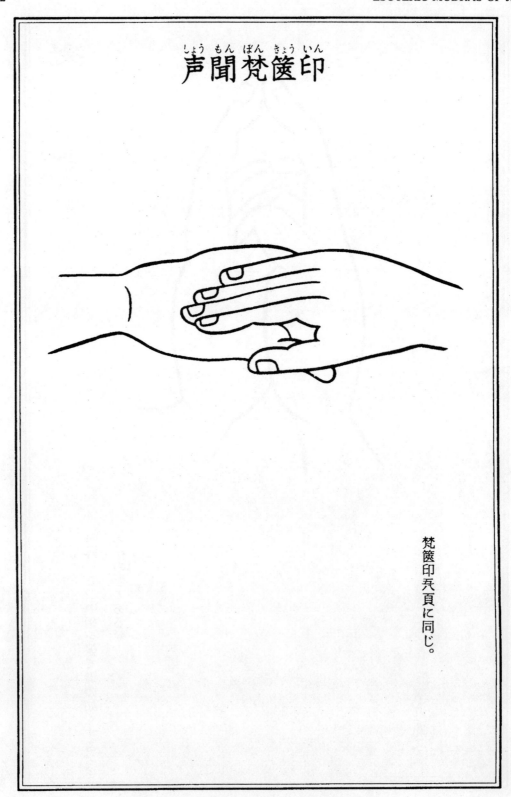

声聞梵篋印

梵篋印兵頁に同じ。

The pothi mudrā of a śrāvaka

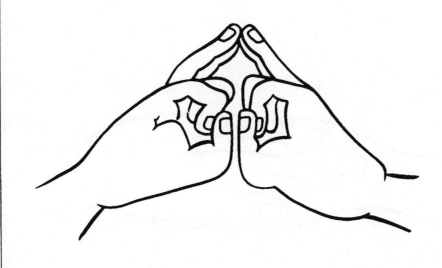

仁王経根本印 経台印と名づく

二手背を合わせ、二頭・小指を屈し、二大指を以って二頭・小指の甲の上を押す。二中・無名指の背を合わせて直く立つ。中・無名指は経台を表す。般若波羅蜜多根本印・般若無尽蔵・般若眼・般若根本・金剛般若心等とも名づける。真言は、

Mūla-mudrā of the Kāruṇika-rāja-sūtra (Sutra of Benevolent Kings)

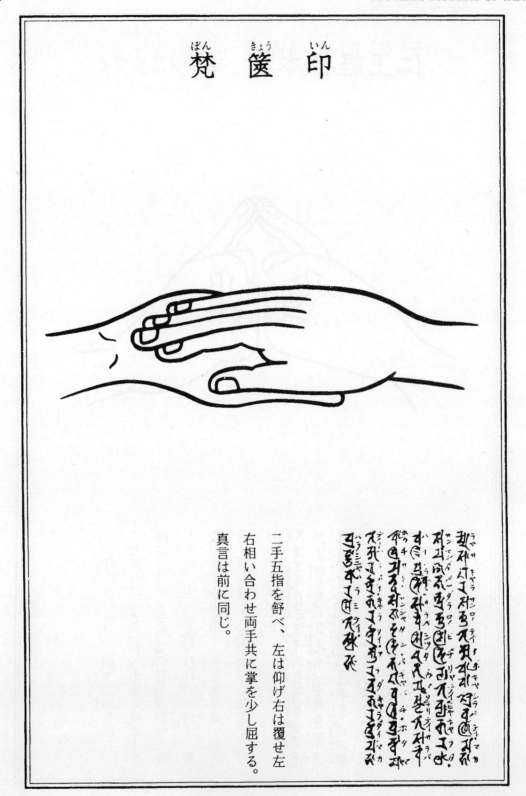

梵篋印

二手五指を舒べ、左は仰げ右は覆せ左
右相い合わせ両手共に掌を少し屈する。
真言は前に同じ。

Pothi mudrā

<ruby>請<rt>しょう</rt>雨<rt>う</rt>経<rt>きょう</rt>智<rt>ち</rt>吉<rt>きち</rt>祥<rt>じょう</rt>印<rt>いん</rt></ruby>

Jñāna-śrī-mudrā of the Mahāmegha-sūtra

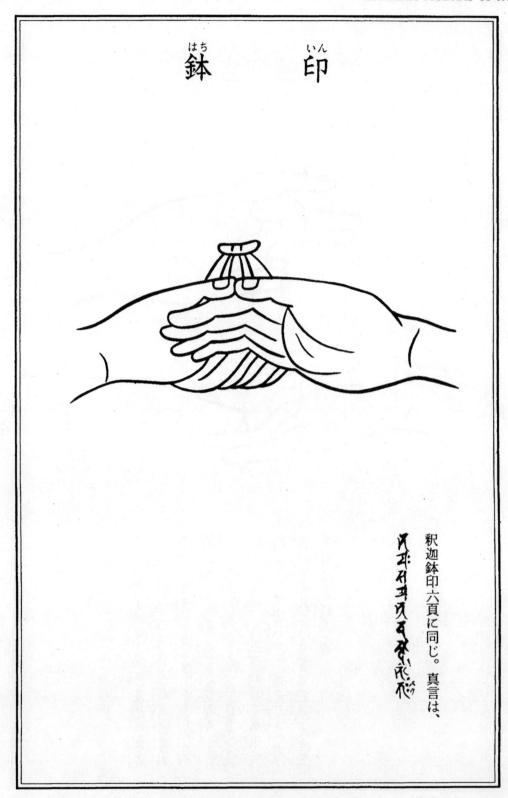

鉢 印

釈迦鉢印六頁に同じ。真言は、

Pātra-mudrā (of the alms-bowl)

聖<ruby>観<rt>かん</rt></ruby><ruby>音<rt>のん</rt></ruby>

観音印四頁に同じ。 真言は前に同じ。

Mudrā of Ārya Avalokiteśvara

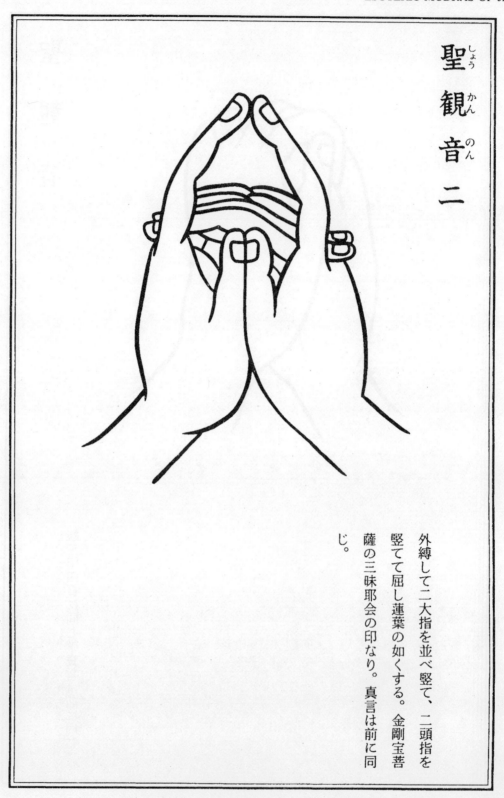

聖観音二
(しょう)(かん)(のん)

外縛して二大指を並べ竪て、二頭指を竪てて屈し蓮葉の如くする。金剛宝菩薩の三昧耶会の印なり。真言は前に同じ。

Mudrā of Ārya Avalokiteśvara, no. 2

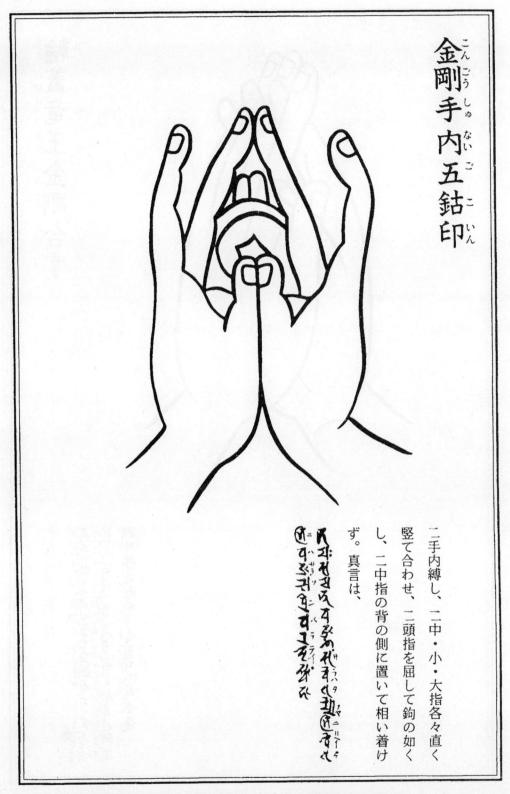

金剛手内五鈷印

二手内縛し、二中・小・大指各々直く
竪て合わせ、二頭指を屈して鉤の如く
し、二中指の背の側に置いて相い着け
ず。真言は、

Interior five-pronged vajra mudrā of Vajrapāṇi

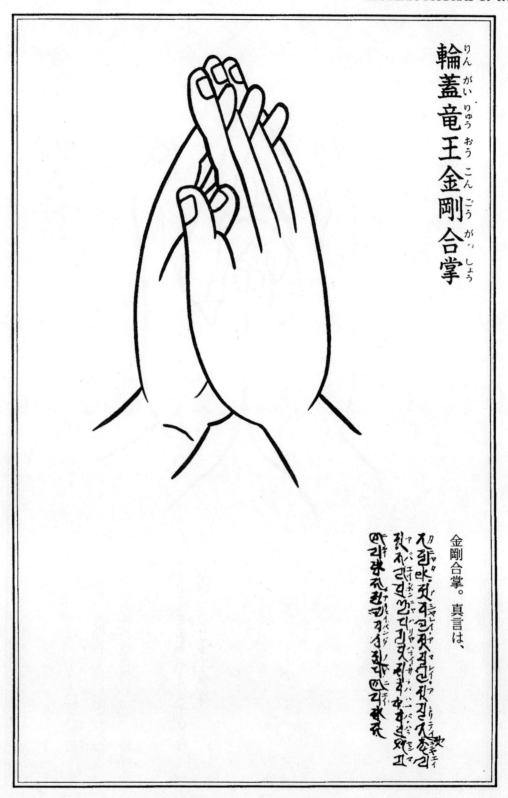

輪蓋竜王金剛合掌

金剛合掌。真言は、

Vajrāñjali of the Nāgarāja Ringai

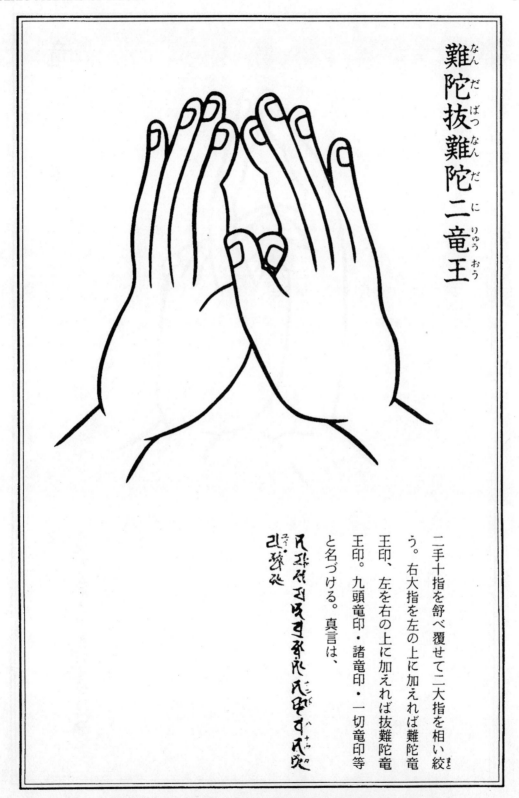

難陀抜難陀二竜王

二手十指を舒べ覆せて二大指を相い絞う。右大指を左の上に加えれば難陀竜王印、左を右の上に加えれば抜難陀竜王印。九頭竜印・諸竜印・一切竜印等と名づける。真言は、

Mudrā of the two Nāgarājas Nanda and Upananda

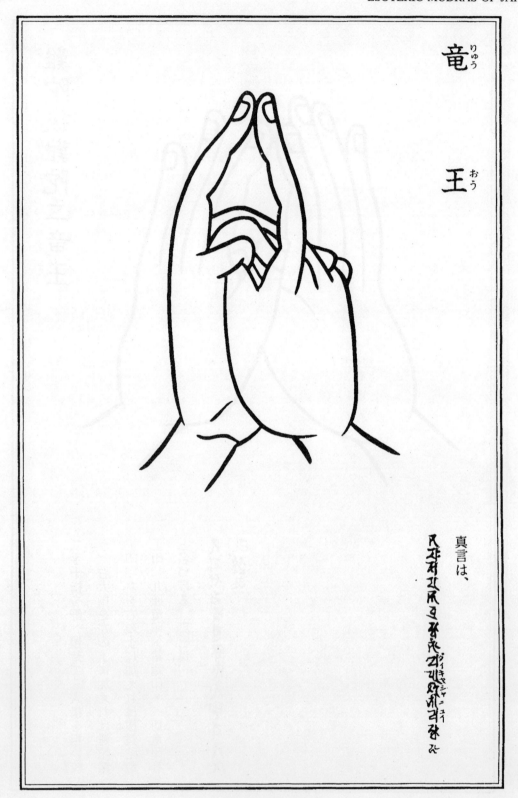

竜
りゅう

王
おう

真言は、

Mudrā of nāgarāja

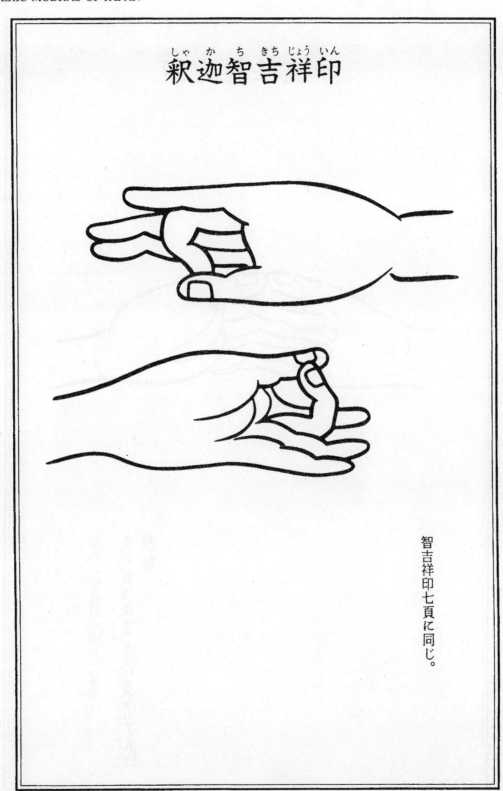

釈迦智吉祥印

智吉祥印七頁に同じ。

Jñāna-śrī-mudrā of Śākyamuni

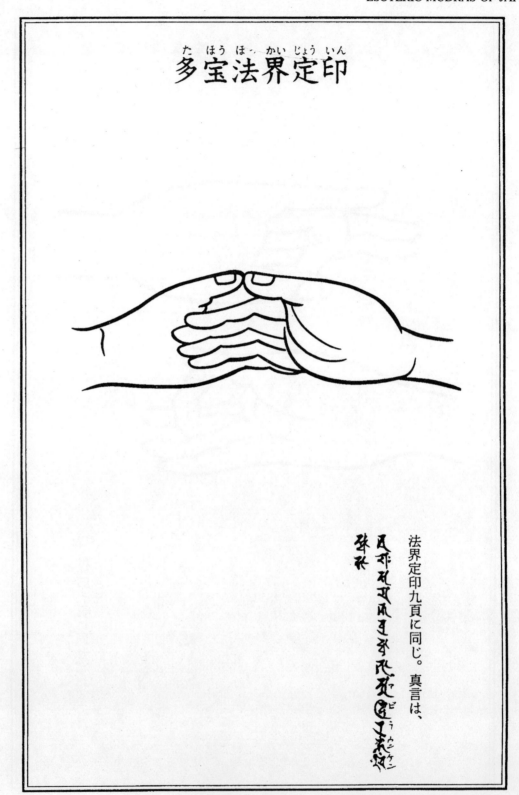

Dharmadhātu-dhyāna-mudrā of Prabhūta-ratna

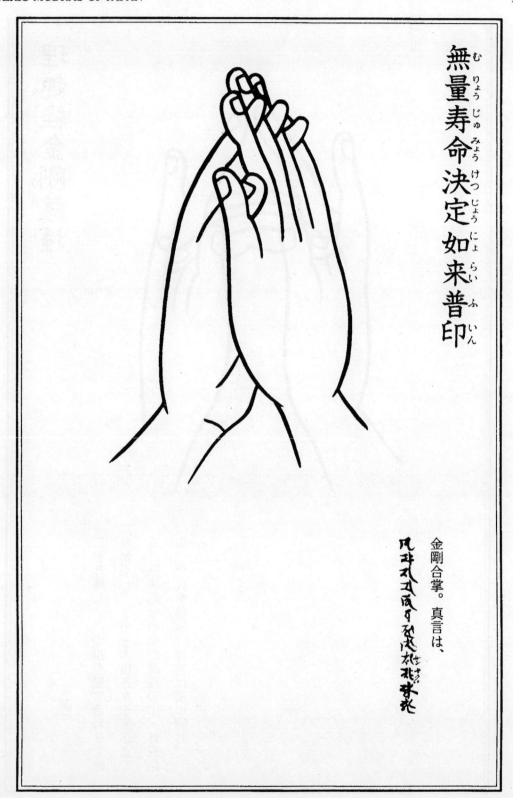

無量寿命決定如来普印

金剛合掌。真言は、

Mudrā of Amitāyus

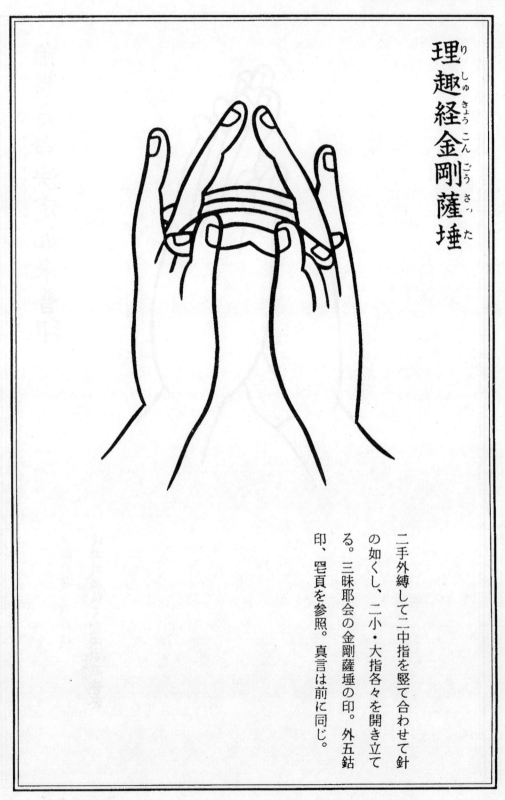

理趣経金剛薩埵

二手外縛して二中指を竪て合わせて針
の如くし、二小・大指各々を開き立て
る。三昧耶会の金剛薩埵の印。外五鈷
印、罕頁を参照。真言は前に同じ。

Mudrā of Vajrasattva the main deity of the Naya-sūtra

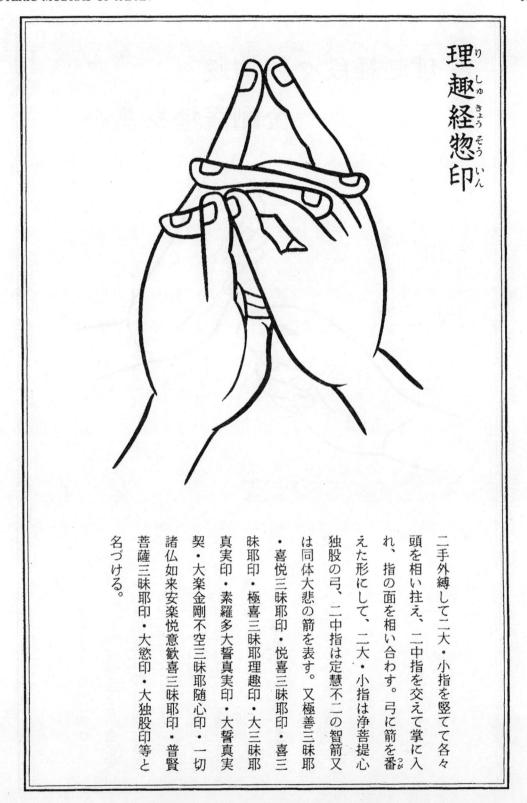

理趣経惣印
（り）（しゅ）（きょう）（そう）（いん）

二手外縛して二大・小指を竪てて各々頭を相い拄え、二中指を交えて掌に入れ、指の面を相い合わす。弓に箭を番えた形にして、二大・小指は浄菩提心独股の弓、二中指は定慧不二の智箭又は同体大悲の箭を表す。又極善三昧耶・喜悦三昧耶印・悦喜三昧耶印・喜三昧耶印・極喜三昧耶理趣印・大三昧耶真実印・素羅多大誓真実印・大誓真実契・大楽金剛不空三昧耶随心印・一切諸仏如来安楽悦意歓喜三昧耶印・普賢菩薩三昧耶印・大慾印・大独股印等と名づける。

Conventional mudrā of the Naya-sūtra

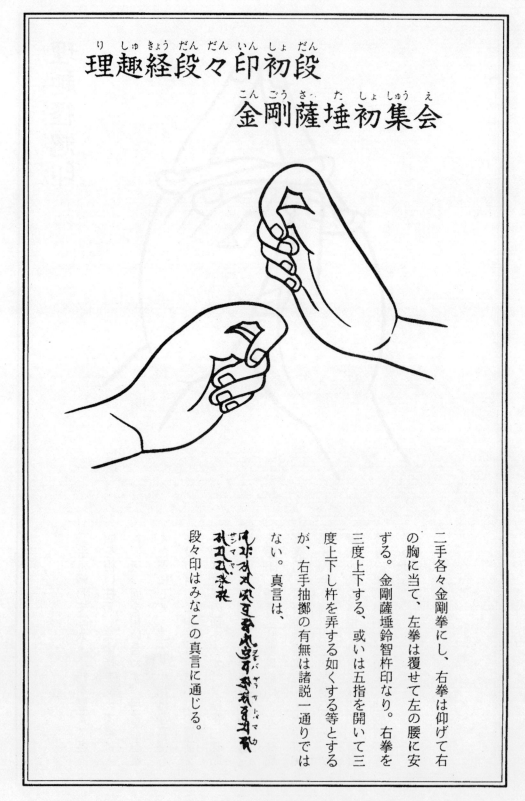

理趣経段々印初段

金剛薩埵初集会

二手各々金剛拳にし、右拳は仰げて右の胸に当て、左拳は覆せて左の腰に安ずる。金剛薩埵鈴智杵印なり。右拳を三度上下する、或いは五指を開いて三度上下し杵を弄する如くする等とするが、右手抽擲の有無は諸説一通りではない。真言は、

段々印はみなこの真言に通じる。

Mudrā of the Vajrasattva-varga of the first chapter of the Naya-sūtra

理趣経二段　毘盧遮那理趣会段

智拳印三六頁に同じ。真言は前に同じ。

Mudrā of Vairocana in the Naya-sūtra

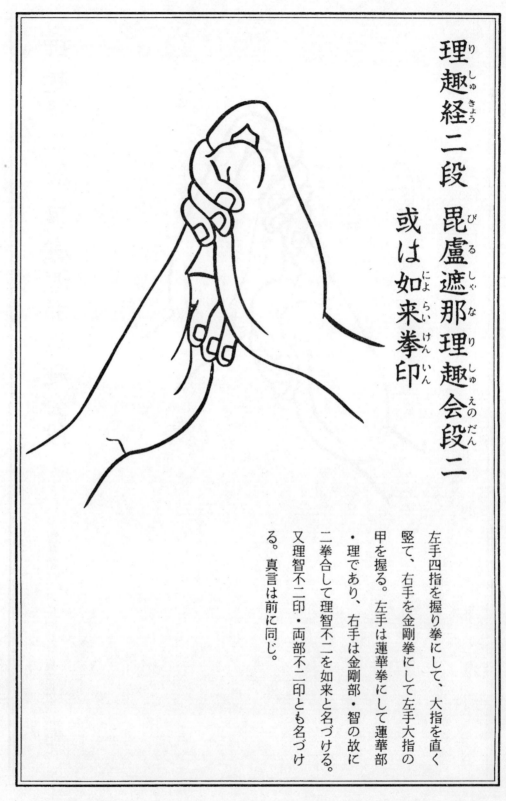

理趣経二段 毘盧遮那理趣会段二
或は如来拳印

左手四指を握り拳にして、大指を直く
堅て、右手を金剛拳にして左手大指の
甲を握る。左手は蓮華拳にして蓮華部
・理であり、右手は金剛拳にして金剛部・智の故に
二拳合して理智不二を如来と名づける。
又理智不二印・両部不二印とも名づけ
る。真言は前に同じ。

Mudrā of the Vairocana-varga of the second chapter of the Naya-sūtra

理趣経三段 降三世

降三世大印四頁に同じ。

Mudrā of Trailokya-vijaya of the third chapter of the Naya-sūtra

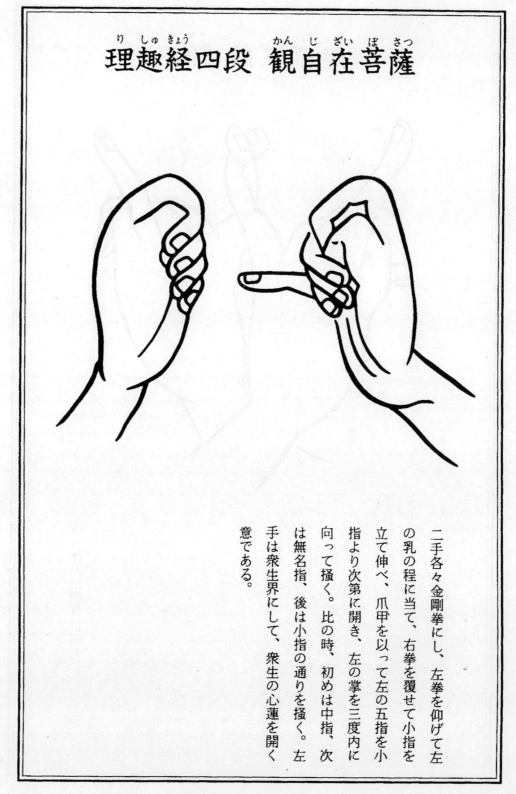

理趣経四段　観自在菩薩

意である。
手は衆生界にして、衆生の心蓮を開く
は無名指、後は小指の通りを掻く。左
向って掻く。比の時、初めは中指、次
指より次第に開き、左の掌を三度内に
立て伸べ、爪甲を以って左の五指を小
の乳の程に当て、右拳を覆せて小指を
二手各々金剛拳にし、左拳を仰げて左

Mudrā of Avalokiteśvara Bodhisattva of the fourth chapter of the Naya-sūtra

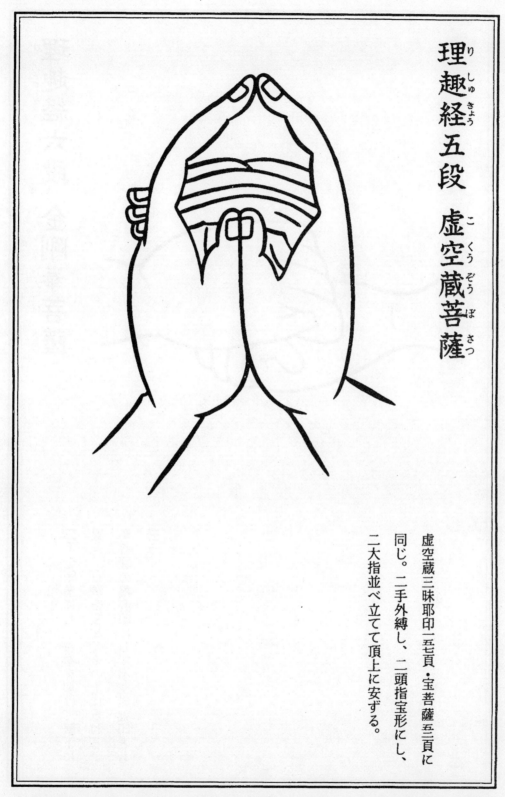

理趣経五段　虚空蔵菩薩

虚空蔵三昧耶印一五七頁・宝菩薩五三頁に
同じ。二手外縛し、二頭指宝形にし、
二大指並べ立てて頂上に安ずる。

Mudrā of Ākāśagarbha Bodhisattva of the fifth chapter of the Naya-sūtra

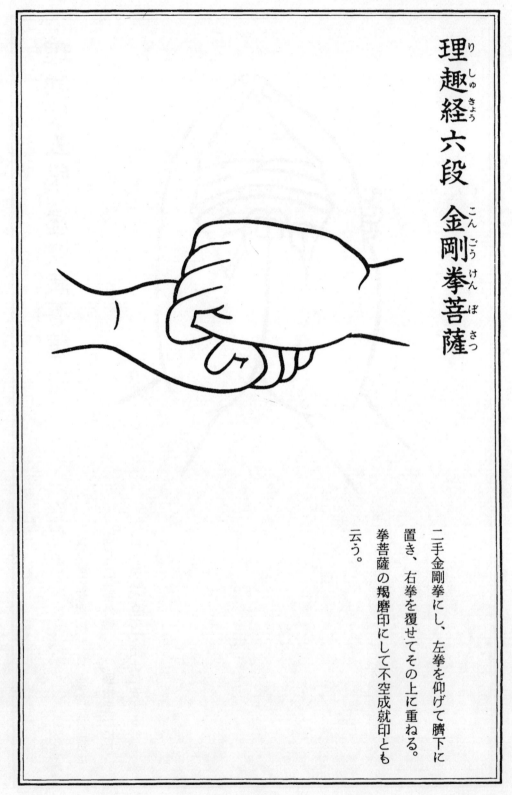

理趣経六段　金剛拳菩薩

二手金剛拳にし、左拳を仰げて臍下に置き、右拳を覆せてその上に重ねる。拳菩薩の羯磨印にして不空成就印とも云う。

Mudrā of Vajramuṣṭi Bodhisattva of the sixth chapter of the Naya-sūtra

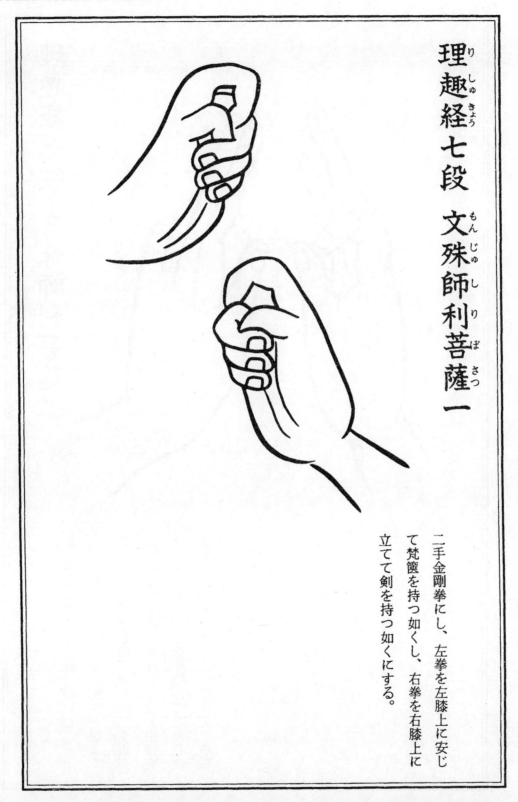

理趣経七段　文殊師利菩薩一

二手金剛拳にし、左拳を左膝上に安じ
て梵篋を持つ如くし、右拳を右膝上に
立てて剣を持つ如くにする。

Mudrā of Mañjuśrī Bodhisattva of the seventh chapter of the Naya-sūtra

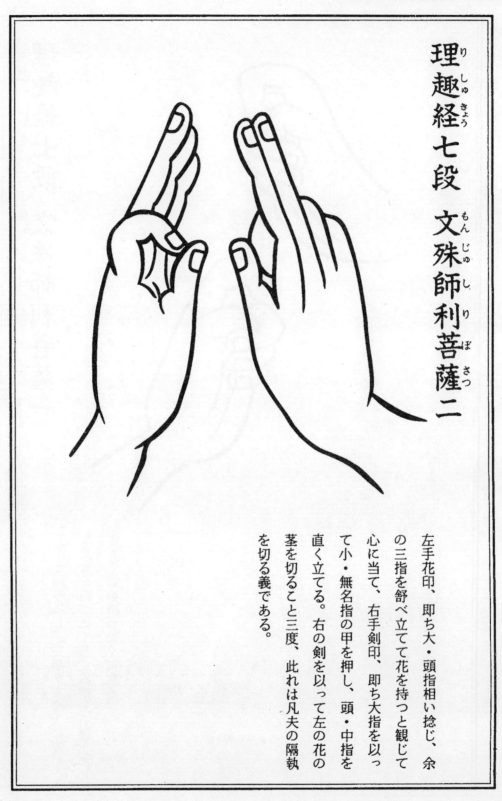

理趣経七段 文殊師利菩薩二

左手花印、即ち大・頭指相い捻じ、余の三指を舒べ立てて花を持つと観じて心に当て、右手剣印、即ち大指を以って小・無名指の甲を押し、頭・中指を直く立てる。右の剣を以って左の花の茎を切ること三度、此れは凡夫の隔執を切る義である。

Mudrā of Mañjuśrī Bodhisattva of the seventh chapter of the Naya-sūtra, no. 2

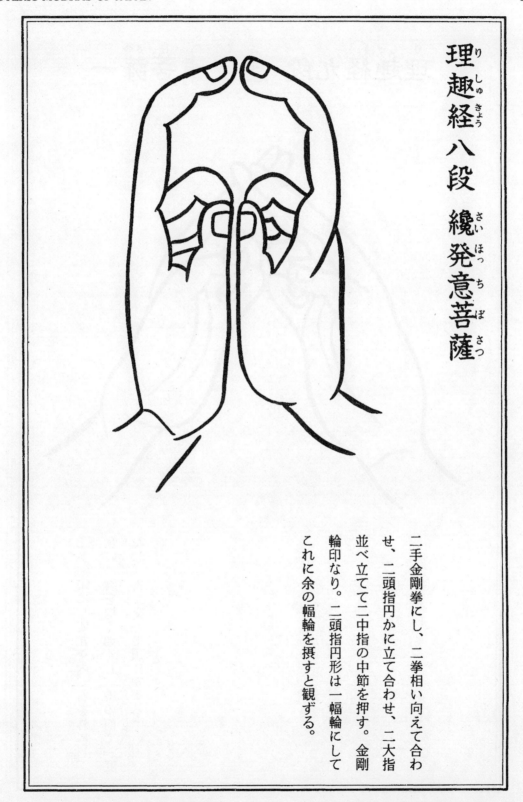

理趣経 八段 纔発意菩薩

これに余の幅輪を摂すと観ずる。輪印なり。二頭指円形は一幅輪にして並べ立てて二中指の中節を押す。金剛せ、二頭指円かに立て合わせ、二大指二手金剛拳にし、二拳相い向えて合わ

Mudrā of Sacittotpāda Bodhisattva of the eighth chapter of the Naya-sūtra

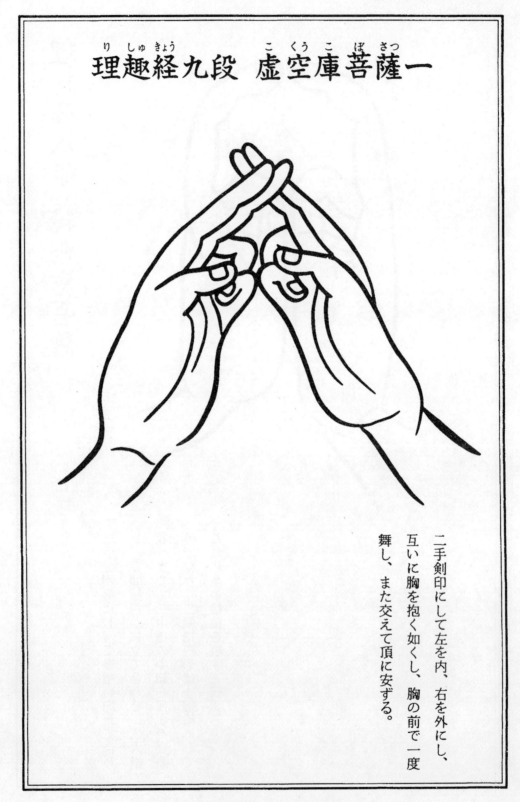

理趣経九段　虚空庫菩薩一

二手剣印にして左を内、右を外にし、
互いに胸を抱く如くし、胸の前で一度
舞し、また交えて頂に安ずる。

Mudrā of Gaganagañja Bodhisattva
of the ninth chapter of the Naya-sūtra, no. 1

理趣経九段　虚空庫菩薩二

二手の大指各々小指の甲を捻じ、余の
六指を舒べ立てて互いに交叉し、印を
覆せて右に三度転ずる。金剛界三昧耶
会の金剛業菩薩の印なり。

Mudrā of Gaganagañja Bodhisattva
of the ninth chapter of the Naya-sūtra, no. 2

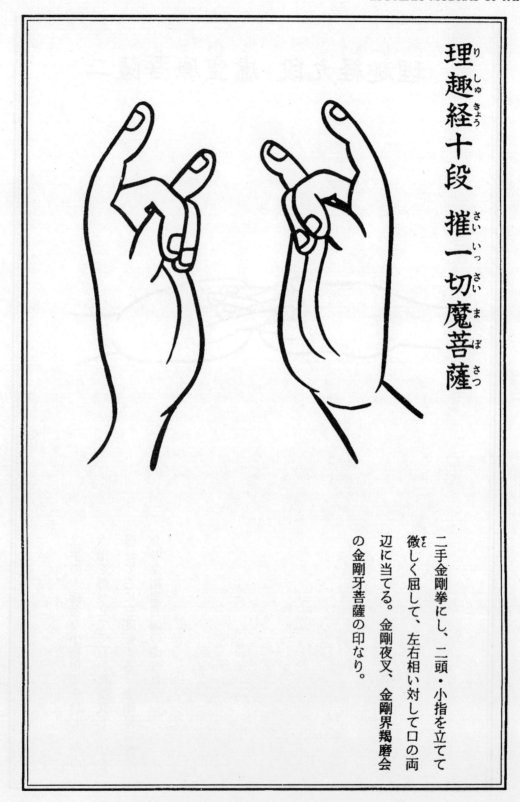

理趣経十段　摧一切魔菩薩

の金剛牙菩薩の印なり。
辺に当てる。金剛夜叉、金剛界羯磨会
微しく屈して、左右相い対して口の両
二手金剛拳にし、二頭・小指を立てて

Mudrā of Sarva-māra-pramardin Bodhisattva
of the tenth chapter of the Naya-sūtra

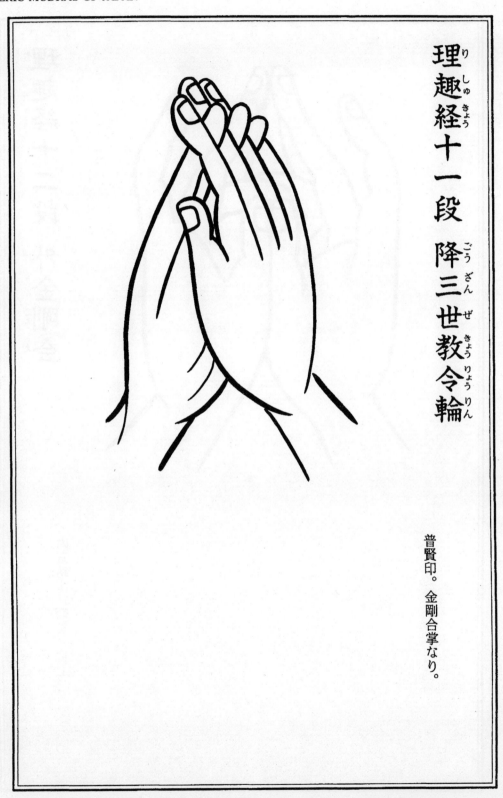

理趣経十一段 降三世教令輪

普賢印。金剛合掌なり。

Mudrā of Trailokyavijaya of the eleventh chapter of the Naya-sūtra

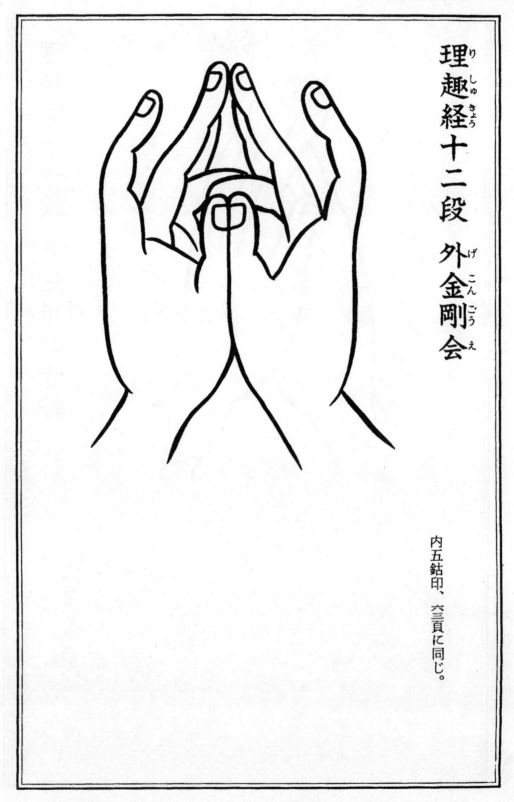

理趣経十二段　外金剛会

内五鈷印、六三頁に同じ。

Mudrā of the bāhya-vajrāvalī of the twelfth chapter of the Naya-sūtra

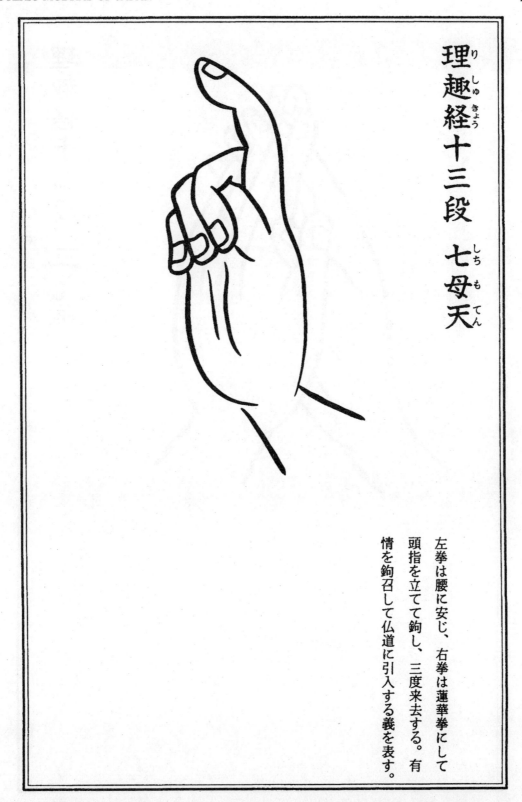

理趣経十三段　七母天

左拳は腰に安じ、右拳は蓮華拳にして
頭指を立てて鉤し、三度来去する。有
情を鉤召して仏道に引入する義を表す。

Mudrā of the Sapta-mātṛkā of the thirteenth chapter of the Naya-sūtra

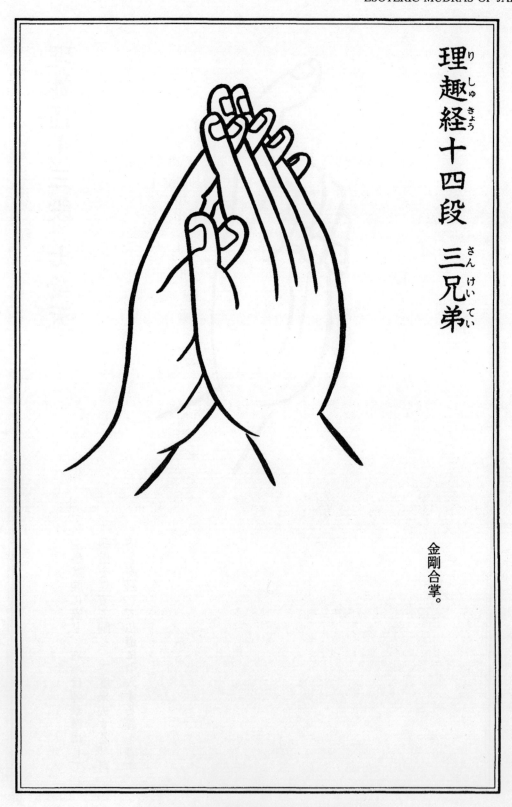

理趣経十四段　三兄弟

金剛合掌。

Mudrā of the Bhrātṛ-traya or Trimūrti
of the fourteenth chapter of the Naya-sūtra

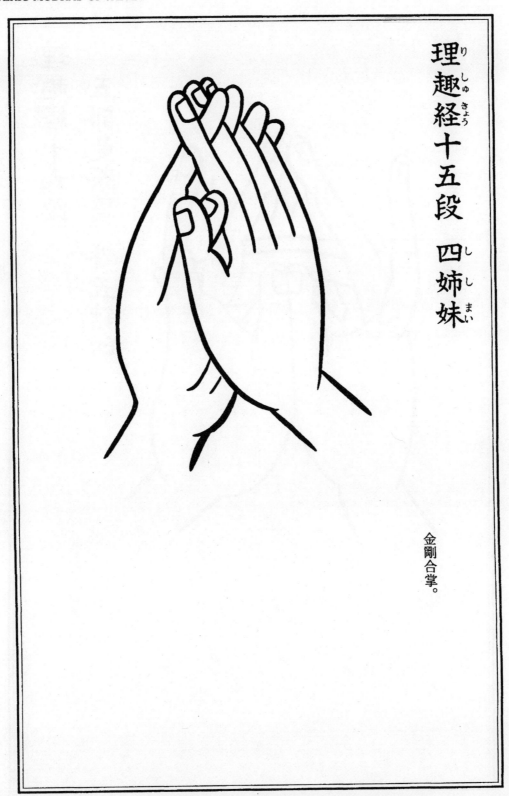

理趣経十五段　四姉妹

金剛合掌。

Mudrā of the Catur-bhaginī 'Four Sisters'
of the fifteenth chapter of the Naya-sūtra

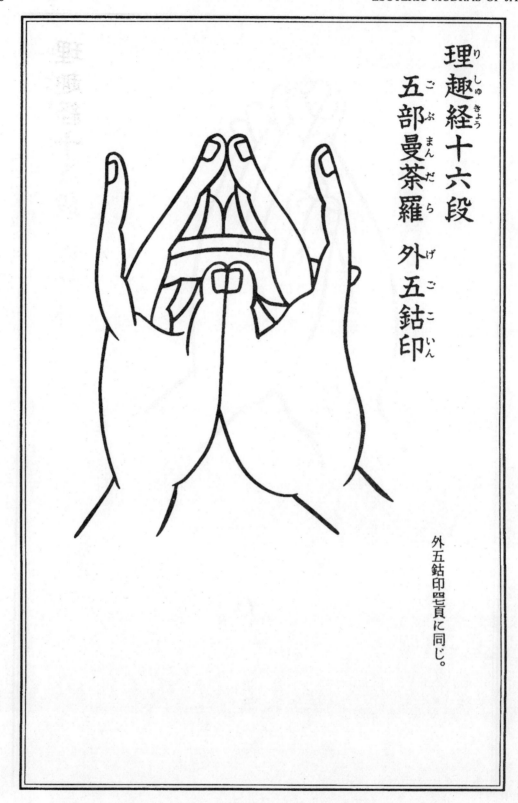

理趣経十六段
五部曼荼羅 外五鈷印

外五鈷印𦥯頁に同じ。

The outward five-pronged vajra mudrā of the pañca-kula-maṇḍala
of the sixteenth chapter of the Naya-sūtra

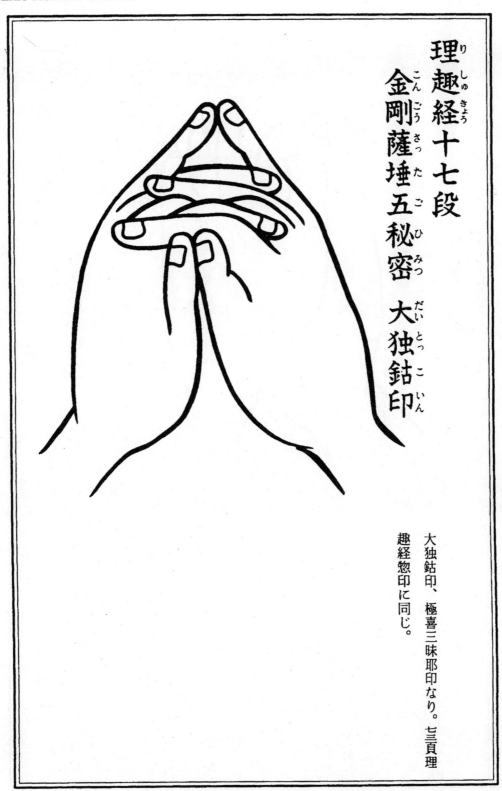

理趣経十七段
金剛薩埵五秘密 大独鈷印

大独鈷印、極喜三昧耶印なり。七三頁理趣経惣印に同じ。

Mudrā of the Vajrasattva-pañcaguhya
of the seventeenth chapter of the Naya-sūtra

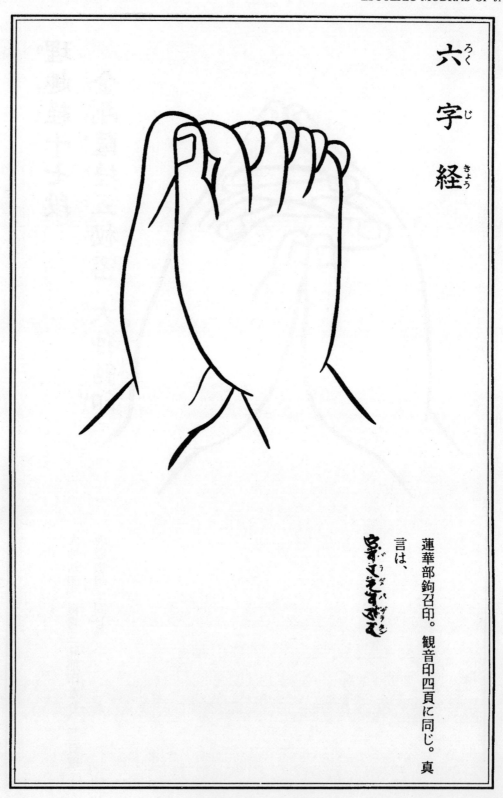

六字経

蓮華部鉤召印。観音印四頁に同じ。真
言は、

ウダバザラタン
हूँ

Mudrā of the Ṣaḍakṣara-sūtra

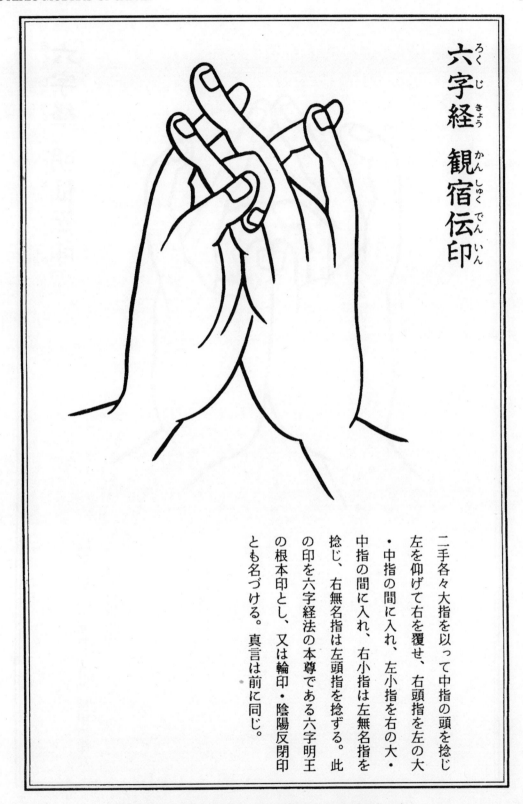

六字経 観宿伝印

二手各々大指を以って中指の頭を捻じ
左を仰げて右を覆せ、右頭指を左の大
・中指の間に入れ、左小指を右の大
中指の間に入れ、右小指は左無名指を
捻じ、右無名指は左頭指を捻ずる。此
の印を六字経法の本尊である六字明王
の根本印とし、又は輪印・陰陽反閉印
とも名づける。真言は前に同じ。

Mudrā of the Ṣaḍakṣara-sūtra, kanshukuden-in

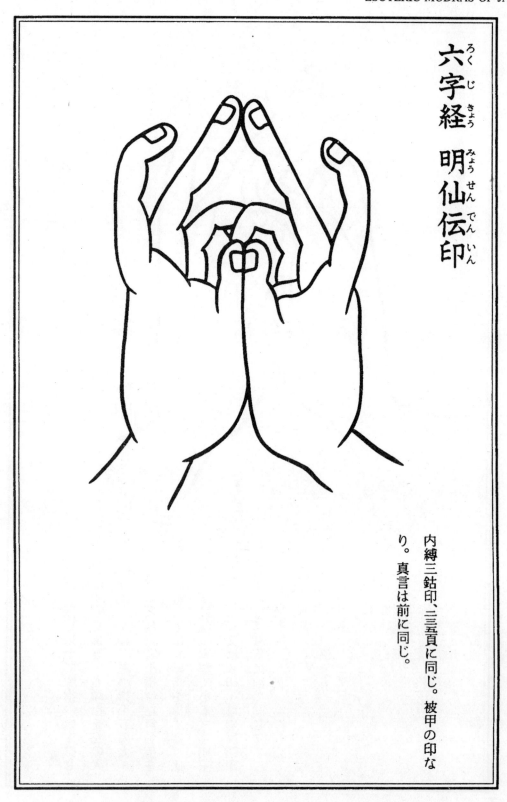

六字経 明仙伝印

内縛三鈷印、三三五頁に同じ。被甲の印なり。真言は前に同じ。

Mudrā of the Ṣaḍakṣara-sūtra, myōsenden-in

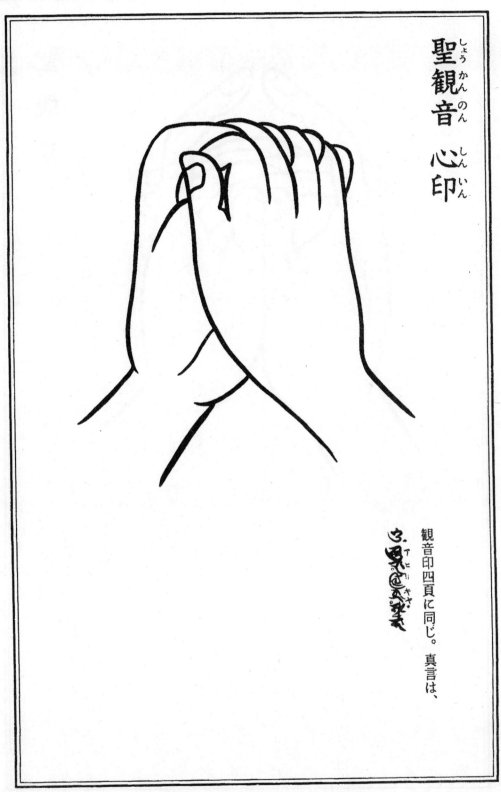

聖観音　心印

観音印四頁に同じ。　真言は、

Citta-mudrā of Ārya Avalokiteśvara

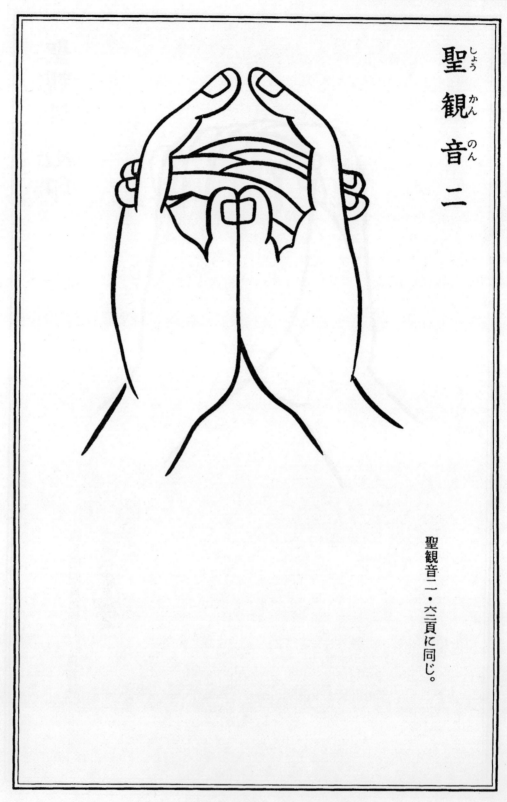

聖観音二

聖観音二・六三頁に同じ。

Second mudrā of Ārya Avalokiteśvara

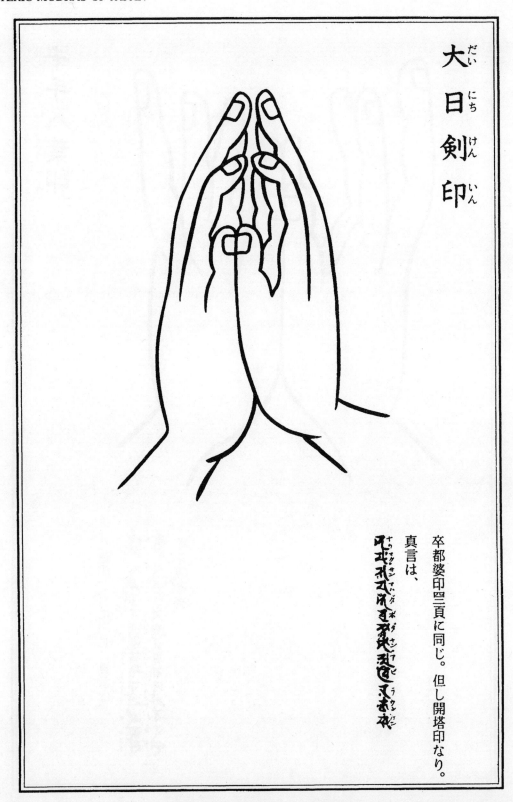

大日剣印

真言は、卒都婆印二頁に同じ。但し開塔印なり。

Khaḍga-mudrā of Vairocana

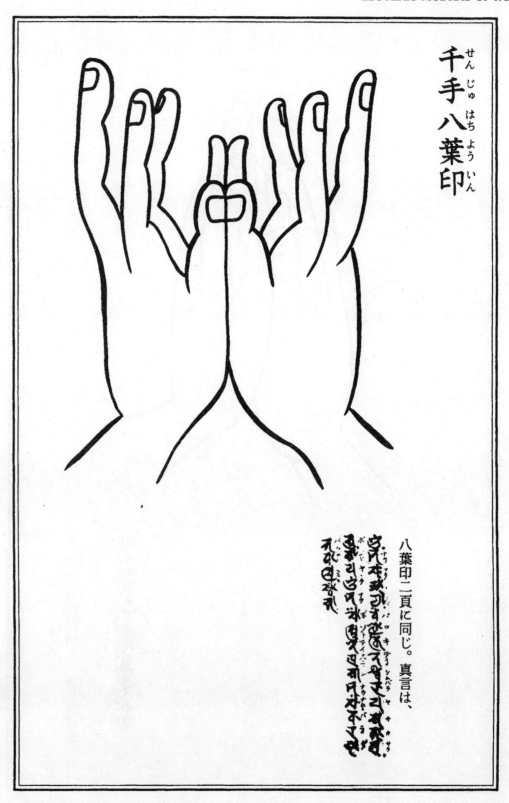

千手八葉印

八葉印二頁に同じ。真言は、

Aṣṭa-dala-mudrā (eight-petalled lotus mudrā) of Sahasra-bhuja Avalokiteśvara

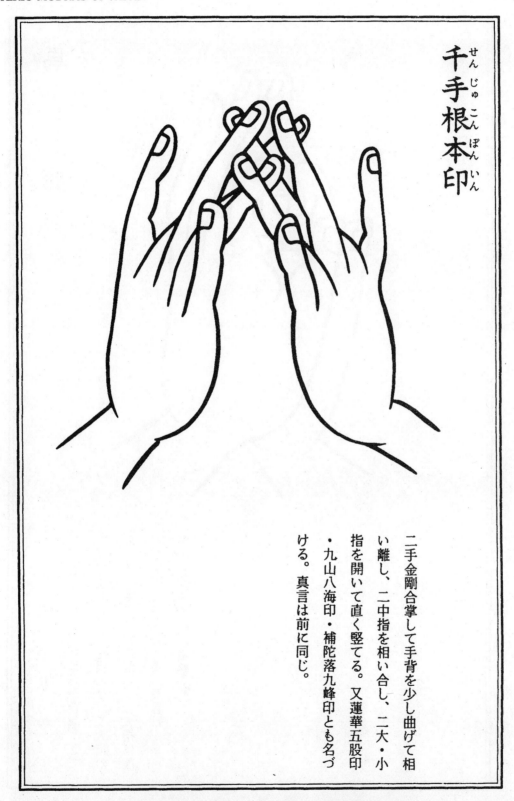

千手根本印

二手金剛合掌して手背を少し曲げて相い離し、二中指を相い合し、二大・小指を開いて直く竪てる。又蓮華五股印・九山八海印・補陀落九峰印とも名づける。　真言は前に同じ。

Mūla-mudrā of Sahasra-bhuja Avalokiteśvara

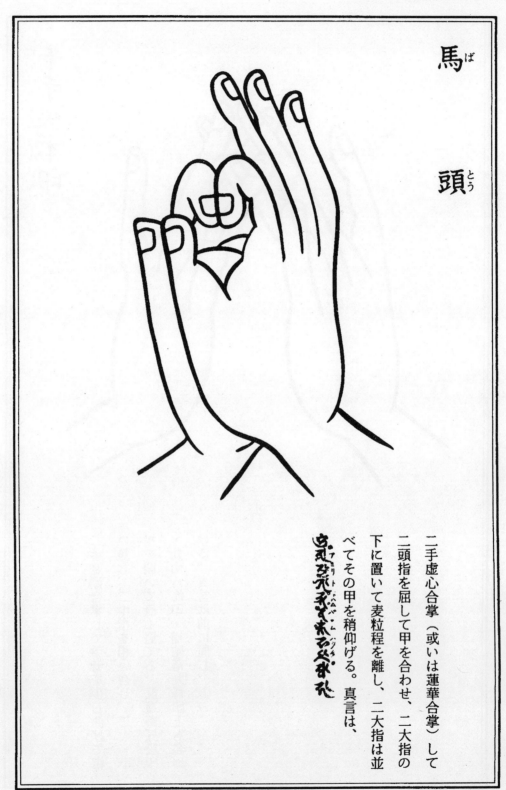

馬
_ば

頭
_{とう}

二手虚心合掌（或いは蓮華合掌）して
二頭指を屈して甲を合わせ、二大指の
下に置いて麦粒程を離し、二大指は並
べてその甲を稍仰げる。真言は、

Mudrā of Hayagrīva, no. 1

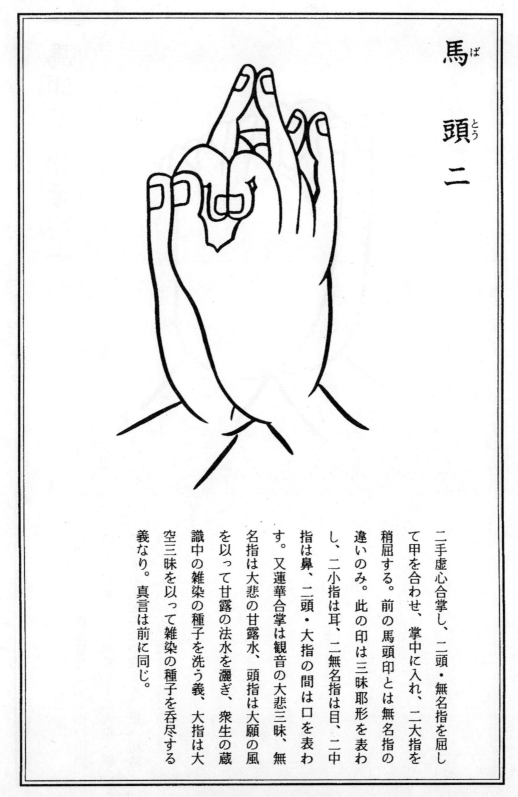

馬
頭
二

二手虚心合掌し、二頭・無名指を屈し
て甲を合わせ、掌中に入れ、二大指を
稍屈する。前の馬頭印とは無名指の
違いのみ。此の印は三昧耶形を表わ
し、二小指は耳、二無名指は目、二中
指は鼻、二頭・大指の間は口を表わ
す。又蓮華合掌は観音の大悲三昧、無
名指は大悲の甘露水、頭指は大願の風
を以って甘露の法水を灑ぎ、衆生の蔵
識中の雑染の種子を洗う義、大指は大
空三昧を以って雑染の種子を呑尽する
義なり。真言は前に同じ。

Mudrā of Hayagrīva, no. 2

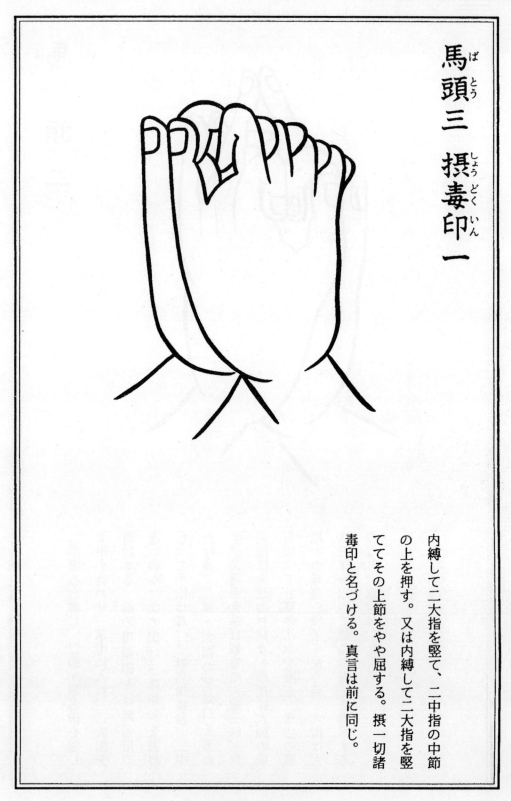

馬頭三　摂毒印一

毒印と名づける。真言は前に同じ。
てその上節をやや屈する。摂一切諸
の上を押す。又は内縛して二大指を竪
内縛して二大指を竪て、二中指の中節

Viṣa-pāna-mudrā of Hayagrīva, no. 1

馬頭四　摂毒印二

金剛合掌して二中指を竪て合わせ、二
頭指を以って各々二無名指を鉤してそ
の頭指を以って中指の上節を押し、小
指を並べ竪てて掌中に入れ、二大指を
並べ竪てて小指と聚め、悪業煩悩不祥
厄難を噉食すと観想し、大指を以って
三度噉む。又悪難噉食印と名づける。
真言は前に同じ。

Viṣa-pāna-mudrā of Hayagrīva, no. 2

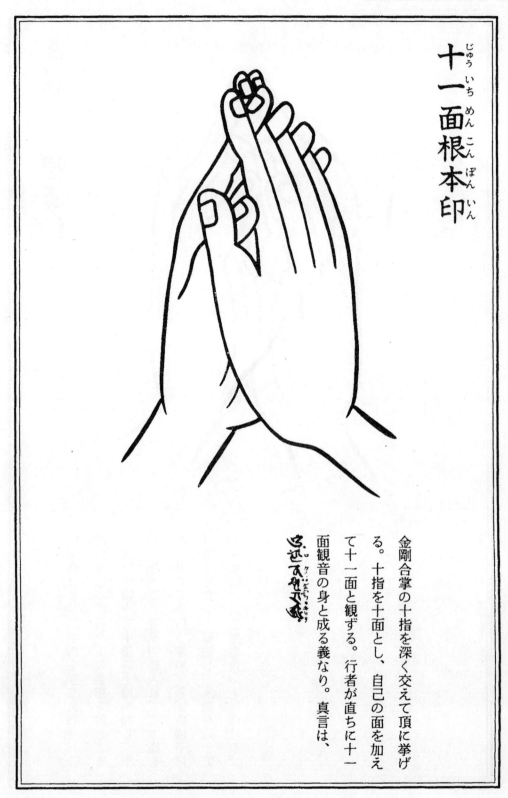

十一面根本印

金剛合掌の十指を深く交えて頂に挙げる。十指を十面とし、自己の面を加えて十一面と観ずる。行者が直ちに十一面観音の身と成る義なり。真言は、

Mūla-mudrā of Ekādaśa-mukha Avalokiteśvara

准胝 第一根本契

二小・無名指を内に相い叉え、二中指を直く竪てて頭を相い着け二頭指の頭を二中指の上節の側に附け二大指を各各二頭指の側に附ける。これを三股印と名づける。三股は面上の三目、即ち仏・蓮・金の三部を表す。又は大・頭・中・無名・小指を次第に法界体性・大円鏡・平等性・妙観察・成所作智の五智に配する。真言は、

The first mūla-mudrā of Cundī

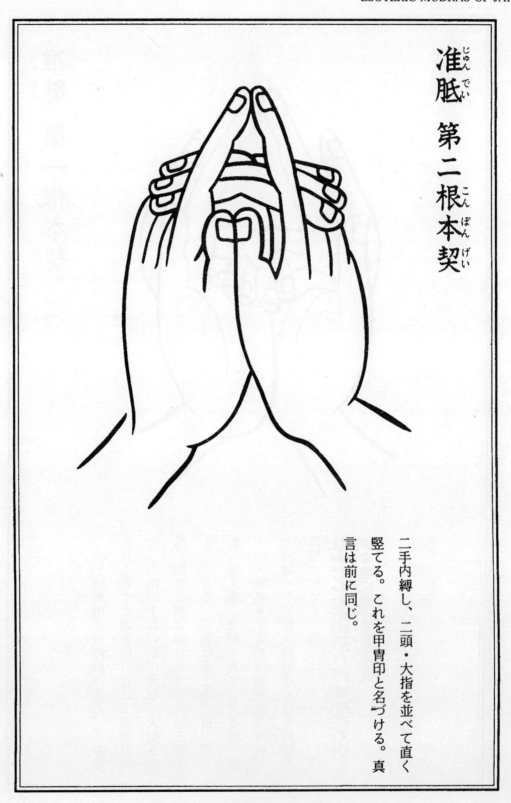

准� 第二根本契

二手内縛し、二頭・大指を並べて直く
竪てる。これを甲冑印と名づける。真
言は前に同じ。

The second mūla-mudrā of Cundī

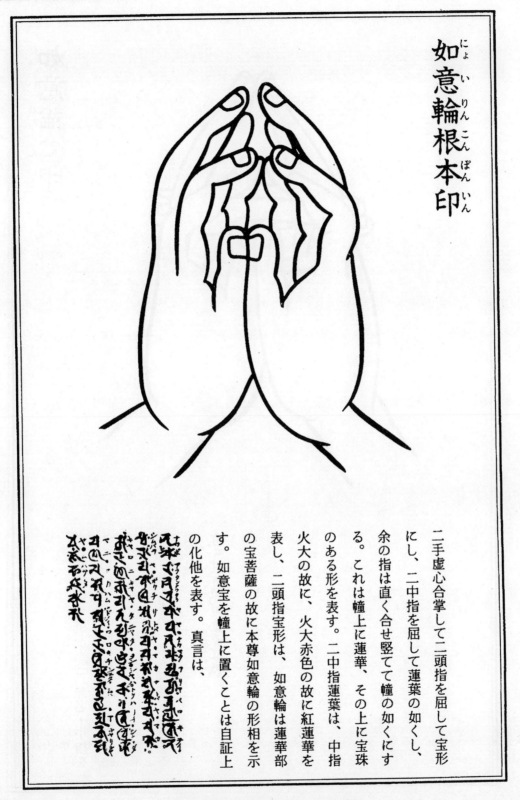

如意輪根本印

二手虚心合掌して二頭指を屈して宝形にし、二中指を屈して蓮葉の如くし、余の指は直く合せ竪てて幢の如くにする。これは幢上に蓮華、その上に宝珠のある形を表す。二中指蓮葉は、中指火大の故に、火大赤色の故に紅蓮華を表し、二頭指宝形は、如意輪は蓮華部の宝菩薩の故に本尊如意輪の形相を示す。如意宝を幢上に置くことは自証上の化他を表す。真言は、

Mūla-mudrā of Cintāmaṇi-cakra

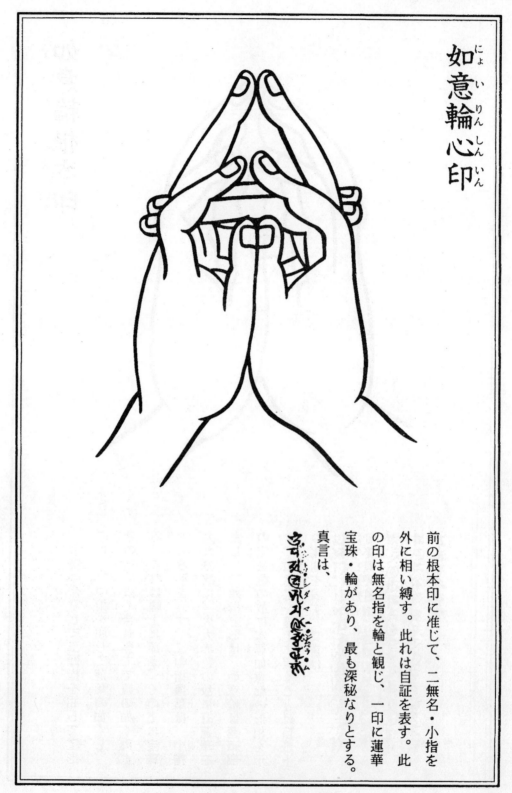

如意輪心印
にょ
い
りん
しん
いん

前の根本印に准じて、二無名・小指を
外に相い縛す。此れは自証を表す。此
の印は無名指を輪と観じ、一印に蓮華
宝珠・輪があり、最も深秘なりとする。
真言は、

Citta-mudrā of Cintāmaṇi-cakra

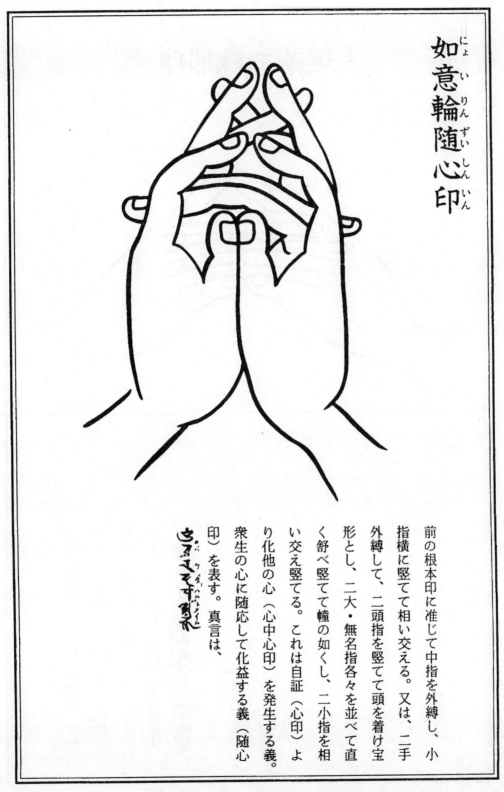

如意輪随心印

前の根本印に准じて中指を外縛し、小
指横に竪てて相い交える。又は、二手
外縛して、二頭指を竪てて頭を着け宝
形とし、二大・無名指各々を並べて直
く舒べ竪てて瞳の如くし、二小指を相
い交え竪てる。これは自証（心印）よ
り化他の心（心中心印）を発生する義。
衆生の心に随応して化益する義（随心
印）を表す。真言は、

Anucitta-mudrā of Cintāmaṇi-cakra

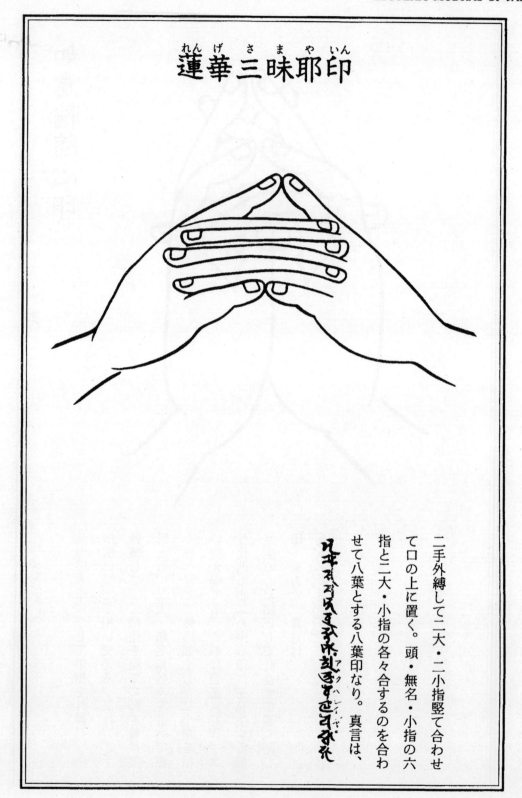

蓮華三昧耶印

二手外縛して二大・二小指竪て合わせて口の上に置く。頭・無名・小指の六指と二大・小指の各々合するのを合わせて八葉とする八葉印なり。真言は、

ナウマク・サンマンダ・ボダナン・アク（ハレイバ）・サハリバ・ソギャタ・ビシャ・ギシャ・ギジャ・サラバタ・キャンケン

Padma-samaya-mudrā

如意輪塔印
にょ い りん とう いん

卒都婆印四三頁に同じ。真言は前に同じ。

Stūpa-mudrā of Cintāmaṇi-cakra

不空羂索

二手蓮華合掌して、二頭・大指を外縛
し、右大指を左の大・頭指の間（虎口）
に入れる。蓮華羂索印と名づける。蓮
華合掌は蓮華部の本表示、本有自性の
蓮華を表し、大・頭四指を縛するのは
索を表し、索の端に蓮華ありと観ずる。
索は本誓を表し、四種の索を以って、
世間の漁夫の魚を釣る如くに、極悪の
衆生を済度する。真言は、

Mudrā of Amoghapāśa

灌_{かん}頂_{じょう}密_{みつ}印_{いん}

卒都婆印四三頁に同じ。真言は前に同じ。

Guhya-mudrā of abhiṣeka (kanjō)

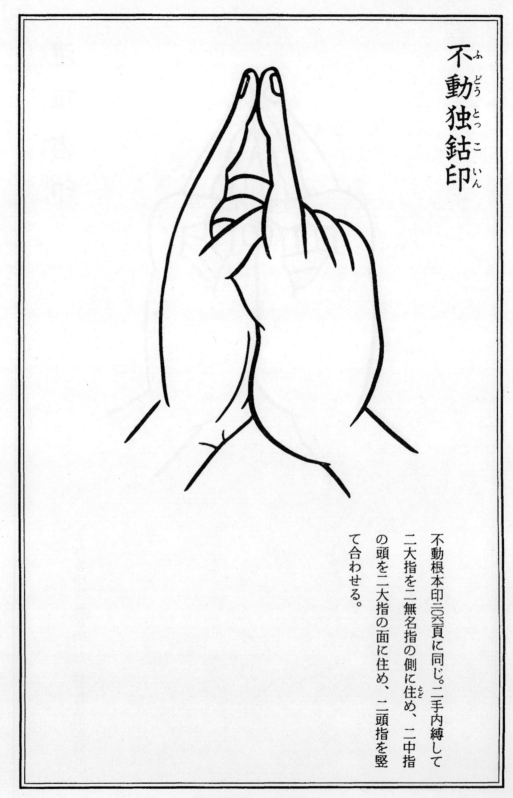

不動独鈷印

不動根本印二〇六頁に同じ。二手内縛して二大指を二無名指の側に住め、二中指の頭を二大指の面に住め、二頭指を竪て合わせる。

Mudrā of Acala

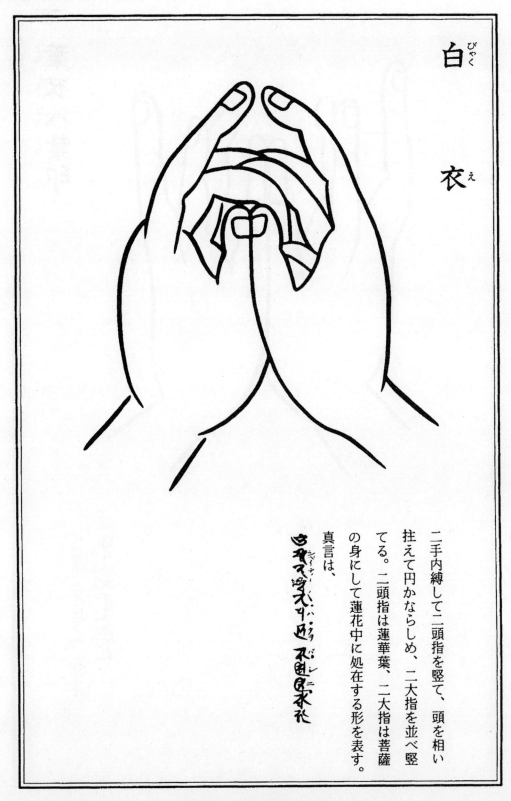

白
衣

二手内縛して二頭指を竪て、頭を相い
拄えて円かならしめ、二大指を並べ竪
てる。二頭指は蓮華葉、二大指は菩薩
の身にして蓮花中に処在する形を表す。
真言は、

Mudrā of Pāṇḍara-vāsinī

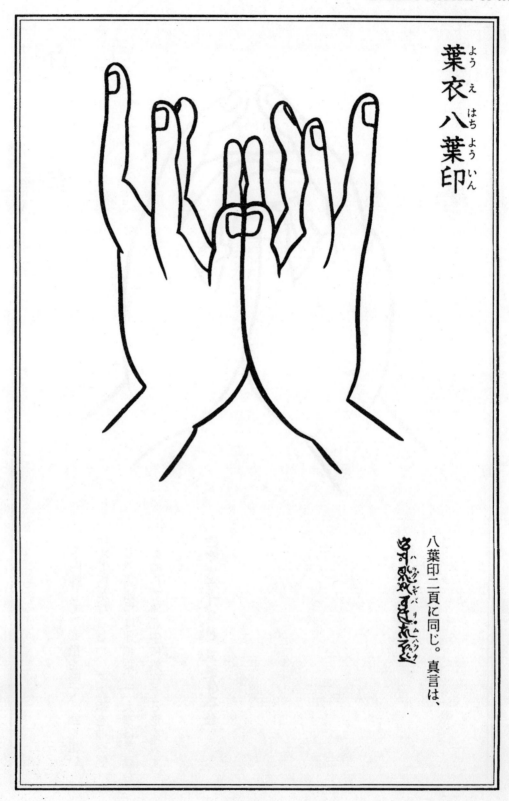

葉衣八葉印

八葉印二頁に同じ。真言は、

Aṣṭa-dala-mudrā (eight-petalled lotus mudrā) of Parṇaśabarī

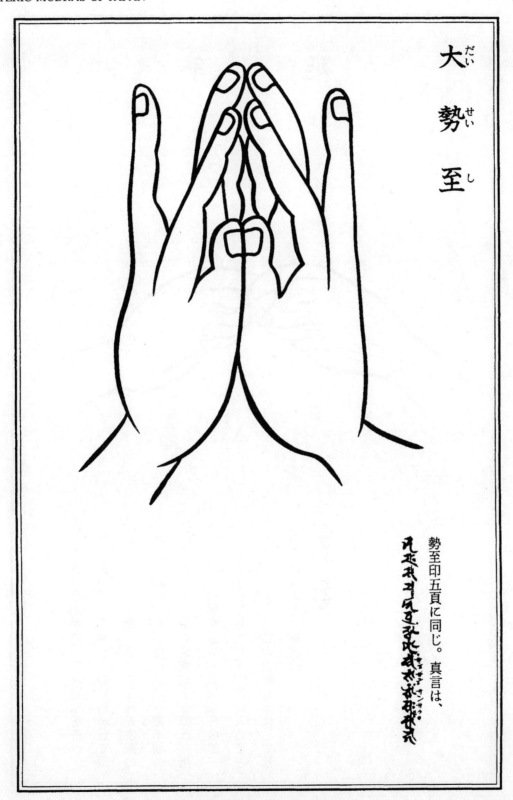

大
勢
至

だい
せい
し

勢至印五頁に同じ。真言は、

Mudrā of Mahāsthāmaprāpta

延^{えん} 命^{めい}

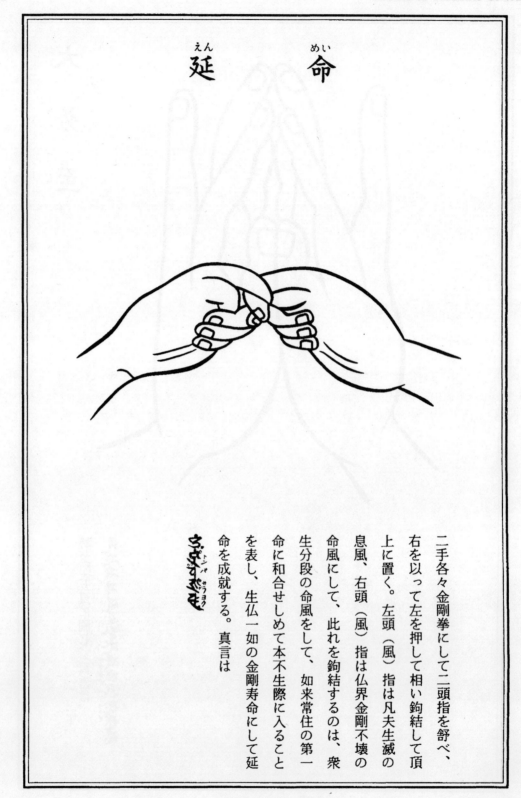

命を成就する。真言は
を表し、生仏一如の金剛寿命にして延
命に和合せしめて本不生際に入ること
生分段の命風をして、如来常住の第一
命風にして、此れを鉤結するのは、衆
息風、右頭（風）指は仏界金剛不壊の
上に置く。左頭（風）指は凡夫生滅の
右を以って左を押して相い鉤結して頂
二手各々金剛拳にして二頭指を舒べ、

Mudrā of Āyuṣī

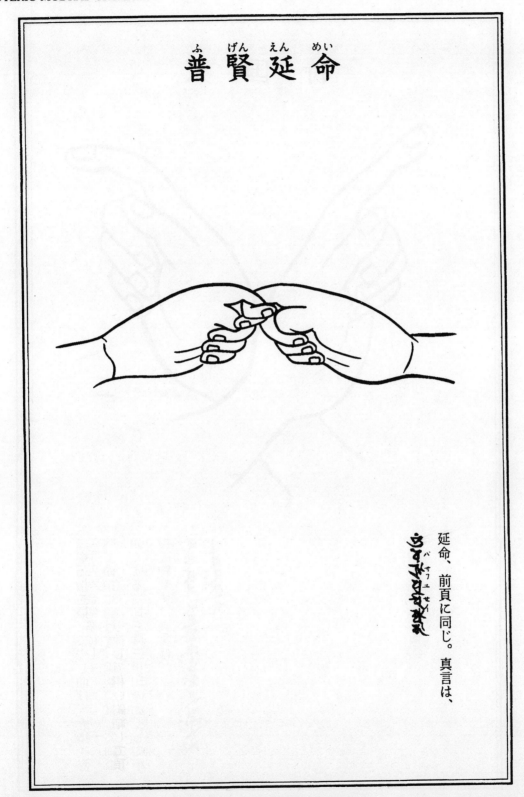

普賢延命

延命、前頁に同じ。真言は、

Mudrā of Samantabhadrāyus

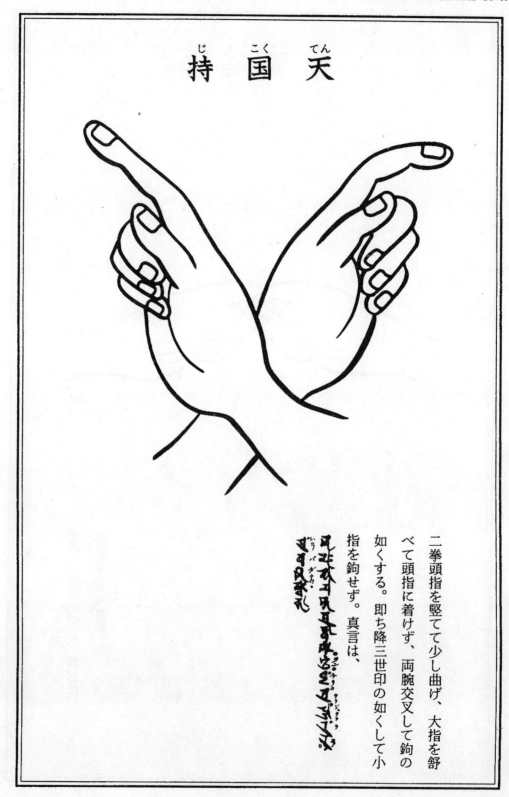

持国天
じ こく てん

二拳頭指を竪てて少し曲げ、大指を舒
べて頭指に着けず、両腕交叉して鉤の
如くする。即ち降三世印の如くして小
指を鉤せず。真言は、

Mudrā of Dhṛtarāṣṭra

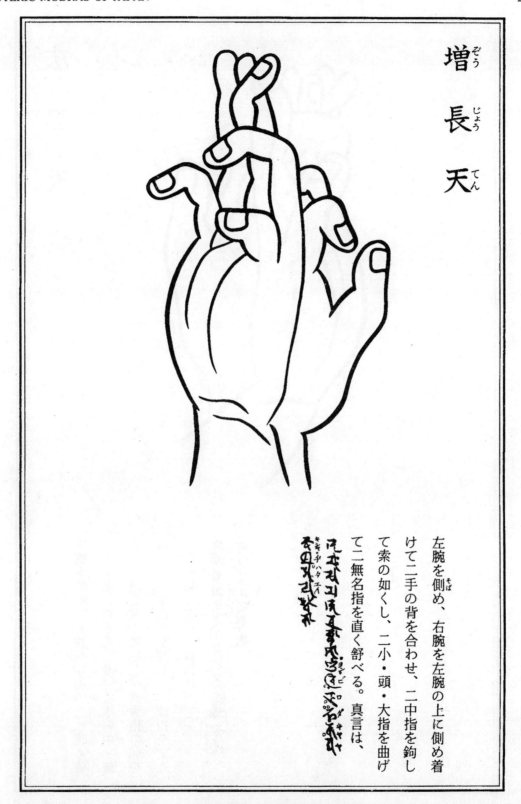

増長天

左腕を側め、右腕を左腕の上に側め着けて二手の背を合わせ、二中指を鉤して索の如くし、二小・頭・大指を曲げて二無名指を直く舒べる。真言は、

Mudrā of Virūḍhaka

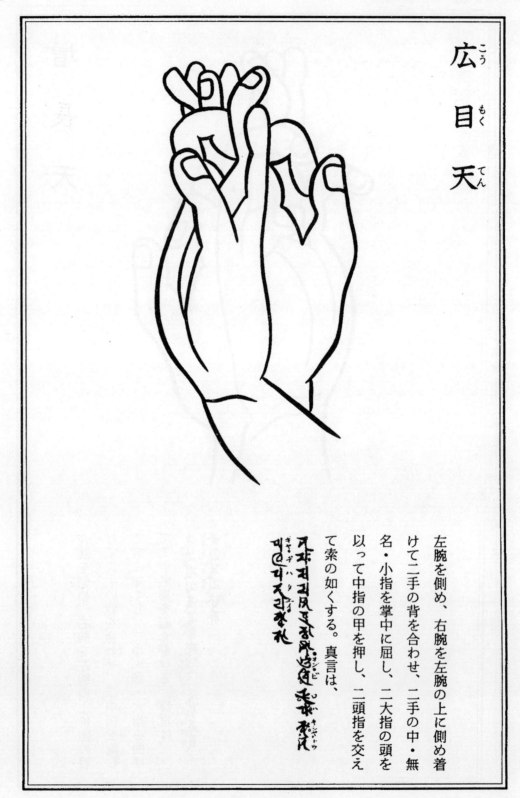

広目天

左腕を側め、右腕を左腕の上に側め着
けて二手の背を合わせ、二手の中・無
名・小指を掌中に屈し、二大指の頭を
以って中指の甲を押し、二頭指を交え
て索の如くする。真言は、

Mudrā of Virūpākṣa

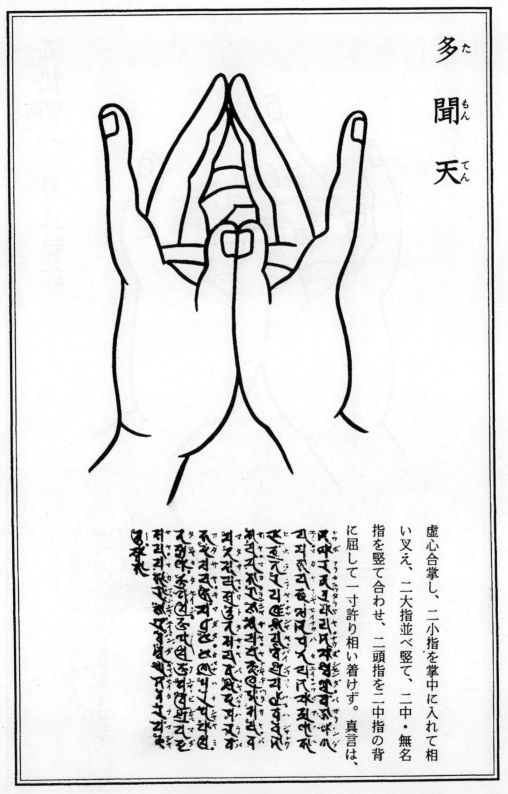

多聞天
た
もん
てん

虚心合掌し、二小指を掌中に入れて相
い叉え、二大指並べ竪て、二中・無名
指を竪て合わせ、二頭指を二中指の背
に屈して一寸許り相い着けず。真言は、

Mudrā of Vaiśravaṇa

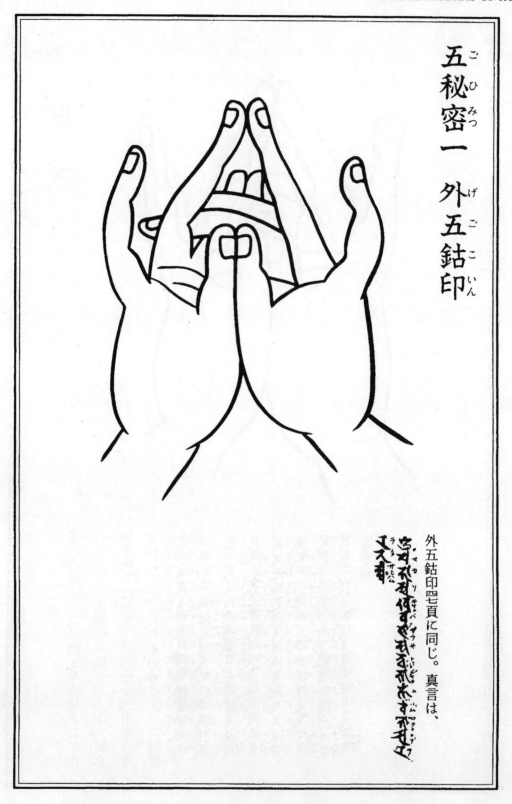

Outward five-pronged vajra mudrā of Pañca-guhya, no. 1

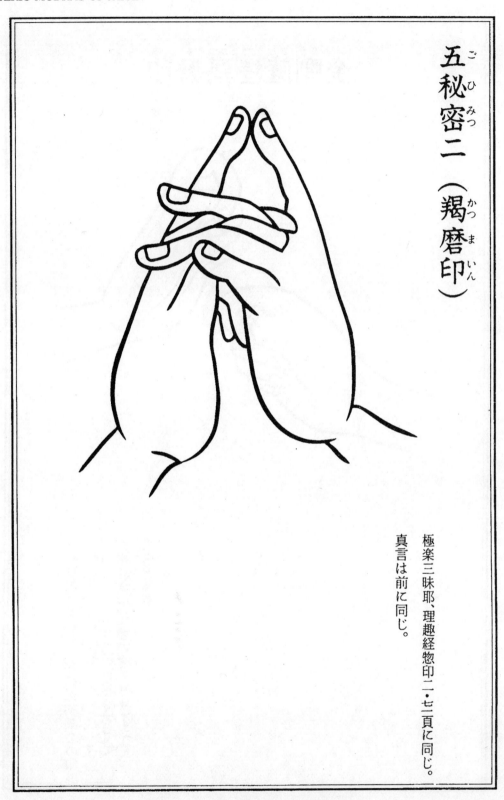

五秘密二（羯磨印）

極楽三昧耶、理趣経惣印二・七二頁に同じ。
真言は前に同じ。

Karma-mudrā of Pañca-guhya, no. 2

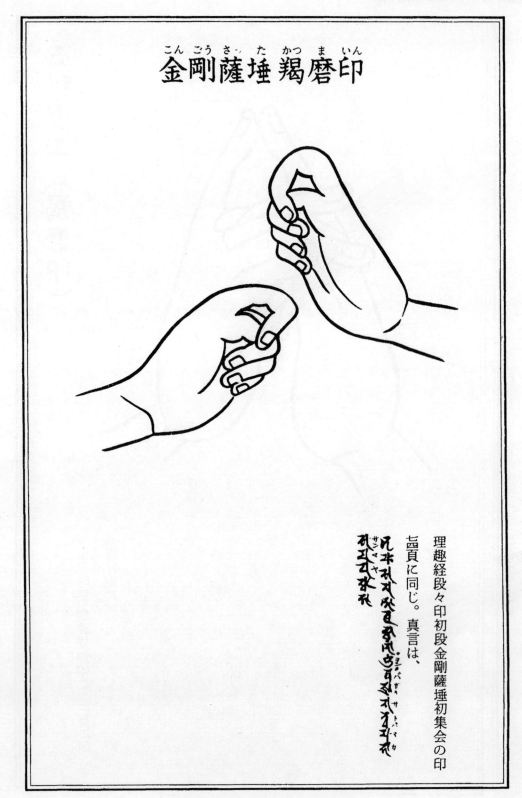

金剛薩埵羯磨印

理趣経段々印初段金剛薩埵初集会の印
七四頁に同じ。真言は、

Karma-mudrā of Vajrasattva

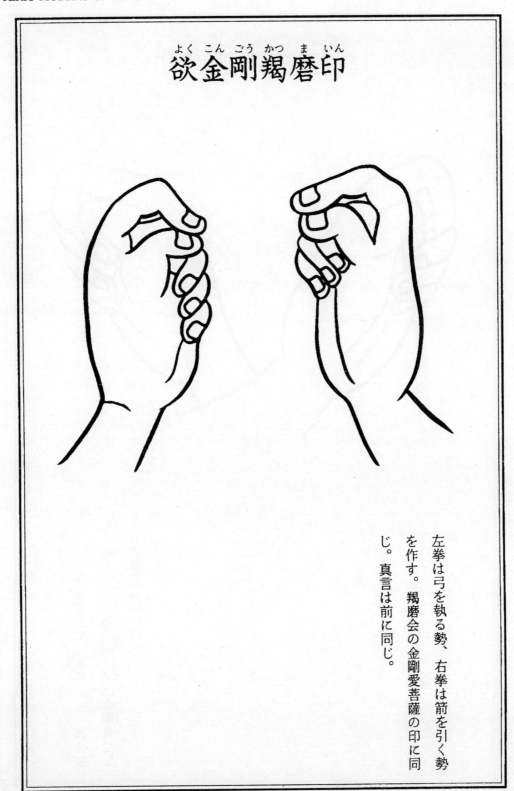

欲金剛羯磨印

左拳は弓を執る勢、右拳は箭を引く勢を作す。羯磨会の金剛愛菩薩の印に同じ。真言は前に同じ。

Karma-mudrā of Iṣṭavajra

計里計羅羯磨印

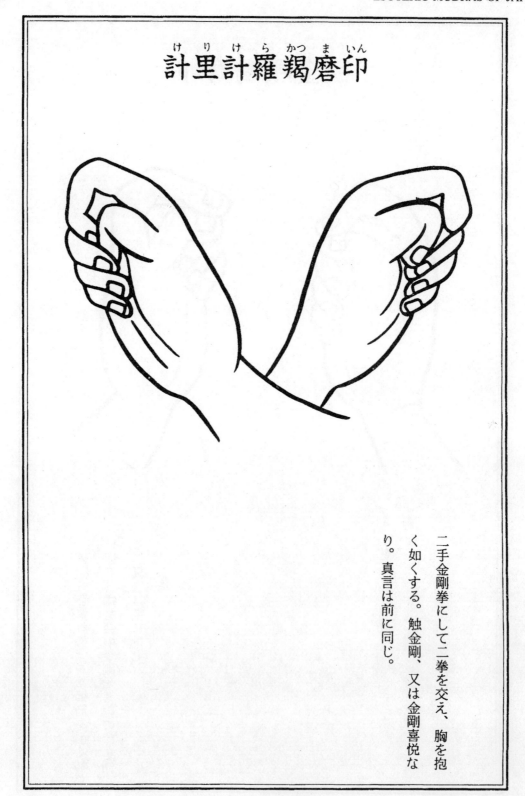

二手金剛拳にして二拳を交え、胸を抱く如くする。触金剛、又は金剛喜悦なり。真言は前に同じ。

Karma-mudrā of Kelikilavajra

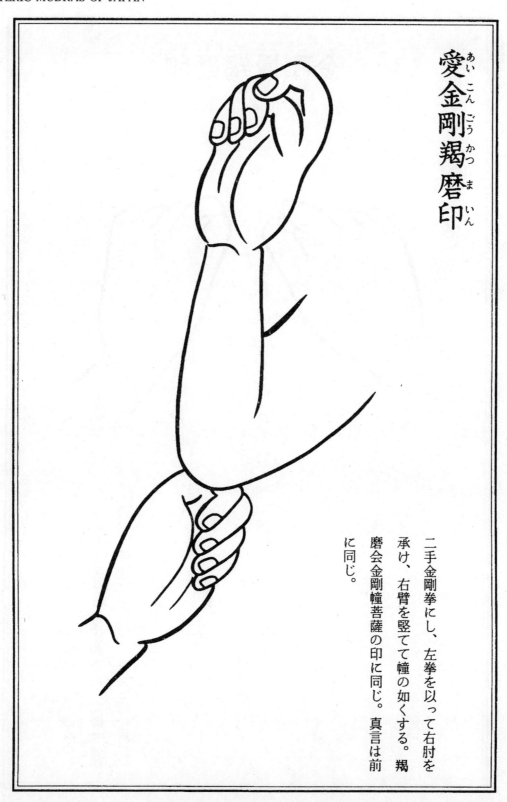

愛金剛羯磨印

二手金剛拳にし、左拳を以って右肘を
承け、右臂を竪てて幢の如くする。羯
磨会金剛幢菩薩の印に同じ。真言は前
に同じ。

Karma-mudrā of Rāgavajra

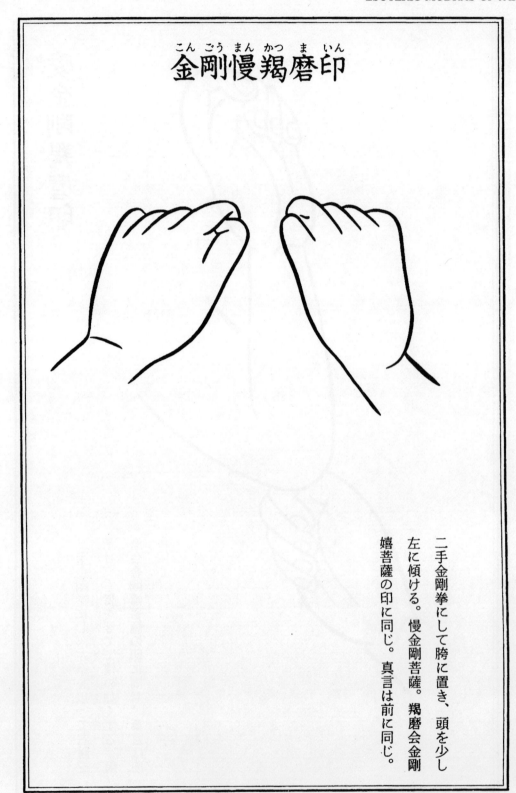

金剛慢羯磨印

二手金剛拳にして胯に置き、頭を少し左に傾ける。慢金剛菩薩。羯磨会金剛嬉菩薩の印に同じ。真言は前に同じ。

Karma-mudrā of Mānavajra

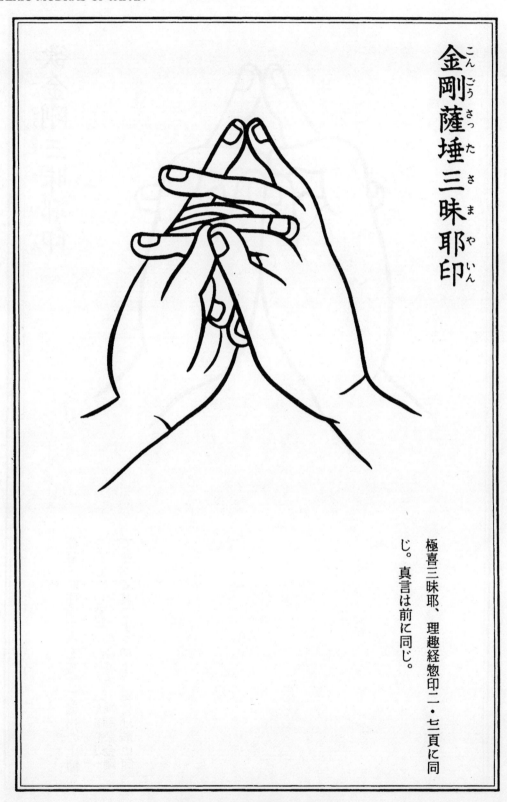

金剛薩埵三昧耶印

極喜三昧耶、理趣経惣印二・七二頁に同
じ。真言は前に同じ。

Samaya-mudrā of Vajrasattva

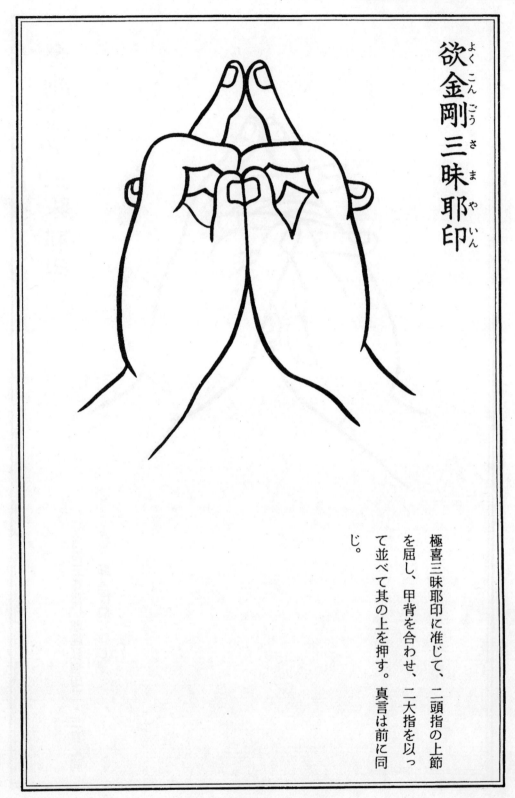

欲金剛三昧耶印

極喜三昧耶印に准じて、二頭指の上節を屈し、甲背を合わせ、二大指を以って並べて其の上を押す。真言は前に同じ。

Samaya-mudrā of Iṣṭavajra

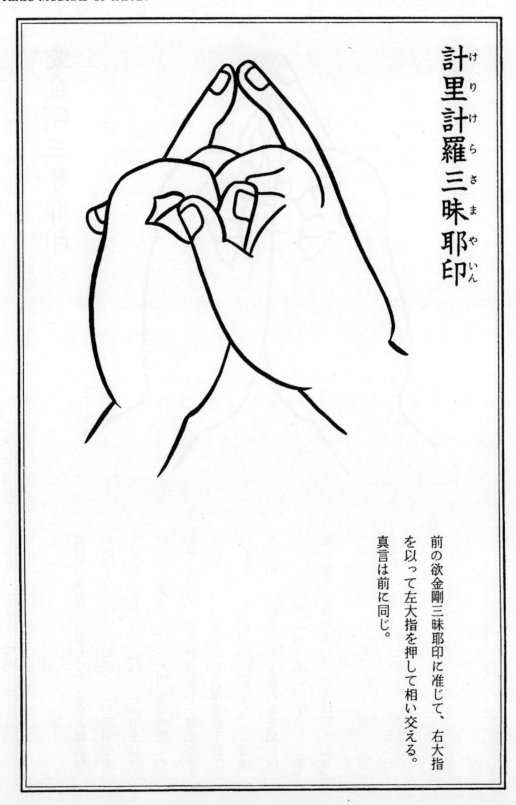

計里計羅三昧耶印

<ruby>計<rt>け</rt></ruby><ruby>里<rt>り</rt></ruby><ruby>計<rt>け</rt></ruby><ruby>羅<rt>ら</rt></ruby><ruby>三<rt>さ</rt></ruby><ruby>昧<rt>ま</rt></ruby><ruby>耶<rt>や</rt></ruby><ruby>印<rt>いん</rt></ruby>

前の欲金剛三昧耶印に准じて、右大指
を以って左大指を押して相い交える。
真言は前に同じ。

Samaya-mudrā of Kelikilavajra

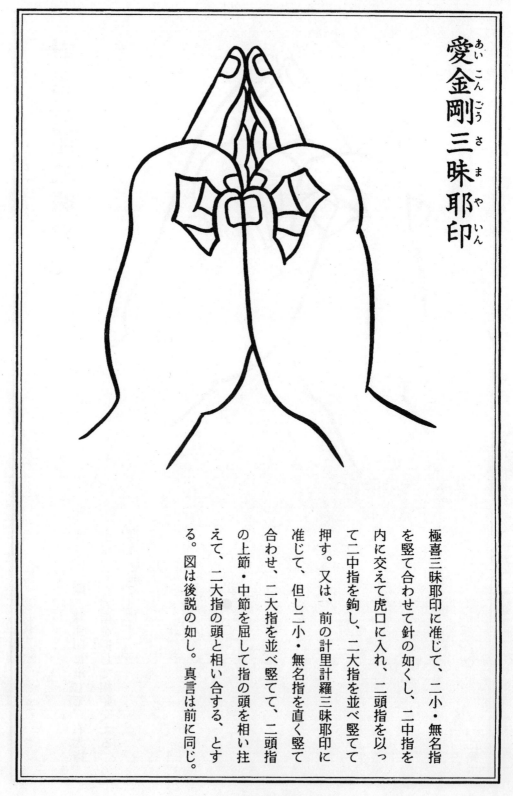

愛_{あい}金_{こん}剛_{ごう}三_さ昧_ま耶_や印_{いん}

極喜三昧耶印に准じて、二小・無名指を竪て合わせて針の如くし、二中指を内に交えて虎口に入れ、二頭指を以って二中指を鈎し、二大指を並べ竪てて押す。又は、前の計里計羅三昧耶印に准じて、但し二小・無名指を直く竪て合わせ、二大指を並べ竪てて、二頭指の上節・中節を屈して指の頭を相い拄えて、二大指の頭と相い合する、とする。図は後説の如し。真言は前に同じ。

Samaya-mudrā of Rāgavajra

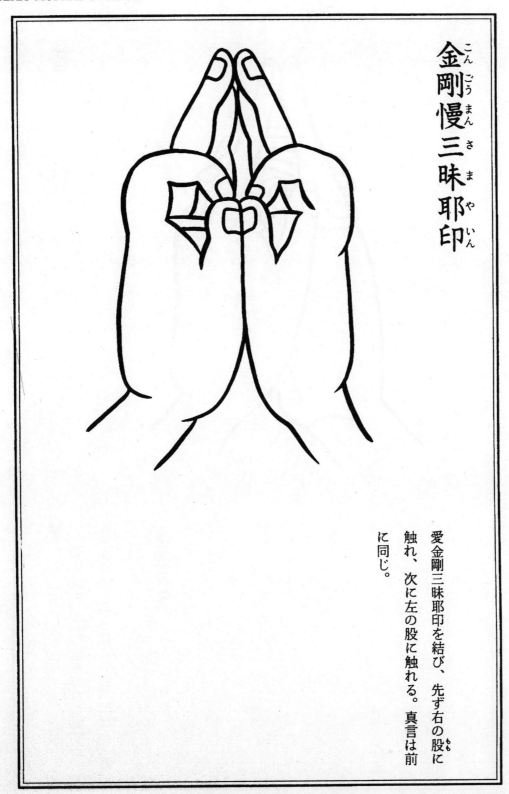

金剛慢三昧耶印

愛金剛三昧耶印を結び、先ず右の股に触れ、次に左の股に触れる。真言は前に同じ。

Samaya-mudrā of Mānavajra

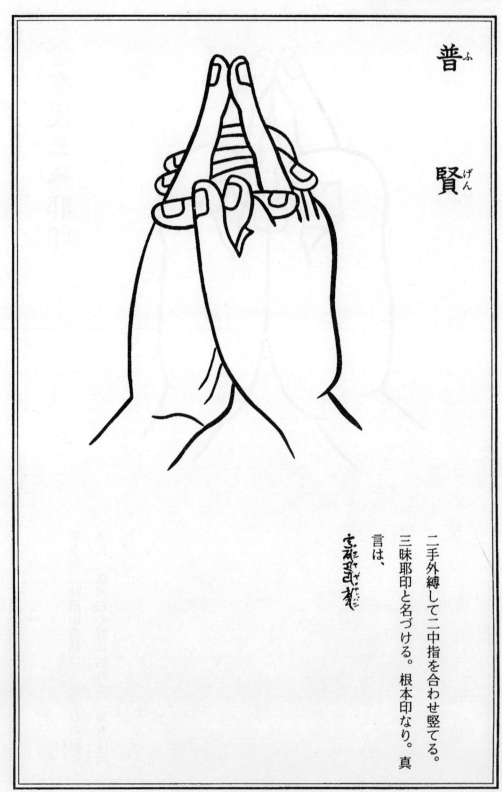

普
賢

二手外縛して二中指を合わせ竪てる。
三昧耶印と名づける。根本印なり。真
言は、

Mudrā of Samantabhadra

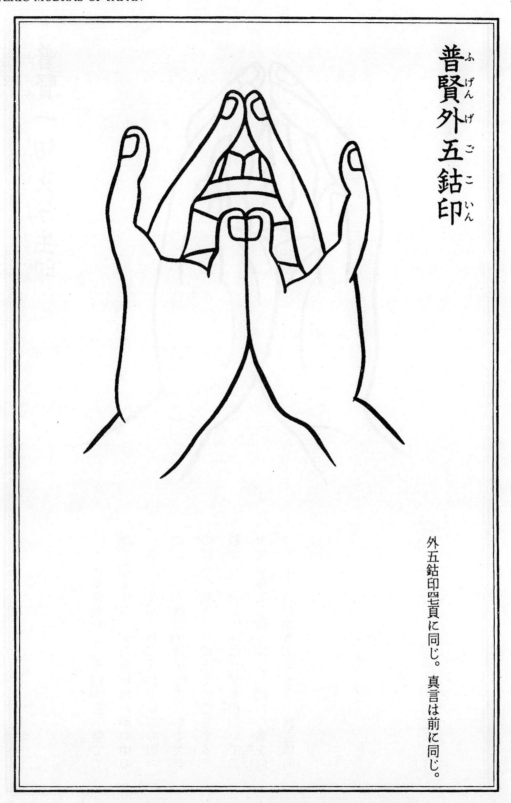

普賢外五鈷印
ふげんげごこいん

外五鈷印四亖頁に同じ。真言は前に同じ。

Outward five-pronged vajra mudrā of Samantabhadra

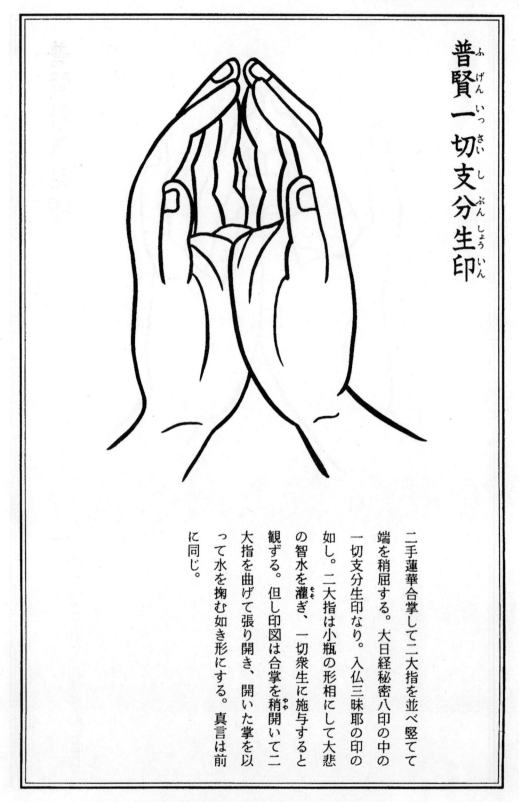

普賢一切支分生印

二手蓮華合掌して二大指を並べ竪てて端を稍屈する。大日経秘密八印の中の一切支分生印なり。入仏三昧耶の印の如し。二大指は小瓶の形相にして大悲の智水を灌ぎ、一切衆生に施与すると観ずる。但し印図は合掌を稍開いて二大指を曲げて張り開き、開いた掌を以って水を掬む如き形にする。真言は前に同じ。

Sarvāṅgodbhava-mudrā of Samantabhadra

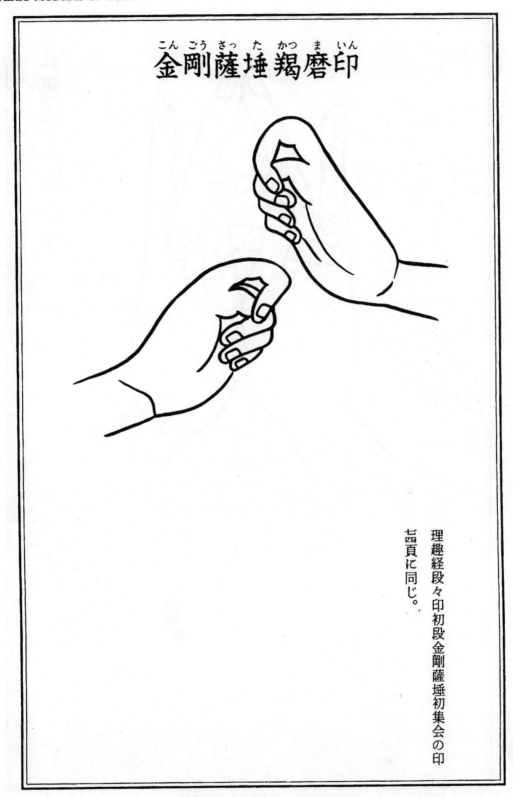

金剛薩埵羯磨印

理趣経段々印初段金剛薩埵初集会の印
七四頁に同じ。

Karma-mudrā of Vajrasattva

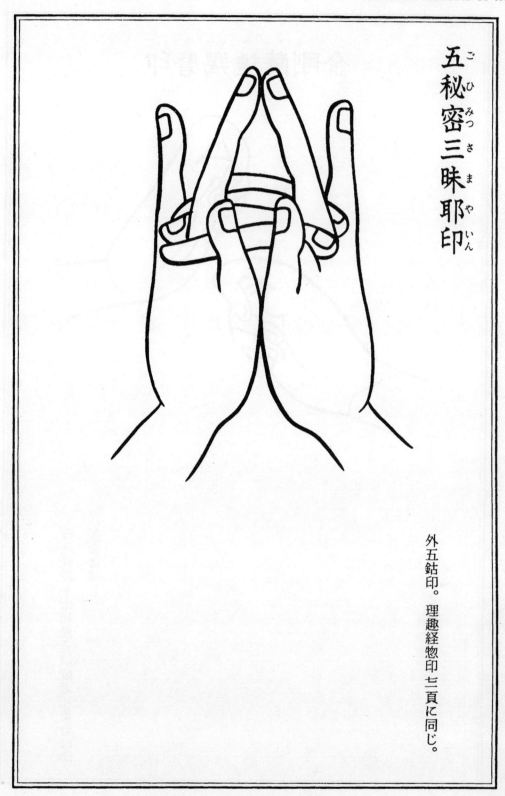

五秘密三昧耶印

外五鈷印。理趣経惣印七二頁に同じ。

Samaya-mudrā of Pañca-guhya

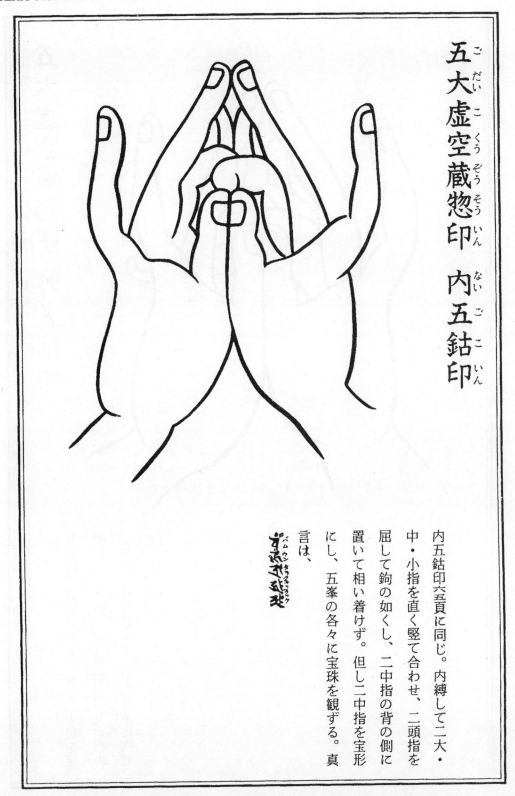

五大虚空蔵惣印　内五鈷印

言は、
にし、五峯の各々に宝珠を観ずる。真
置いて相い着けず。但し二中指を宝形
屈して鈎の如くし、二中指の背の側に
中・小指を直く竪て合わせ、二頭指を
内五鈷印六五頁に同じ。内縛して二大・

Inward five-pronged vajra mudrā of the Five Great Ākāśagarbha

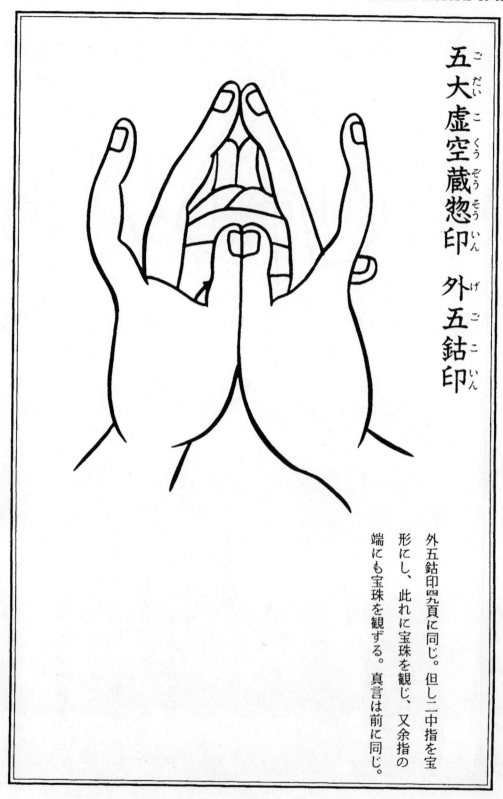

五大虚空蔵惣印　外五鈷印

外五鈷印四九頁に同じ。但し二中指を宝形にし、此れに宝珠を観じ、又余指の端にも宝珠を観ずる。真言は前に同じ。

Outward five-pronged vajra mudrā of the Five Great Ākāśagarbha

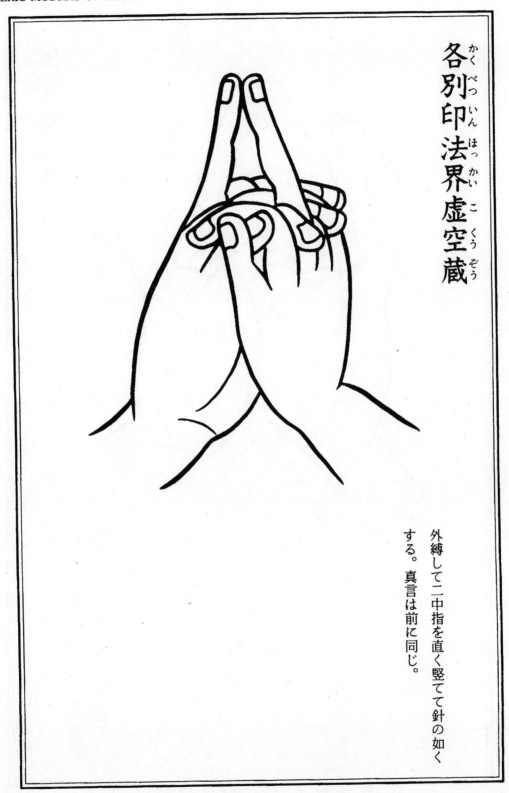

各別印 法界虚空蔵
かく べっ つい いん ほっ かい こ くう ぞう

外縛して二中指を直く竪てて針の如く
する。真言は前に同じ。

Mudrā of Dharmadhātu-Ākāśagarbha

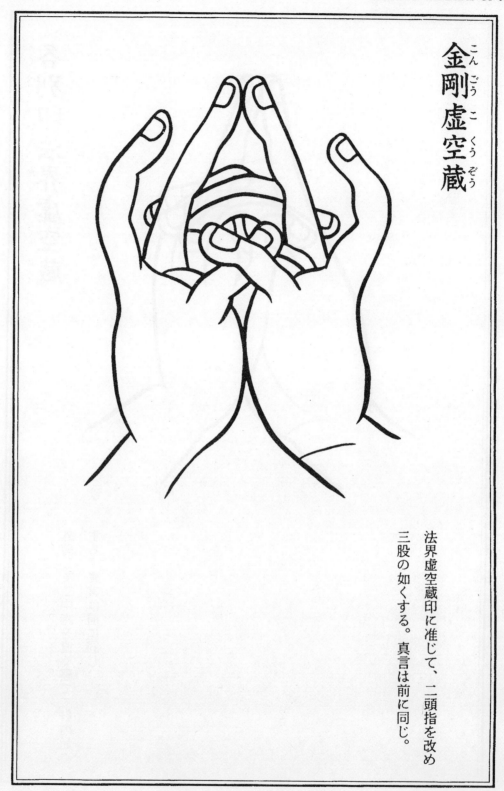

金剛虚空蔵

法界虚空蔵印に准じて、二頭指を改め
三股の如くする。真言は前に同じ。

Mudrā of Vajra-Ākāśagarbha

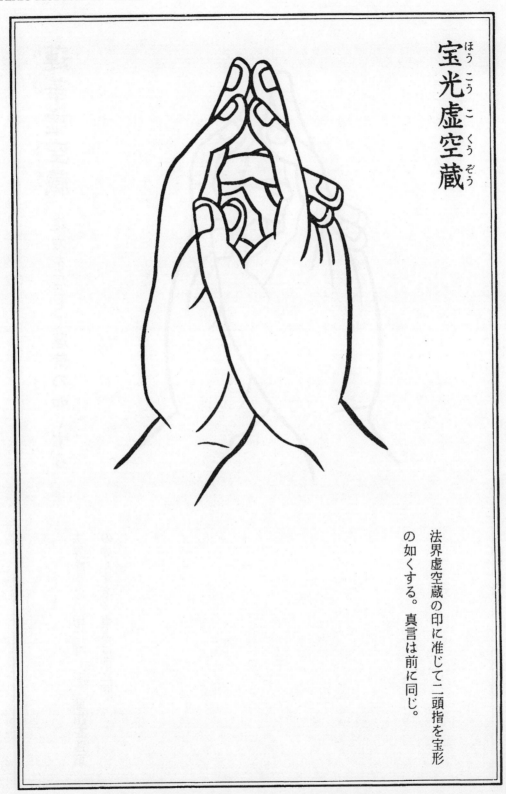

宝光虚空蔵

法界虚空蔵の印に准じて二頭指を宝形
の如くする。真言は前に同じ。

Mudrā of Ratnaprabha-Ākāśagarbha

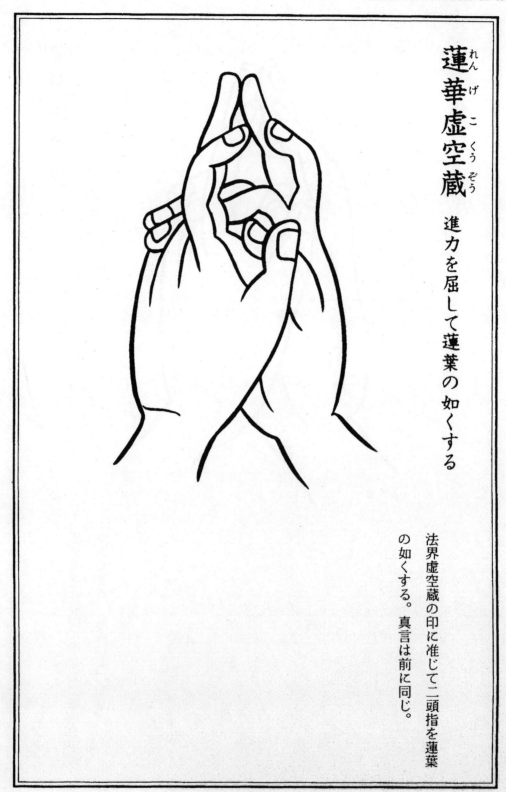

蓮華虚空蔵

進力を屈して蓮葉の如くする

法界虚空蔵の印に准じて二頭指を蓮葉の如くする。真言は前に同じ。

Mudrā of Padma-Ākāśagarbha

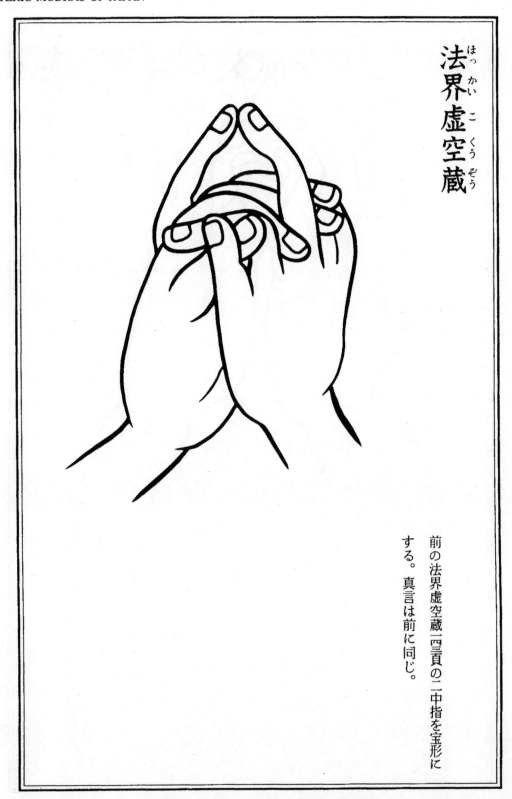

法界虚空蔵
ほっかい こくうぞう

前の法界虚空蔵一四三頁の二中指を宝形に
する。真言は前に同じ。

Mudrā of Dharmadhātu-Ākāśagarbha

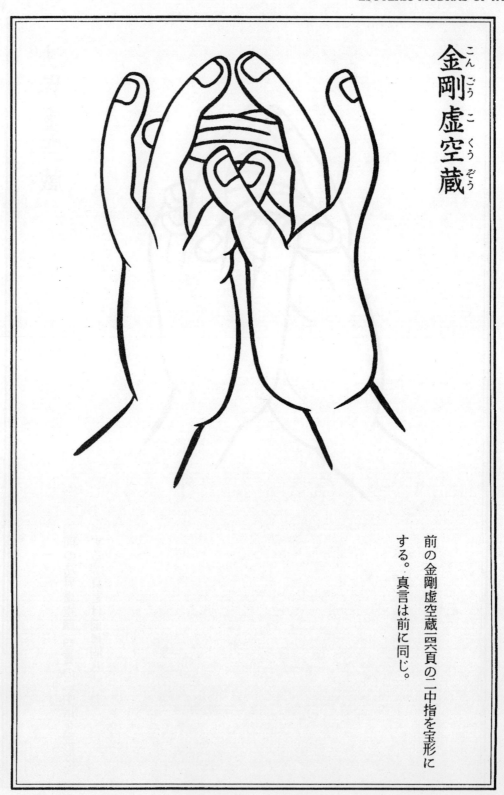

金剛虚空蔵

前の金剛虚空蔵一四六頁の二中指を宝形に
する。真言は前に同じ。

Mudrā of Vajra-Ākāśagarbha

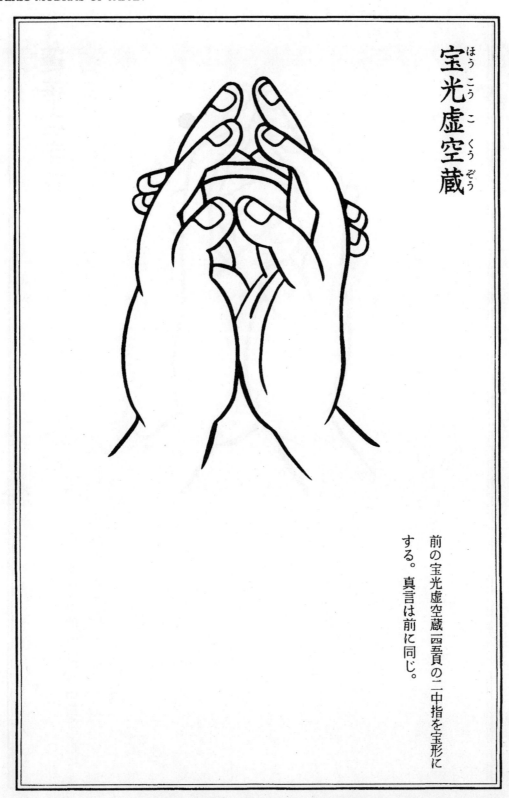

宝光虚空蔵
ほう こう くう ぞう

前の宝光虚空蔵一四五頁の二中指を宝形に
する。真言は前に同じ。

Mudrā of Ratnaprabha-Ākāśagarbha

蓮華虚空蔵

前の蓮花虚空蔵一兲頁の二中指を宝形にする。真言は前に同じ。

Mudrā of Padma-Ākāśagarbha

業用虚空蔵

法界虚空蔵の印一四七頁に准じて〈二手外
縛して二中指を宝形にし〉、二無名・頭
指を互いに立て交える。真言は前に同
じ。

Mudrā of Karma-Ākāśagarbha

金剛吉祥印

真言は、

金剛合掌し、二小指を内に相い鉤し、二無名指を並べ屈して掌中に入れ、二中指を合して峯の如くし、二頭指を屈して二中指の上節を捻じ、二大指を以って各二中指の初文を捻ず。但し初文は捻じ難き故に中節を捻ずるとする洞泉口決あり。金剛吉祥成就印・吉祥成就印等とも名づけ、天変怪異を除くのに用いる。此の印を仏眼の最秘印とし、印に五眼を具する。又師子冠印とする。

Vajra-śrī-mudrā

破諸宿曜印

破
諸
宿
曜
印
一
貢
に
同
じ
。

成就一切明印

成就一切明印三頁に同じ。

Sarva-vidyā-siddhi-mudrā

虚空蔵三昧耶印

宝菩薩吾〇頁に同じ。但し白宝口鈔には
外縛を内縛とする義を詳説する。 虚空
蔵菩薩の根本印なり。 真言は、

Samaya-mudrā of Ākāśagarbha, no. 1

虚空蔵二

虚心合掌して二大指を以って並べ屈し
て掌中に入れる。胎蔵部の虚空蔵なり。
真言は前に同じ。

Mudrā of Ākāśagarbha, no. 2

虚こくう空ぞう蔵 三

右手の五指を仰げ舒べて、頭・大指を
相い捻じ、香を捻ずる如き状にし、頭
指の第二節を屈して第一節を極めて端
直ならしむ。或いは右手を拳にして、
頭・大指を相い捻じ、宝形とするとす
る説もある。真言は前に同じ。

Mudrā of Ākāśagarbha, no. 3

八字文殊大精進印

破諸宿曜印三頁に同じ。真言は、

Mahāvīrya-mudrā of Aṣṭākṣara Mañjuśrī, no. 1

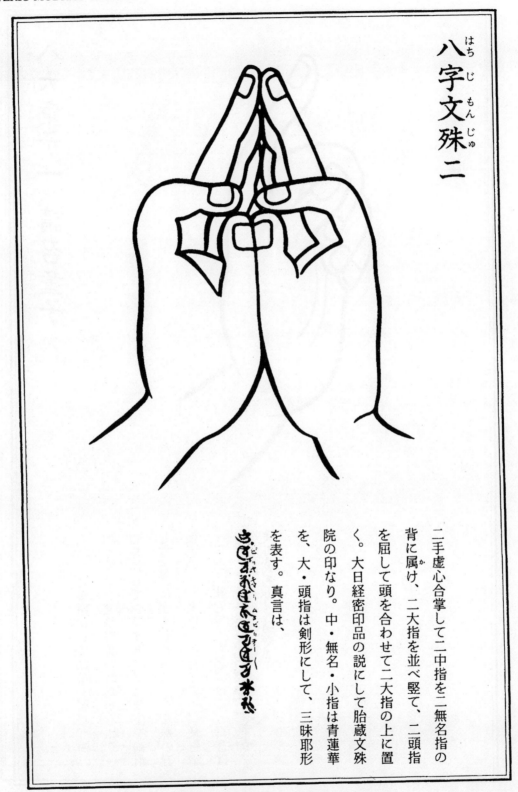

八字文殊二

二手虚心合掌して二中指を二無名指の
背に属け、二大指を並べ竪て、二頭指
を屈して頭を合わせて二大指の上に置
く。大日経密印品の説にして胎蔵文殊
院の印なり。中・無名・小指は青蓮華
を、大・頭指は剣形にして、三昧耶形
を表す。真言は、

Mudrā of Aṣṭākṣara Mañjuśrī, no. 2

八大童子一　請召童子

右手を蓮華拳にして頭指を屈し、鉤の如くする。文殊菩薩の教勅する如く一切を作して召請する。又は衆生を鉤引して菩提に至らしめるなり。文殊の五使者の一、又同八大童子の一。又召請・招召・鉤召等とも名づける。真言は、

Ākarṣaṇī, the first of the Eight Great Dōji

八大童子二 計設尼

右手を蓮華拳にし、頭・中指を直く舒
べ竪てる。青竜軌によれば大指を以っ
て小・無名指の甲を押し、擬勢にする。
これは剣印である。文殊五使者の一、
同八大童子の一。計設尼は美髪の意で
あり、髪は心智の標相の故に計設尼は
心智の清浄を表す。真言は、

ナウマク・サマンダ・ボダナン・ヘイ
シニヤ・バッチ・ソハ

Keśinī, the second of the Eight Great Dōji

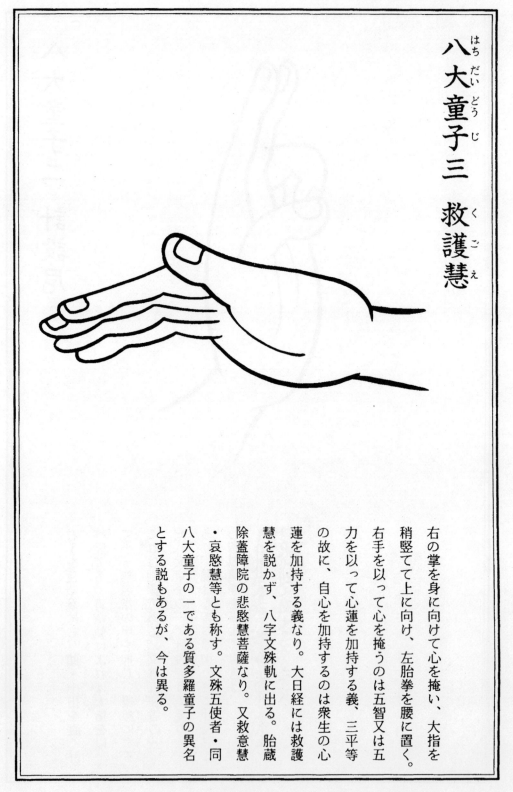

八大童子三　救護慧

右の掌を身に向けて心を掩い、大指を
稍竪てて上に向け、左胎拳を腰に置く。
右手を以って心を掩うのは五智又は五
力を以って心蓮を加持する義、三平等
の故に、自心を加持するのは衆生の心
蓮を加持する義なり。大日経には救護
慧を説かず、八字文殊軌に出る。胎蔵
除蓋障院の悲愍慧菩薩なり。又救意慧
・哀愍慧等とも称す。文殊五使者・同
八大童子の一である質多羅童子の異名
とする説もあるが、今は異る。

Paritrāṇ-āśaya-mati, the third of the Eight Great Dōji

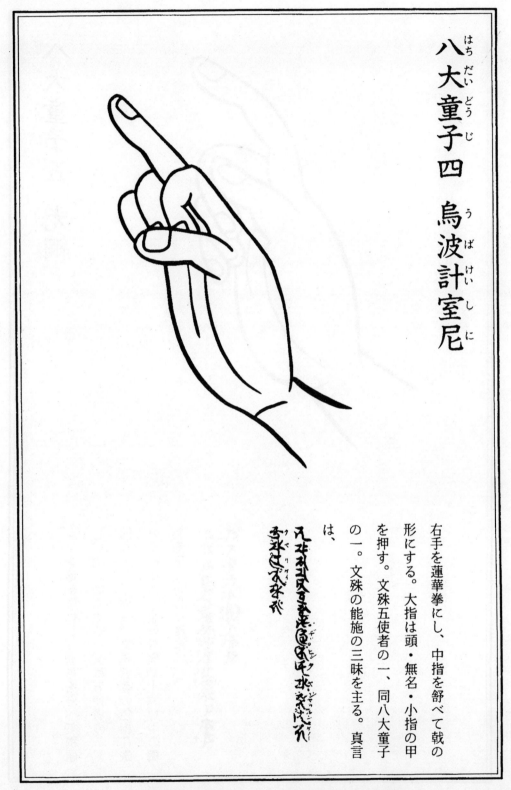

八大童子四 烏波計室尼

右手を蓮華拳にし、中指を舒べて戟の形にする。大指は頭・無名・小指の甲を押す。文殊五使者の一、同八大童子の一。文殊の能施の三昧を主る。真言は、

Upakeśinī, the fourth of the Eight Great Dōji

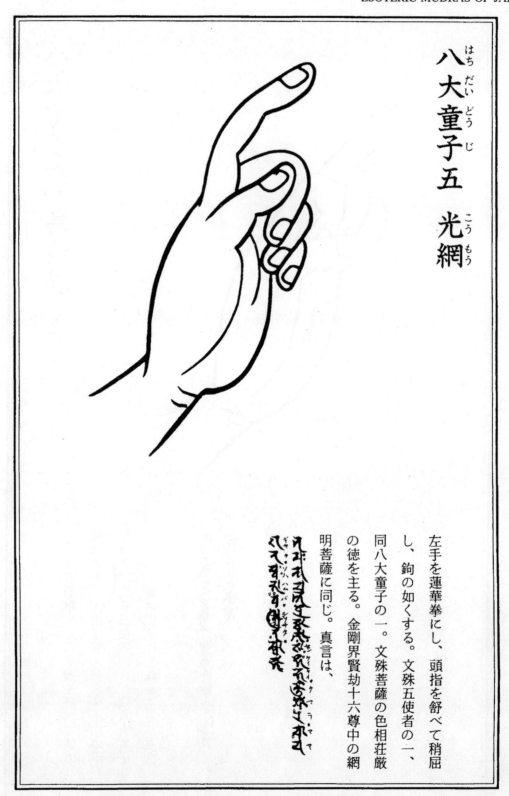

八大童子五　光網

左手を蓮華拳にし、頭指を舒べて稍屈し、鉤の如くする。文殊五使者の一、同八大童子の一。文殊菩薩の色相荘厳の徳を主る。金剛界賢劫十六尊中の網明菩薩に同じ。真言は、

Jālinīprabha, the fifth of the Eight Great Dōji

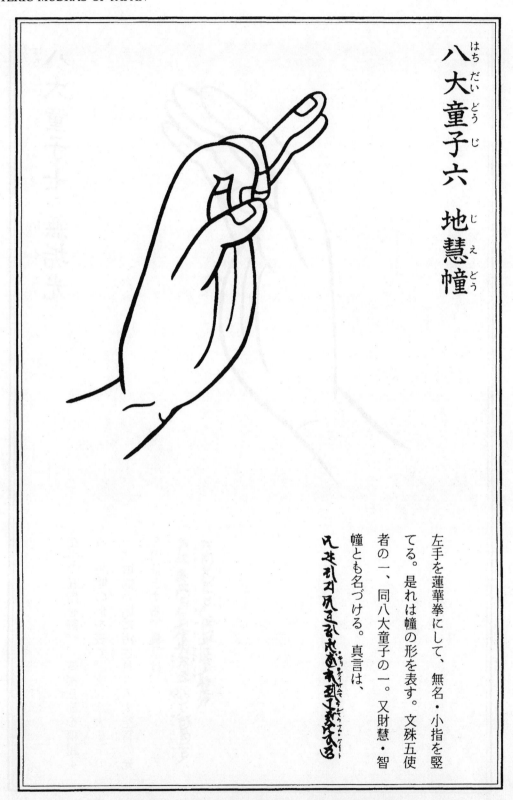

八大童子六　地慧幢

左手を蓮華拳にして、無名・小指を竪
てる。是れは幢の形を表す。文殊五使
者の一、同八大童子の一。又財慧・智
幢とも名づける。真言は、

Vasumatī, the sixth of the Eight Great Dōji

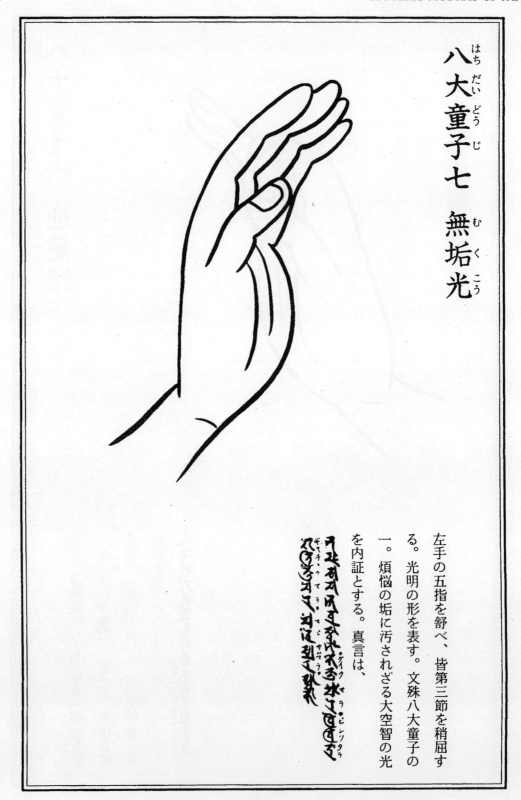

八大童子七　無垢光

左手の五指を舒べ、皆第三節を稍屈す
る。光明の形を表す。文殊八大童子の
一。煩悩の垢に汚されざる大空智の光
を内証とする。真言は、

Vimalaprabha, the seventh of the Eight Great Dōji

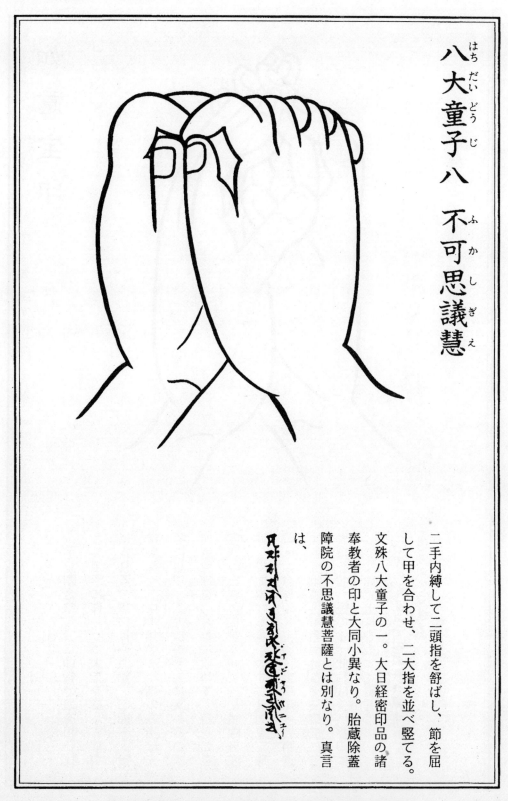

八大童子八　不可思議慧

二手内縛して二頭指を舒ばし、節を屈
して甲を合わせ、二大指を並べ竪てる。
文殊八大童子の一。大日経密印品の諸
奉教者の印と大同小異なり。胎蔵除蓋
障院の不思議慧菩薩とは別なり。真言
は、

Acintyamati, the eighth of the Eight Great Dōji

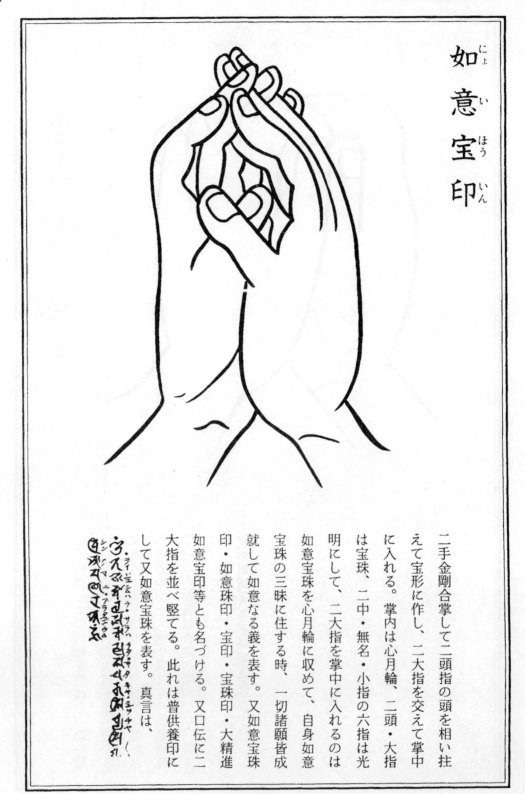

如
意
宝
印

二手金剛合掌して二頭指の頭を相い拄
えて宝形に作し、二大指を交えて掌中
に入れる。掌内は心月輪、二頭・大指
は宝珠、二中・無名・小指の六指は光
明にして、二大指を掌中に入れるのは
如意宝珠を心月輪に収めて、自身如意
宝珠の三昧に住する時、一切諸願皆成
就して如意なる義を表す。又如意宝珠
印・如意珠印・宝印・宝珠印・大精進
如意宝印等とも名づける。又口伝に二
大指を並べ竪てる。此れは普供養印に
して又如意宝珠を表す。真言は、

Cintāmaṇi-mudrā

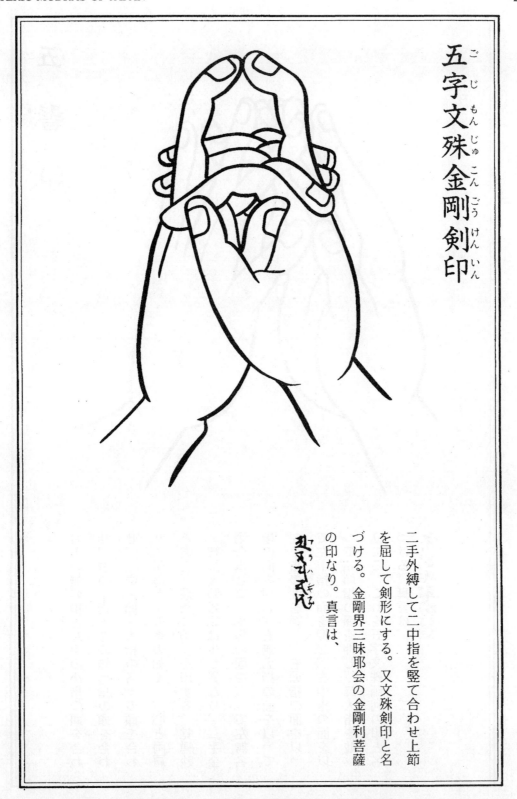

五字文殊金剛劍印

二手外縛して二中指を竪て合わせ上節を屈して劍形にする。又文殊劍印と名づける。金剛界三昧耶会の金剛利菩薩の印なり。真言は、

Vajra-khaḍga-mudrā of Pañcākṣara Mañjuśrī

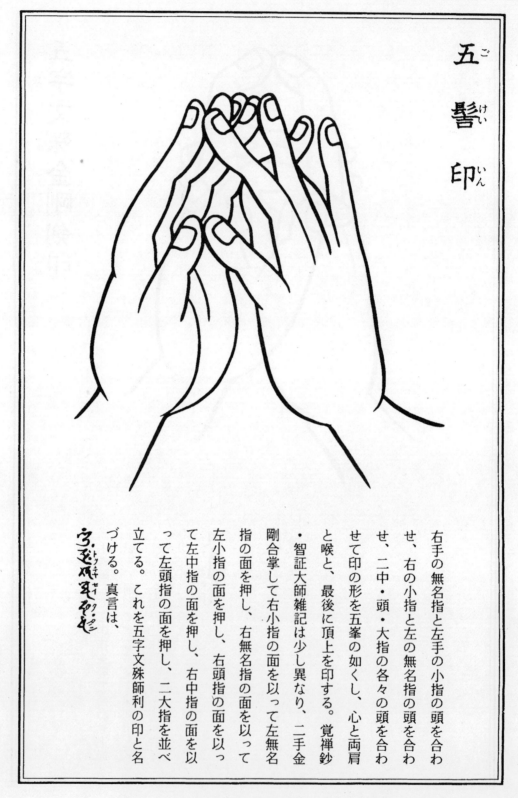

五髻印

右手の無名指と左手の小指の頭を合わせ、右の小指と左の無名指の頭を合わせ、二中・頭・大指の各々の頭を合わせて印の形を五峯の如くし、心と両肩と喉と、最後に頂上を印する。覚禅鈔・智証大師雑記は少し異なり、二手金剛合掌して右小指の面を以って左無名指の面を押し、右無名指の面を以って左小指の面を押し、右頭指の面を以って左中指の面を押し、右中指の面を以って左頭指の面を押し、二大指を並べ立てる。これを五字文殊師利の印と名づける。真言は、

Pañcoṣṇīṣa-mudrā (mudrā of the Five Uṣṇīṣas)

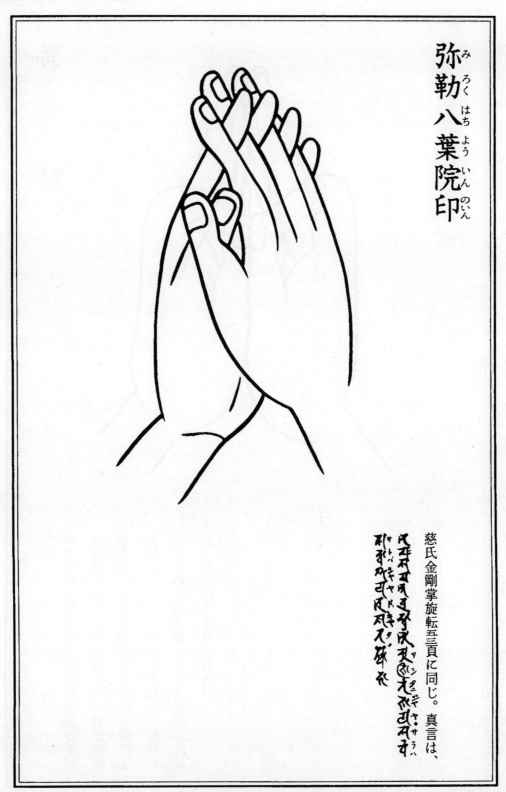

弥勒　八葉院印

慈氏金剛掌旋転五三頁に同じ。　真言は、

Aṣṭadala-mudrā of Maitreya

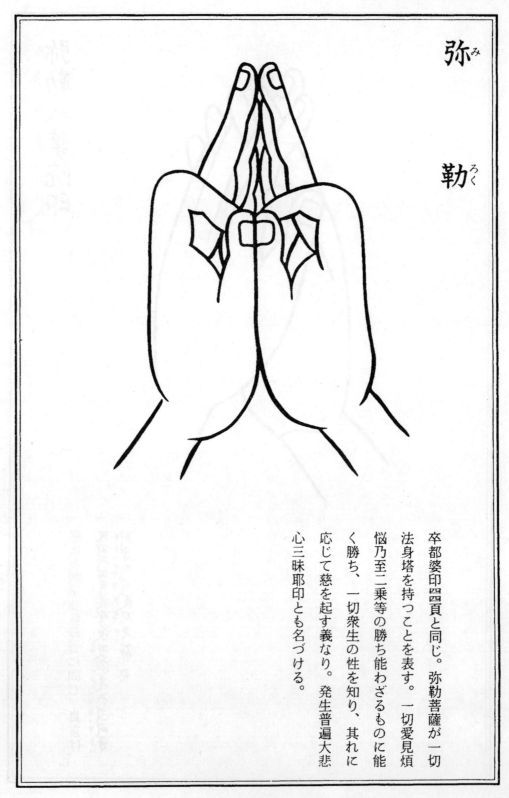

弥^み

勒^{ろく}

心三昧耶印とも名づける。応じて慈を起す義なり。発生普遍大悲く勝ち、一切衆生の性を知り、其れに悩乃至二乗等の勝ち能わざるものに能法身塔を持つことを表す。一切愛見煩卒都婆印四頁と同じ。弥勒菩薩が一切

Mudrā of Maitreya

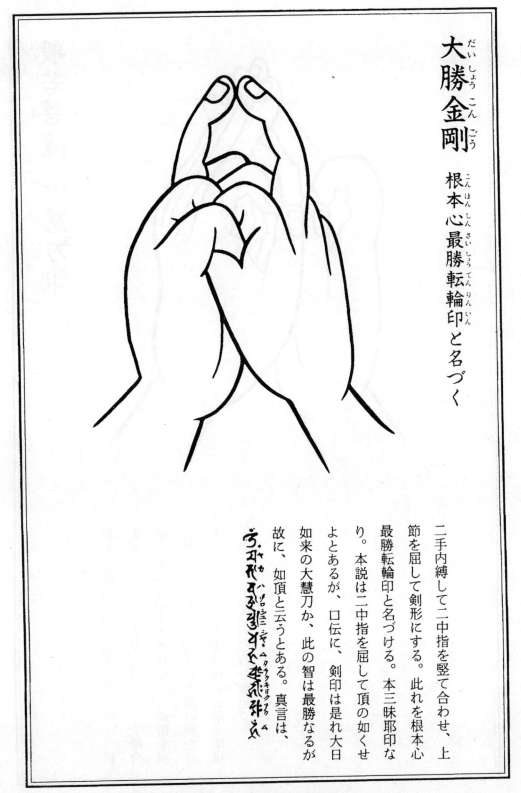

大勝金剛
だい しょう こん ごう

根本心最勝転輪印と名づく
こん ぽん しん しん さい しょう てん りん いん いん

二手内縛して二中指を竪て合わせ、上
節を屈して剣形にする。此れを根本心
最勝転輪印と名づける。本三昧耶印な
り。本説は二中指を屈して頂の如くせ
よとあるが、口伝に、剣印は是れ大日
如来の大慧刀か、此の智は最勝なるが
故に、如頂と云うとある。真言は、

Mudrā of Mahāvijaya-vajra

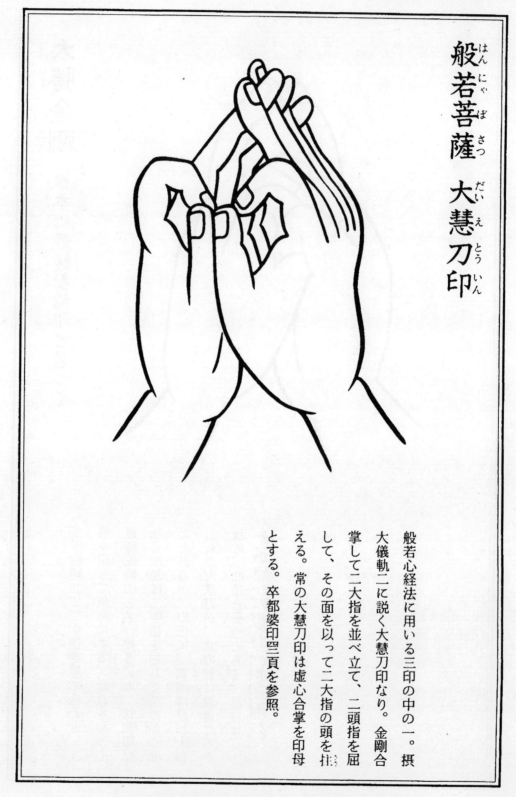

般若菩薩　大慧刀印

般若心経法に用いる三印の中の一。摂
大儀軌二に説く大慧刀印なり。金剛合
掌して二大指を並べ立て、二頭指を屈
して、その面を以って二大指の頭を拄
える。常の大慧刀印は虚心合掌を印母
とする。卒都婆印咒頁を参照。

Mahājñāna-khadga-mudrā of Prajñāpāramitā
(the mudrā of the sword of supreme knowledge)

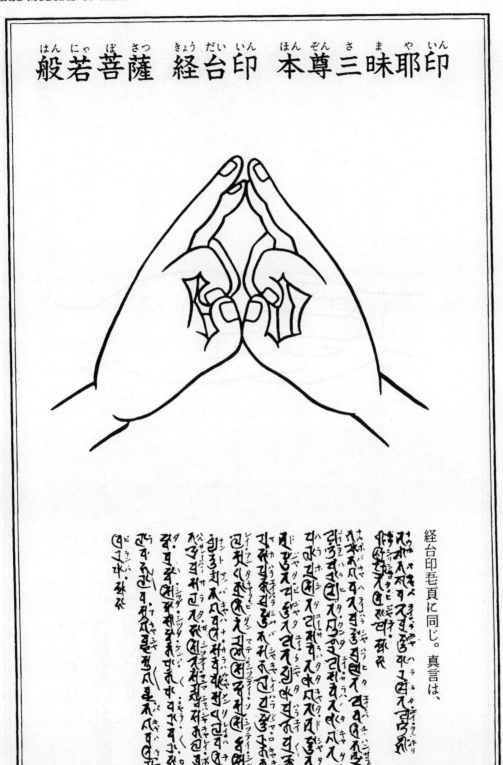

般若菩薩　経台印　本尊三昧耶印

Samaya-mudrā of Prajñāpāramitā

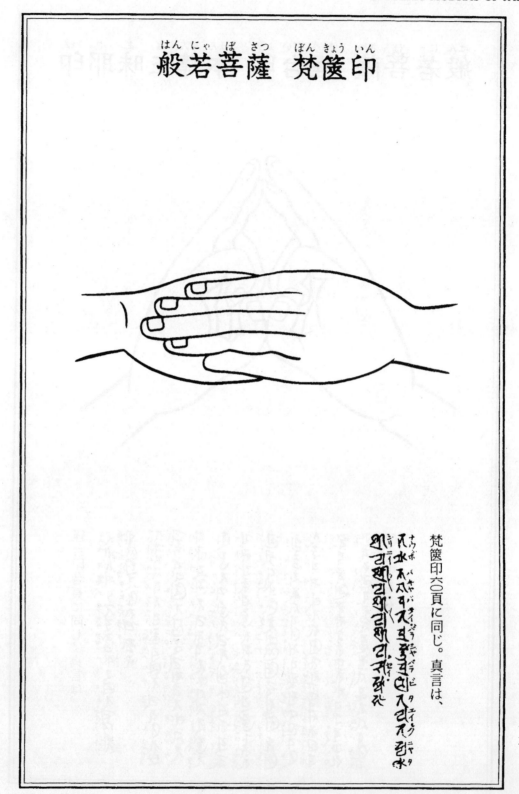

般若菩薩　梵篋印

梵篋印六〇頁に同じ。真言は、

Sanskrit pothi mudrā of Prajñāpāramitā

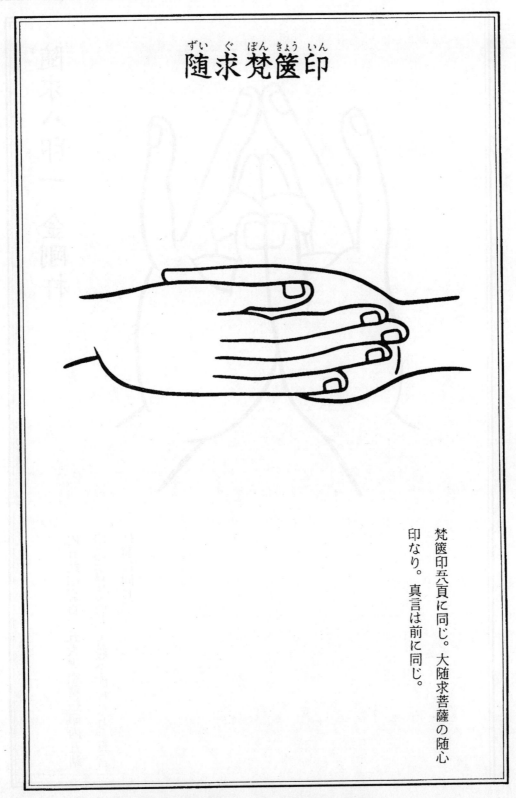

随求梵篋印
ずい ぐ ぼん きょう いん

梵篋印五六頁に同じ。大随求菩薩の随心
印なり。真言は前に同じ。

Sanskrit pothi mudrā of Pratisarā

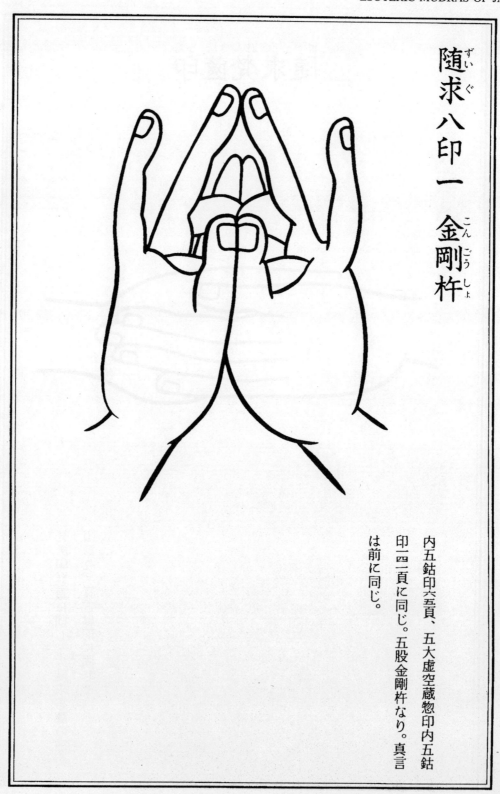

随求八印一　金剛杵

内五鈷印六五頁、五大虚空蔵惣印内五鈷印二四二頁に同じ。五股金剛杵なり。真言は前に同じ。

Vajra-mudrā, first of the eight mudrās of Pratisarā

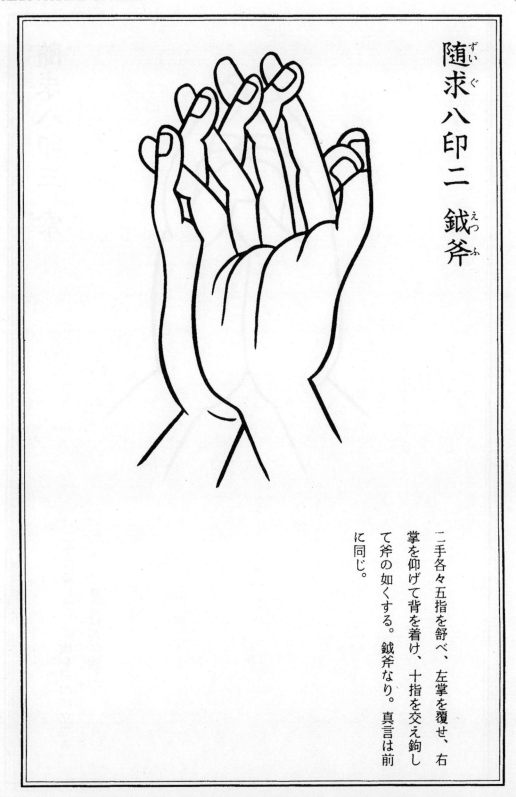

随求八印二 鉞斧

二手各々五指を舒べ、左掌を覆せ、右掌を仰げて背を着け、十指を交え鉤して斧の如くする。鉞斧なり。真言は前に同じ。

Paraśu (axe)-mudrā, second of the eight mudrās of Pratisarā

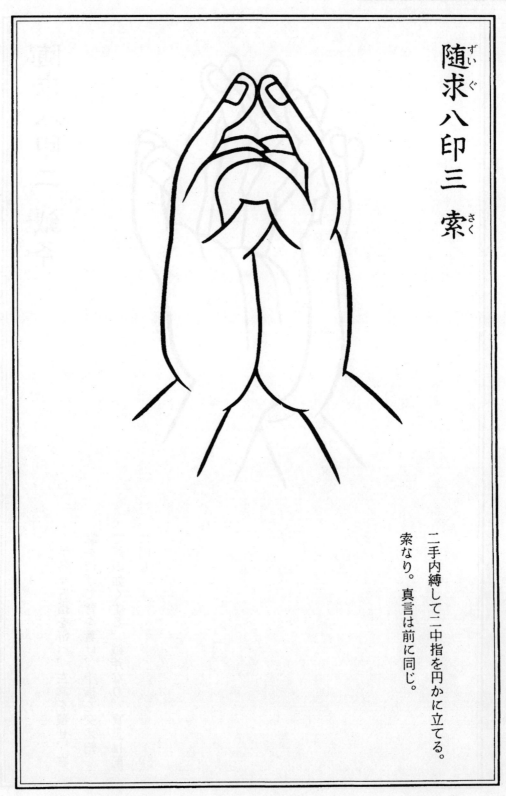

随求八印三 索

二手内縛して二中指を円かに立てる。索なり。真言は前に同じ。

Pāśa (noose)-mudrā, third of the eight mudrās of Pratisarā

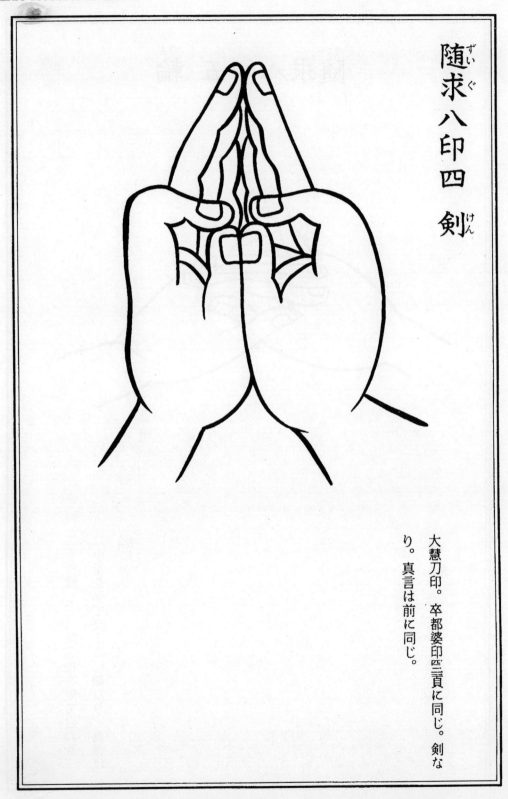

随求八印四 剣
ずいぐ けん

大慧刀印。卒都婆印㊁三頁に同じ。剣な
り。真言は前に同じ。

Khaḍga (sword)-mudrā, fourth of the eight mudrās of Pratisarā

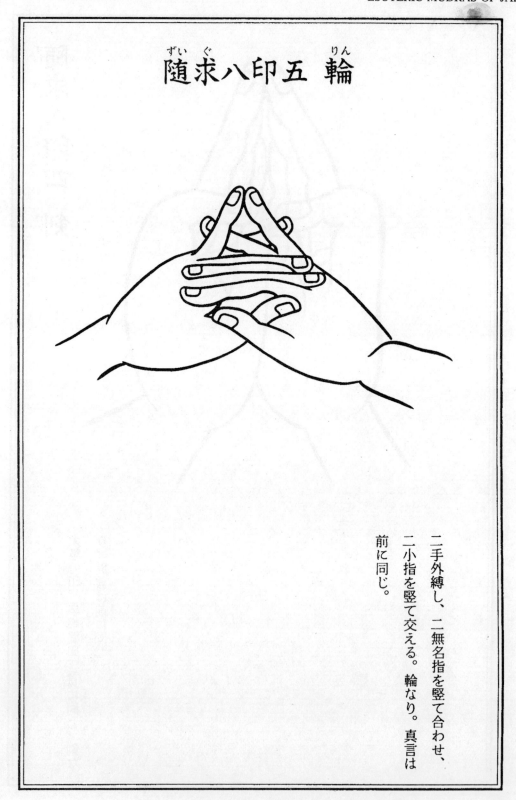

随求八印五 輪

二手外縛し、二無名指を竪て合わせ、
二小指を竪て交える。　輪なり。　真言は
前に同じ。

Cakra-mudrā, fifth of the eight mudrās of Pratisarā

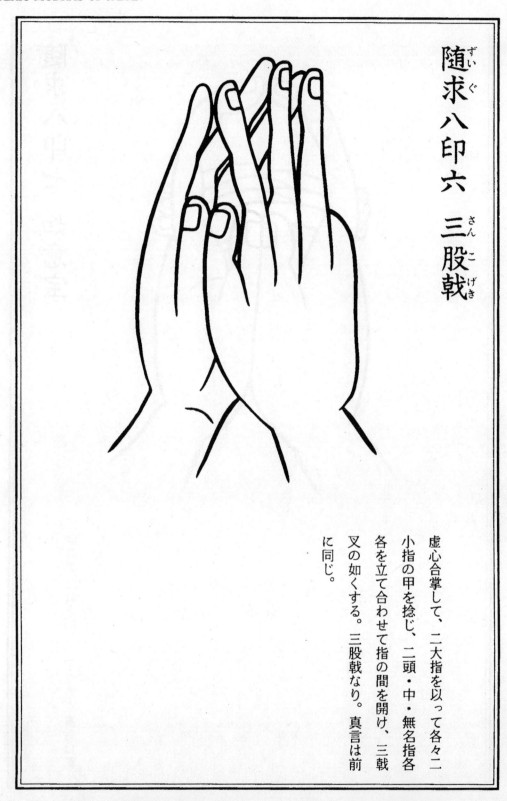

随求八印六　三股戟

虚心合掌して、二大指を以って各々二
小指の甲を捻じ、二頭・中・無名指各
各を立て合わせて指の間を開け、三戟
叉の如くする。三股戟なり。真言は前
に同じ。

Triśūla (trident)-mudrā, sixth of the eight mudrās of Pratisarā

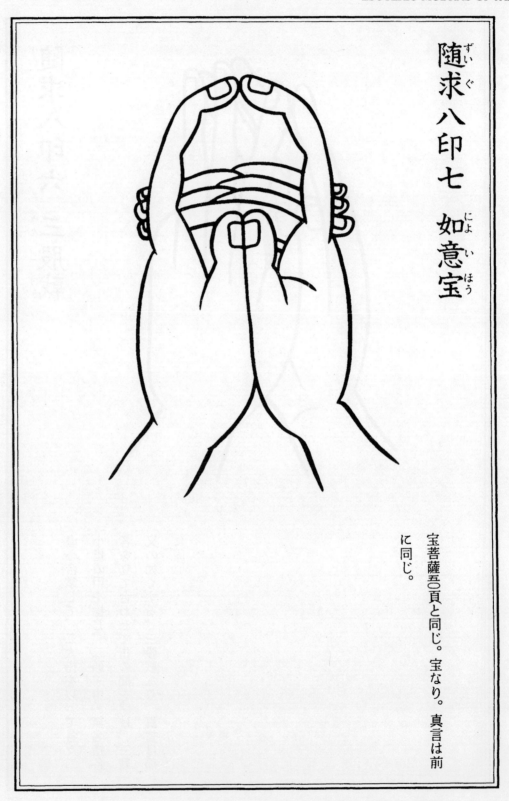

随求八印七 如意宝

宝菩薩五〇頁と同じ。宝なり。真言は前に同じ。

Cintāmaṇi-mudrā, seventh of the eight mudrās of Pratisarā

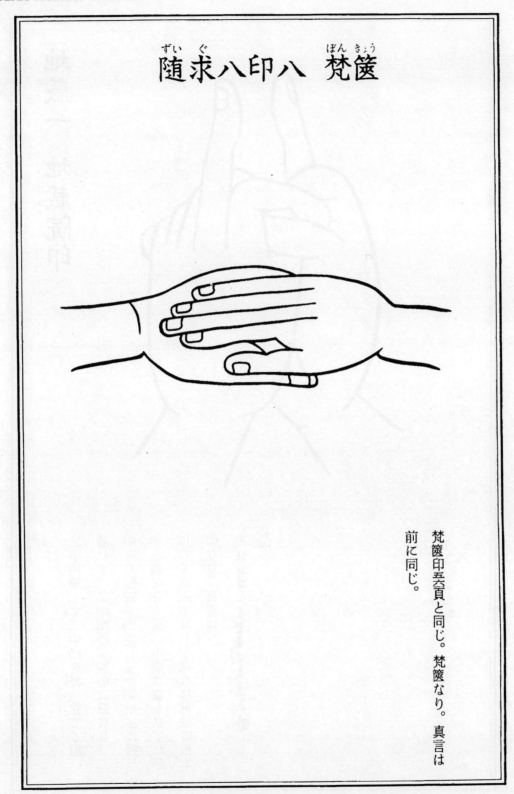

随求八印八　梵篋

梵篋印五六頁と同じ。梵篋なり。真言は
前に同じ。

Pothi-mudrā, eighth of the eight mudrās of Pratisarā

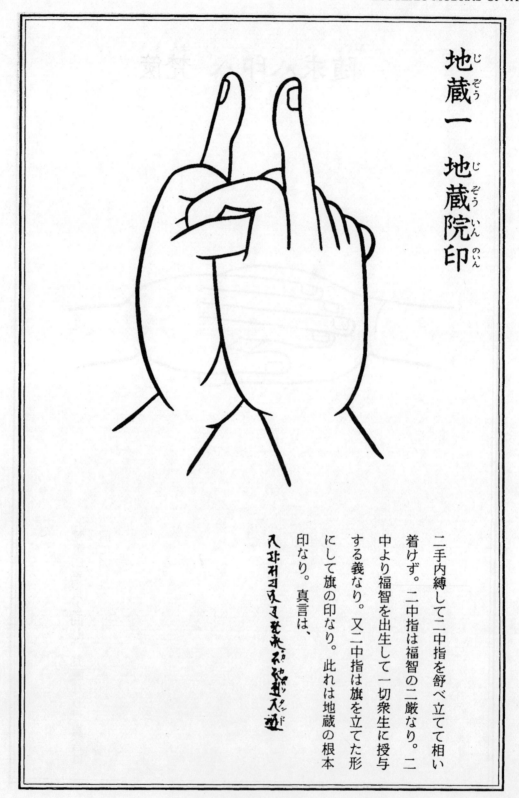

地蔵一　地蔵院印

二手内縛して二中指を舒べ立てて相い
着けず。二中指は福智の二厳なり。二
中より福智を出生して一切衆生に授与
する義なり。又二中指は旗を立てた形
にして旗の印なり。此れは地蔵の根本
印なり。真言は、

Mudrā of Kṣitigarbha, no. 1

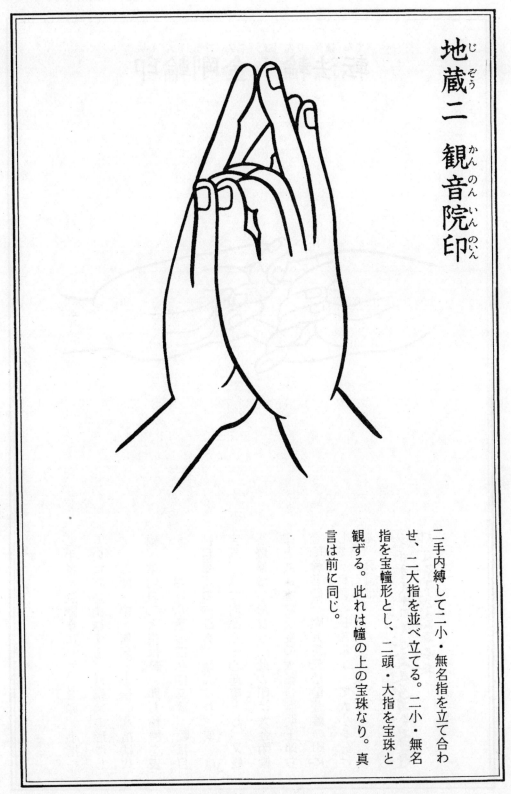

地蔵二　観音院印

二手内縛して二小・無名指を立て合わせ、二大指を並べ立てる。二小・無名指を宝幢形とし、二頭・大指を宝珠と観ずる。此れは幢の上の宝珠なり。真言は前に同じ。

Mudrā of Kṣitigarbha, no. 2

転法輪小金剛輪印

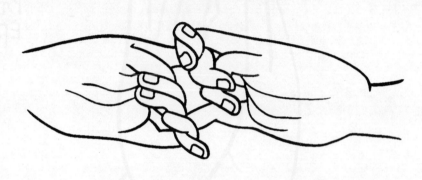

二手各々金剛拳にして、二頭・小指を
互いに相い鉤結する。八輻輪の形にし
て、二頭・中・無名・小指の八指は八
輻、掌内の二大指は轂、即ち輪臍を表
す。八輻は八葉の四仏四菩薩、轂は自
性自受用の内証智の境界なり。或いは
宝珠、八弁肉団心・心蓮等とし、又曼
荼羅輪壇の形なり。此の印は大金剛輪
印と共に弥勒所変の大輪金剛明王即ち
金剛輪菩薩、纔発意転法輪菩薩の印に
して、真言の長短によって大小を分け
る。真言は、

Mudrā of dharma-cakra-pravartana

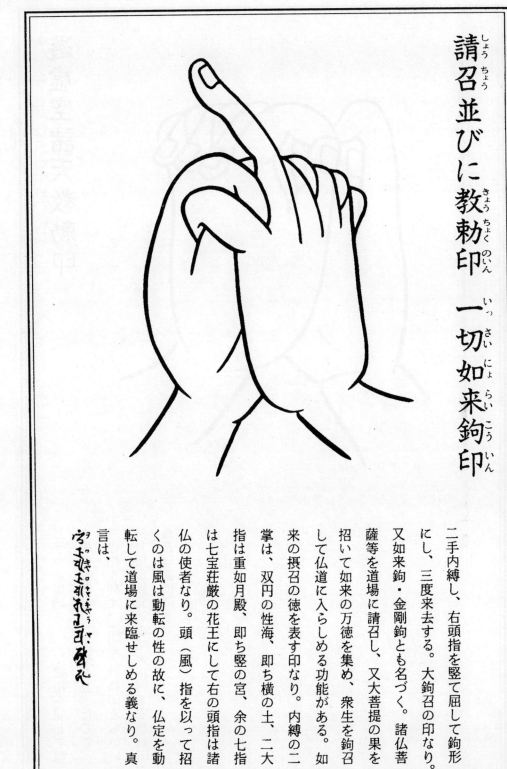

請召並びに教勅印 一切如来鉤印

二手内縛し、右頭指を竪て屈して鉤形にし、三度来去する。大鉤召の印なり。又如来鉤・金剛鉤とも名づく。諸仏菩薩等を道場に請召し、又大菩提の果を招いて如来の万徳を集め、衆生を鉤召して仏道に入らしめる功能がある。如来の摂召の徳を表す印なり。内縛の二掌は、双円の性海、即ち横の土、二大指は重如月殿、即ち竪の宮、余の七指は七宝荘厳の花王にして右の頭指は諸仏の使者なり。頭（風）指を以って招くのは風は動転の性の故に、仏定を動転して道場に来臨せしめる義なり。真言は、

Sarva-tathāgat-āṅkuśa-mudrā

遊虚空諸天教勅印

二手を金剛縛とし、二頭指を屈して相
方の背を着け、二大指を並べたてて、
二頭指を押す。遊空天教勅印ともいい
日月星辰妙見等の諸天に対する教勅印。
真言は前に同じ。

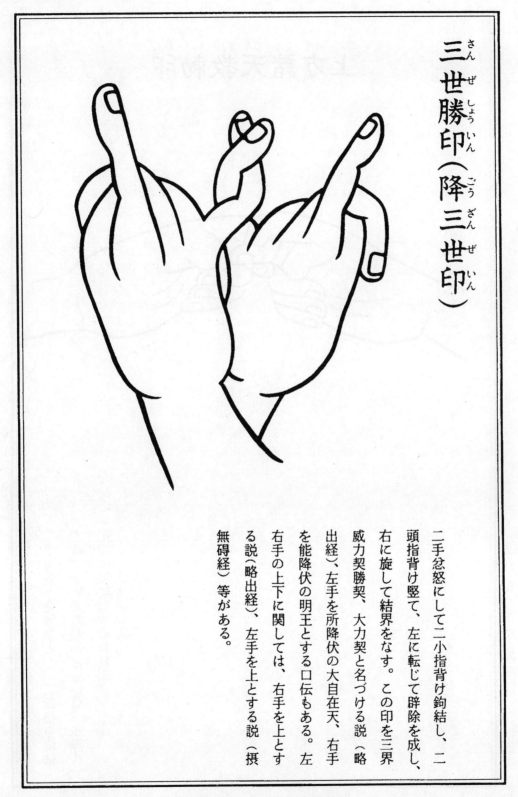

三世勝印（降三世印）

二手忿怒にして二小指背け鉤結し、二
頭指背け竪て、左に転じて辟除を成し、
右に旋して結界をなす。この印を三界
威力契勝契、大力契と名づける説（略
出経）、左手を所降伏の大自在天、右手
を能降伏の明王とする口伝もある。左
右手の上下に関しては、右手を上とす
る説（略出経）、左手を上とする説（摂
無碍経）等がある。

Mudrā of Trailokyavijaya

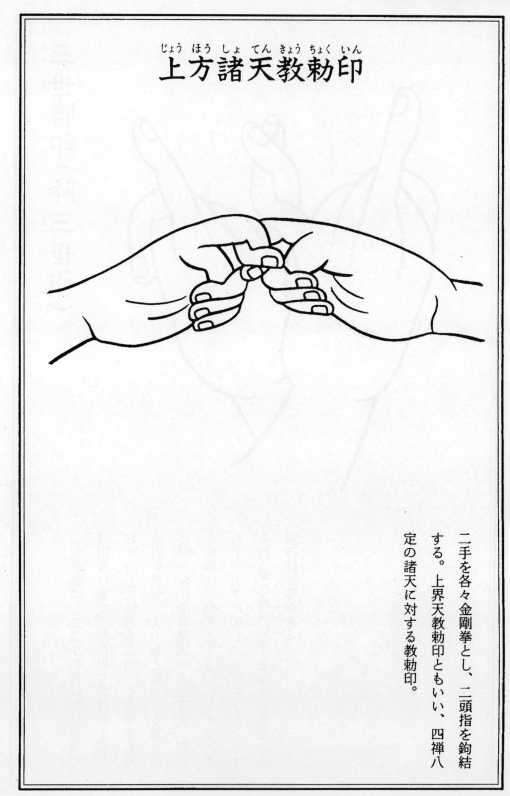

じょう ほう しょ てん きょう ちょく いん
上方諸天教勅印

二手を各々金剛拳とし、二頭指を鉤結
する。上界天教勅印ともいい、四禅八
定の諸天に対する教勅印。

Mudrā of Jōhō Shōten of the Sky

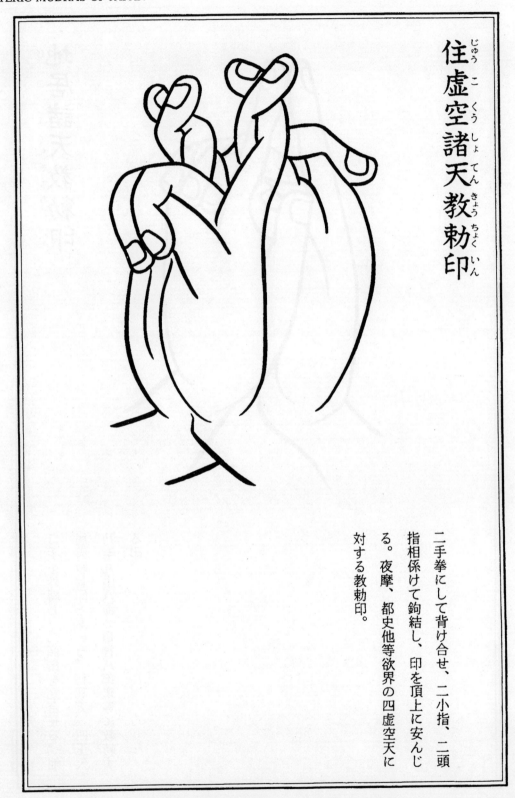

住虚空諸天教勅印

二手拳にして背け合せ、二小指、二頭
指相係けて鈎結し、印を頂上に安んじ
る。夜摩、都史他等欲界の四虚空天に
対する教勅印。

Mudrā of Jūkokū Shōten of the Antarikṣa

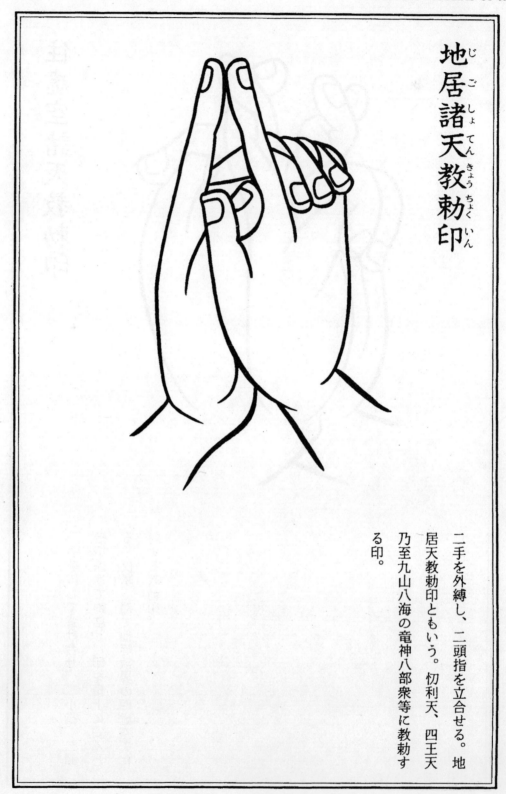

地居諸天教勅印

二手を外縛し、二頭指を立合せる。地
居天教勅印ともいう。忉利天、四王天
乃至九山八海の竜神八部衆等に教勅す
る印。

Mudrā of Jigo Shōten of the Earth

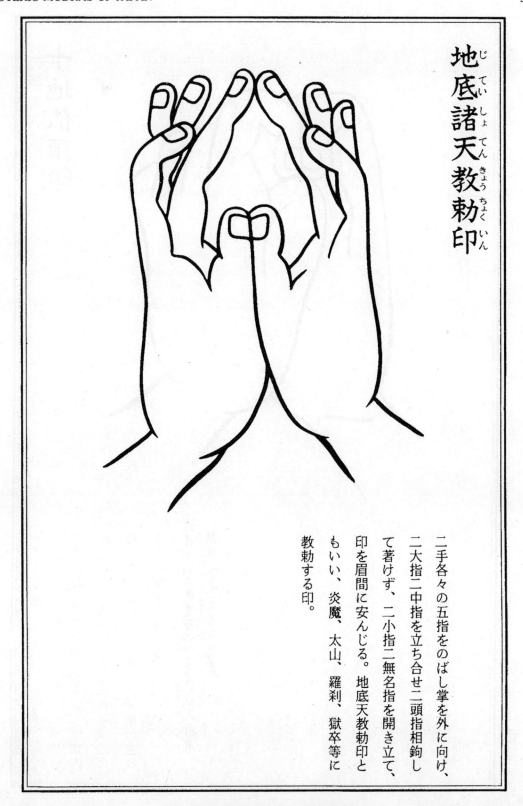

地底諸天教勅印

二手各々の五指をのばし掌を外に向け、
二大指二中指を立ち合せ二頭指相鉤し
て著けず、二小指二無名指を開き立て、
印を眉間に安んじる。地底天教勅印と
もいい、炎魔、太山、羅刹、獄卒等に
教勅する印。

Mudrā of Jitei Shōten of Pātāla

十地仏頂印

二手内縛して二大指を並べ屈して掌内
に入れ二頭指を屈して甲を合せ、二大
指の甲の上に置く（或は二大指の曲れ
る上を押す）。真言は、

Daśa-bhūmy-uṣṇīṣa-mudrā

大釣古
だい ちょう こ

仏部心三昧耶の印。二手内縛して二大
指を並べたて、微し屈して頭指に着け
ず。仏部召請印。印母の内縛拳は心月
輪の形にして仏心、二空指は大空不二
の仏智顕明を表す。この印相は師子冠
印、師子口印とも名づける大精進印。

小三古
（しょう　さん　こ）

右手大指の面を以って中指の甲を捻ずる。この他小三鈷の印には大指の面を以て小指の甲を捻ずるもの（仏部三鈷印）、大指の面を以て無名指の甲を捻ずるもの（蓮華部三鈷印）、大指の面を以て頭指の甲を捻ずるもの（金剛部三鈷印）があり、それぞれ印義が異なる。

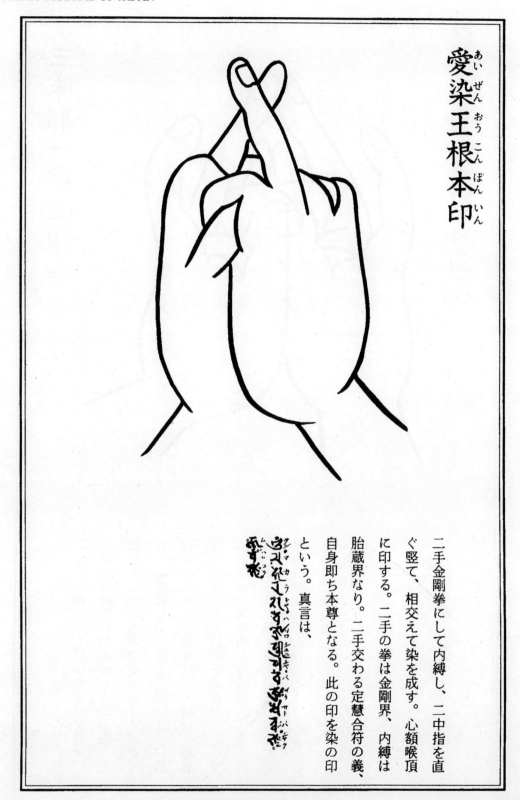

愛染王根本印

二手金剛拳にして内縛し、二中指を直
ぐ竪て、相交えて染を成す。心額喉頂
に印する。二手の拳は金剛界、内縛は
胎蔵界なり。二手交わる定慧合符の義、
自身即ち本尊となる。此の印を染の印
という。真言は、

Mūla-mudrā of Rāgarāja

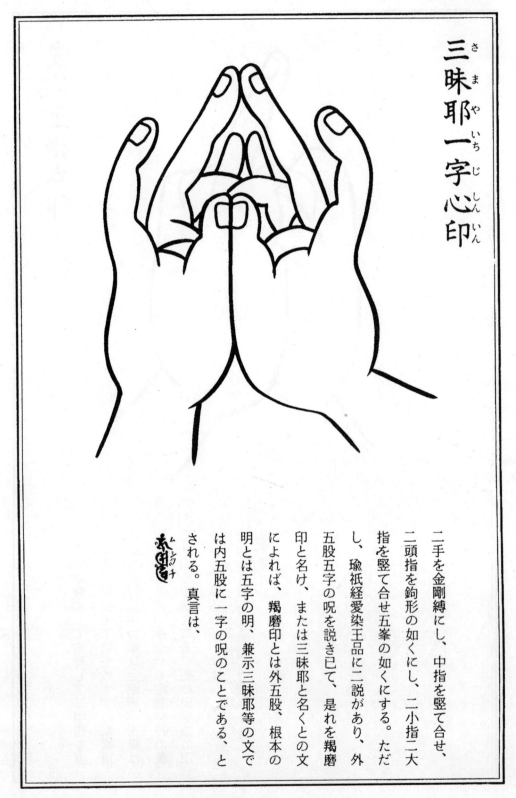

三昧耶一字心印

二手を金剛縛にし、中指を竪て合せ、二頭指を鉤形の如くにし、二小指二大指を竪て合せ五峯の如くにする。ただし、瑜祇経愛染王品に二説があり、外五股五字の呪を説き已て、是れを羯磨印と名け、または三昧耶と名くとの文によれば、羯磨印とは外五股、根本の明とは五字の明、兼示三昧耶等の文では内五股に一字の呪のことである、とされる。真言は、

Samaya-ekākṣara-citta-mudrā

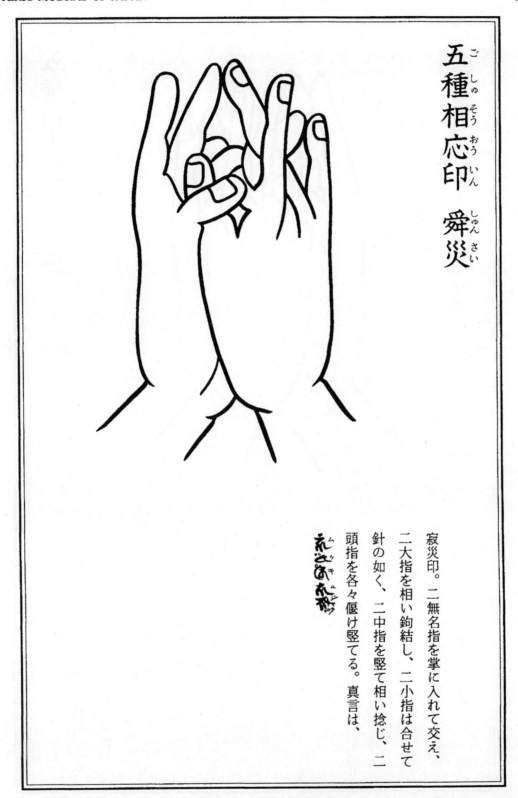

五種相応印　舜災

寂災印。二無名指を掌に入れて交え、二大指を相い鈎結し、二小指は合せて針の如く、二中指を竪て相い捻じ、二頭指を各々偃け竪てる。真言は、

Mudrā of śāntika homa

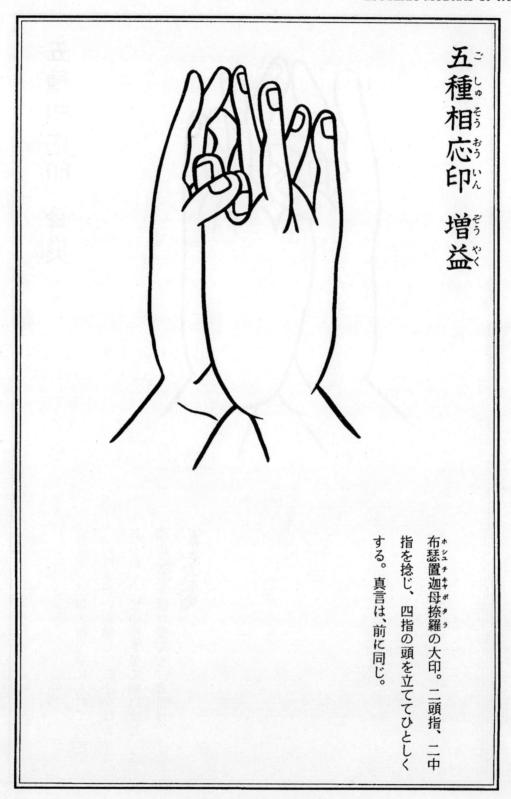

五種相応印　増益

布瑟置迦母捺羅の大印。二頭指、二中
指を捻じ、四指の頭を立ててひとしく
する。真言は、前に同じ。

Mudrā of pauṣṭika homa

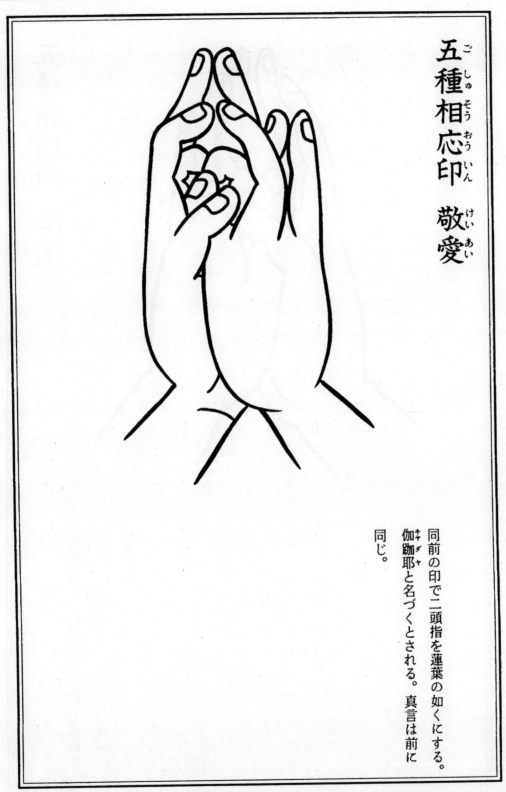

五種相応印 敬愛

同前の印で二頭指を蓮葉の如くにする。
伽跚耶と名づくとされる。真言は前に
同じ。

Mudrā of vaśīkaraṇa homa

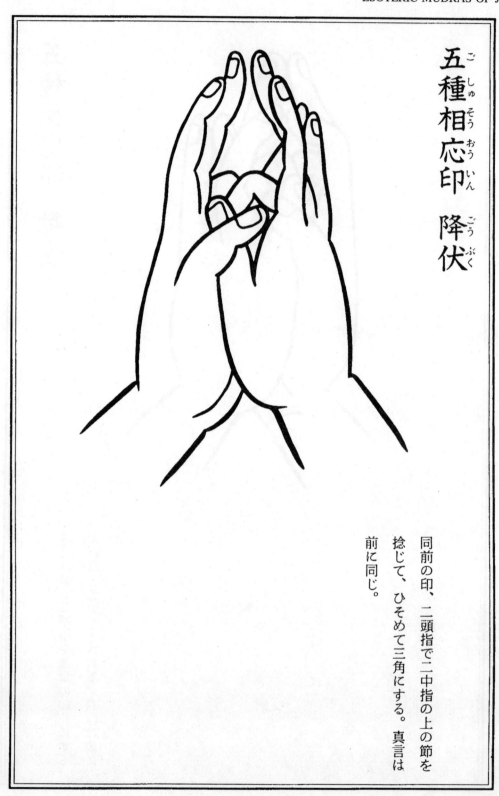

五種相応印　降伏

同前の印、二頭指で二中指の上の節を
捻じて、ひそめて三角にする。真言は
前に同じ。

Mudrā of ābhicāruka homa

五種相応印　鉤召

同前の印の二頭指を屈して鉤の如くし、誦ずるに随って招召する。金剛央倶施なり。五種相応印は口伝に異があり、或は内五股印を本とし、或は内縛して二中二頭指を竪て、或は内縛して二中指のみを竪てて、五種の印をなす、とされる。真言は前に同じ。

Mudrā of aṅkuśa (goad)

不動根本印

独鈷印。内縛して二頭指を立て合せ、二大指を以て二無名指の甲を押す。針印ともいい、二頭指を剣、二大二無名指を索とする義、或は二無名指二中指を四魔、二大指を以てこれを押すは四魔を降伏する義とする等種々の口伝がある。 真言は

Mula-mudrā of Acala

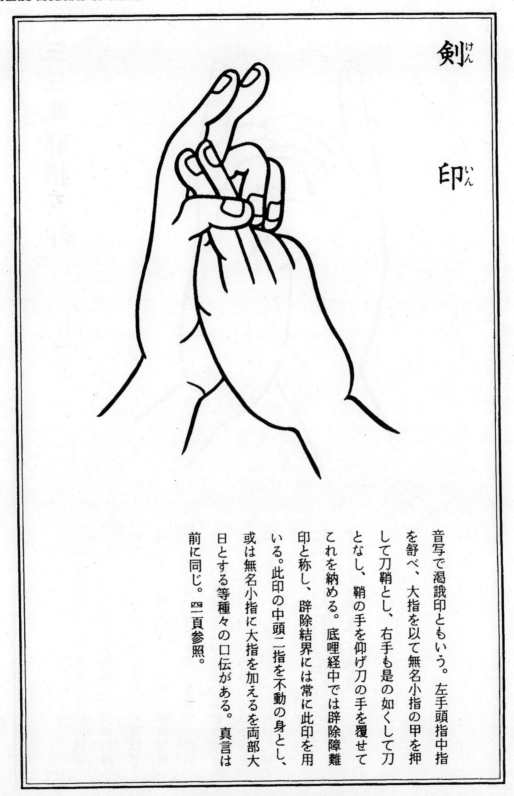

剣印

音写で渇誐印ともいう。左手頭指中指
を舒べ、大指を以て無名小指の甲を押
して刀鞘とし、右手も是の如くして刀
となし、鞘の手を仰げ刀の手を覆せて
これを納める。底哩経中では辟除障難
印と称し、辟除結界には常に此印を用
いる。此印の中頭二指を不動の身とし、
或は無名小指に大指を加えるを両部大
日とする等種々の口伝がある。真言は
前に同じ。四頁参照。

Khaḍga-mudrā (sword)

三三昧耶摂召印
（さんざんまやせっちょういん）

一切如来所生印と号する。印相に異説
があり、一伝は先ず外縛して次に内縛
になし、二小指を開き立つ。内縛は菩
提心、二小指を開くは、右の小指は檀戒
忍の功徳分、左の小指は進禅慧の慧明
分とし、萬徳を此の二分に納め尽すと
する。実運の口伝は外縛して二小指を
開き立て、二大指を並べて掌中に入る。
真言は、
ナウマクサラバタタギャテイビャクサラバボタボジサトベビョサロバタタラタラランナウマヤマンナウマヤマンナウマキャラチラジニソワカ

Trisamaya... mudrā

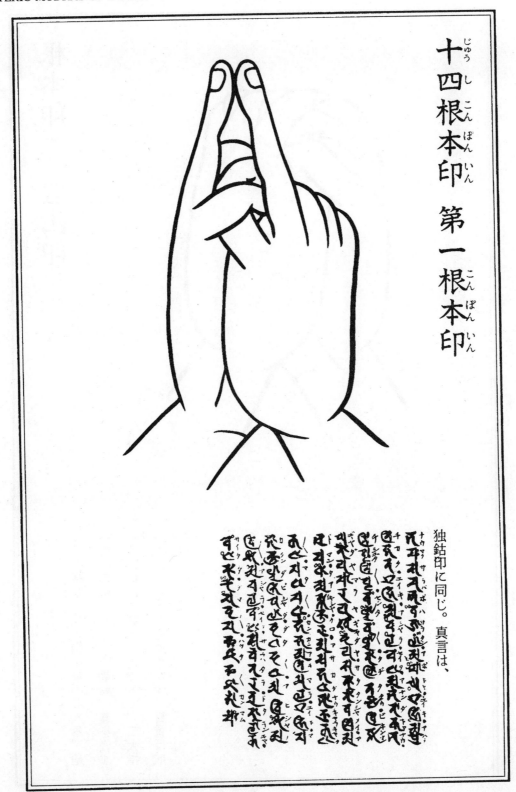

Fourteen mūla-mudrās: 1 mūla-mudrā

根本印二　宝山印

二手内縛して二大指を掌中に入る。是れ盤石の座にして、不動転の義を表す。底哩経には内縛とするのみで、二大指を掌に入れることを説かず。真言は前に同じ。

Fourteen mūla-mudrās: 2 Ratnagiri-mudrā

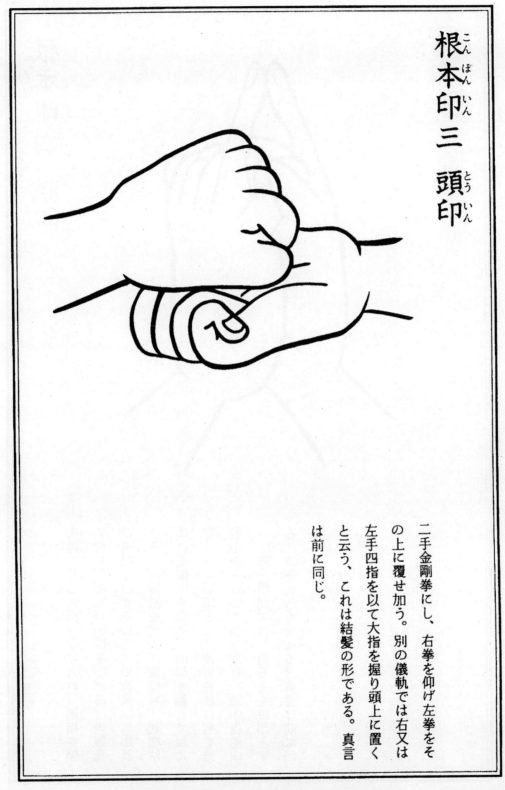

根本印三　頭印

二手金剛拳にし、右拳を仰げ左拳をその上に覆せ加う。別の儀軌では右又は左手四指を以て大指を握り頭上に置くと云う、これは結髪の形である。真言は前に同じ。

Fourteen mūla-mudrās: 3 śīrṣa-mudrā (head)

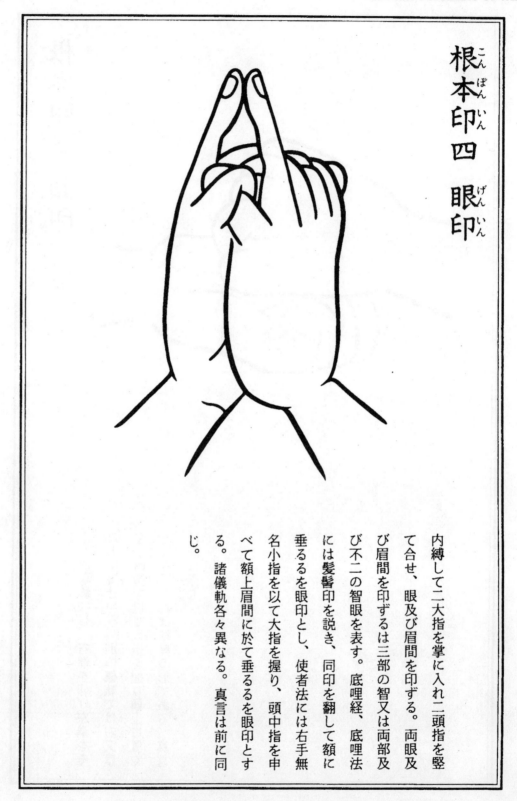

根本印四　眼印

内縛して二大指を掌に入れ二頭指を竪て合せ、眼及び眉間を印ずる。両眼及び眉間を印ずるは三部の智又は両部及び不二の智眼を表す。底哩経、底哩法には髪髻印を説き、同印を翻して額に垂るるを眼印とし、使者法には右手無名小指を以て大指を握り、頭中指を申べて額上眉間に於て垂るるを眼印とする。諸儀軌各々異なる。真言は前に同じ。

Fourteen mūla-mudrās: 4 cakṣur-mudrā (eyes)

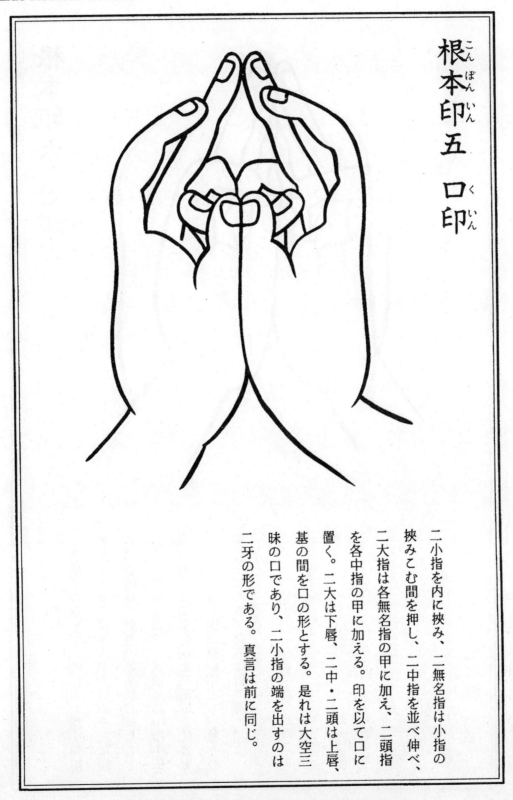

根本印五　口印

二小指を内に挾み、二無名指は小指の
挾みこむ間を押し、二中指を並べ伸べ、
二大指は各無名指の甲に加え、二頭指
を各中指の甲に加える。　印を以て口に
置く。　二大は下唇、二中・二頭は上唇、
基の間を口の形とする。　是れは大空三
昧の口であり、二小指の端を出すのは
二牙の形である。　真言は前に同じ。

Fourteen mūla-mudrās: 5 mukha-mudrā (face)

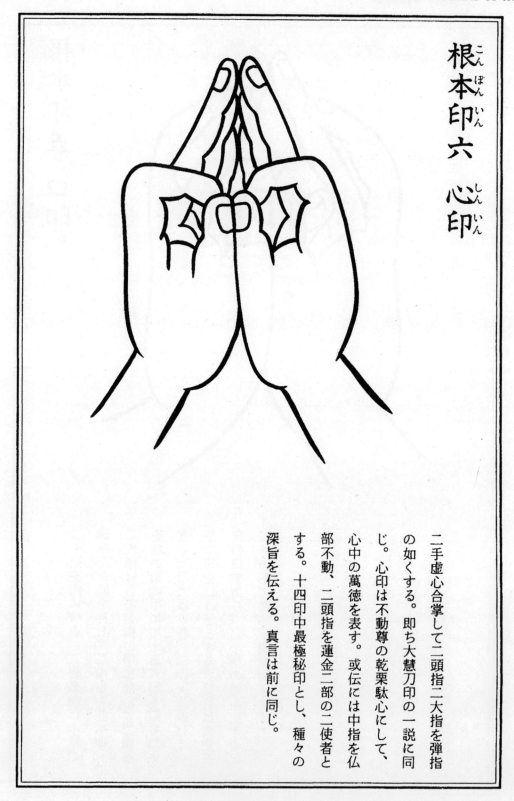

根本印六　心印

二手虚心合掌して二頭指二大指を弾指
の如くする。即ち大慧刀印の一説に同
じ。心印は不動尊の乾栗駄心にして、
心中の萬徳を表す。或伝には中指を仏
部不動、二頭指を蓮金二部の二使者と
する。十四印中最極秘印とし、種々の
深旨を伝える。真言は前に同じ。

Fourteen mūla-mudrās: 6 citta-mudrā (mind)

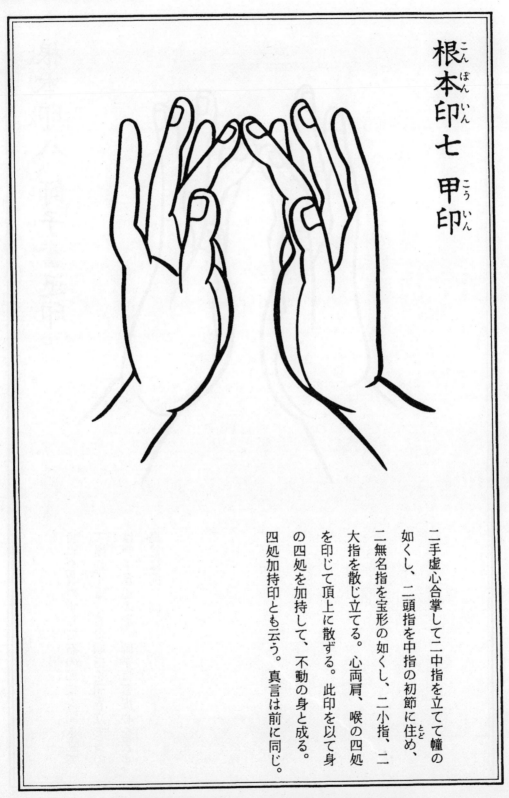

根本印七 甲印

二手虚心合掌して二中指を立てて幢の如くし、二頭指を中指の初節に住め、二無名指を宝形の如くし、二小指、二大指を散じ立てる。心両肩、喉の四処を印じて頂上に散ずる。此印を以て身の四処を加持して、不動の身と成る。四処加持印とも云う。真言は前に同じ。

Fourteen mūla-mudrās: 7 kavaca-mudrā (armour)

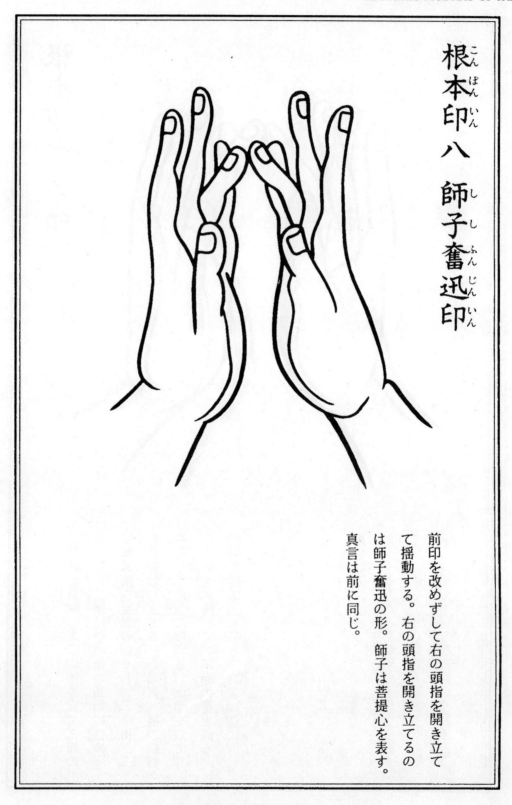

根本印八　師子奮迅印

真言は前に同じ。
は師子奮迅の形。師子は菩提心を表す。
て揺動する。右の頭指を開き立てるの
前印を改めずして右の頭指を開き立て

Fourteen mūla-mudrās: 8 kavaca-mudrā

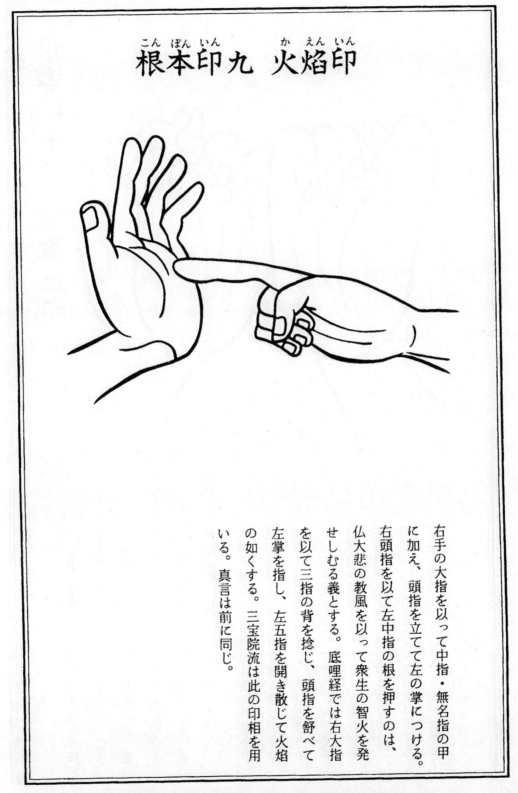

こんぽんいん　かえんいん
根本印九　火焔印

右手の大指を以って中指・無名指の甲
に加え、頭指を立てて左の掌につける。
右頭指を以て左中指の根を押すのは、
仏大悲の教風を以って衆生の智火を発
せしむる義とする。　底哩経では右大指
を以て三指の背を捻じ、頭指を舒べて
左掌を指し、左五指を開き散じて火焔
の如くする。　三宝院流は此の印相を用
いる。　真言は前に同じ。

Fourteen mūla-mudrās: 9 agni-jvālā-mudrā (flames)

根本印十　火焔輪止印

言は前に同じ。
以て業煩悩の火を滅する義である。真
置けば火自ら滅する。即ち大空の智を
中指頭指（火風）の間に大指（空）を
を頭指中指の間に出し、二拳背を合す。
制火印、遮火印ともいう。二拳各大指

Fourteen mūla-mudrās: 10 agni-cakra-śamana-mudrā
(extinguishing the circle of fire)

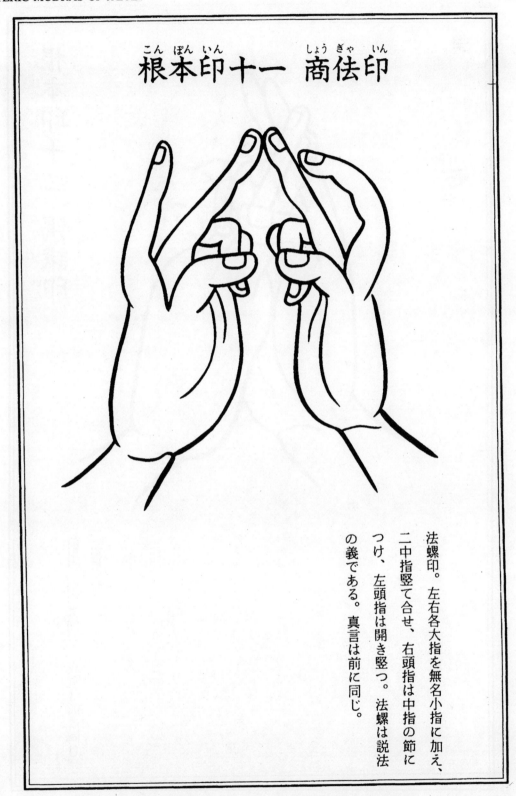

根本印十一　商佉印

法螺印。左右各大指を無名小指に加え、二中指竪て合せ、右頭指は中指の節につけ、左頭指は開き竪つ。法螺は説法の義である。真言は前に同じ。

Fourteen mūla-mudrās: 11 śaṅkha-mudrā (conch)

根本印十二　渇誐印

前出、剣印に同じ。真言は前に同じ。
四頁参照。

Fourteen mūla-mudrās: 12 khaḍga-mudrā (sword)

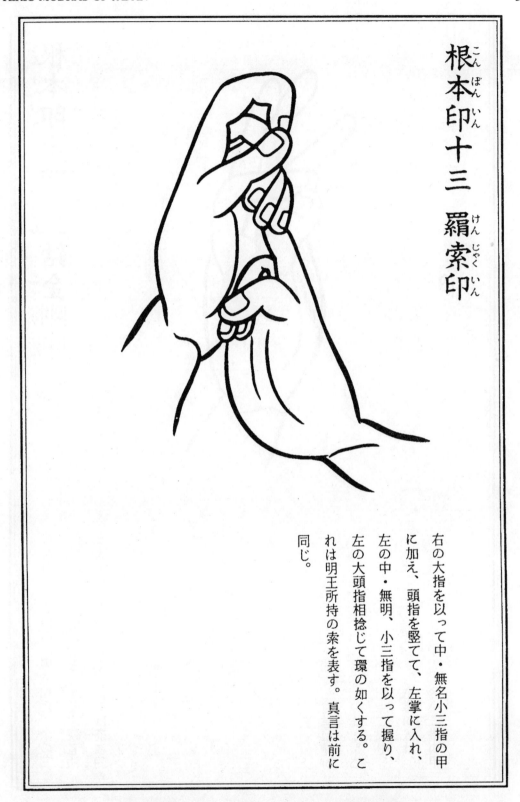

根本印十三　羂索印

右の大指を以って中・無名小三指の甲
に加え、頭指を竪てて、左掌に入れ、
左の中・無明、小三指を以って握り、
左の大頭指相捻じて環の如くする。こ
れは明王所持の索を表す。真言は前に
同じ。

Fourteen mūla-mudrās: 13 pāśa-mudrā (noose)

根本印十四　三鈷金剛印

右大指を以て頭指の甲に加え、余の三指を舒べて三鈷のごとくする。使者法では無畏清浄印と名く。真言は前に同じ。

Fourteen mūla-mudrās: 14 mudrā of the three-pronged vajra

降三世（大印）

大印。前出。四〇頁、一九二頁参照。真言は、

オン・ソンバ・ニソンバ・ウン・バザラ・ウン・ハッタ

Mahāmudrā of Trailokya-vijaya

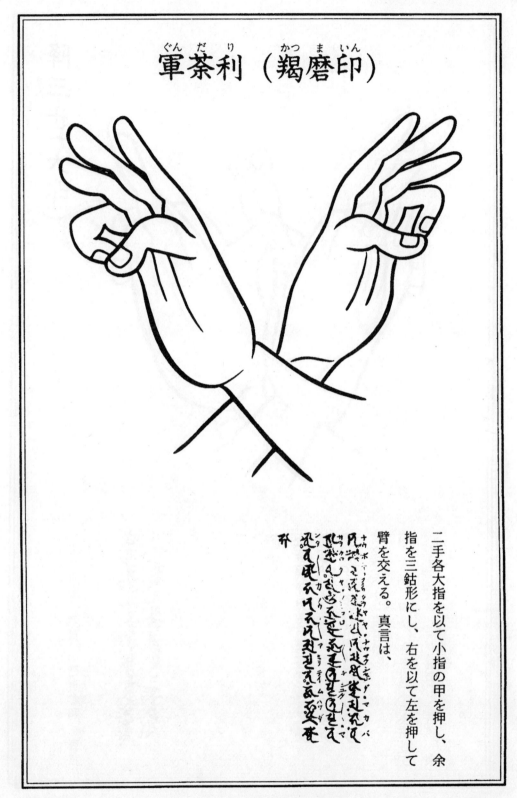

軍荼利（羯磨印）

二手各大指を以て小指の甲を押し、余
指を三鈷形にし、右を以て左を押して
臂を交える。真言は、

Karma-mudrā of Kuṇḍalin

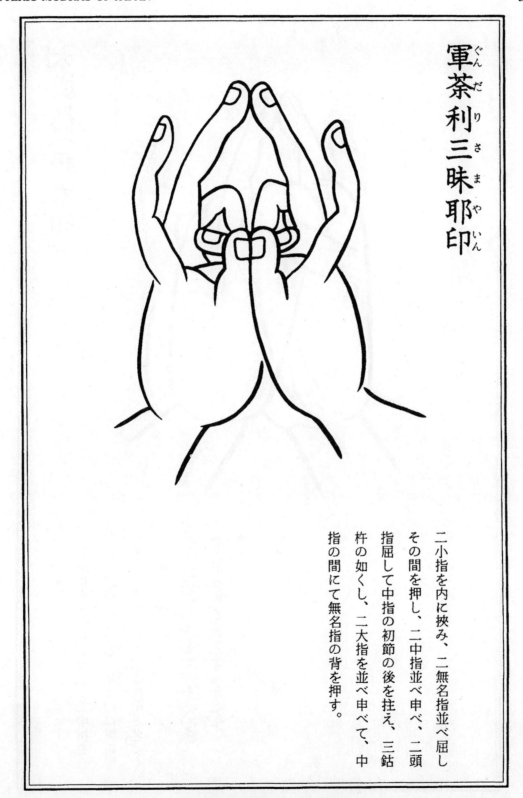

軍荼利三昧耶印

二小指を内に挟み、二無名指並べ屈し
その間を押し、二中指並べ申べ、二頭
指屈して中指の初節の後を拄え、三鈷
杵の如くし、二大指を並べ申べて、中
指の間にて無名指の背を押す。

Samaya-mudrā of Kuṇḍalin

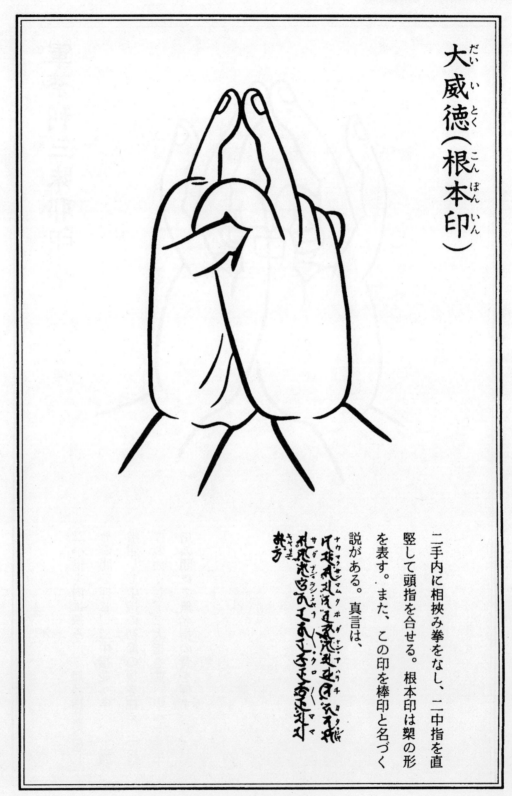

大威徳（根本印）

二手内に相挾み拳をなし、二中指を直竪して頭指を合せる。根本印は橖の形を表す。また、この印を棒印と名づく説がある。真言は、

Mūla-mudrā of Yamāntaka

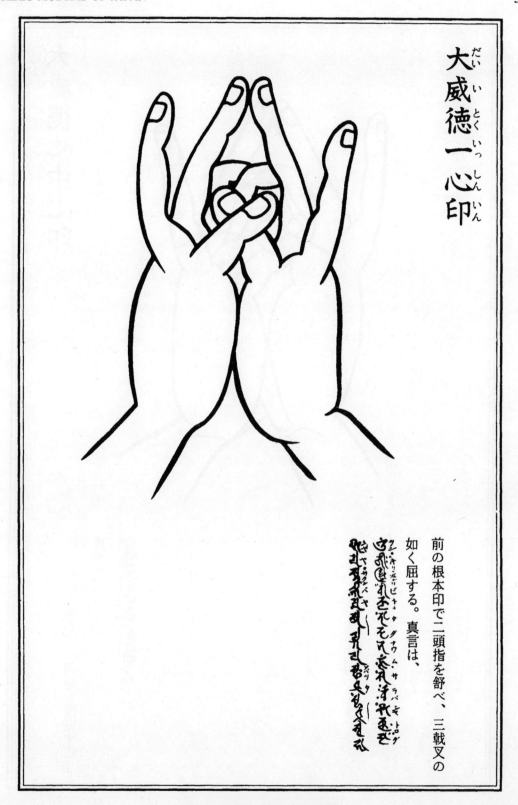

大威徳一心印

前の根本印で二頭指を舒べ、三戟叉の如く屈する。真言は、

Citta-mudrā of Yamāntaka

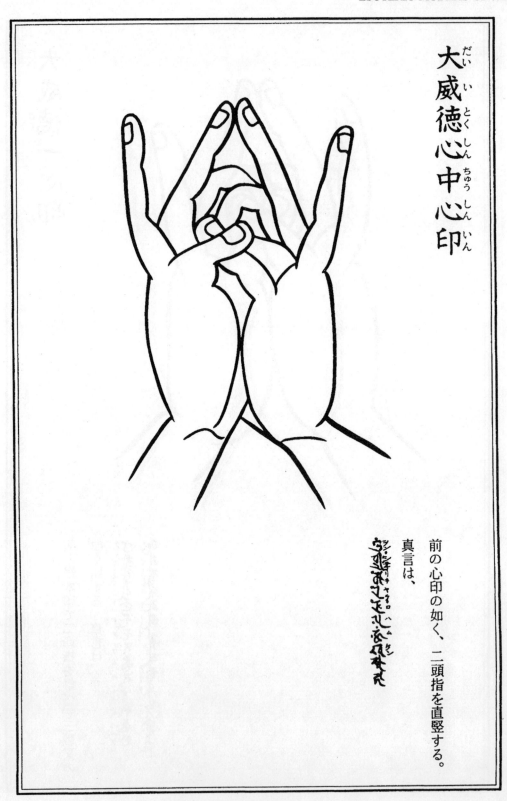

大
威
徳
心
中
心
印

前
の
心
印
の
如
く
、
二
頭
指
を
直
竪
す
る
。

真
言
は
、

Cittāntaś-citta-mudrā of Yamāntaka

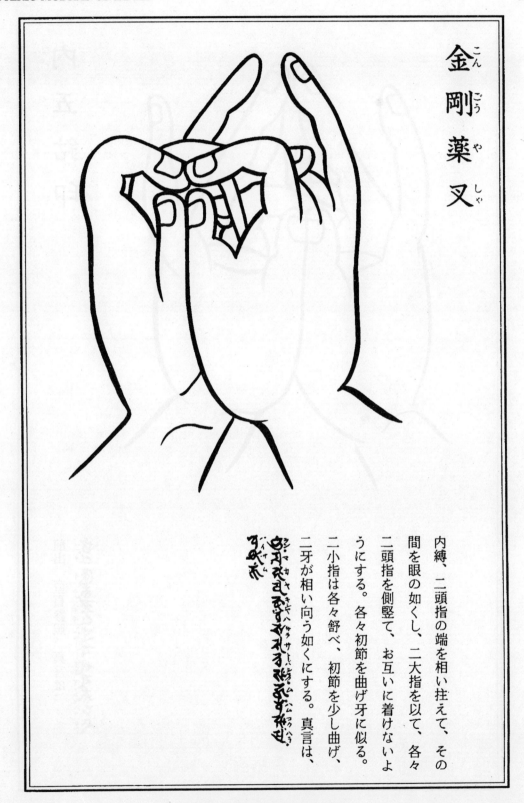

金剛薬叉

内縛、二頭指の端を相い拄えて、その間を眼の如くし、二大指を以て、各々二頭指を側竪て、お互いに着けないようにする。各々初節を曲げ牙に似る。二小指は各々舒べ、初節を少し曲げ、二牙が相い向う如くにする。真言は、

Mūla-mudrā of Vajrayakṣa

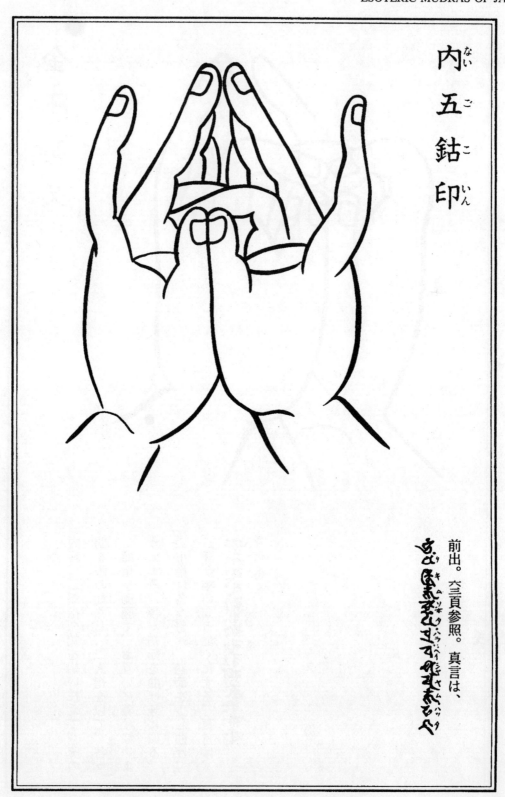

内五鈷印

前出。六三頁参照。真言は、

Mudrā of the outward five-pronged vajra

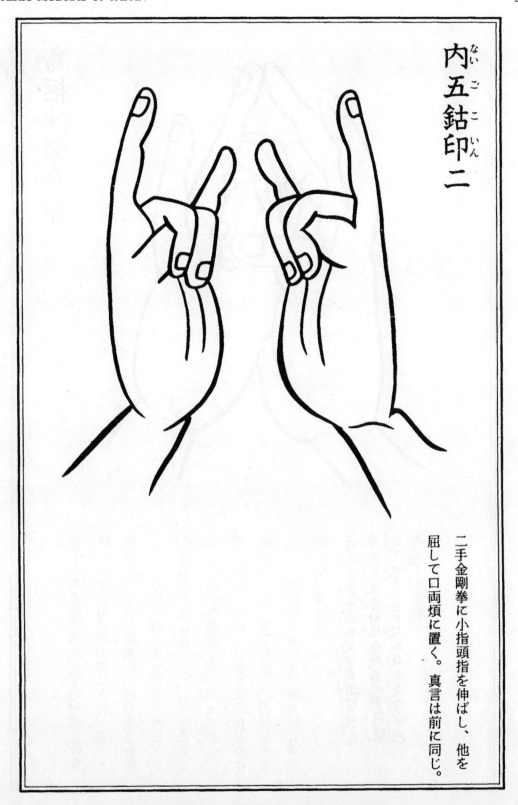

内五鈷印二

二手金剛拳に小指頭指を伸ばし、他を
屈して口両煩に置く。真言は前に同じ。

Mudrā of the inward five-pronged vajra

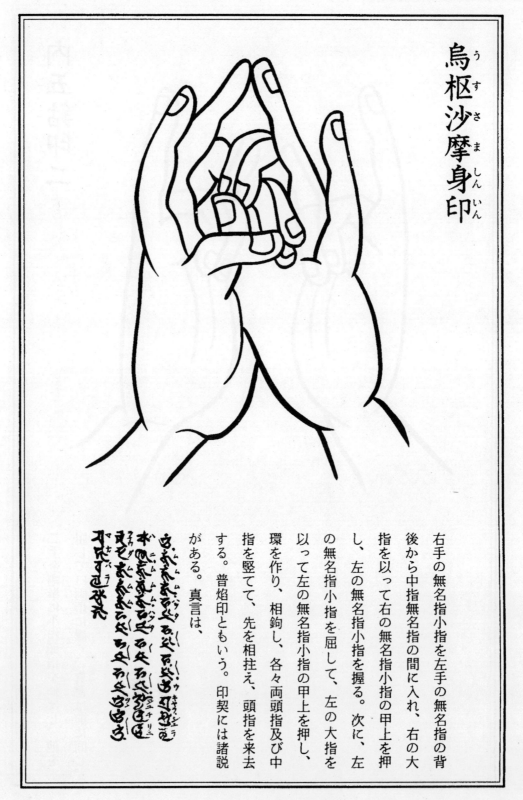

烏枢沙摩身印

右手の無名指小指を左手の無名指の背後から中指無名指の間に入れ、右の大指を以って右の無名指小指の甲上を押し、左の無名指小指を握る。次に、左の無名指小指を屈して、左の大指を以って左の無名指小指の甲上を押し、環を作り、相鉤し、各々両頭指及び中指を竪てて、先を相拄え、頭指を来去する。普焰印ともいう。印契には諸説がある。真言は、

Kāya-mudrā of Ucchuṣma

烏枢沙摩 或説用独鈷印

内縛して小指大指を立て合わす。この
印は薄伽梵根本印とも名づけられる。
二大二小指は独鈷の両頭であり、召請
には二大指を双べて招き、奉送には外
に弾く。　真言は、

（梵字真言）

... - mudrā of Ucchuṣma

烏枢沙摩 又印（或説用独鈷印）

虚心合掌して二小指を屈して掌の中に
入れ、二大指を以て二小指の甲を押さ
え、二無名指二中指二頭指を立ち合せ
各々微かに相去する。

... - mudrā of Ucchuṣma

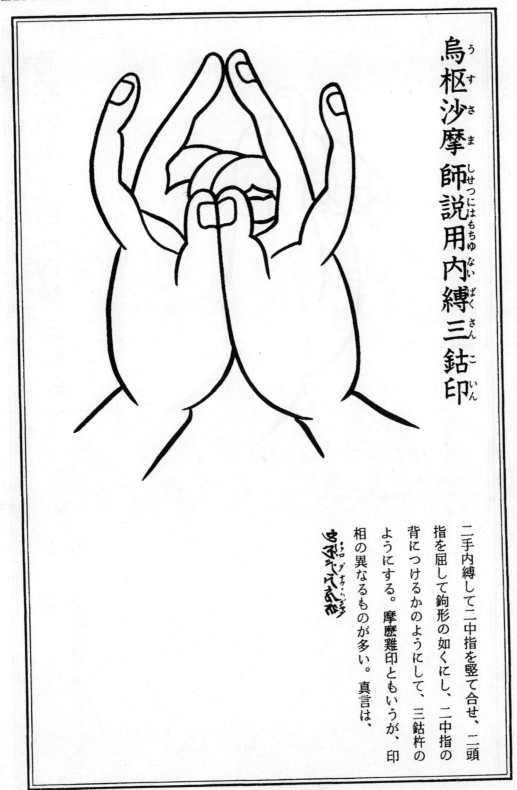

烏枢沙摩師説用内縛三鈷印

二手内縛して二中指を竪て合せ、二頭指を屈して鈎形の如くにし、二中指の背につけるかのようにして、三鈷杵のようにする。摩廢難印ともいうが、印相の異なるものが多い。真言は、

... - mudrā of Ucchuṣma

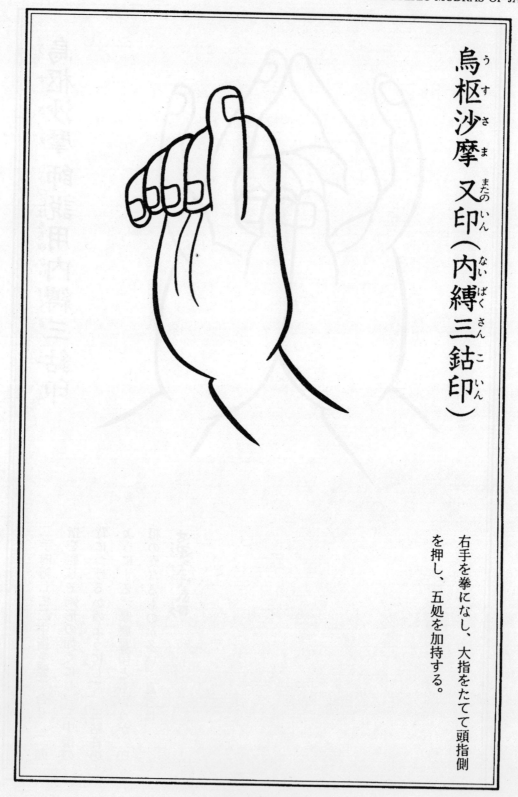

烏
枢
沙
摩
又
印
（
内
縛
三
鈷
印
）

右手を拳になし、大指をたてて頭指側
を押し、五処を加持する。

... - mudrā of Ucchuṣma

金剛童子根本印

師子印と号する。二中指を以て相背を
竪てて、二無名指、中指の中節の外に
横に交える。二頭指鉤して二無名指の
甲を押して二無名指を屈せしめて二大
指を並べて立てる。智證伝では、二中
指二寸程相い去く、とある。真言は、

Mūla-mudrā of Vajrakumāra

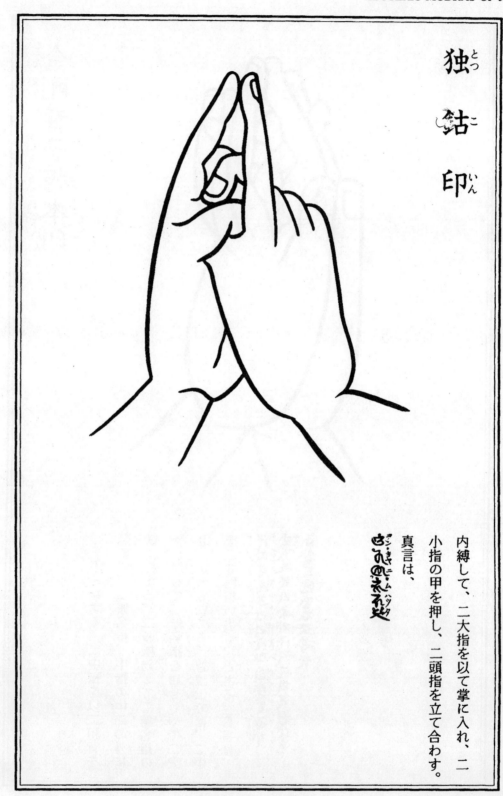

独鈷印

真言は、

内縛して、二大指を以て掌に入れ、二
小指の甲を押し、二頭指を立て合わす。

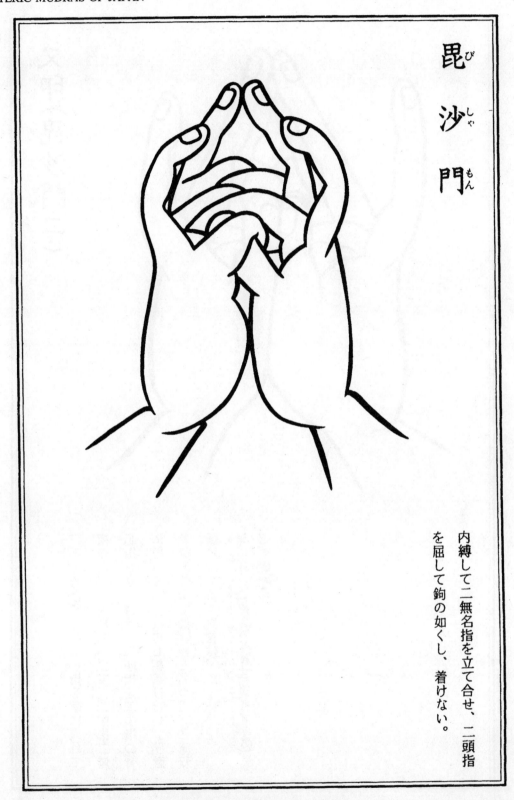

毘
沙
門

内縛して二無名指を立て合せ、二頭指
を屈して鉤の如くし、着けない。

Mudrā of Vaiśravaṇa, no. 1

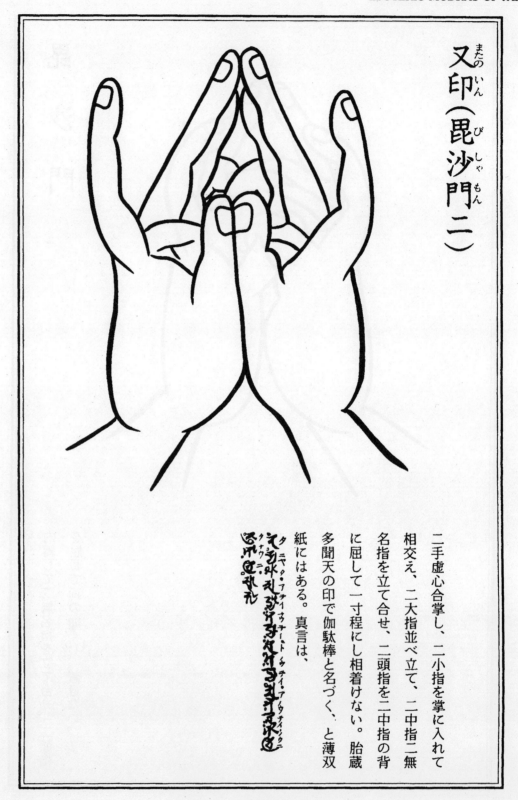

又印（毘沙門二）

二手虚心合掌し、二小指を掌に入れて相交え、二大指並べ立て、二中指二無名指を立て合せ、二頭指を二中指の背に屈して一寸程にし相着けない。胎蔵多聞天の印で伽駄棒と名づく、、と薄双紙にはある。　真言は、

Mudrā of Vaiśravaṇa, no. 2

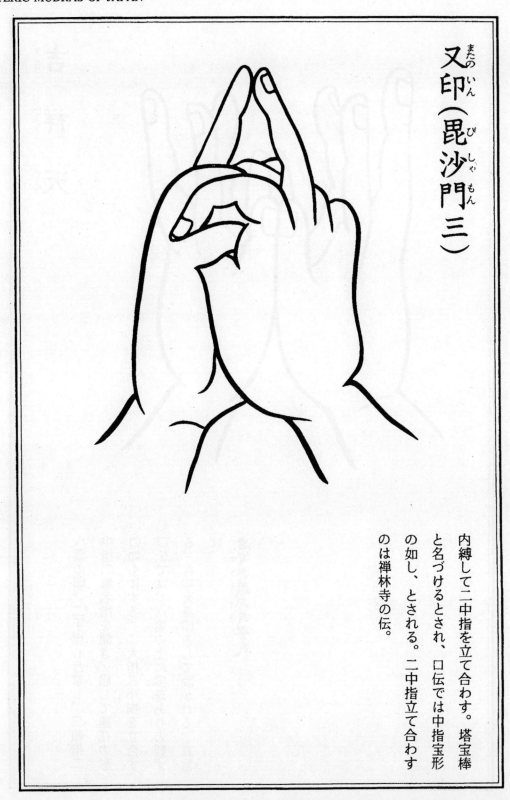

又印（毘沙門三）

内縛して二中指を立て合わす。塔宝棒と名づけるとされ、口伝では中指宝形の如し、とされる。二中指立て合わすのは禅林寺の伝。

Mudrā of Vaiśravaṇa, no. 3

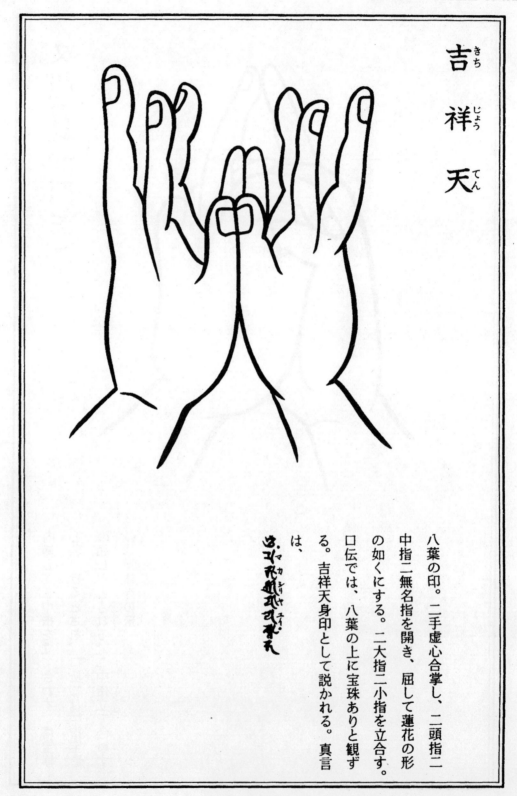

吉祥天
（きち）（じょう）（てん）

八葉の印。二手虚心合掌し、二頭指二
中指二無名指を開き、屈して蓮花の形
の如くにする。二大指二小指を立合す。
口伝では、八葉の上に宝珠ありと観ず
る。吉祥天身印として説かれる。真言
は、

曩莫・摩訶・室利耶・曳・莎賀吉祥天

Mudrā of Śrīdevī

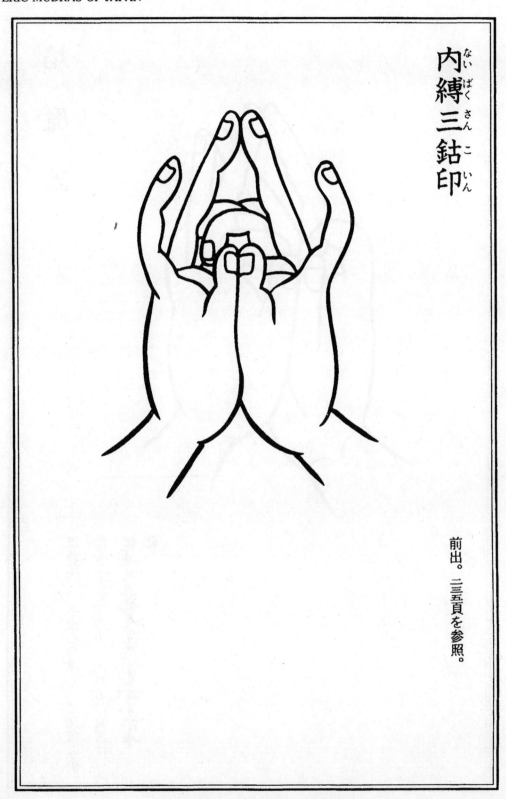

内^{ない}縛^{ばく}三^{さん}鈷^こ印^{いん}

前出。二三五頁を参照。

Inward three-pronged vajra mudrā

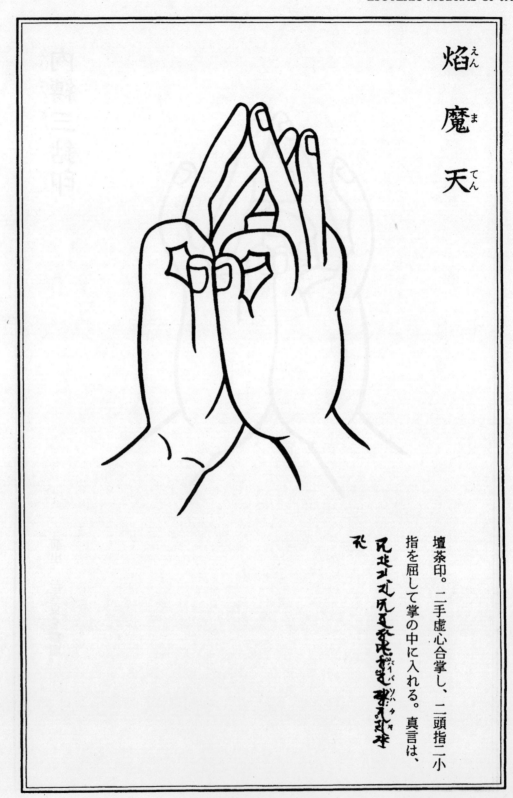

焰^{えん}
魔^ま
天^{てん}

壇茶印。二手虚心合掌し、二頭指二小
指を屈して掌の中に入れる。真言は、

Mudrā of Yamarāja

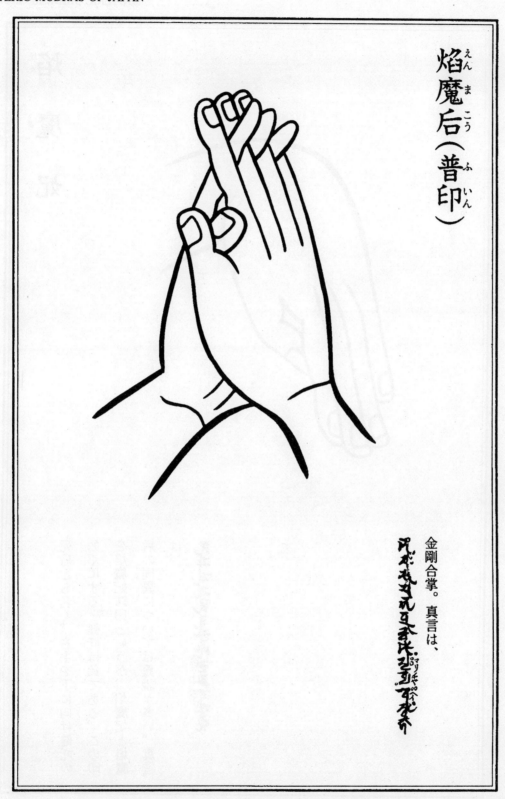

焰魔后（普印）

金剛合掌。真言は、

Mudrā of Yama-mātā (mother of Yama)

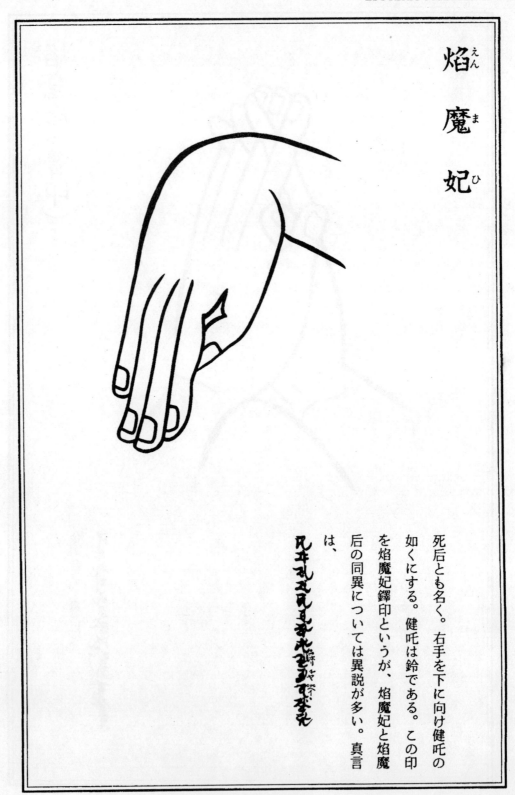

焰魔妃（えん）（ま）（ひ）

死后とも名く。右手を下に向け健吒の
如くにする。健吒は鈴である。この印
を焰魔妃鐸印というが、焰魔妃と焰魔
后の同異については異説が多い。真言
は、

Mudrā of Yamī

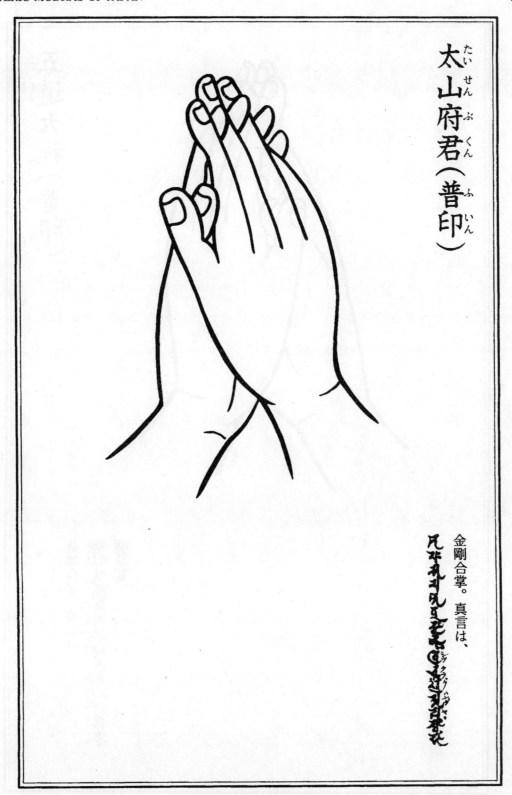

太山府君（普印）

金剛合掌。真言は、

Mudrā of Citragupta

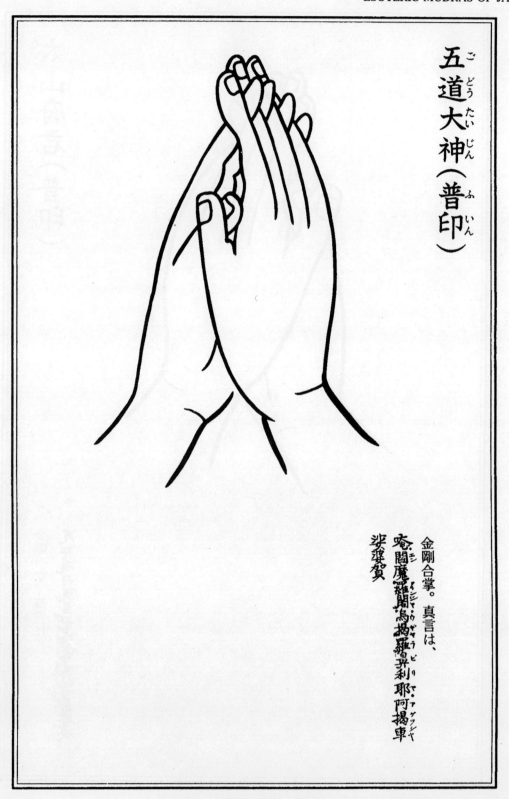

五道大神（普印）

金剛合掌。真言は、

唵・閻魔羅闍烏掲羅弁刹耶・阿掲車・娑婆賀

Mudrā of Pañcapatha Mahādeva

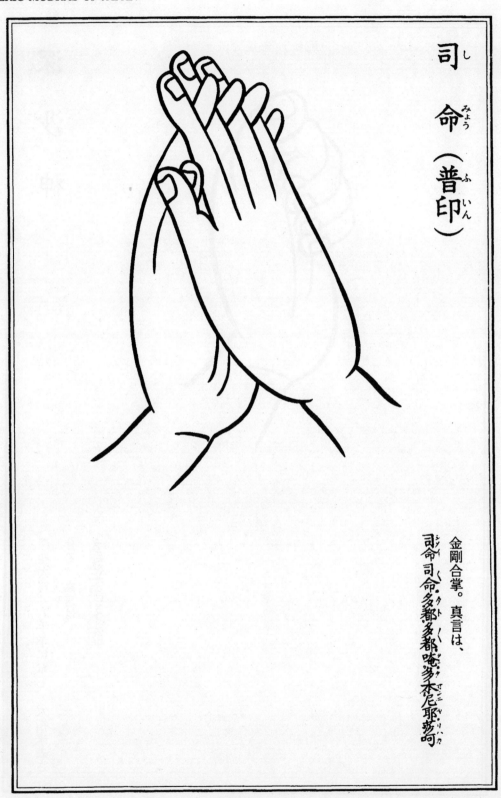

司 命（普印）
し みょう ふ いん

金剛合掌。真言は、
司命司命多都多都唵多本尼耶娑呬

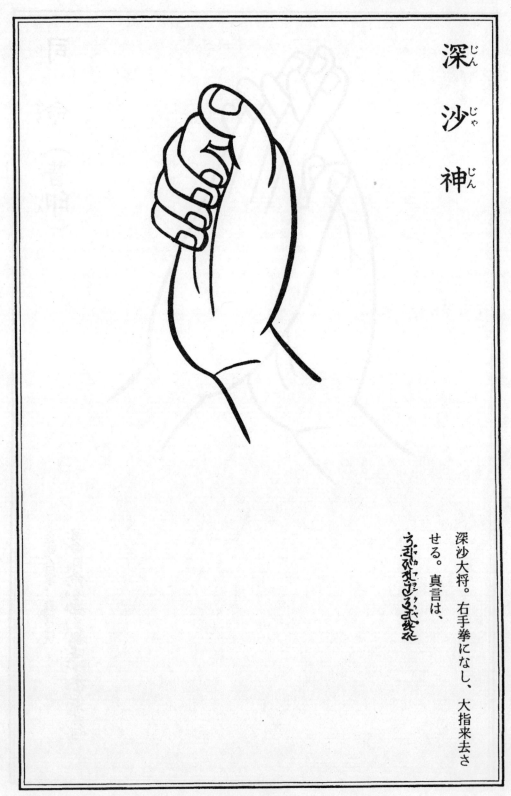

深沙神

深沙大将。右手拳になし、大指来去さ
せる。真言は、

Mudrā of Deep-sand Deity (Mahāraṇyaka?)

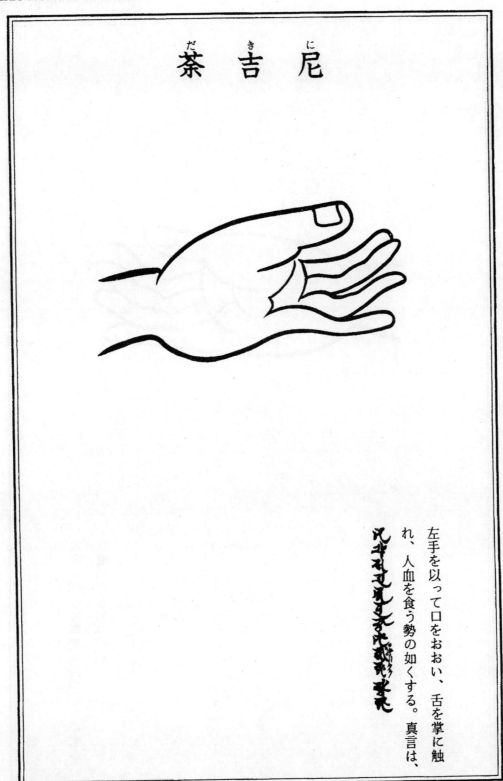

茶吉尼

左手を以って口をおおい、舌を掌に触れ、人血を食う勢の如くする。真言は、

Mudrā of ḍākinī

左手を仰げて髑髏を持つ如くにする。
伏魔印とも名づける。

Mudrā of Cāmuṇḍā

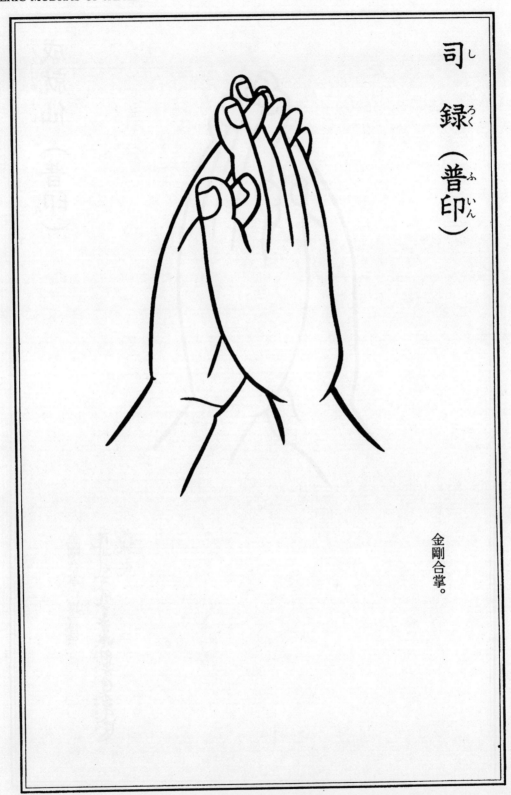

司録（普印）
し
ろく
ふ
いん

金剛合掌。

Mudrā of Citragupta

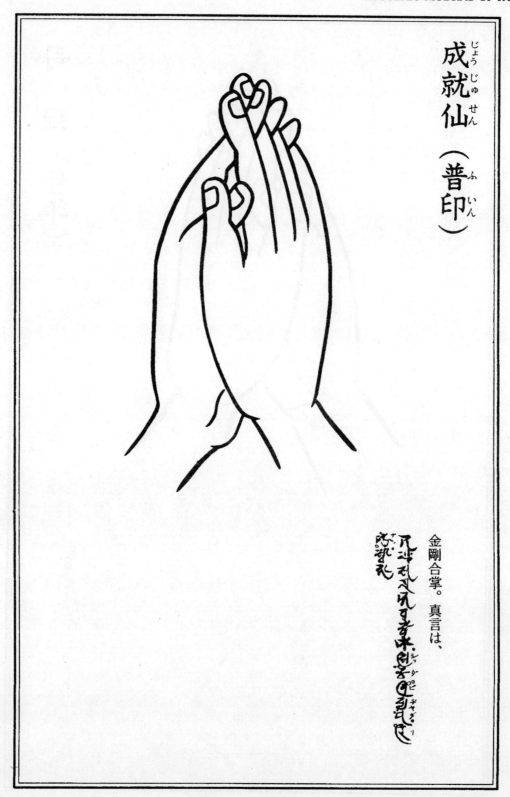

成就仙（普印）

金剛合掌。真言は、

Mudrā of siddha-ṛṣi

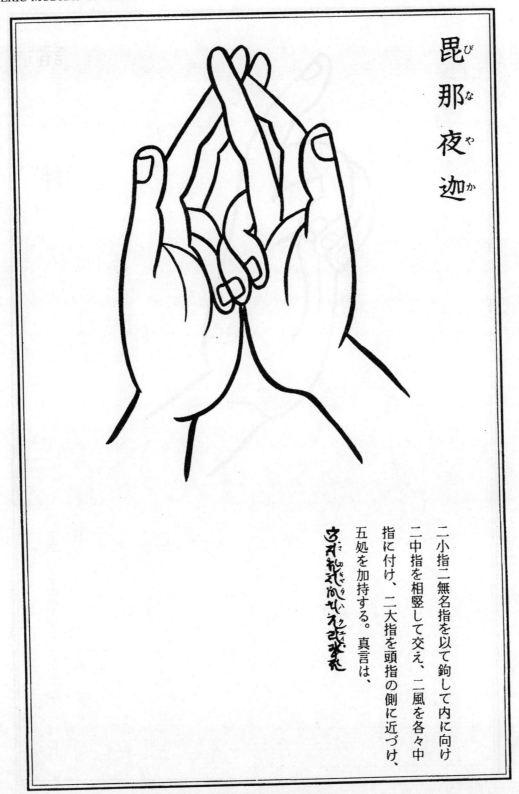

毘_び那_な夜_や迦_か

二小指二無名指を以て鉤して内に向け
二中指を相竪して交え、二風を各々中
指に付け、二大指を頭指の側に近づけ、
五処を加持する。真言は、

Mudrā of Vināyaka

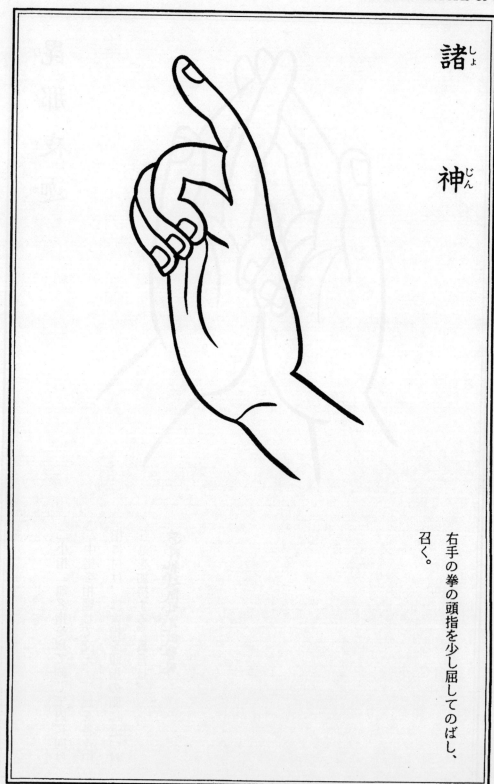

諸（しょ）　神（じん）

右手の拳の頭指を少し屈してのばし、召く。

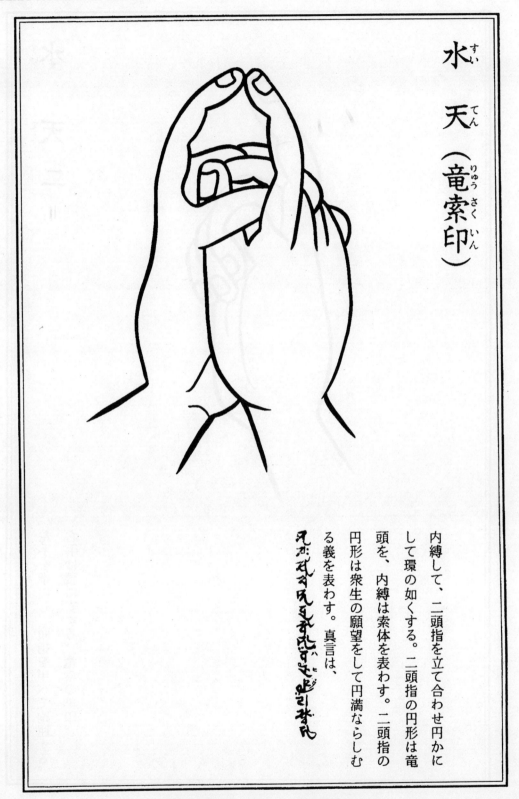

水天（竜索印）

内縛して、二頭指を立て合わせ円かにして環の如くする。二頭指の円形は竜頭を、内縛は索体を表わす。二頭指の円形は衆生の願望をして円満ならしむる義を表わす。真言は、

Pāśa-mudrā of Varuṇa (pāśa 'noose')

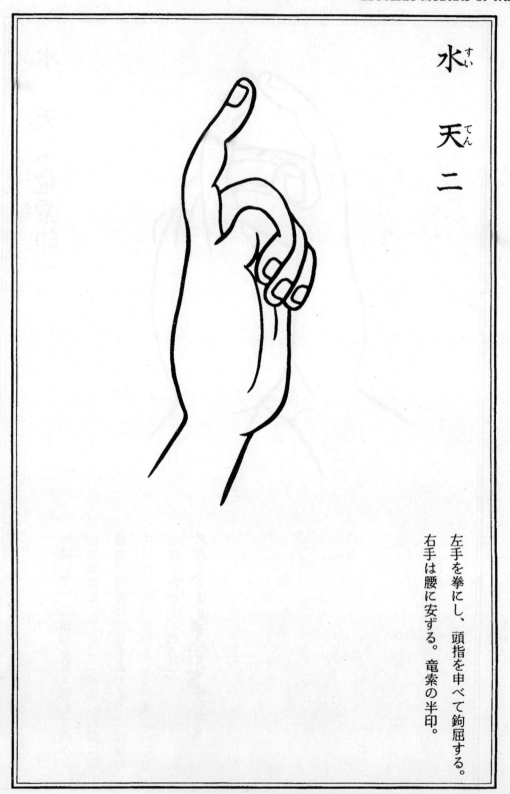

水
天
二

左手を拳にし、頭指を申べて鈎屈する。
右手は腰に安ずる。竜索の半印。

Mudrā of Varuṇa, no. 2

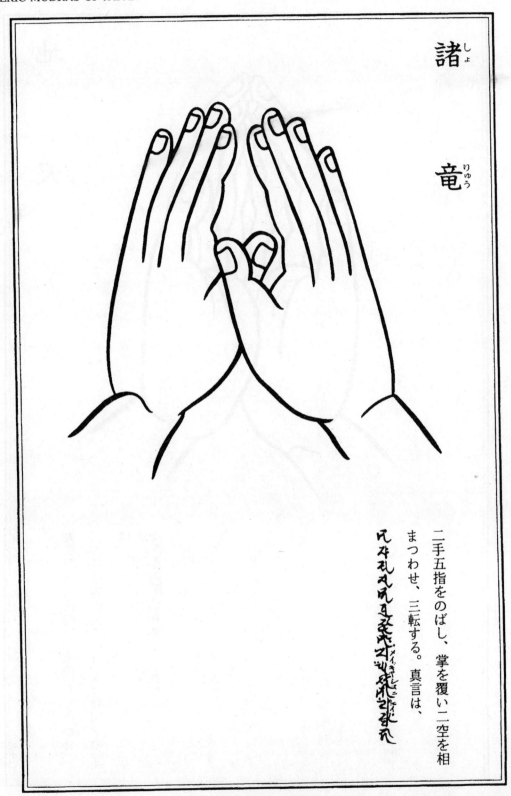

諸
<ruby>諸<rt>しょ</rt></ruby>

<ruby>竜<rt>りゅう</rt></ruby>

二手五指をのばし、掌を覆い二空を相
まつわせ、三転する。真言は、

Mudrā of nāgas

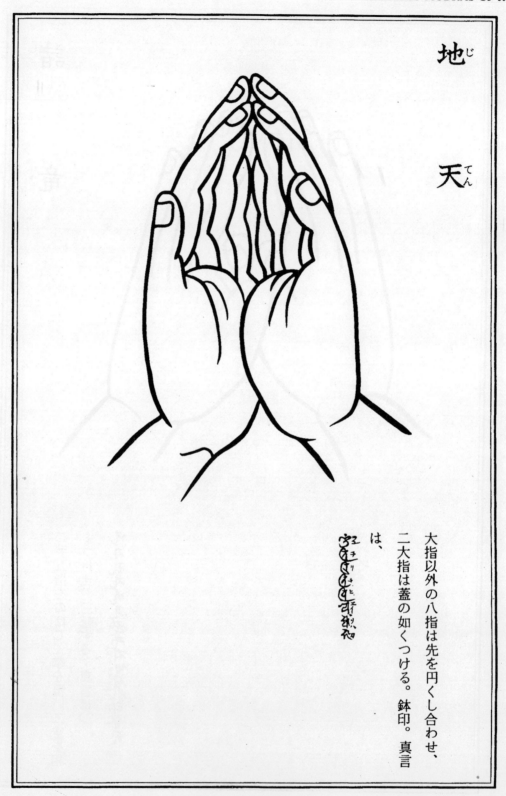

地じ

天てん

大指以外の八指は先を円くし合わせ、
二大指は蓋の如くつける。鉢印。真言
は、

Mudrā of Pṛthivī

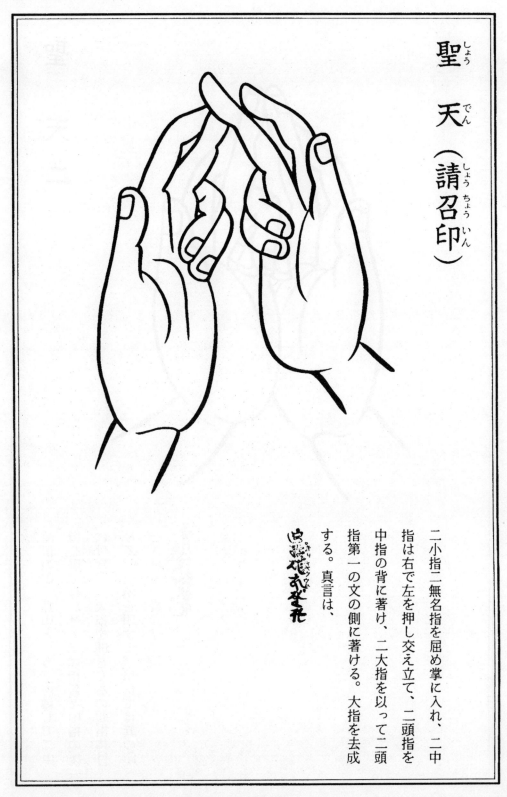

聖天（請召印）

二小指二無名指を屈め掌に入れ、二中
指は右で左を押し交え立て、二頭指を
中指の背に著け、二大指を以って二頭
指第一の文の側に著ける。　大指を去成
する。　真言は、

Mudrā of Gaṇapati, no. 1

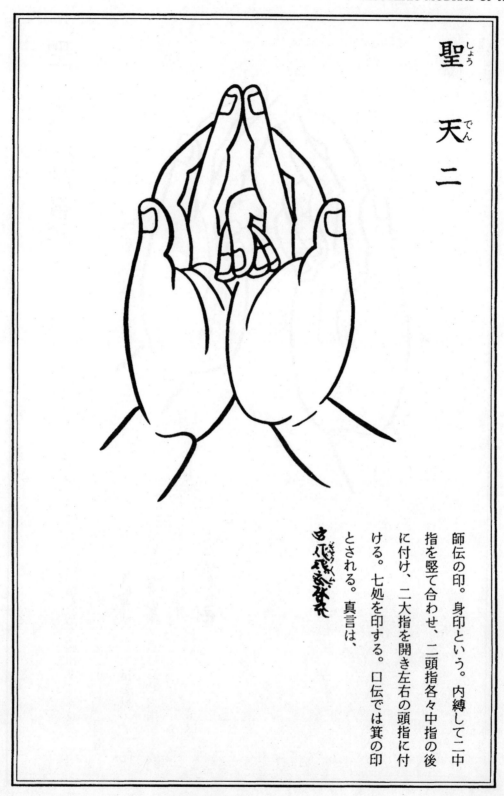

聖
天
二

師伝の印。身印という。内縛して二中
指を竪て合わせ、二頭指各々中指の後
に付け、二大指を開き左右の頭指に付
ける。七処を印する。口伝では箕の印
とされる。真言は、

Mudrā of Gaṇapati, no. 2

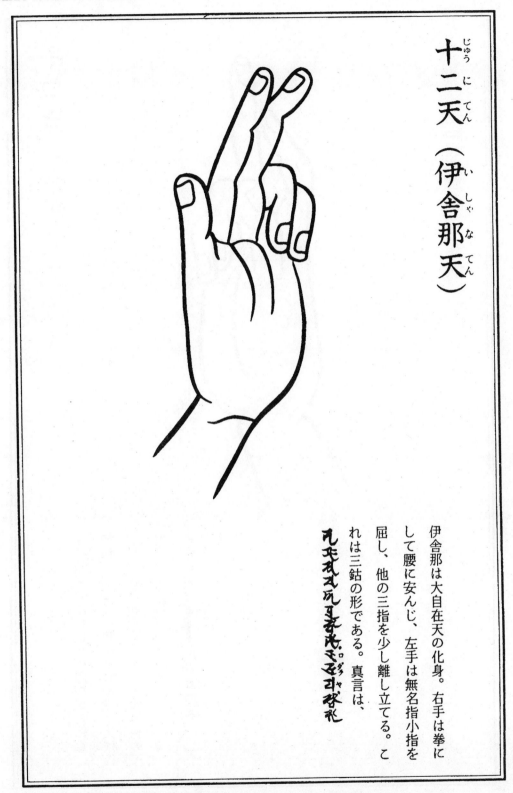

十二天（伊舎那天）

伊舎那は大自在天の化身。右手は拳にして腰に安んじ、左手は無名指小指を屈し、他の三指を少し離し立てる。これは三鈷の形である。真言は、

Mudrā of Īśāna, one of the Twelve Devas

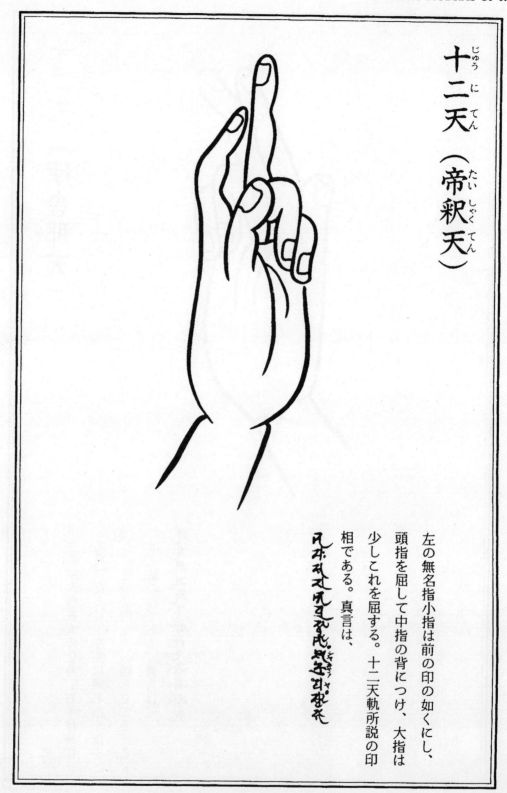

十二天（帝釈天）

左の無名指小指は前の印の如くにし、頭指を屈して中指の背につけ、大指は少しこれを屈する。十二天軌所説の印相である。真言は、

Mudrā of Indra, one of the Twelve Devas

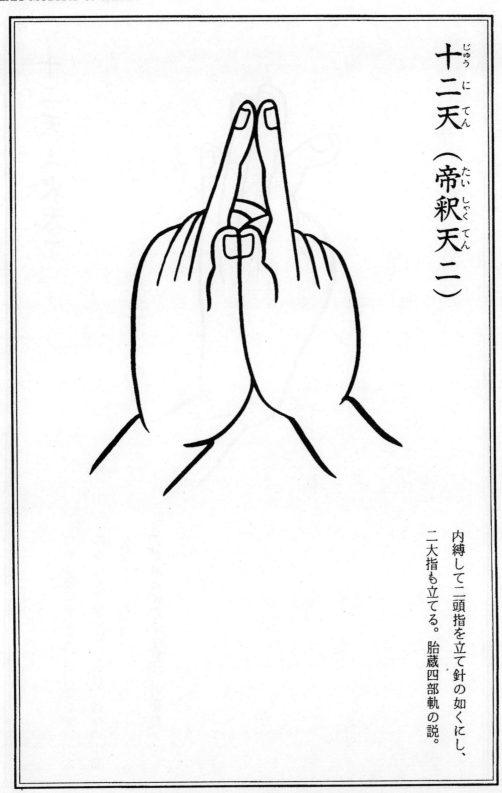

十二天（帝釈天二）

内縛して二頭指を立て針の如くにし、二大指も立てる。胎蔵四部軌の説。

Mudrā of Indra, one of the Twelve Devas

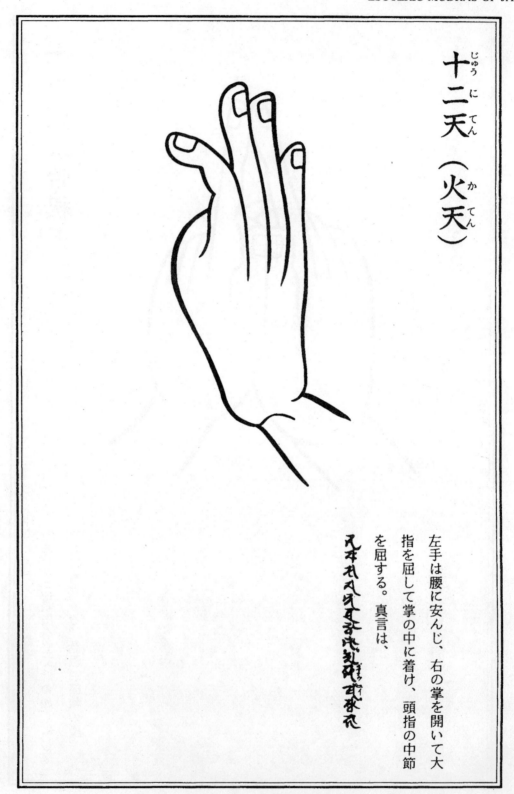

十二天（火天）

左手は腰に安んじ、右の掌を開いて大
指を屈して掌の中に着け、頭指の中節
を屈する。真言は、

Mudrā of Agni, one of the Twelve Devas

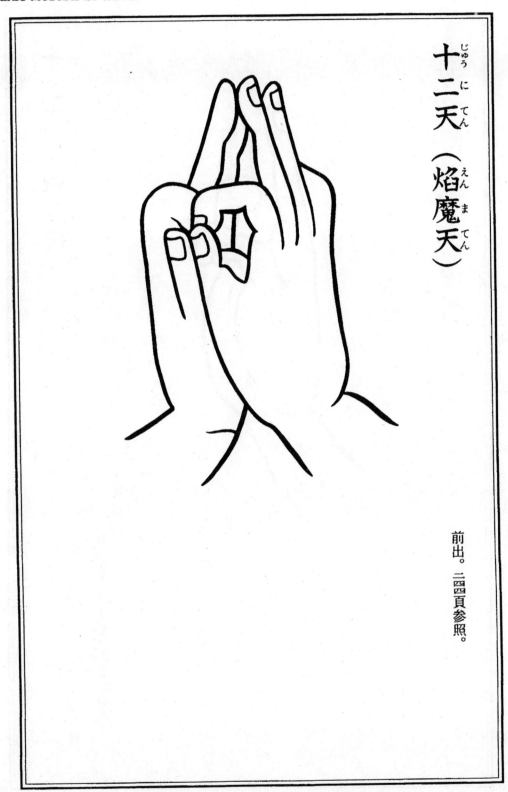

十二天（焰魔天）

前出。二四頁参照。

Mudrā of Yama, one of the Twelve Devas

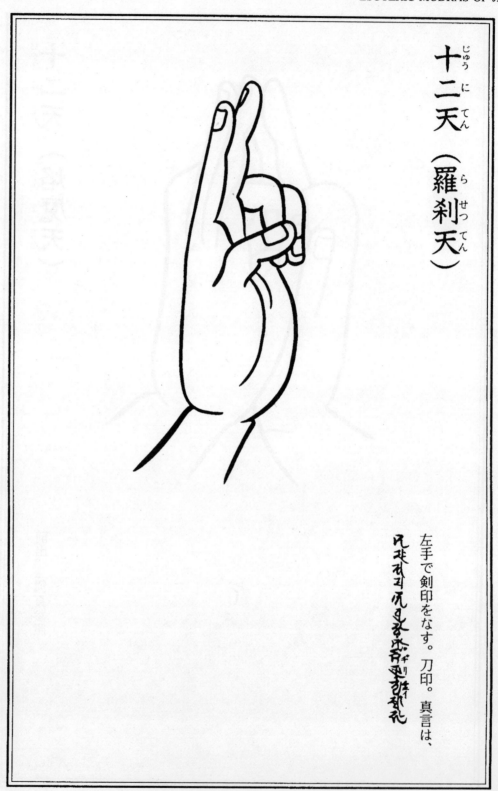

十二天（羅刹天）

左手で剣印をなす。刀印。真言は、

Mudrā of Rākṣasa, one of the Twelve Devas

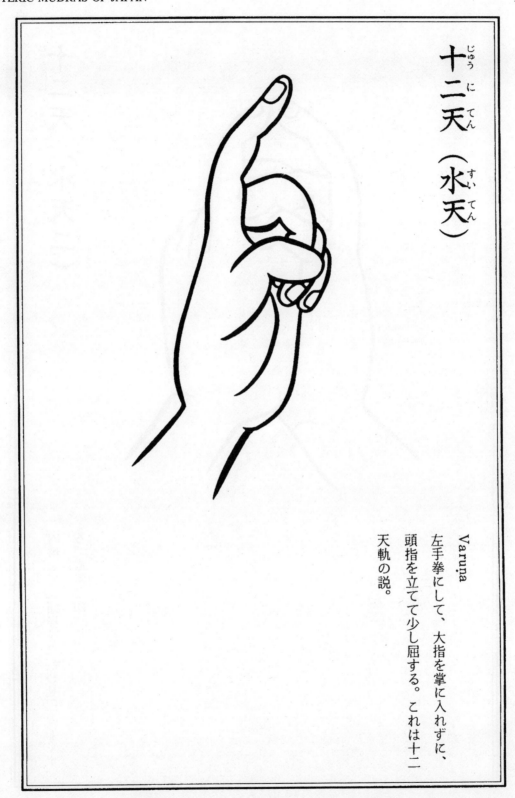

十二天 (水天)

Varuṇa
左手拳にして、大指を掌に入れずに、頭指を立てて少し屈する。これは十二天軌の説。

Mudrā of Varuṇa, one of the Twelve Devas

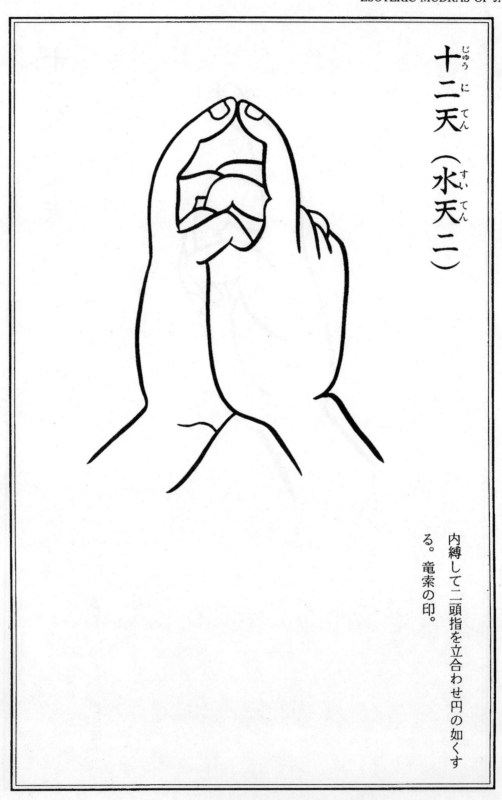

十二天（水天二）

内縛して二頭指を立合わせ円の如くす
る。竜索の印。

Mudrā of Varuṇa, one of the Twelve Devas

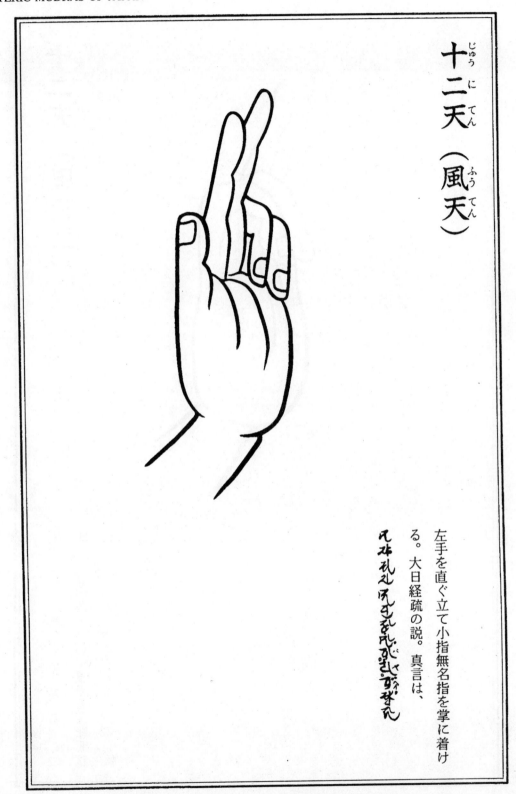

十二天（風天）

左手を直ぐ立て小指無名指を掌に着け
る。大日経疏の説。真言は、

Mudrā of Vāyu, one of the Twelve Devas

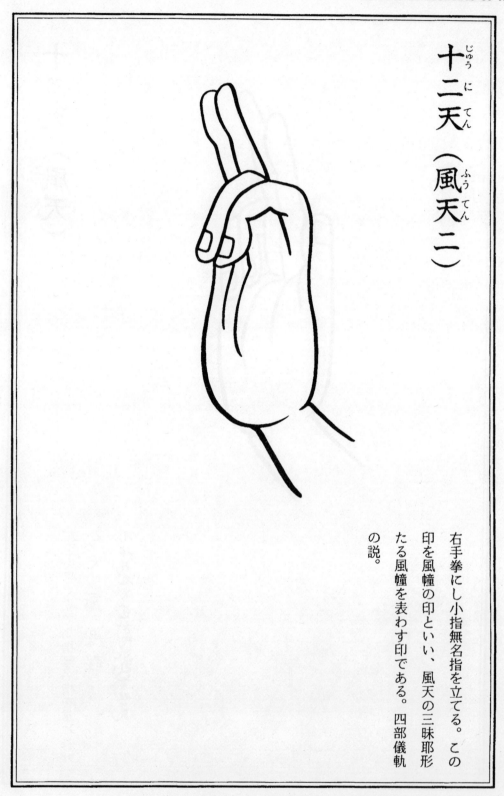

十二天（風天二）

右手拳にし小指無名指を立てる。この印を風幢の印といい、風天の三昧耶形たる風幢を表わす印である。四部儀軌の説。

Mudrā of Vāyu, one of the Twelve Devas

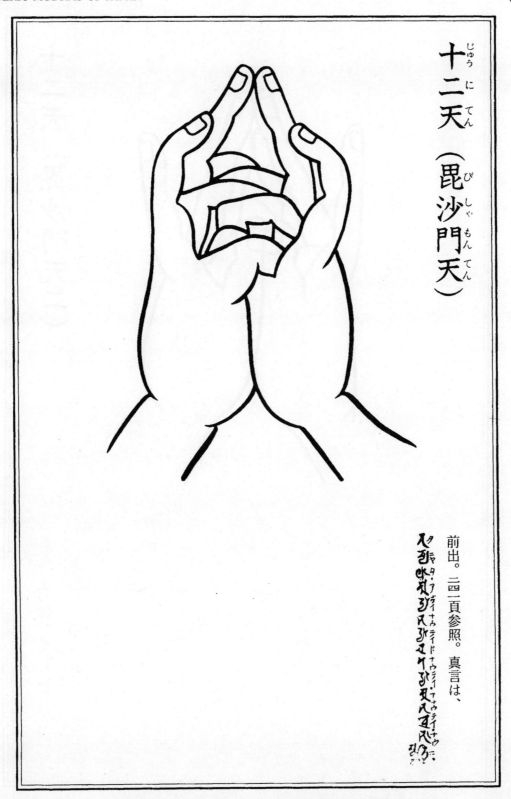

十二天（毘沙門天）

前出。二四二頁参照。真言は、

Mudrā of Vaiśravaṇa, one of the Twelve Devas

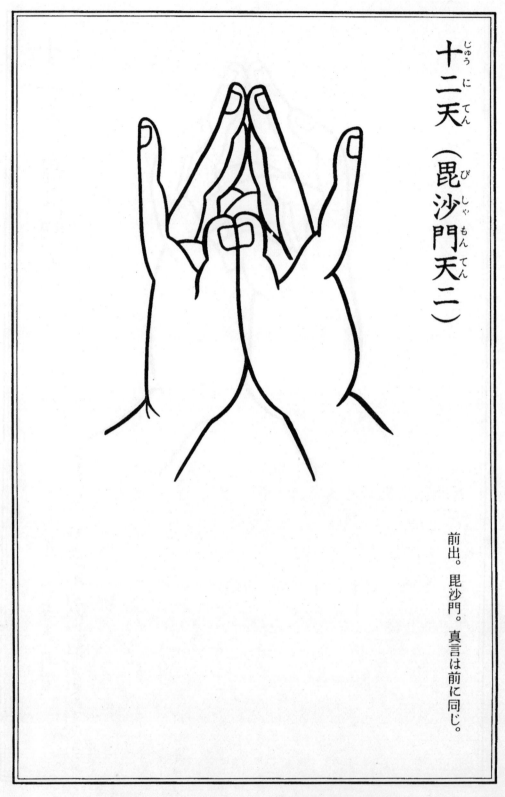

十二天（毘沙門天二）

前出。毘沙門。真言は前に同じ。

Mudrā of Vaiśravaṇa, one of the Twelve Devas

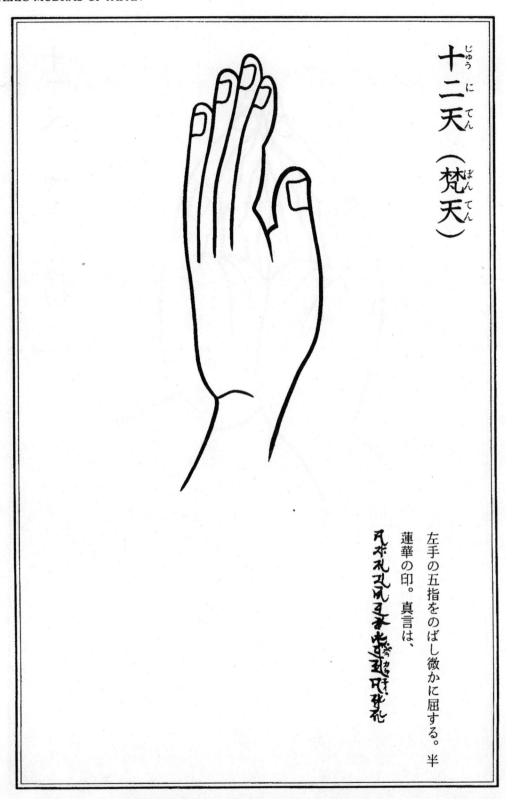

十二天（梵天）

左手の五指をのばし微かに屈する。半
蓮華の印。真言は、

Mudrā of Brahmā, one of the Twelve Devas

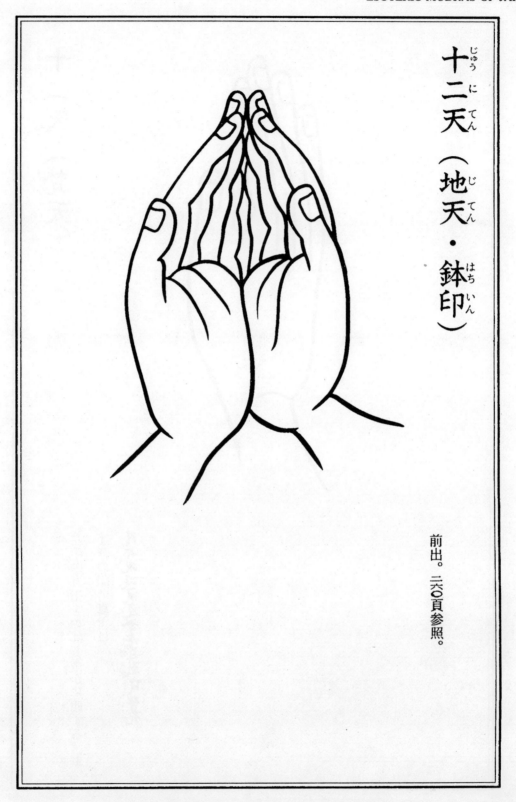

十二天（地天・鉢印）

前出。二六〇頁参照。

Pātra-mudrā of Pṛthivī, one of the Twelve Devas

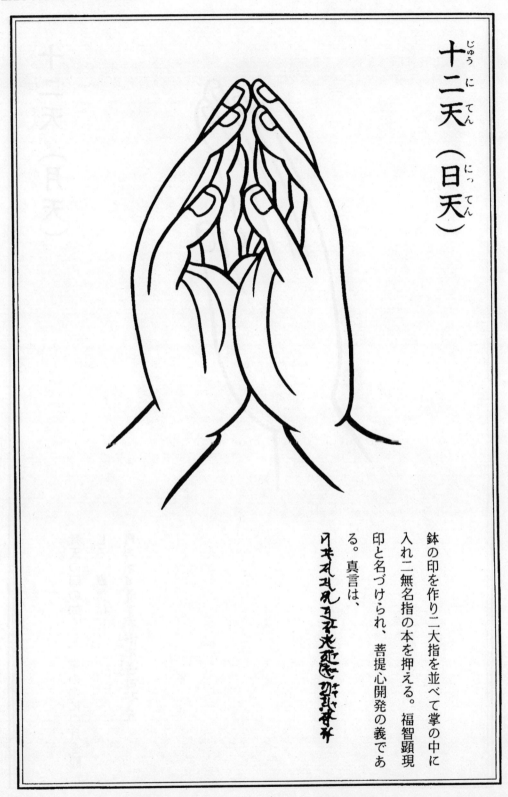

十二天 (日天)

鉢の印を作り二大指を並べて掌の中に入れ二無名指の本を押える。福智顕現印と名づけられ、菩提心開発の義である。真言は、

Mudrā of Sūrya, one of the Twelve Devas

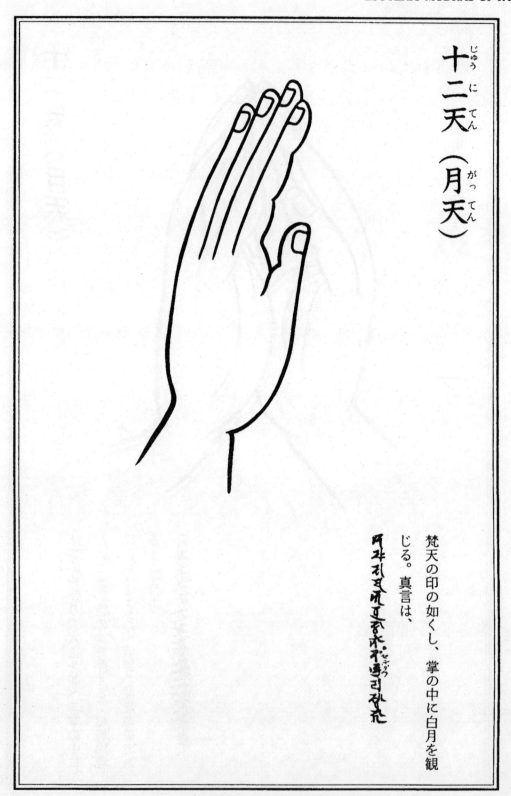

梵天の印の如くし、掌の中に白月を観じる。真言は、

十二天（月天）
じゅう に てん がっ てん

Mudrā of Candra, one of the Twelve Devas

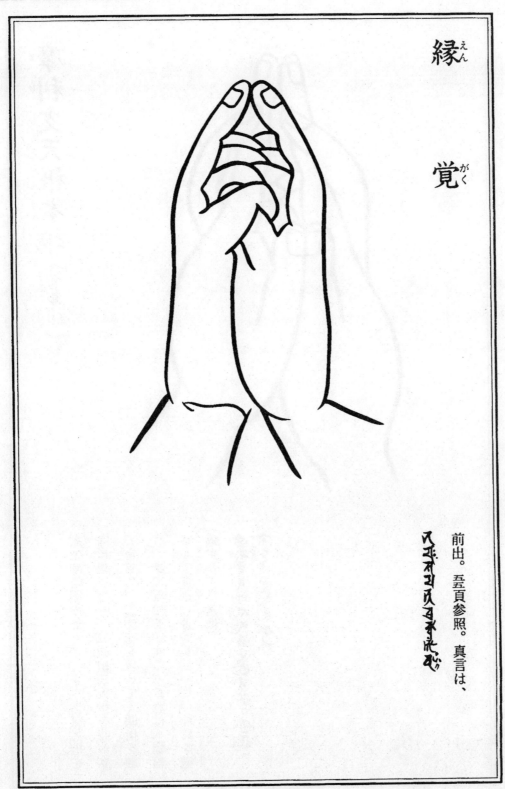

縁（えん）

覚（がく）

前出。吾頁参照。真言は、

Mudrā of Engaku

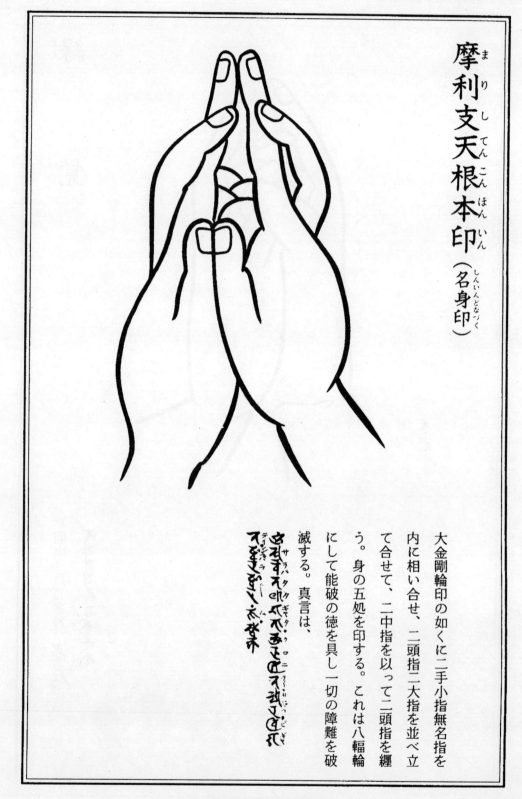

摩利支天根本印（名身印）

大金剛輪印の如くに二手小指無名指を
内に相い合せ、二頭指二大指を並べ立
て合せて、二中指を以って二頭指を纏
う。身の五処を印する。これは八輻輪
にして能破の徳を具し一切の障難を破
滅する。真言は、

サラバタタギャタク・ロニ・テシャ
マリシエイソワカ・・・・・

Mūla-mudrā of Mārīci

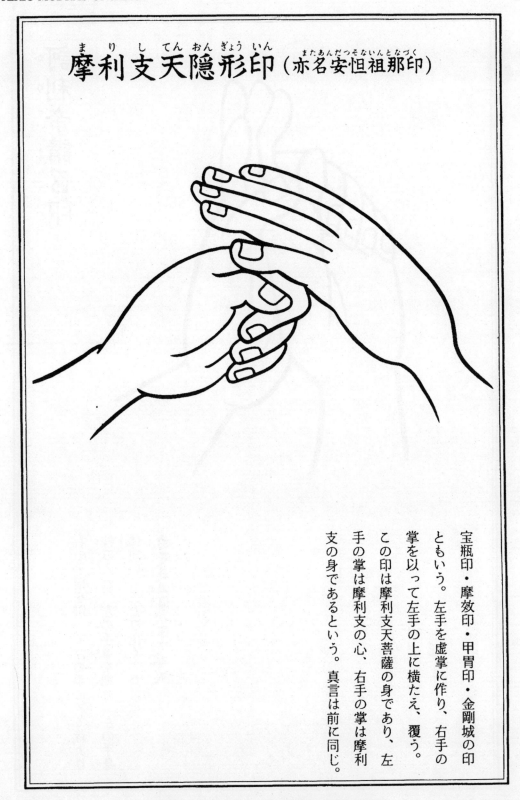

摩利支天隠形印（亦名安怛祖那印）

宝瓶印・摩敔印・甲冑印・金剛城の印ともいう。左手を虚掌に作り、右手の掌を以って左手の上に横たえ、覆う。この印は摩利支天菩薩の身であり、左手の掌は摩利支の心、右手の掌は摩利支の身であるという。真言は前に同じ。

Hiding mudrā (on gyō-in) of Mārīci

訶利帝請召印

右の手指を以って左の手に於て背より
挟み入れ、左の手掌を把り、左の手身
に向いて三たび招く。真言は、

Āhvāna-mudrā (of invoking) Hārīti

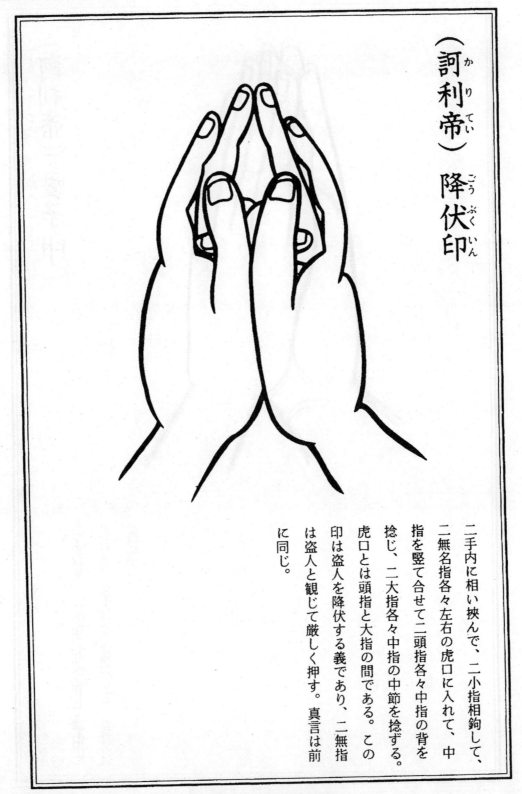

（訶利帝）降伏印

二手内に相い挾んで、二小指相鉤して、二無名指各々左右の虎口に入れて、中指を竪て合せて二頭指各々中指の背を捻じ、二大指各々中指の中節を捻ずる。虎口とは頭指と大指の間である。この印は盗人を降伏する義であり、二無指は盗人と観じて厳しく押す。真言は前に同じ。

Gōbuku-mudrā of Hārīti

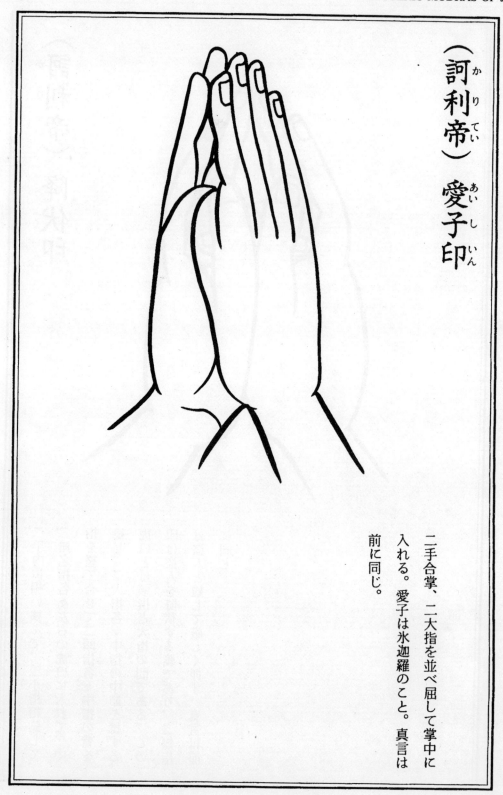

（訶利帝）愛子印

二手合掌、二大指を並べ屈して掌中に入れる。愛子は氷迦羅のこと。真言は前に同じ。

Piṅgala-mudrā of Hārīti

咒賊経降伏印

二手内縛して、二中指を立て合わせ、
二頭指を屈して二中指の上の節につけ、
二大指を並べ立て二中指の中節の文を
押す。二無名指、二頭二大指の跨より
指し出して、二小指相かけて鉤結する。
この印は三鈷の形を表わし、二無名指
は盗人、三鈷を以って盗人を責める形
の故に二大指を以って堅く押す。降伏
印。真言は、

Gōbuku mudrā of ... sūtra

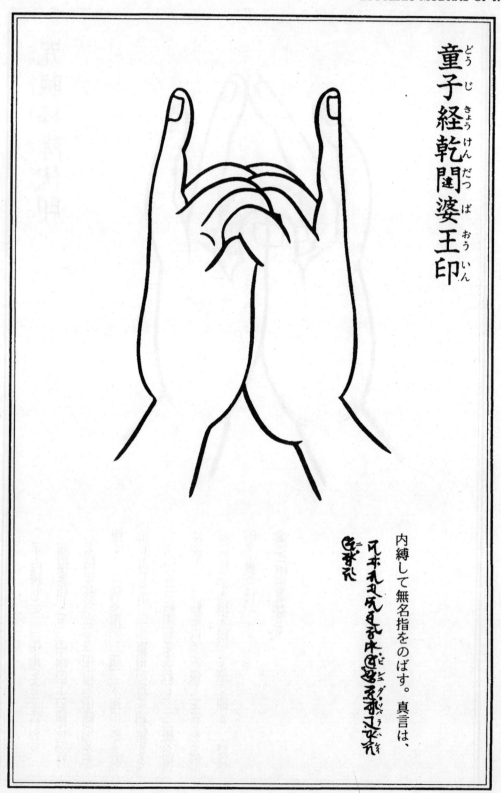

童子経乾闥婆王印

内縛して無名指をのばす。真言は、

Gandharva-rāja-mudrā of Kumāra-sūtra

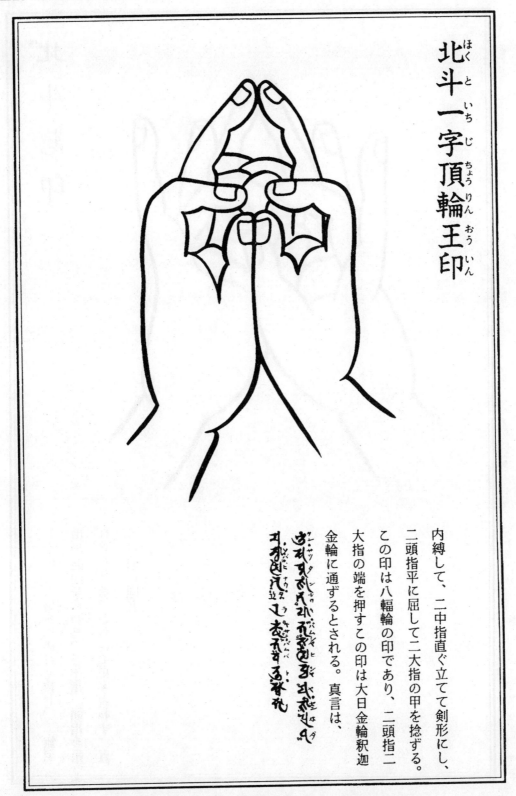

北斗一字頂輪王印

内縛して、二中指直ぐ立てて剣形にし、二頭指平に屈して二大指の甲を捻ずる。この印は八輻輪の印であり、二頭指二大指の端を押すこの印は大日金輪釈迦金輪に通ずるとされる。真言は、

Ekākṣara-cakravarti-mudrā of the North Polar Star

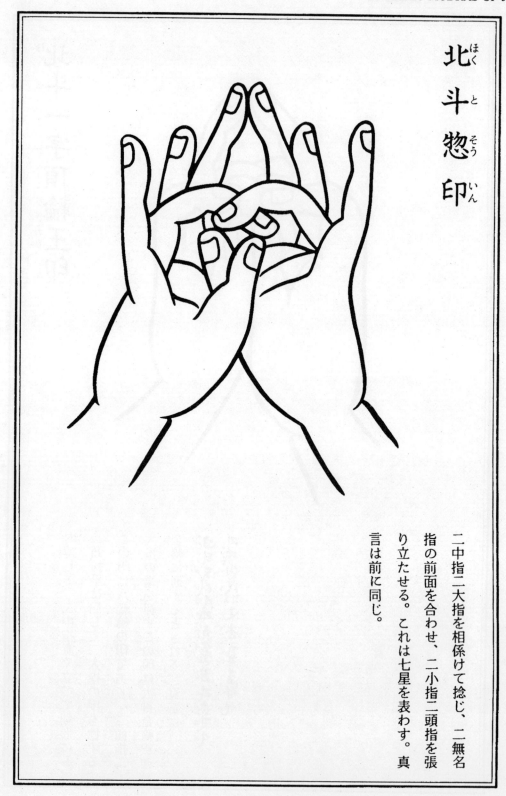

北斗惣印

二中指二大指を相係けて捻じ、二無名指の前面を合わせ、二小指二頭指を張り立たせる。これは七星を表わす。真言は前に同じ。

Distinguishing mudrā (sō-in) of the North Polar Star

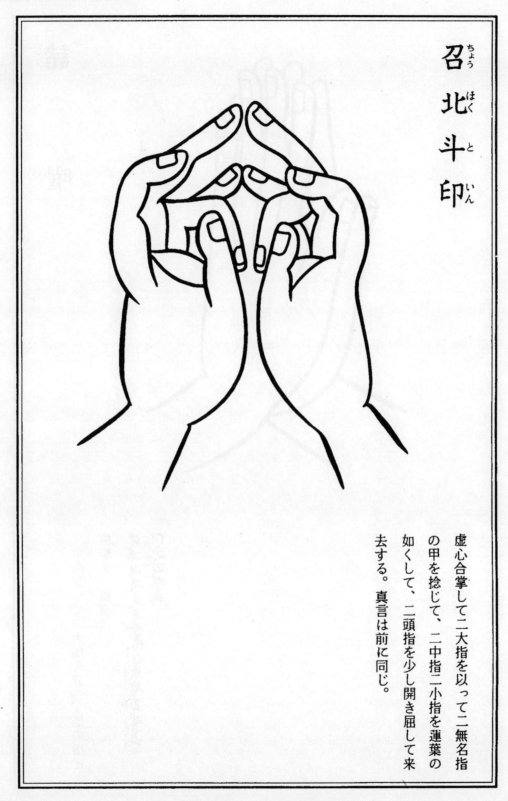

召北斗印

虚心合掌して二大指を以って二無名指
の甲を捻じて、二中指二小指を蓮葉の
如くして、二頭指を少し開き屈して来
去する。真言は前に同じ。

to mudrā of the North Polar Star

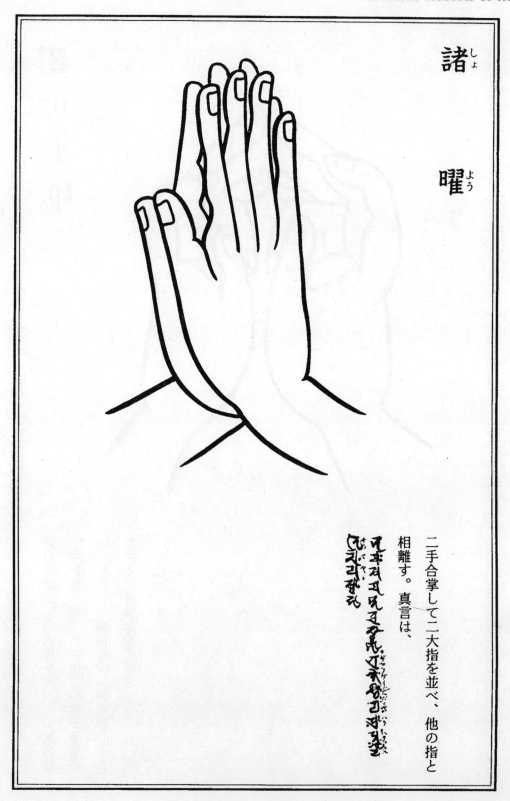

諸
曜

二手合掌して二大指を並べ、他の指と
相離す。真言は、

Mudrā of the week days (vāra)

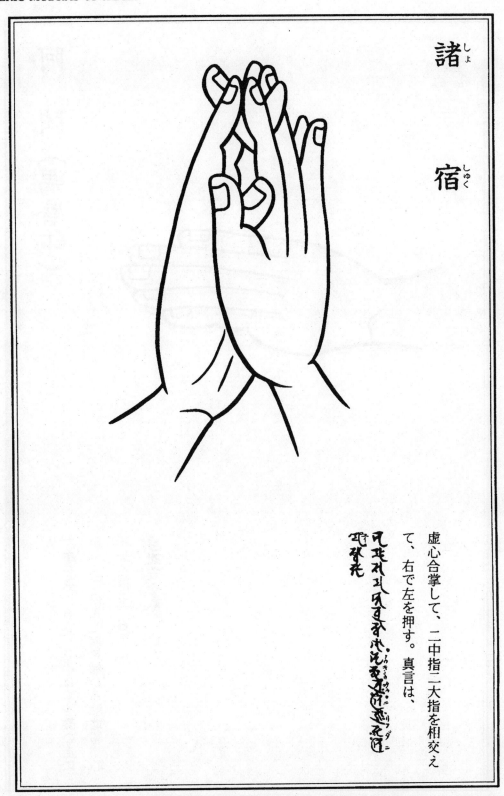

諸
宿

虚心合掌して、二中指二大指を相交え
て、右で左を押す。真言は、

Mudrā of nakṣatras (constellations)

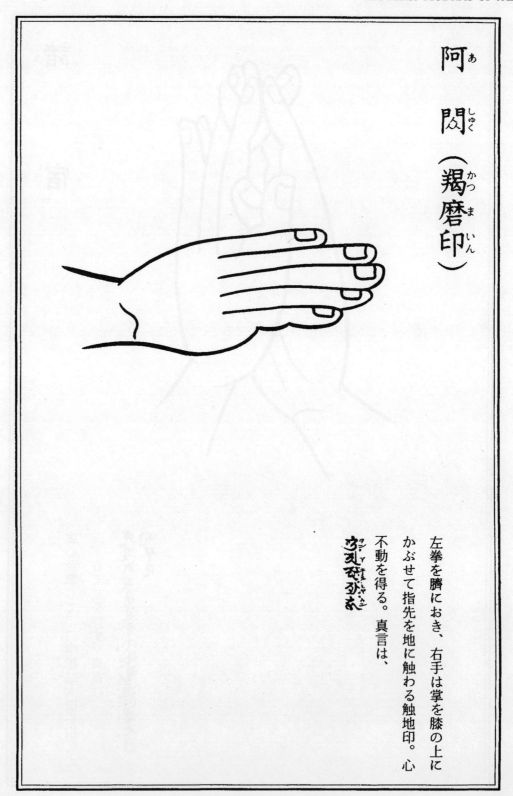

阿閦（羯磨印）

不動を得る。真言は、
かぶせて指先を地に触わる触地印。心
左拳を臍におき、右手は掌を膝の上に

Karma-mudrā of Akṣobhya

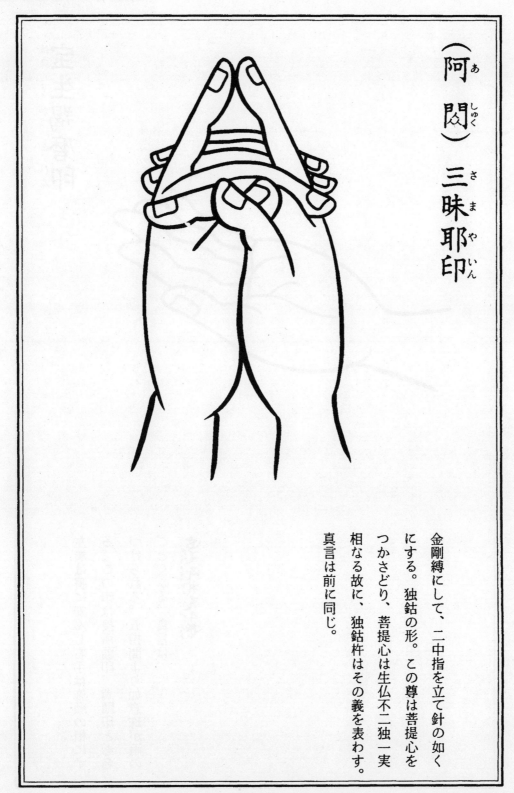

（阿閦あしゅく）三昧耶印さまやいん

金剛縛にして、二中指を立て針の如く
にする。独鈷の形。この尊は菩提心を
つかさどり、菩提心は生仏不二独一実
相なる故に、独鈷杵はその義を表わす。
真言は前に同じ。

Samaya-mudrā of Akṣobhya

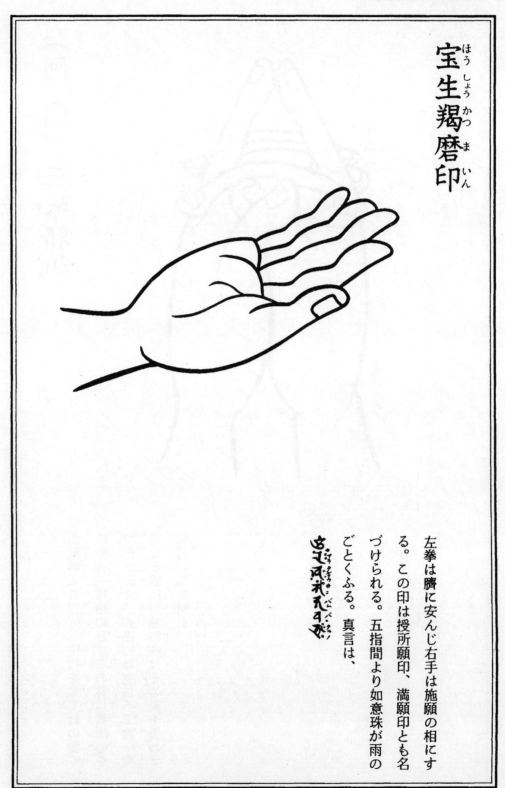

宝
生
羯
磨
印

左拳は臍に安んじ右手は施願の相にす
る。この印は授所願印、満願印とも名
づけられる。　五指間より如意珠が雨の
ごとくふる。　真言は、

Karma-mudrā of Ratnasambhava

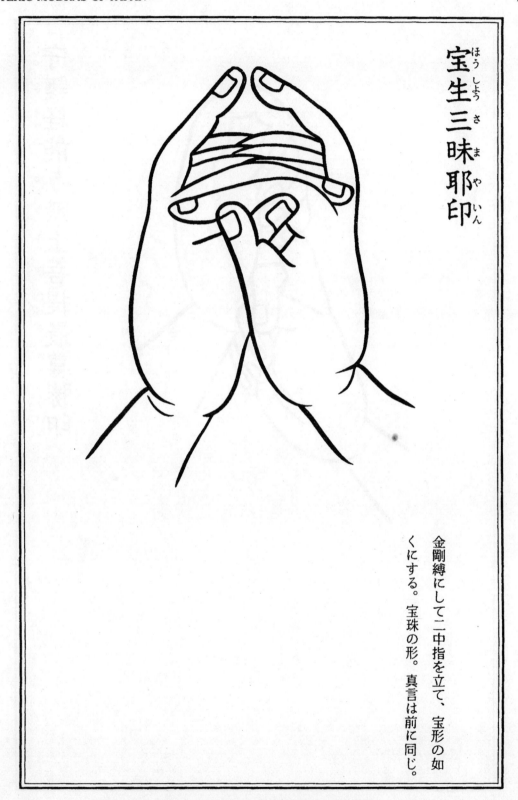

宝生三昧耶印

金剛縛にして二中指を立て、宝形の如くにする。宝珠の形。真言は前に同じ。

Samaya-mudrā of Ratnasambhava

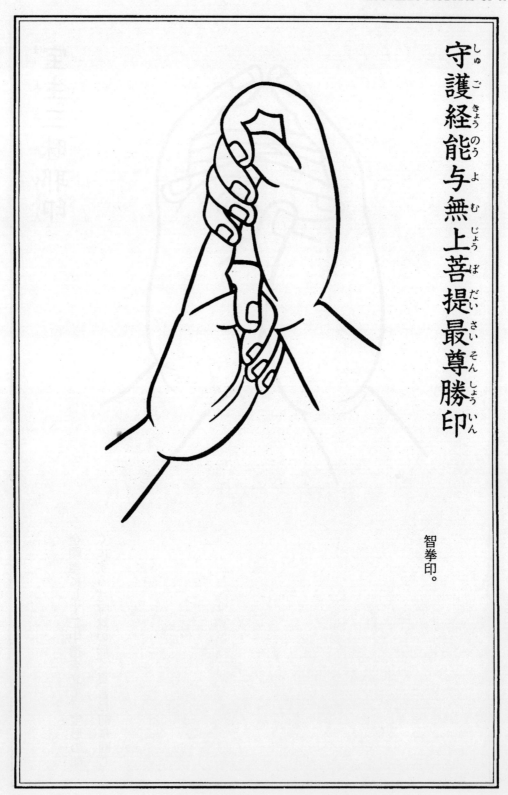

守護経能与無上菩提最尊勝印

智拳印。

Vijaya-mudrā of the Rakṣā-sūtra

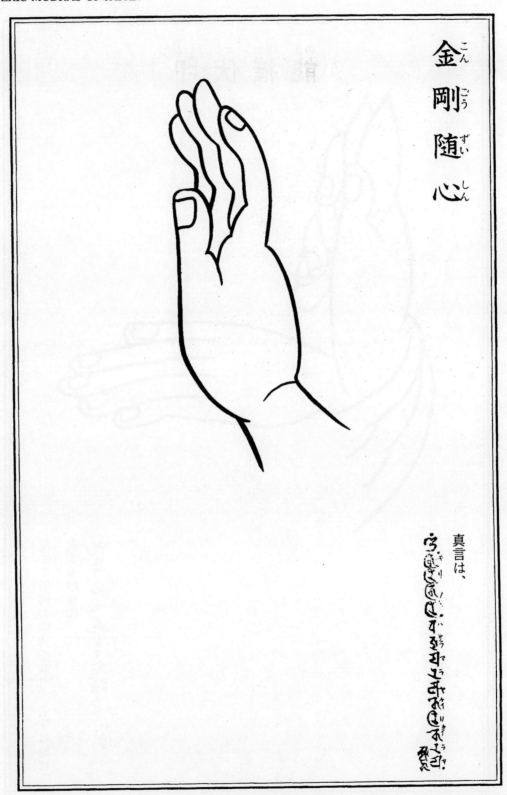

金剛随心

真言は、

Mudrā of Kongōzui

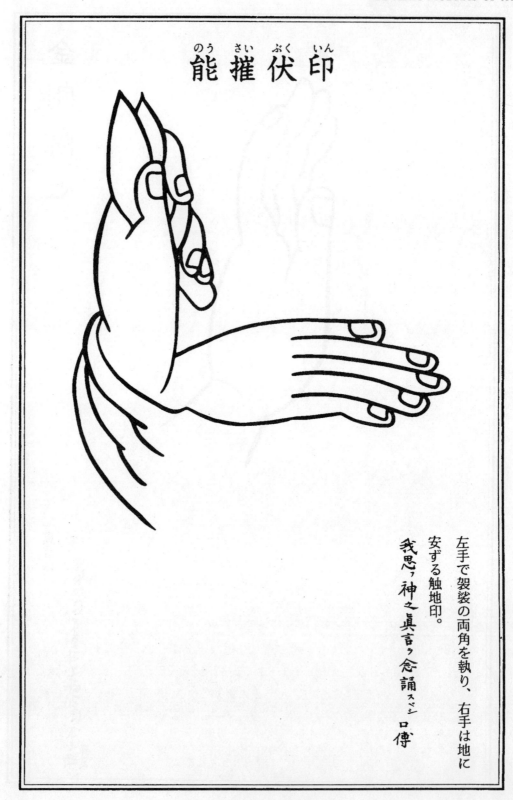

能摧伏印

左手で袈裟の両角を執り、右手は地に安ずる触地印。

我思ノ神之眞言ノ念誦スベシ 口傳

Mudrā (bukuin) of Nōsai

満_{まん}願_{がん}印_{いん}

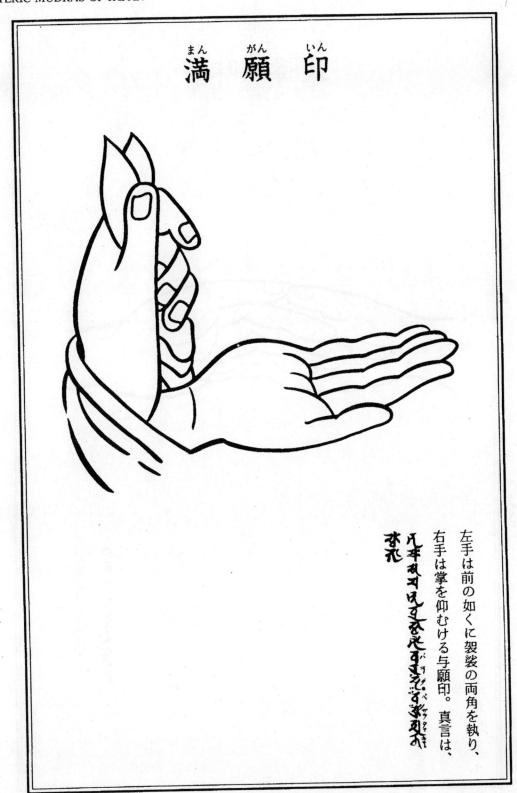

左手は前の如くに袈裟の両角を執り、右手は掌を仰むける与願印。真言は、

Mudrā of Mangan

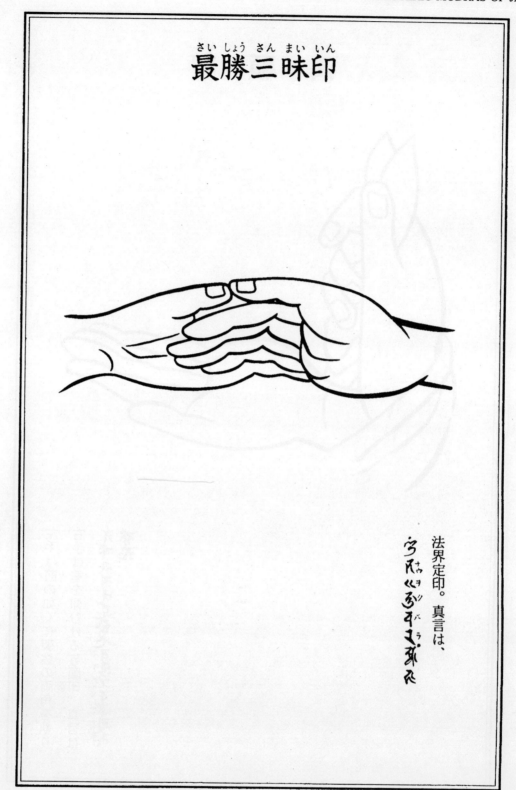

さい しょう さん まい いん
最勝三昧印

法界定印。真言は、

Samaya-mudrā of Vijaya

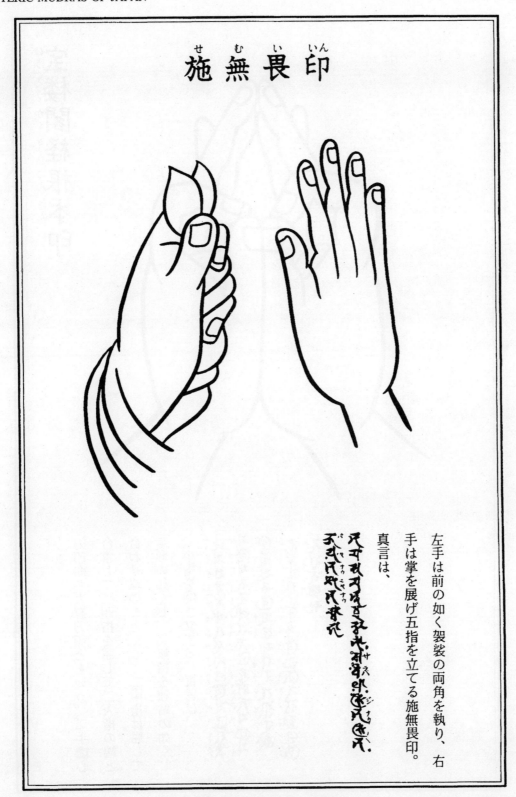

施無畏印

左手は前の如く袈裟の両角を執り、右手は掌を展げ五指を立てる施無畏印。

真言は、

Mudrā of Abhayaṁdada

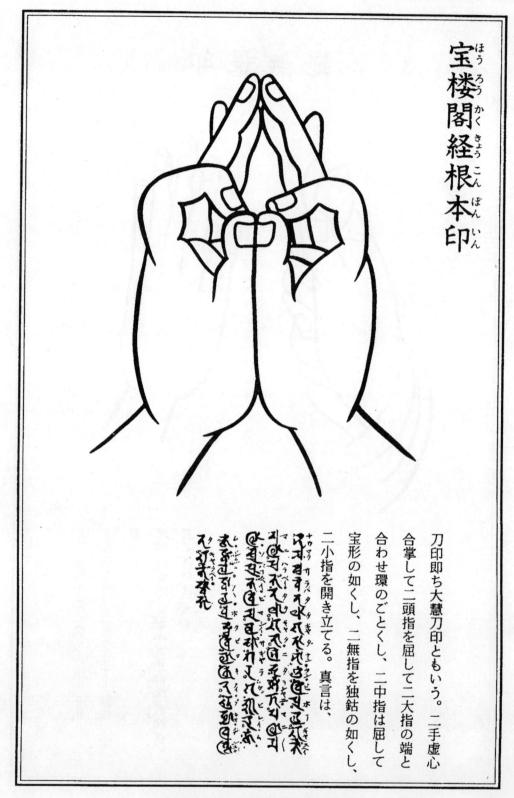

宝楼閣経根本印

刀印即ち大慧刀印ともいう。二手虚心
合掌して二頭指を屈して二大指の端と
合わせ環のごとくし、二中指は屈して
宝形の如くし、二無指を独鈷の如くし、
二小指を開き立てる。真言は、

Mūla-mudrā of Ratnakūṭa-sūtra

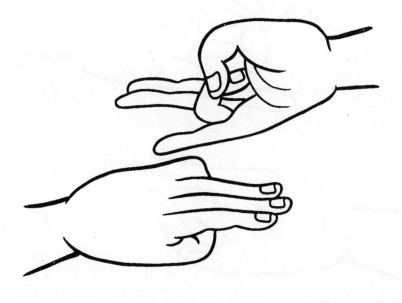

宝楼閣経心印（亦名安慰印）

右手掌を仰け、心に安んじ、大指と無
名指を相捻じ、他の三指を申べて心を
掩い、左は前の如く左の膝の上を覆う。
安慰の印とも名づける。真言は、

Citta-mudrā of Ratnakūṭa-sūtra

ほう ろう かく きょう ずい しん いん
宝楼閣経随心印

右手は心印の如くし、左手は大指と頭
指を相捻じて環の如くにして、他の三
指は展べて左の膝の上に置く。この印
はよく一切の事業を成弁して一切の罪
を滅して一切の煩悩を除き、仏菩提を
得るとされる。真言は、

Anucitta-mudrā of Ratnakūṭa-sūtra

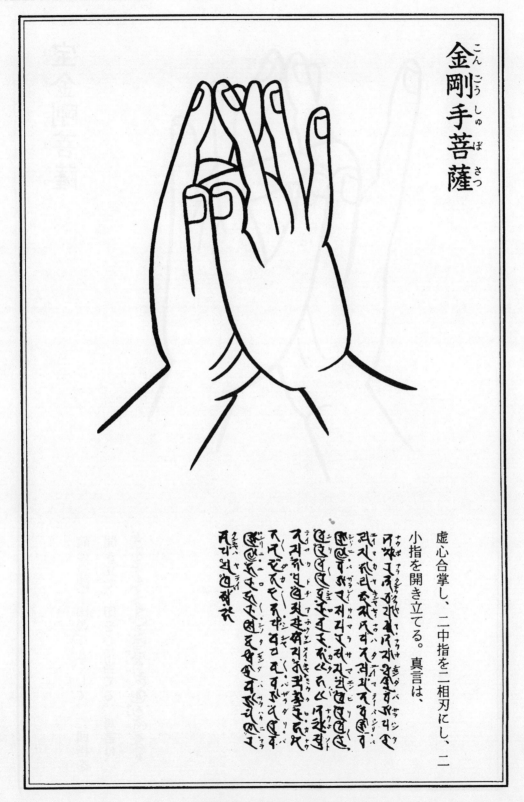

金剛手菩薩

虚心合掌し、二中指を二相刃にし、二
小指を開き立てる。真言は、

Mudrā of Vajrapāṇi

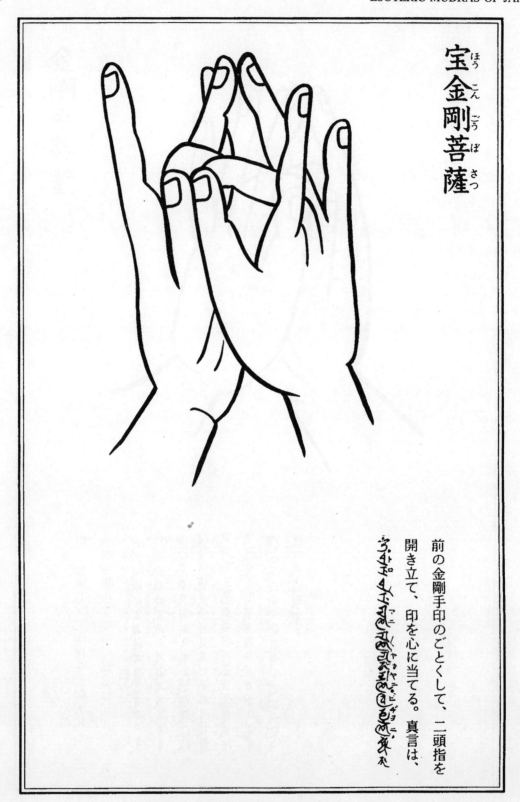

宝金剛菩薩

前の金剛手印のごとくして、二頭指を
開き立て、印を心に当てる。真言は、

Mudrā of Ratnavajra

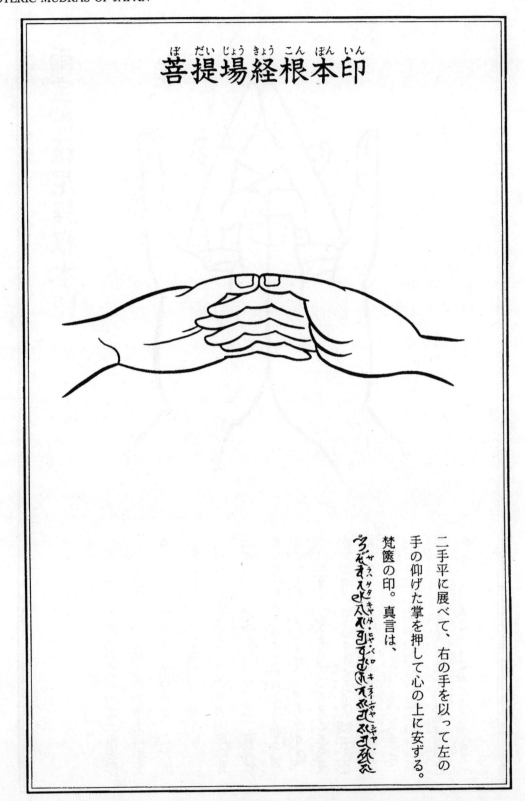

菩提場経根本印

二手平に展べて、右の手を以って左の
手の仰げた掌を押して心の上に安ずる。
梵篋の印。真言は、

Mūla-mudrā of Bodhi-maṇḍa-sūtra

雨宝陀羅尼経根本印

二手を屈して無名指を以って大指を押し、大指を以って無名指の甲上両手を押える。二中指を立て合わせ、二大指をならび立てて二無名指の背を押し、二小指を深く交えて二中指の中節の背に着け、二頭指を直ぐ立てる。真言は、

Mūla-mudrā of Ratna-varṣā-dhāraṇī

無垢浄光陀羅尼 八葉印

前出。二頁参照。真言は、

Aṣṭa-dala-mudrā of Vimala-prabha-dhāraṇī

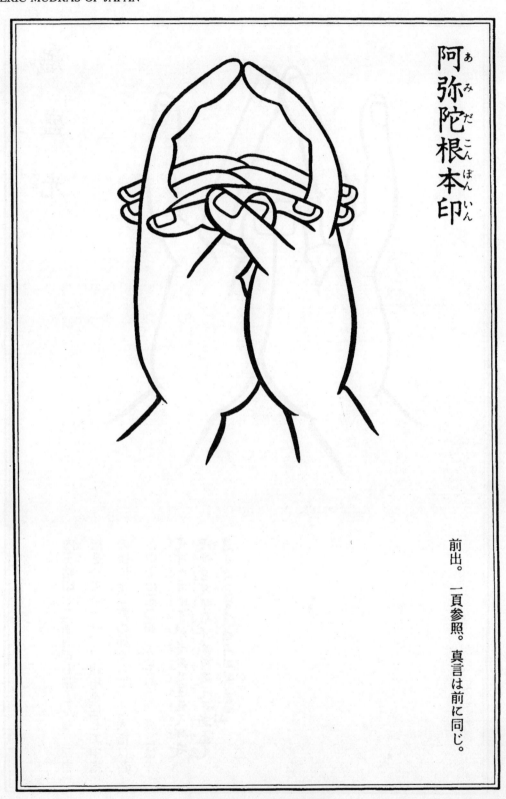

阿弥陀根本印

前出。一頁参照。真言は前に同じ。

Mūla-mudrā of Amitābha

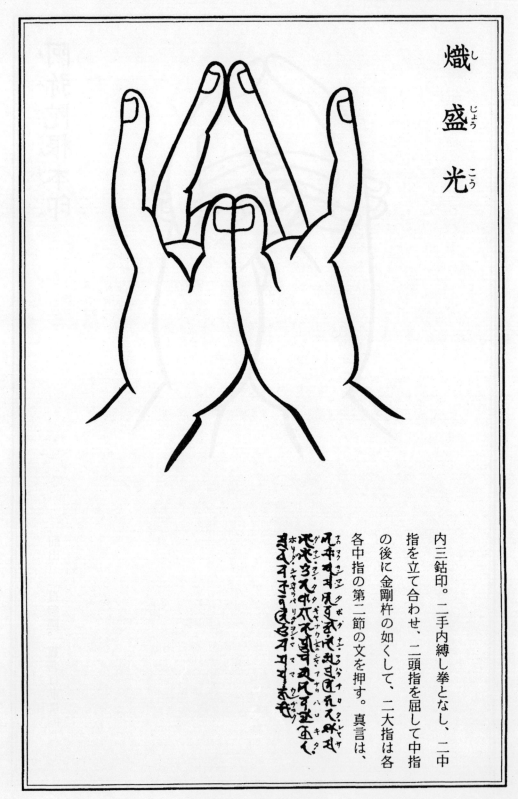

熾
盛
光

^し
^{じょう}
^{こう}

内三鈷印。二手内縛し拳となし、二中指を立て合わせ、二頭指を屈して中指の後に金剛杵の如くして、二大指は各各中指の第二節の文を押す。真言は、

Mudrā of Tejaprabha

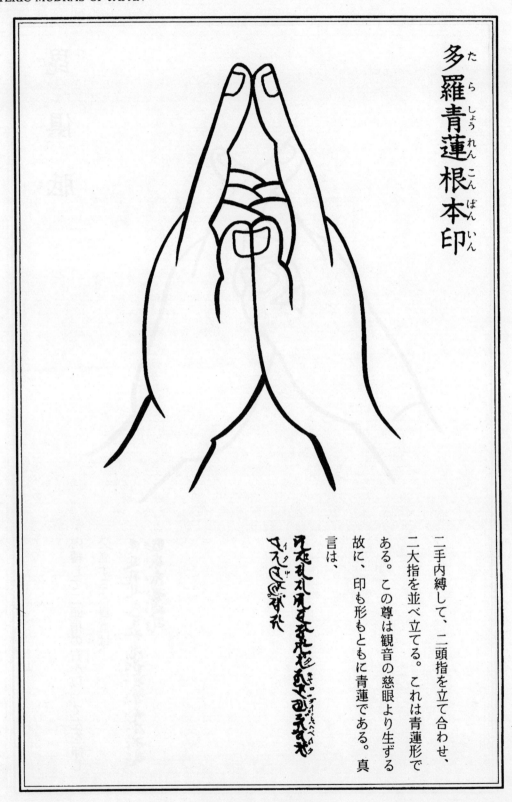

多
羅
青
蓮
根
本
印

二手内縛して、二頭指を立て合わせ、二大指を並べ立てる。これは青蓮形である。この尊は観音の慈眼より生ずる故に、印も形もともに青蓮である。真言は、

Mūla-mudrā of Tārā

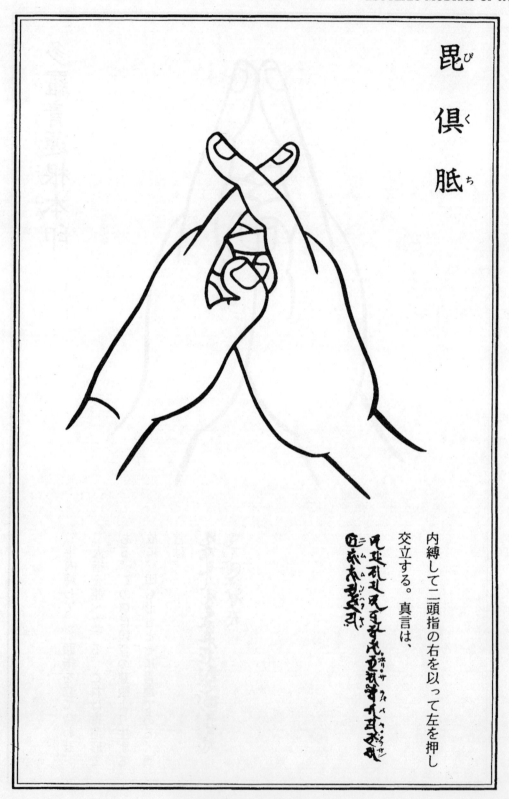

毘
く
倶
び
胝
ち

内縛して二頭指の右を以って左を押し
交立する。真言は、

Mudrā of Bhṛkuṭī, no. 1

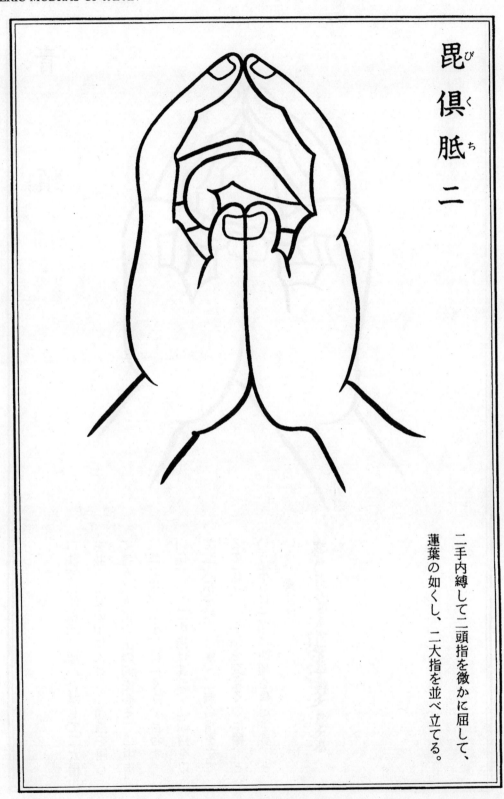

毘(び)俱(く)胝(ち)二

二手内縛して二頭指を微かに屈して、
蓮葉の如くし、二大指を並べ立てる。

Mudrā of Bhṛkuṭī, no. 2

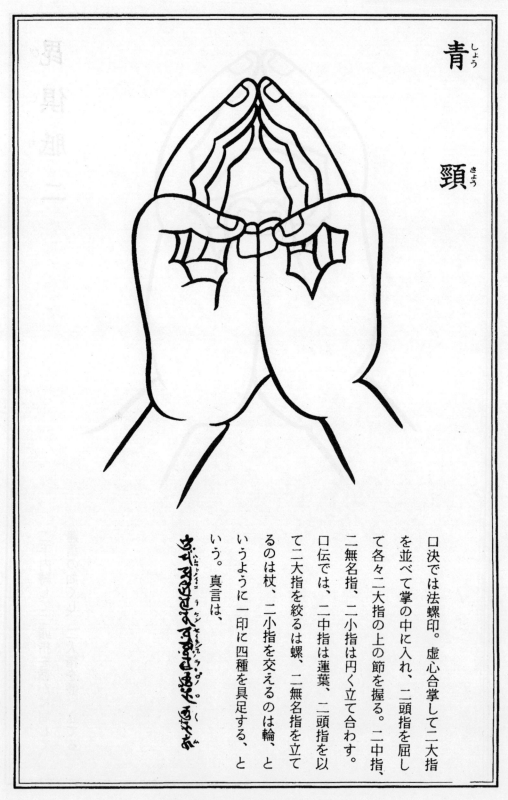

青
頸

口決では法螺印。虚心合掌して二大指を並べて掌の中に入れ、二頭指を屈して各々二大指の上の節を握る。二中指、二無名指、二小指は円く立て合わす。
口伝では、二中指は蓮葉、二頭指を以て二大指を絞るは螺、二無名指を立てるのは杖、二小指を交えるのは輪、というように一印に四種を具足する、という。真言は、

Mudrā of Nīlakaṇṭha Lokeśvara

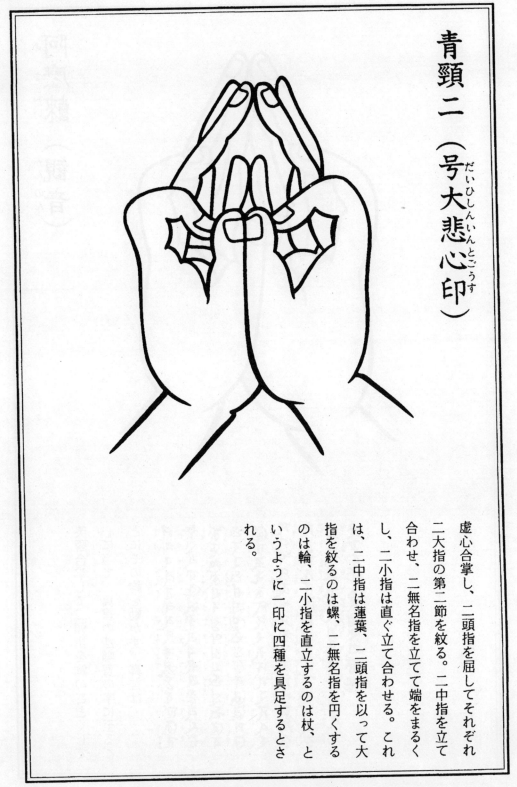

青頸二（号大悲心印）

虚心合掌し、二頭指を屈してそれぞれ二大指の第二節を絞る。二中指を立て合わせ、二無名指を立てて端をまるくし、二小指は直ぐ立て合わせる。これは、二中指は蓮葉、二頭指を以って大指を絞るのは螺、二無名指を円くするのは輪、二小指を直立するのは杖、というように一印に四種を具足するとされる。

Mahākāruṇika-mudrā of Nīlakaṇṭha Lokeśvara, no. 2

阿麼𫽫（観音）

芙蓉合掌して二頭指を鉤のごとくして心に当て、真言の沙嚩賀の字に至るごとにその鉤を動かす。真言は、

Mudrā of Avaṭhai Avalokiteśvara

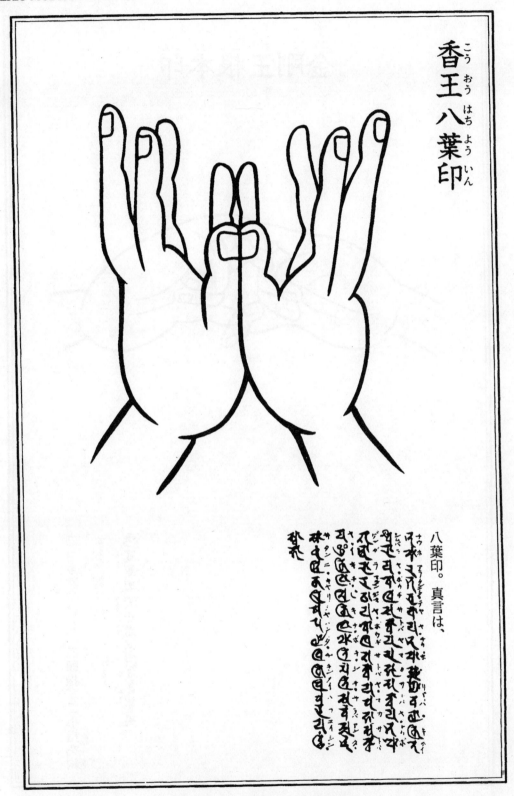

Aṣṭa-dala-mudrā of Gandharāja

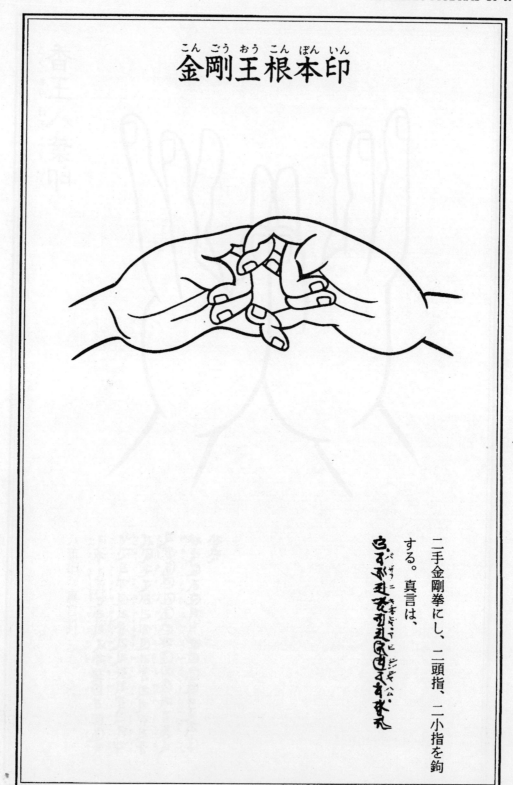

こんごうおうこんぽんいん
金剛王根本印

二手金剛拳にし、二頭指、二小指を鉤する。真言は、

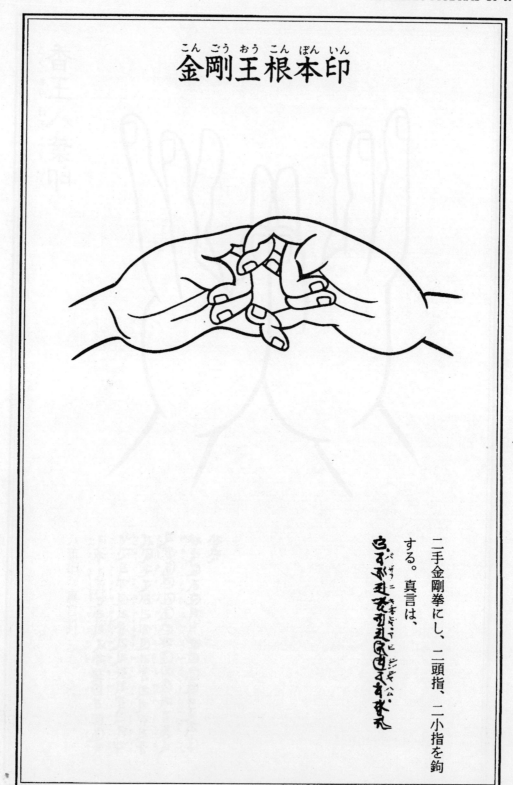

Mūla-mudrā of Vajrarāja

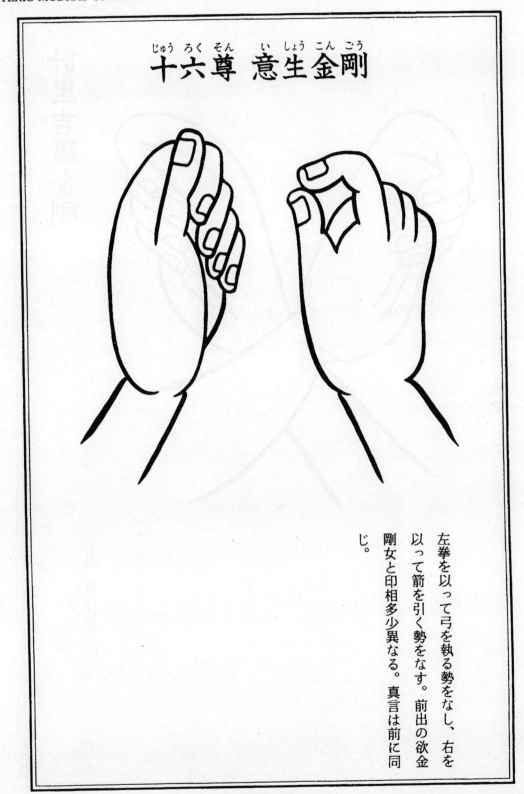

十六尊 意生金剛

左拳を以って弓を執る勢をなし、右を以って箭を引く勢をなす。前出の欲金剛女と印相多少異なる。真言は前に同じ。

Mudrā of Iṣṭavajra

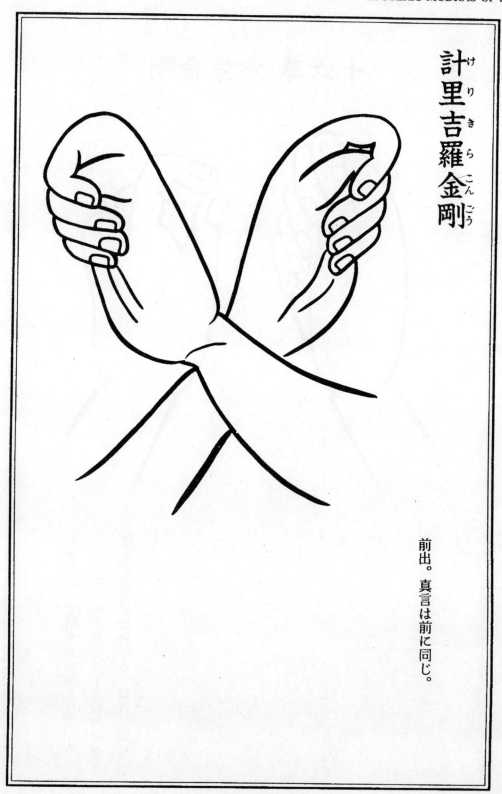

計里吉羅金剛

前出。真言は前に同じ。

Mudrā of Kelikilavajra

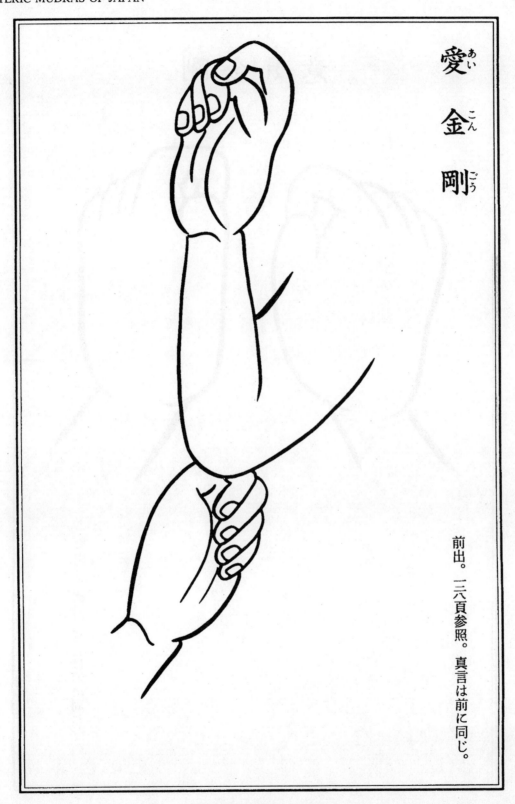

愛_{あい}金_{こん}剛_{ごう}

前出。一三六頁参照。真言は前に同じ。

Mudrā of Rāgavajra

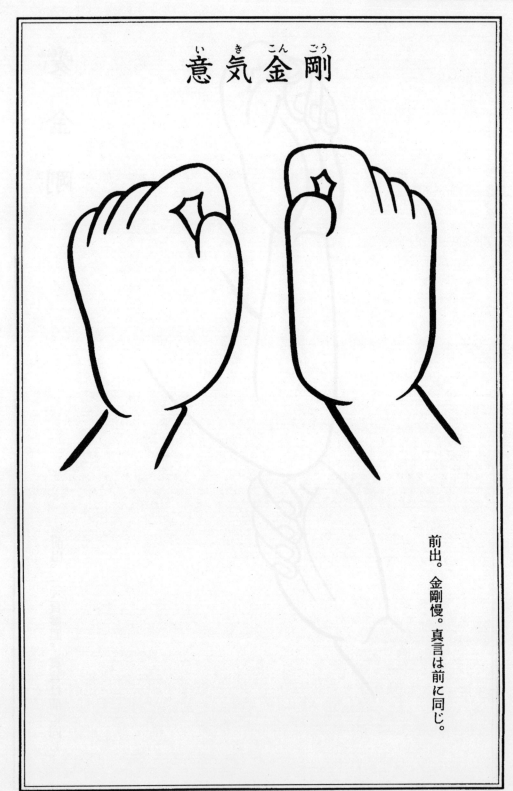

意気金剛

前出。金剛慢。真言は前に同じ。

Mudrā of Mānavajra

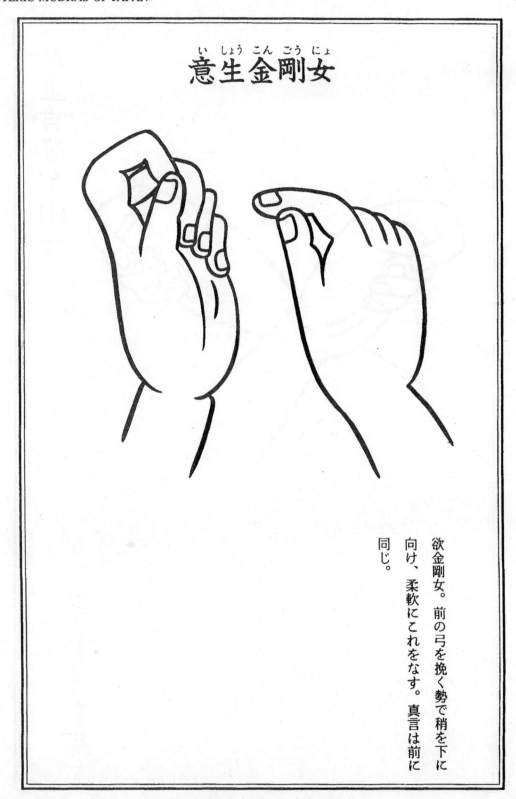

意生金剛女

欲金剛女。前の弓を挽く勢で稍を下に向け、柔軟にこれをなす。真言は前に同じ。

Mudrā of Manojavajriṇī

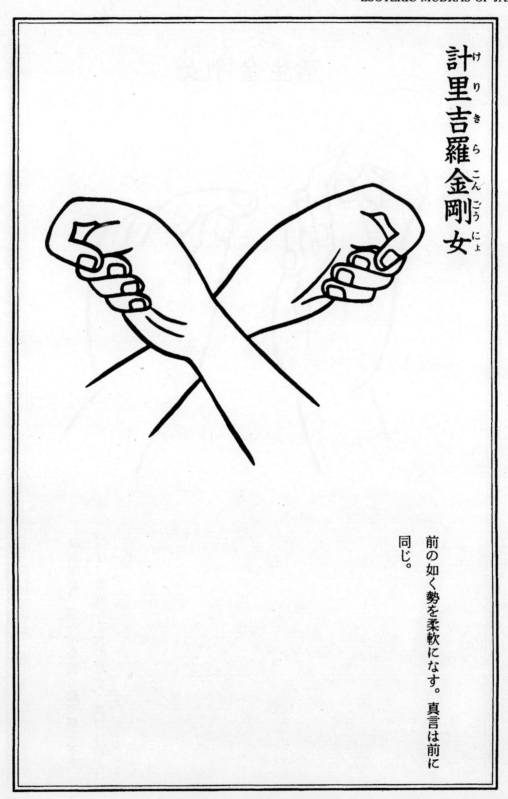

計里吉羅金剛女
（け）（り）（き）（ら）（こん）（ごう）（にょ）

前の如く勢を柔軟になす。真言は前に
同じ。

Mudrā of Kelikilavajriṇī

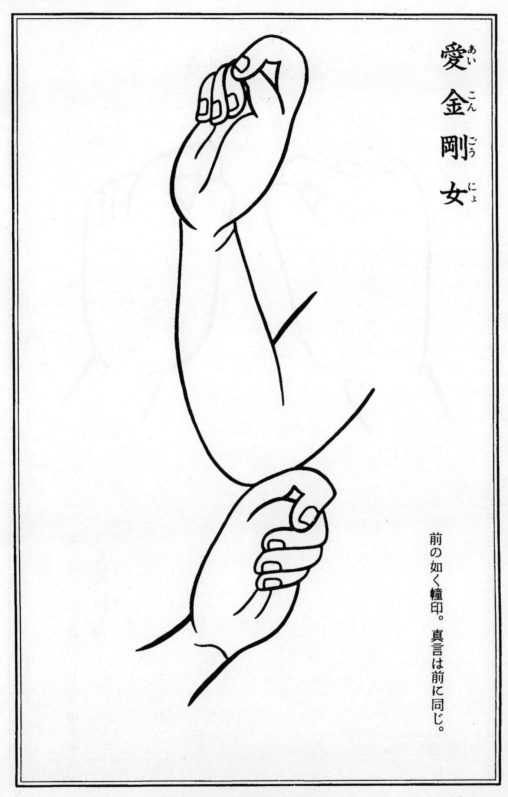

愛<ruby>あい</ruby>金<ruby>こん</ruby>剛<ruby>ごう</ruby>女<ruby>にょ</ruby>

前の如く幢印。真言は前に同じ。

Mudrā of Rāgavajriṇī

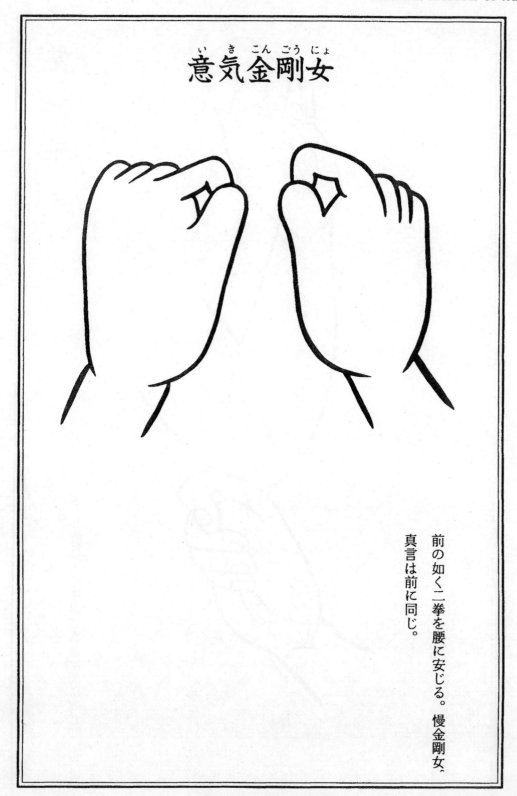

意気金剛女

前の如く二拳を腰に安じる。慢金剛女。
真言は前に同じ。

Mudrā of Mānavajriṇī

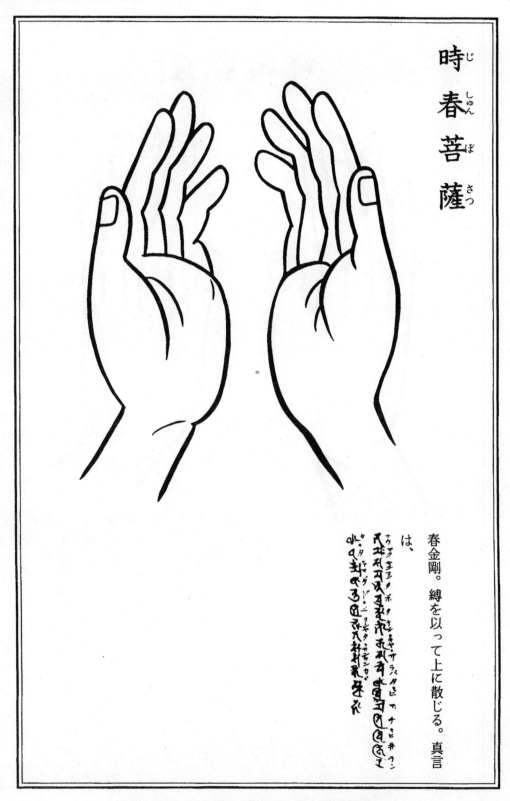

時春菩薩

春金剛。縛を以って上に散じる。真言
は、

ナウマクサンマンダボダナンキャラバサンタビハナサンニヒキソワカ
タラマグドニリシタクサキンカ
水心珠せる回れ相相氣珠花

Mudrā of Vasanta (spring) as a Bodhisattva

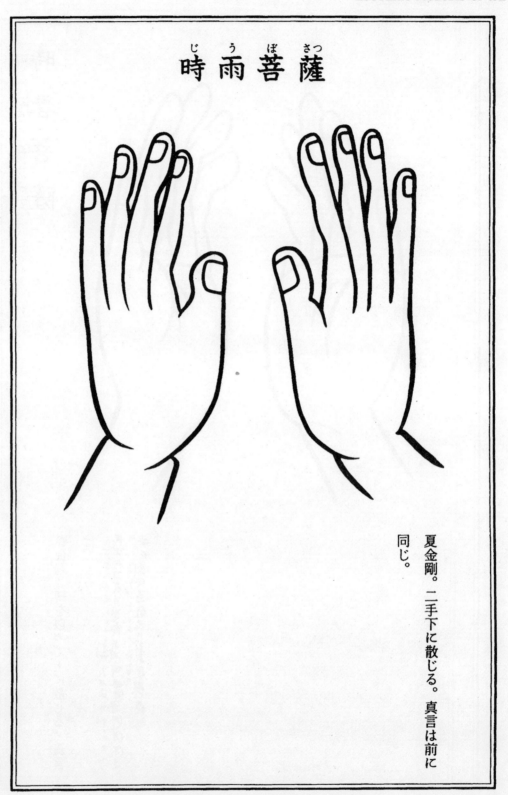

時雨菩薩

夏金剛。二手下に散じる。真言は前に
同じ。

Mudrā of Varṣā (rains) as a Bodhisattva

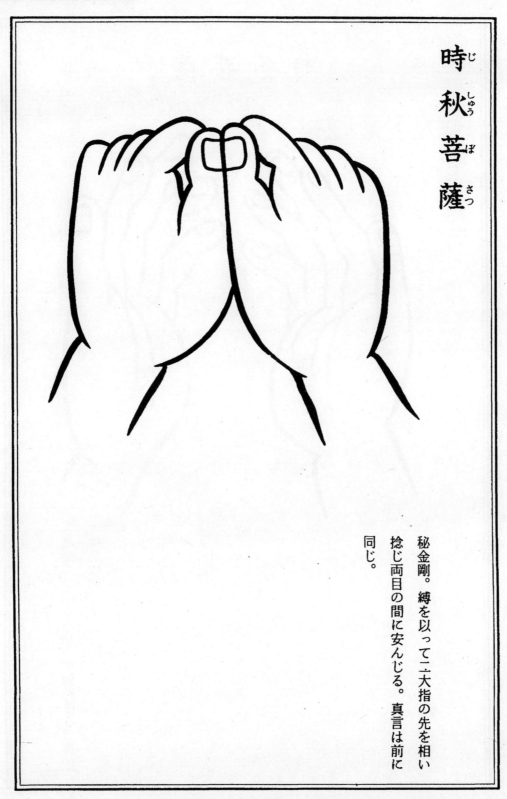

時秋菩薩

秘金剛。縛を以って二大指の先を相い
捻じ両目の間に安んじる。真言は前に
同じ。

Mudrā of Śarad (autumn) as a Bodhisattva

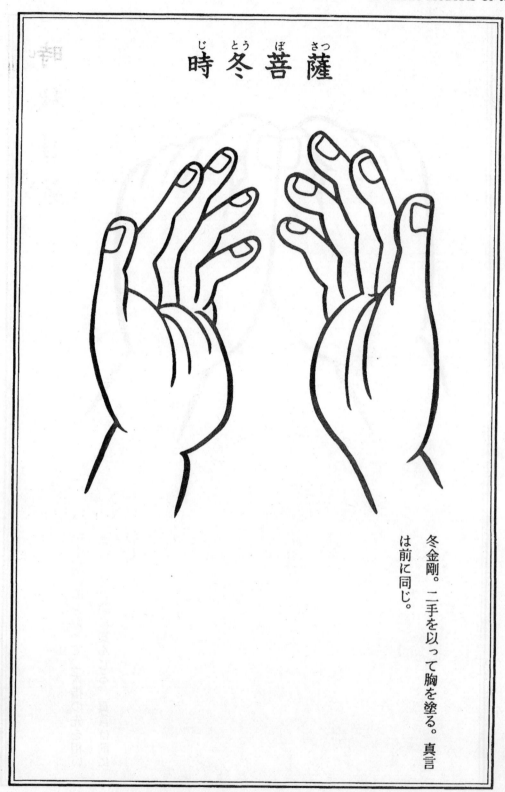

時冬菩薩

冬金剛。二手を以って胸を塗る。真言
は前に同じ。

Mudrā of Hemanta (winter) as a Bodhisattva

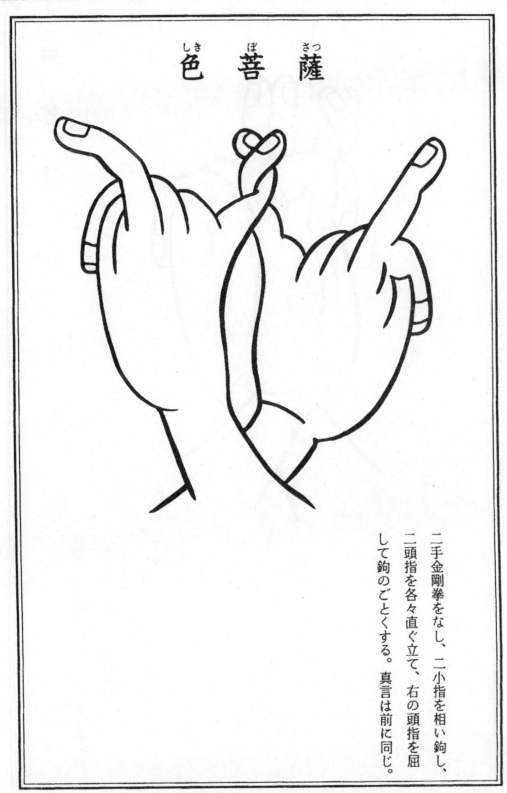

色菩薩

二手金剛拳をなし、二小指を相い鉤し、
二頭指を各々直ぐ立て、右の頭指を屈
して鉤のごとくする。真言は前に同じ。

Mudrā of Rūpa (form) as a Bodhisattva

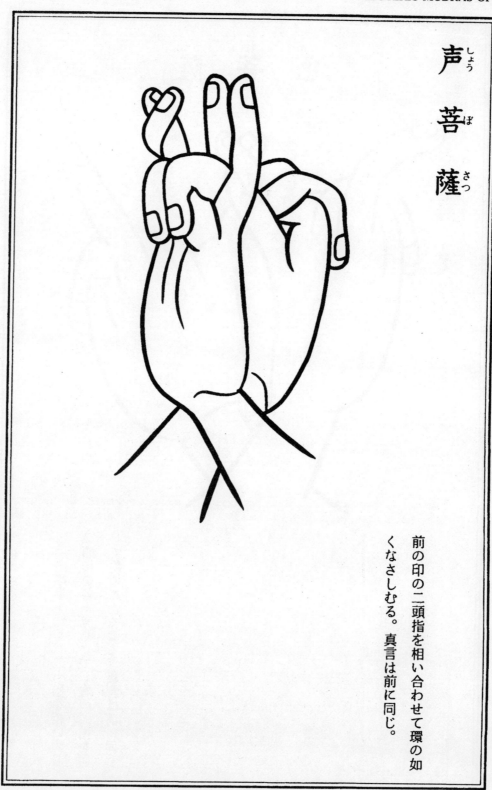

声菩薩

前の印の二頭指を相い合わせて環の如くなさしむる。真言は前に同じ。

Mudrā of Śabda (sound) as a Bodhisattva

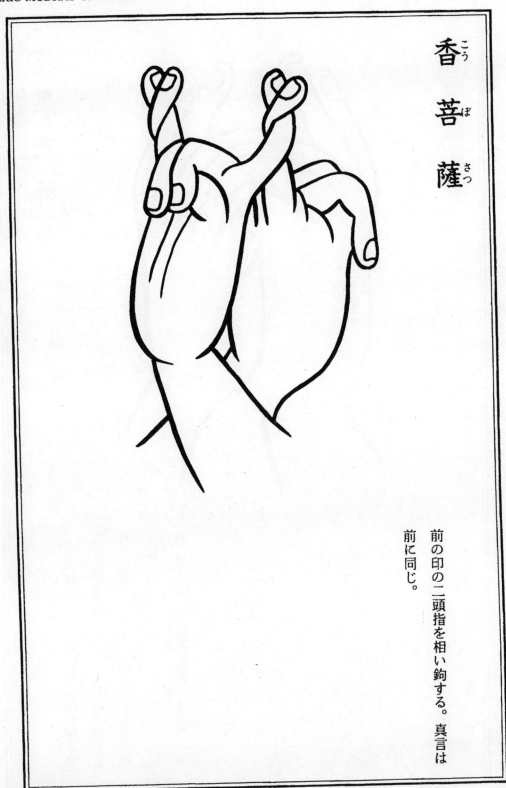

香こう菩ぼ薩さつ

前の印の二頭指を相い鉤する。真言は
前に同じ。

Mudrā of Gandha (smell) as a Bodhisattva

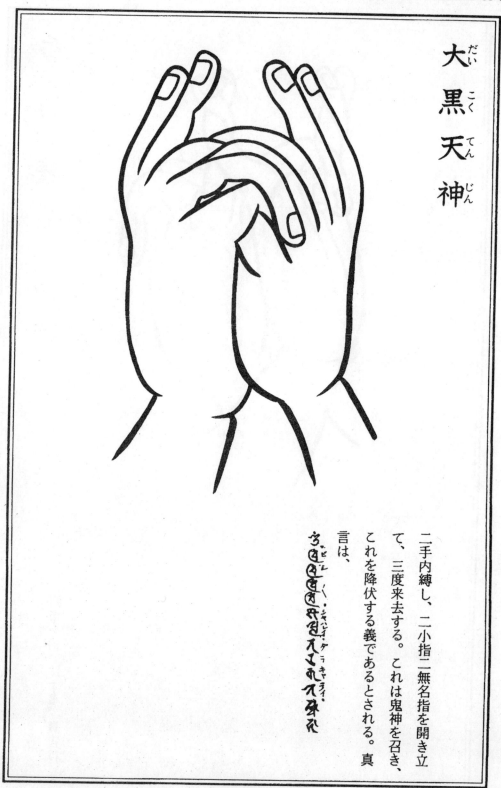

大
黒
天
神

二手内縛し、二小指二無名指を開き立
て、三度来去する。これは鬼神を召き、
これを降伏する義であるとされる。真
言は、

オン・マカキャラヤ・ソワカ

Mudrā of Mahākāla

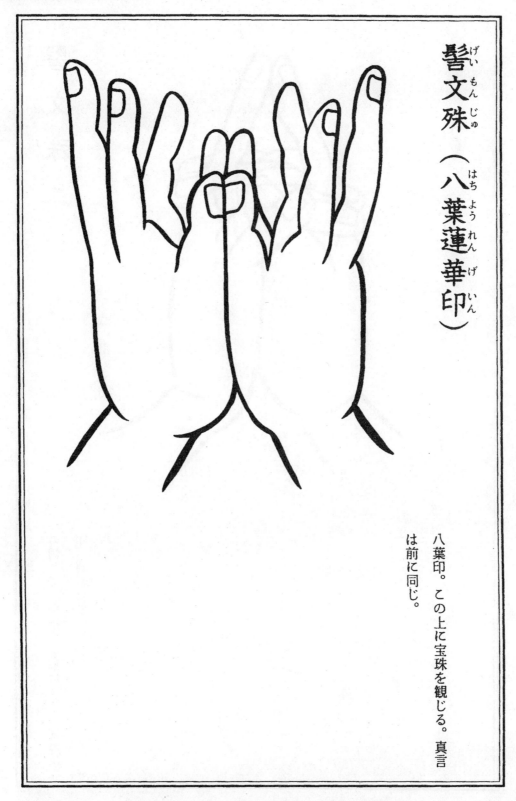

髻文殊（八葉蓮華印）

八葉印。この上に宝珠を観じる。真言は前に同じ。

Aṣṭa-dala-padma-mudrā of Ekaśikha Mañjuśrī

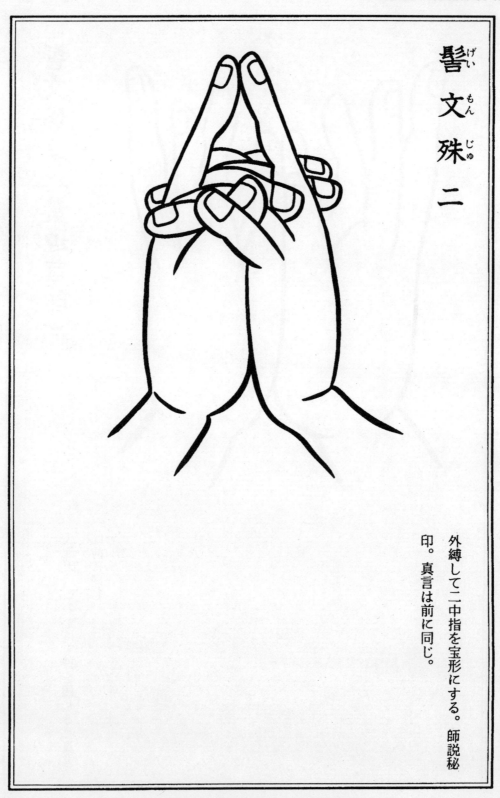

髻文殊二

外縛して二中指を宝形にする。師説秘
印。真言は前に同じ。

Second mudrā of Ekaśikha Mañjuśrī

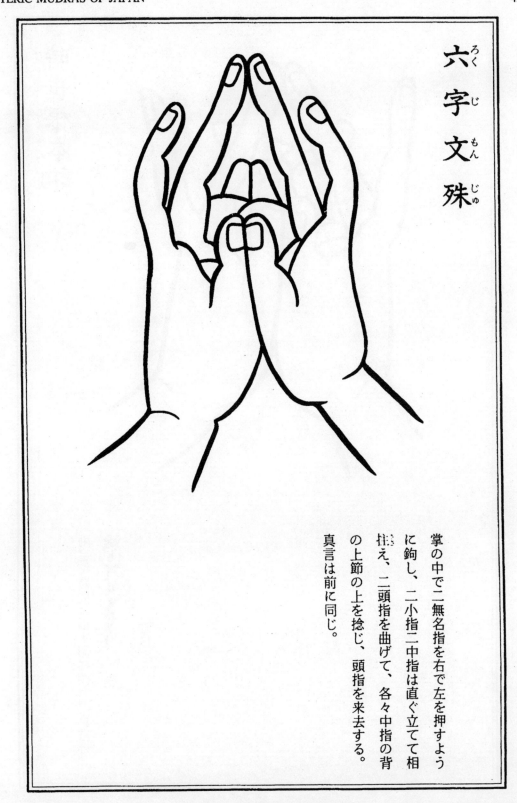

六字文殊

掌の中で二無名指を右で左を押すよう
に鉤し、二小指二中指は直ぐ立てて相
挂え、二頭指を曲げて、各々中指の背
の上節の上を捻じ、頭指を来去する。
真言は前に同じ。

Mudrā of Ṣaḍakṣara Mañjuśrī

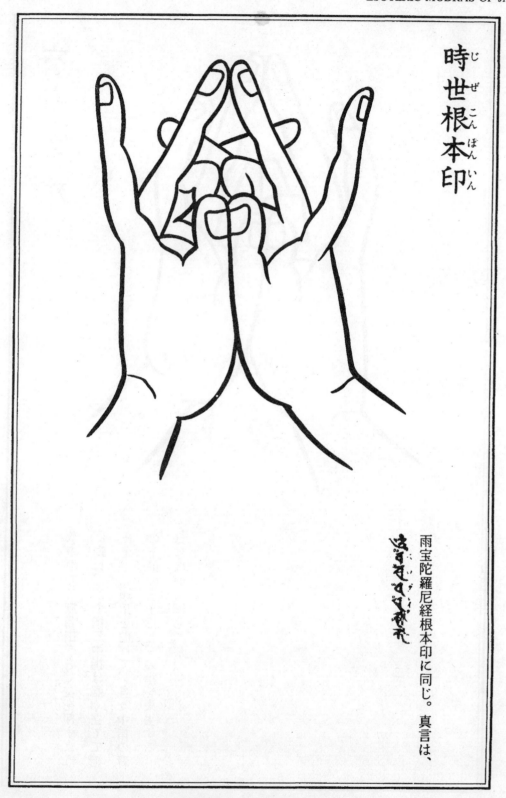

時世根本印

雨宝陀羅尼経根本印に同じ。真言は、

Mūla-mudrā of Kāla-loka

薬王（普印）

金剛合掌。真言は、

Mudrā of Bhaiṣajyarāja

摩_ま訶_か迦_か羅_ら

金剛合掌。真言は、

Mudrā of Mahākāla

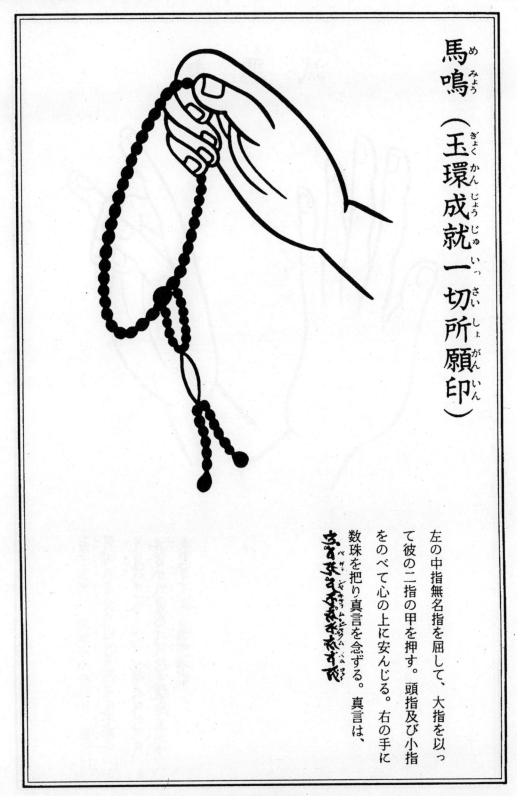

馬鳴（めっ）（みょう）（玉環成就一切所願印）（ぎょく）（かん）（じょう）（じゅ）（いっ）（さい）（しょ）（がん）（いん）

左の中指無名指を屈して、大指を以って彼の二指の甲を押す。頭指及び小指をのべて心の上に安んじる。右の手に数珠を把り真言を念ずる。真言は、

Mudrā of Aśvaghoṣa

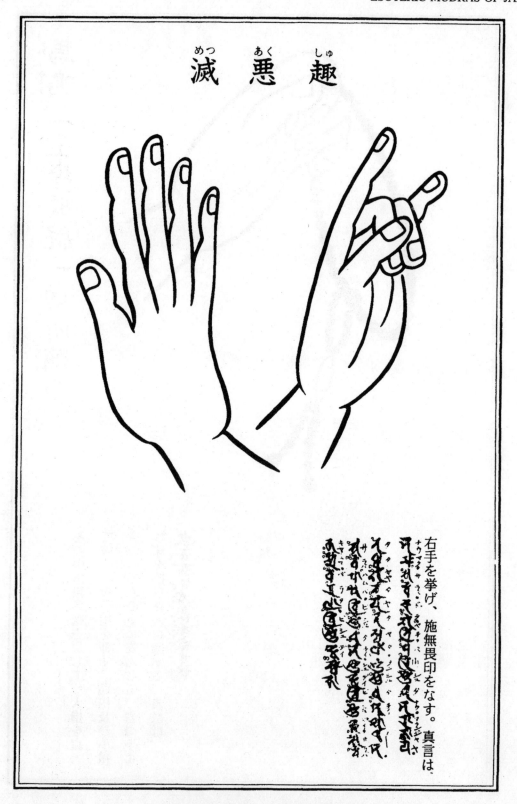

Mudrā of Durgati-pariśodhana

自在天

二手外縛して左で右を押し、二小指二
頭指二大指を直ぐ立てて四処を加持す
る。真言は、

マクイジュバギャキ

Mudrā of Īśvara

梵
天
（三
昧
空
時
水
）

三昧空持水。掌をのべ頭指大指を持っ
て相捻ず。また中指大指を屈して掌の
内に当てる。

Mudrā of Brahmā

帝釈
たい しゃく

内縛して二頭指を直ぐ立てて針の如くし、二大指も並び立てる。

Mudrā of Indra

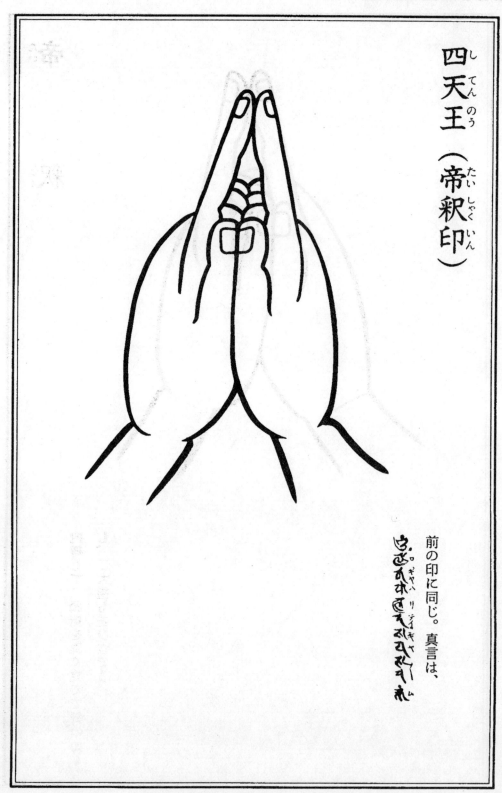

四天王（帝釈印）

前の印に同じ。真言は、

Indra-mudrā of the Catur-mahārāja

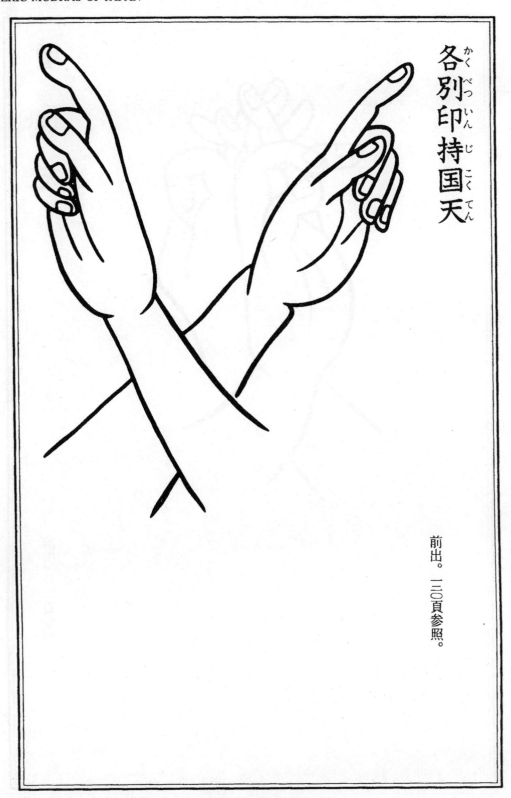

各別印 持国天

前出。一三〇頁参照。

Mudrā of Dhṛtarāṣṭra

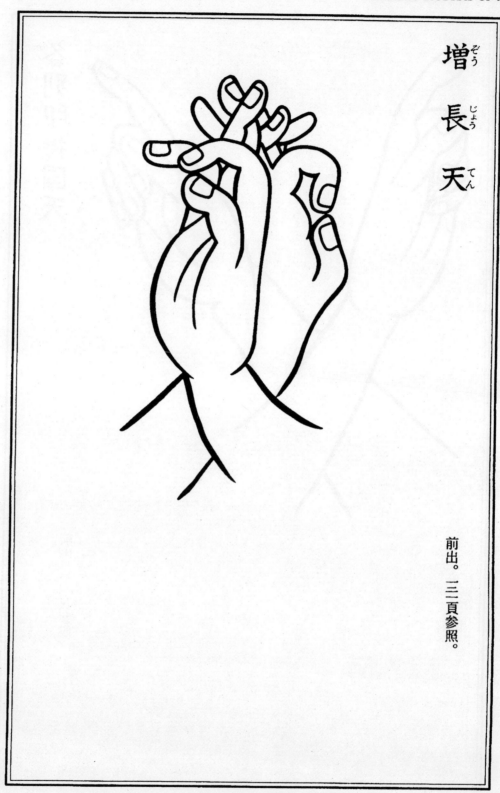

増長天

前出。一三二頁参照。

Mudrā of Virūḍhaka

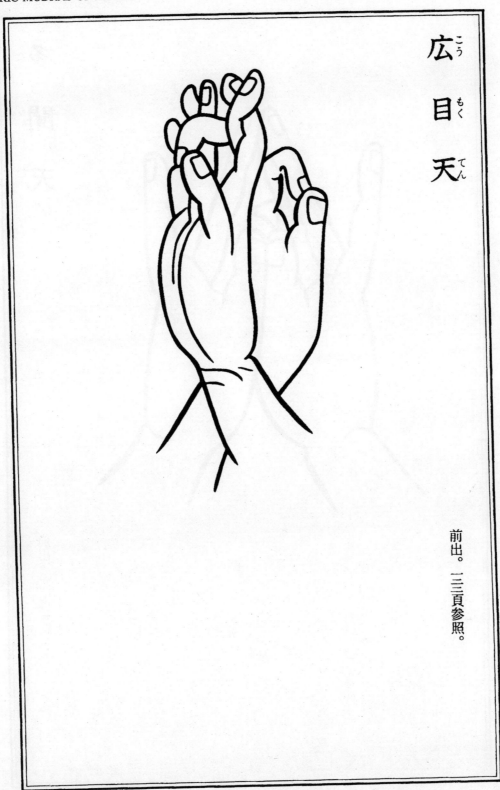

広
目
天
こう
もく
く
てん

前出。一三三頁参照。

Mudrā of Virūpākṣa

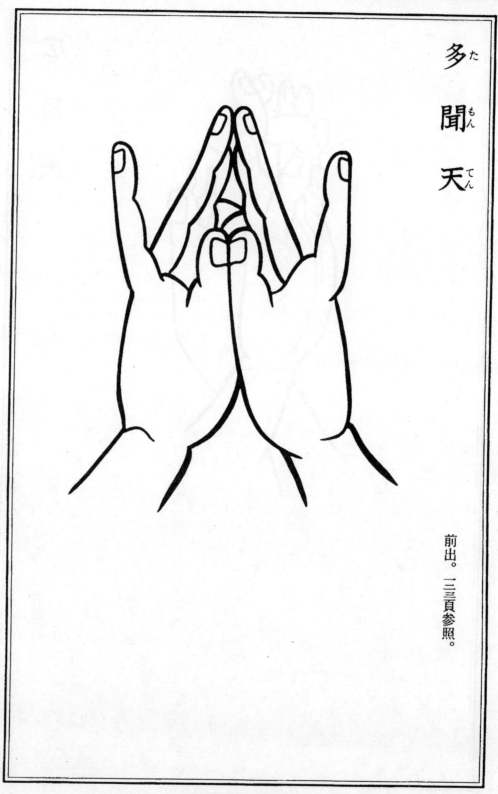

多_た聞_{もん}天_{てん}

前出。一三三頁参照。

Mudrā of Vaiśravaṇa

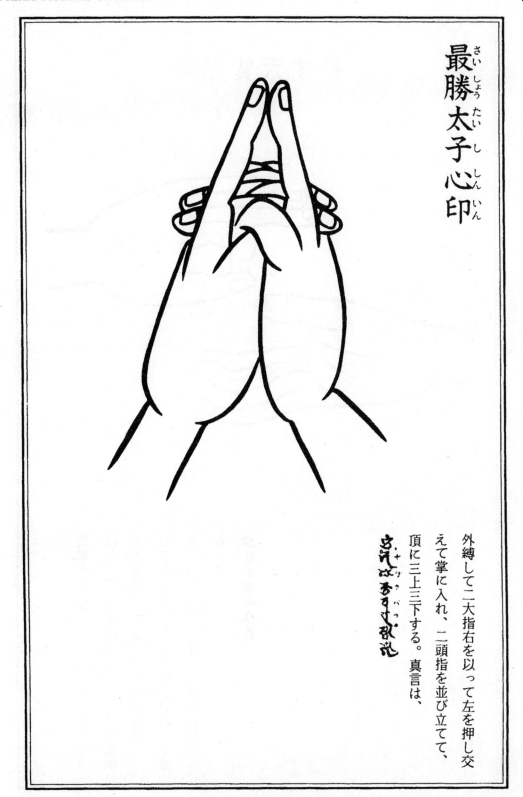

最勝太子心印

外縛して二大指右を以って左を押し交
えて掌に入れ、二頭指を並び立てて、
頂に三上三下する。真言は、

Citta-mudrā of Vijaya

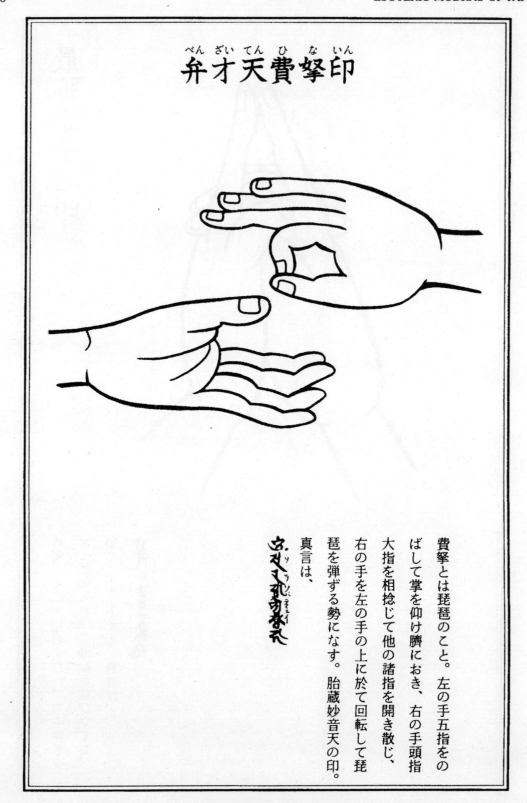

弁才天費挐印

真言は、費挐とは琵琶のこと。左の手五指をのばして掌を仰け臍におき、右の手頭指大指を相捻じて他の諸指を開き散じ、右の手を左の手の上に於て回転して琵琶を弾ずる勢になす。胎蔵妙音天の印。

Vīṇā-mudrā of Sarasvatī

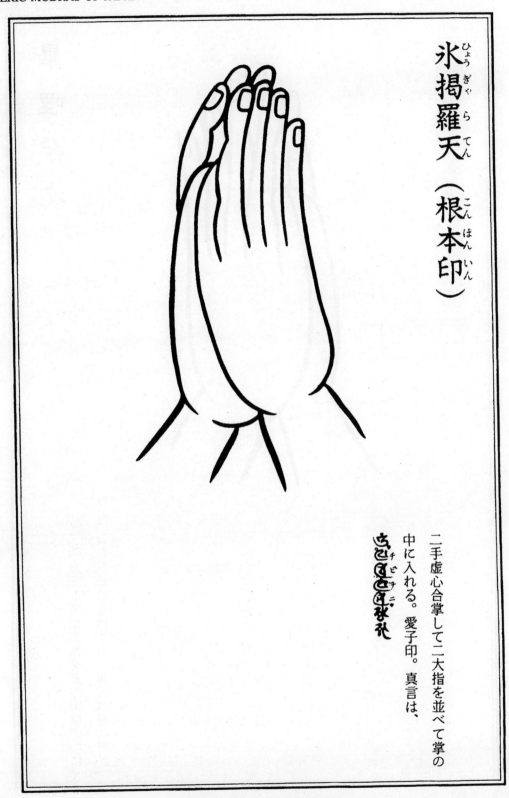

氷掲羅天（根本印）

二手虚心合掌して二大指を並べて掌の
中に入れる。愛子印。真言は、

Mūla-mudrā of Piṅgala-deva

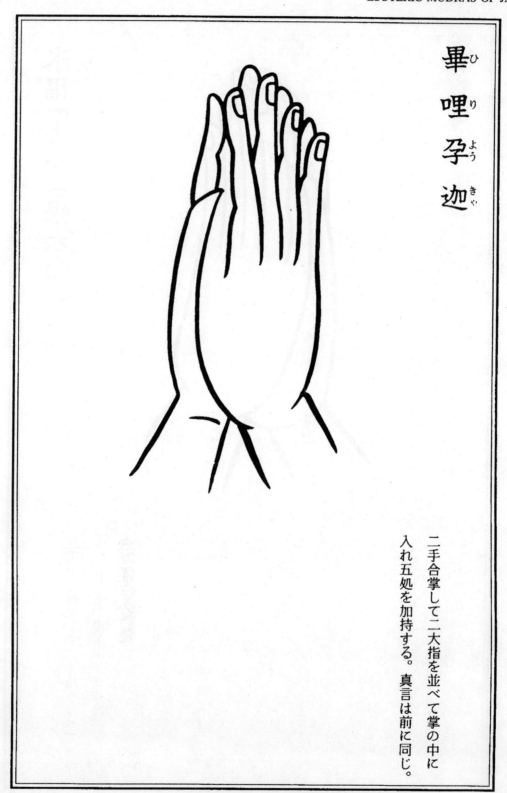

畢_ひ哩_り孕_{よう}迦_{きや}

二手合掌して二大指を並べて掌の中に入れ五処を加持する。真言は前に同じ。

Mudrā of Vṛścika

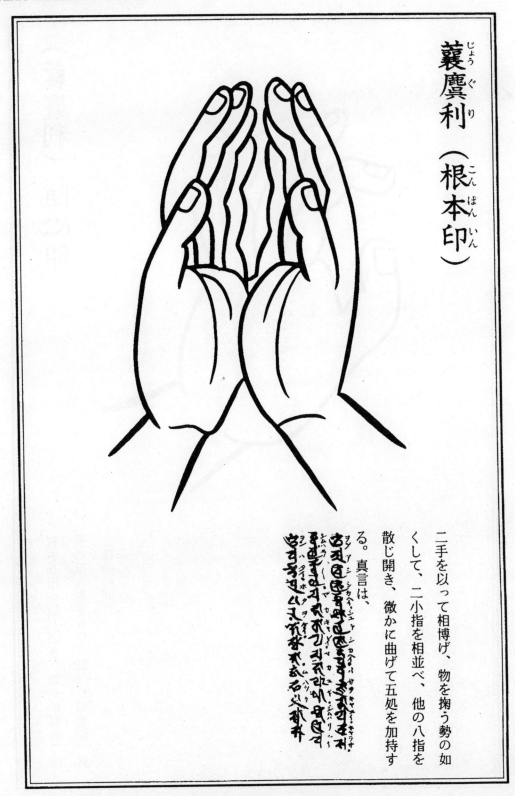

襄麌利（根本印）

二手を以って相博げ、物を掬う勢の如くして、二小指を相並べ、他の八指を散じ開き、微かに曲げて五処を加持する。真言は、

Mūla-mudrā of Jāṅguli

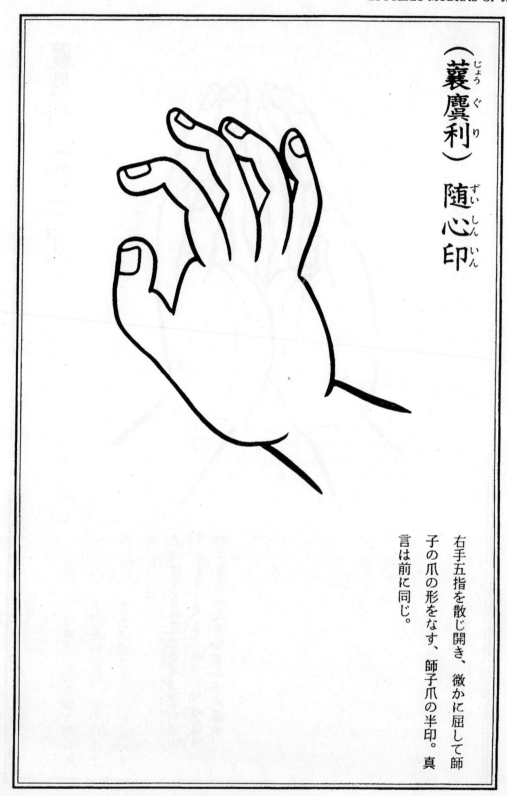

（蘘麌利）随心印

右手五指を散じ開き、微かに屈して師
子の爪の形をなす、師子爪の半印。真
言は前に同じ。

Citta-mudrā of Jāṅguli

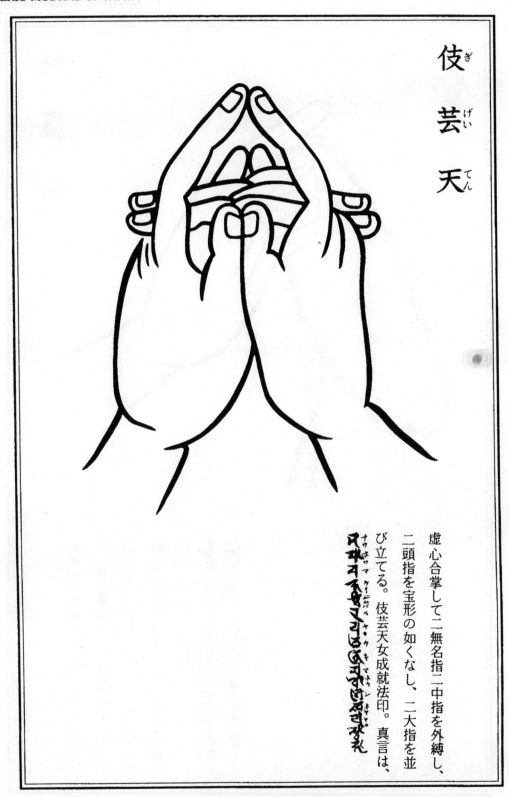

伎芸天

虚心合掌して二無名指二中指を外縛し、二頭指を宝形の如くなし、二大指を並び立てる。伎芸天女成就法印。真言は、

ナウボロマ　ケイジハラ　シャ・ク　キ　マトシ　キャイ　ノウ

Mudrā of Viśvakarmā

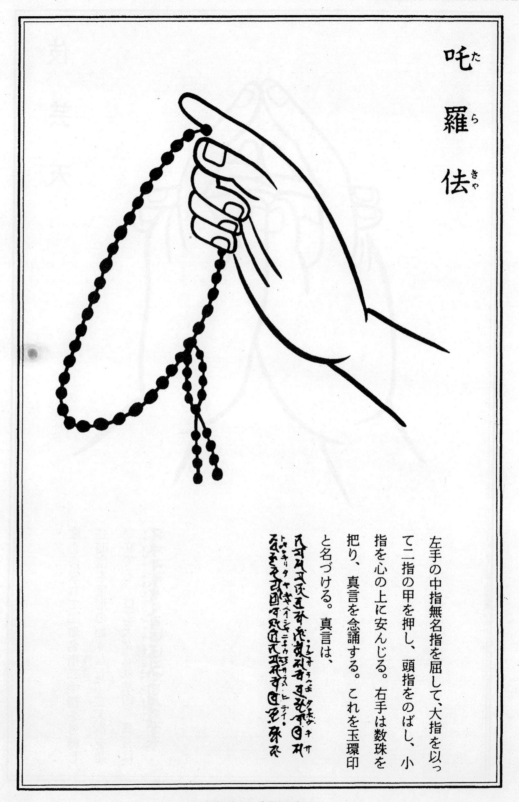

吒_た
羅_ら
伕_{きゃ}

左手の中指無名指を屈して、大指を以っ
て二指の甲を押し、頭指をのばし、小
指を心の上に安んじる。右手は数珠を
把り、真言を念誦する。これを玉環印
と名づける。真言は、

Mudrā of Tāraka

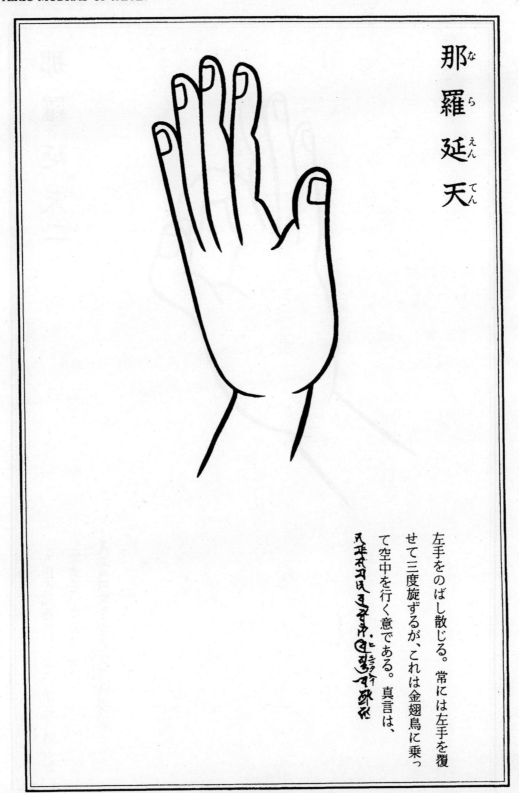

那
羅
延
天

左手をのばし散じる。常には左手を覆せて三度旋ずるが、これは金翅鳥に乗って空中を行く意である。真言は、

Mudrā of Nārāyaṇa, no. 1

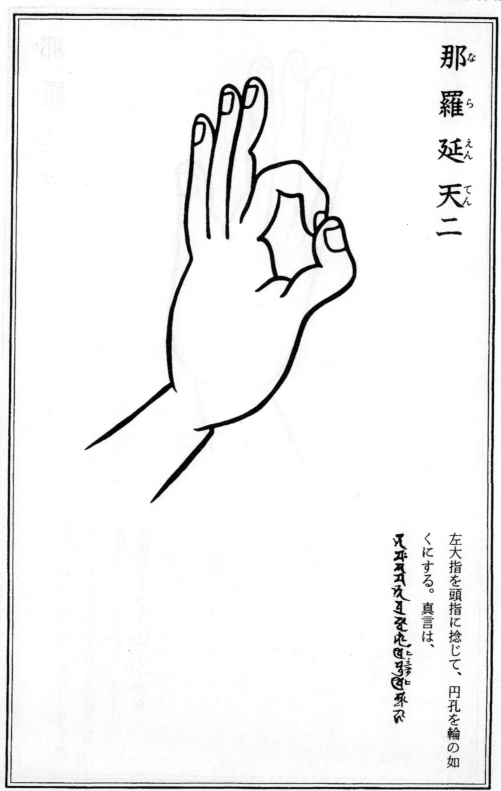

那_な羅_ら延_{えん}天_{てん}二

左大指を頭指に捻じて、円孔を輪の如くにする。真言は、

Mudrā of Nārāyaṇa, no. 2

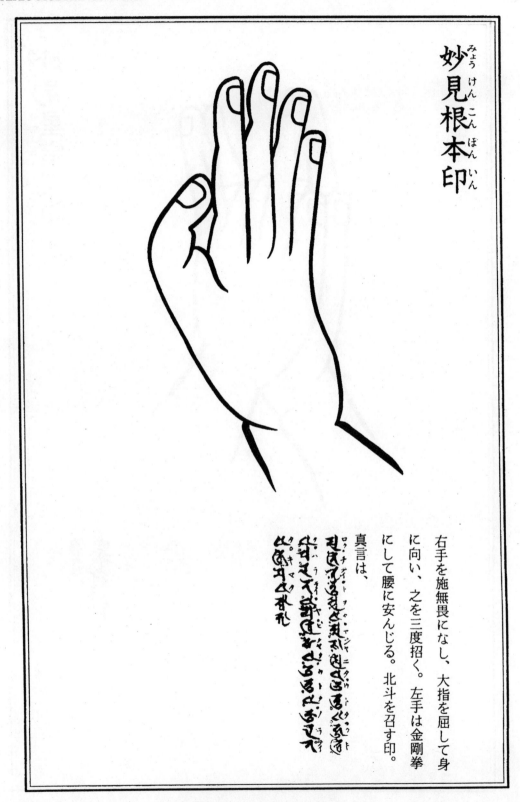

妙見根本印

真言は、

ロク・ナディ・ト・ボダ・ヤシャ・ニタウ
バ・キャク・

右手を施無畏になし、大指を屈して身
に向い、之を三度招く。左手は金剛拳
にして腰に安んじる。北斗を召す印。

Mūla-mudrā of Sudarśana

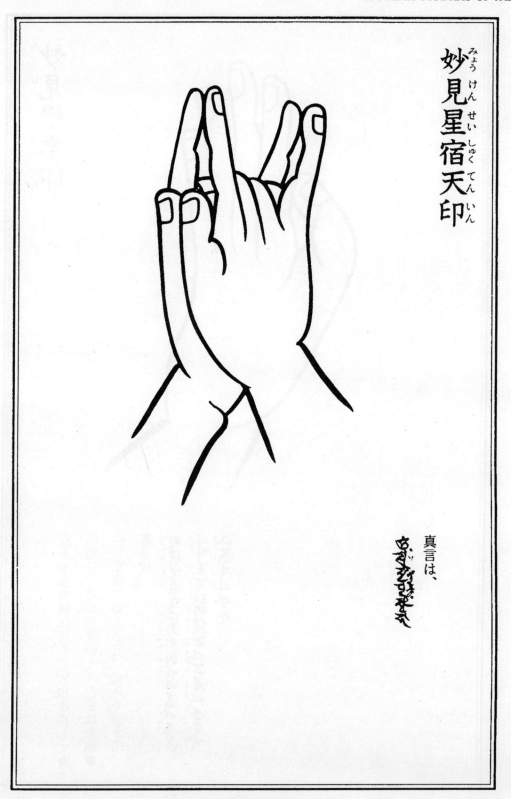

妙見星宿天印

真言は、

Mudrā of Sudarśana

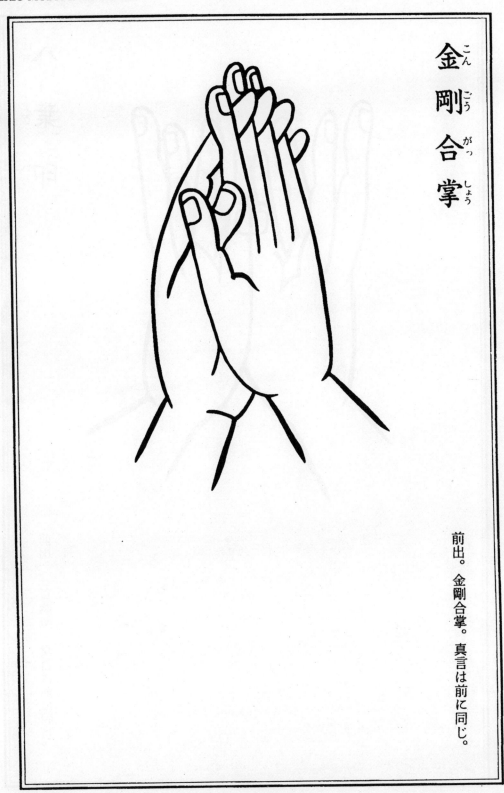

金剛合掌

前出。金剛合掌。真言は前に同じ。

Vajrāñjali

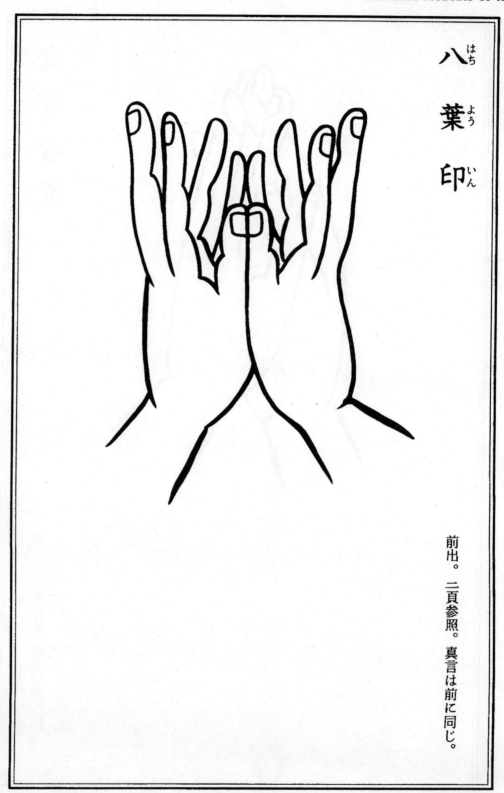

八
葉
印

前出。二頁参照。真言は前に同じ。

Aṣṭa-dala-mudrā

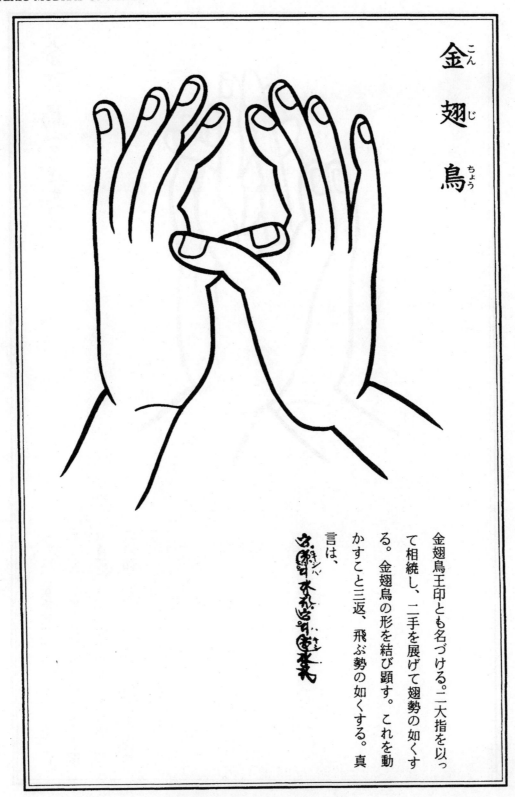

金翅鳥

金翅鳥王印とも名づける。二大指を以って相続し、二手を展げて翅勢の如くする。金翅鳥の形を結び顕す。これを動かすこと三返、飛ぶ勢の如くする。真言は、

Mudrā of Suparṇa or Garuḍa

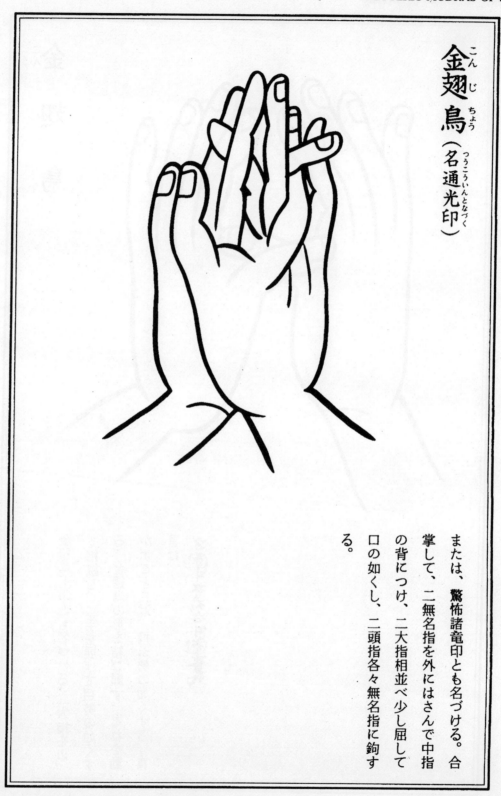

金翅鳥（名通光印）

または、驚怖諸竜印とも名づける。合掌して、二無名指を外にはさんで中指の背につけ、二大指相並べ少し屈して口の如くし、二頭指各々無名指に鉤する。

Mudrā of Suparṇa or Garuḍa.

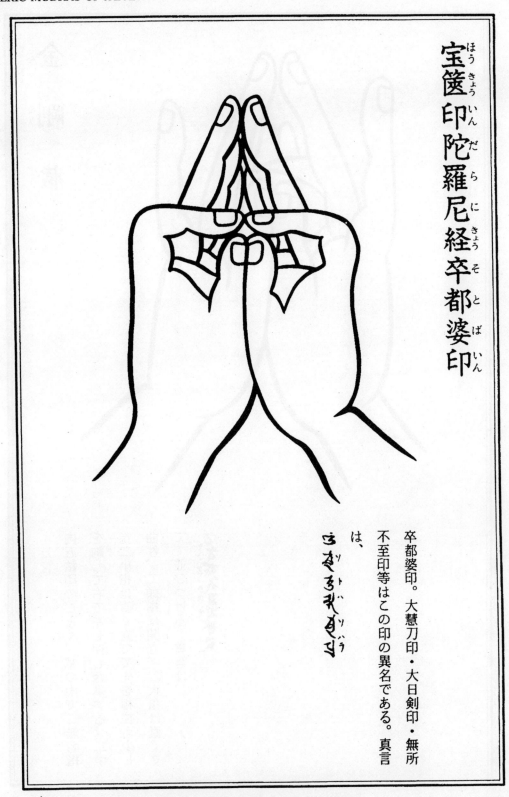

宝篋印陀羅尼経卒都婆印

卒都婆印。大慧刀印・大日剣印・無所
不至印等はこの印の異名である。真言
は、

Stūpa-mudrā of Ratnakūṭa-dhāraṇī

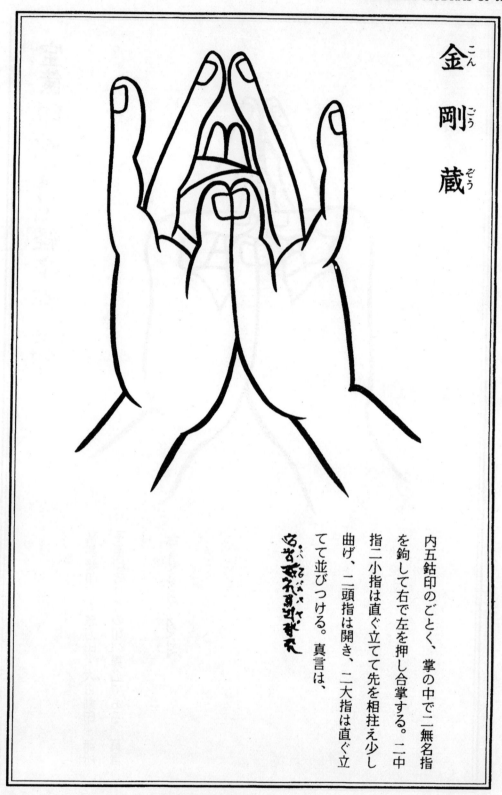

金剛蔵

内五鈷印のごとく、掌の中で二無名指を鈎して右で左を押し合掌する。二中指二小指は直ぐ立てて先を相拄え少し曲げ、二頭指は開き、二大指は直ぐ立てて並びつける。真言は、

Mudrā of Vajragarbha, no. 1

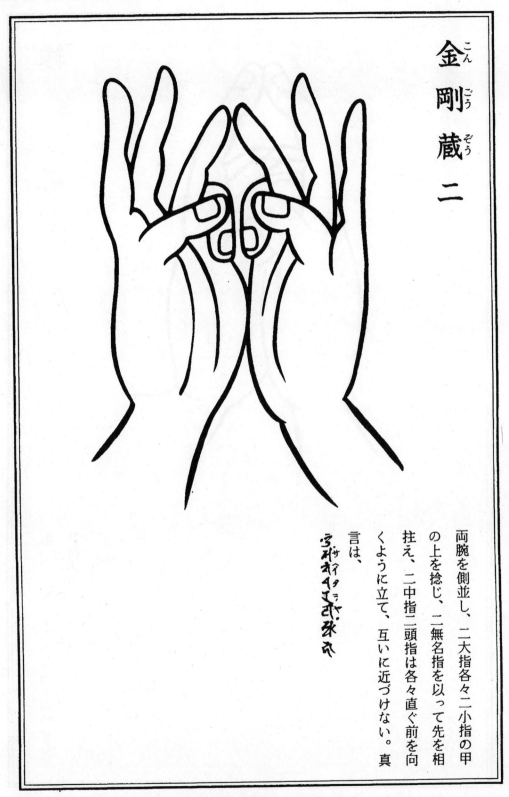

金剛蔵二

両腕を側並し、二大指各々二小指の甲の上を捻じ、二無名指を以って先を相拄え、二中指二頭指は各々直ぐ前を向くように立て、互いに近づけない。真言は、

サンマエイタジャバザラ

Mudrā of Vajragarbha, no. 2

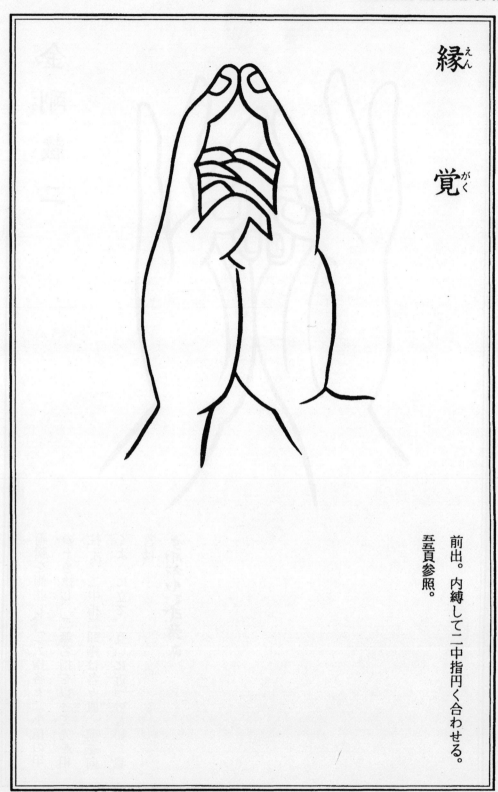

縁^{えん}

覚^{がく}

前出。内縛して二中指円く合わせる。
吾吾頁参照。

声聞梵篋印

梵篋印。左手指の先を右にして仰げの
ばし、右手指は先を左にしてその上に
覆う。真言は、

Sanskrit pothi mudrā of a śrāvaka

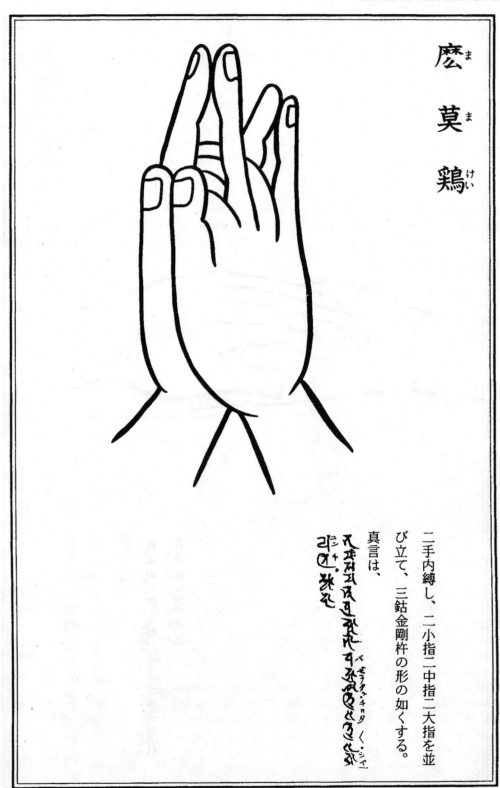

麼^ま 莫^ま 鷄^{けい}

二手内縛し、二小指二中指二大指を並び立て、三鈷金剛杵の形の如くする。

真言は、

Mudrā of Māmakī

INDEX

491

506

ESOTERIC MUDRĀS OF JAPAN

Sō nyō 92
soo yin 40
so yin 40
spear with three points 8
spirit: añjali of ~ 97; closing the ~ 62; ~ of bodhi
 67, 69; ~ of vajra 67; world of ~s 12
sprinkling, purification by ~ 7
śramaṇa 52
śrāvaka 172, 489
Śravaṇa 93
Śrīdevī 358
srotāpatti 5
stotra *see* eulogy
strengthening the defences 43
striking the hands 7, 100
stūpa-mudrā 32, 158, 227, 485
submission, means of becoming Buddha by ~ 11
su chao tshing yin 93
Sudarśana 479, 480
sui 92
sui rin 16, 21, 34, 95
summoning 15
summoning of crimes 66
Śukra 92
Sumeru 74, 75, 95
Sun 92
Suparṇa 70, 483, 484
Sūrya 92, 393
Sūryaprabha 127
Svāti 93
sword (mystic ~) 10, 22, 70, 87, 93, 336
sword of Fudō Myohō/Acala Vidyārāja 38, 157
sword of great knowledge 10, 17, 20, 22, 45, 66
sword of Mahāvairocana 68, 81

ta hai 33, 74
ta hoei tao yin 22
Taishaku-ten=Indra
Taizōkai=Garbhadhātu
Taizōkai shi-ki 34, 36, 48
ta ji 70
ta kaku 11
ta lo 65
ta loen than 35
tan chi 7, 57, 100
tan zi 7, 57, 100

tao chhang koan=dō jō kuan
tao chhang koan ting yin 103
tao fo tshïen chhan hoei kie 5
Tārā 429
Tāraka 476
Tathāgata 16, 23, 26, 27, 28, 29, 30, 69, 71, 72, 76,
 86, 87, 88, 97, *see* Buddha; body of
 knowledge of the ~ 27; helmet of ~ 27; hips of
 the ~ 26; kaji/adhiṣṭhāna of several ~s 86;
 navel of the ~ 26; receptacle of the ~ 27;
 speech of the ~ 28; spirit of the ~ 26; ten
 powers of the ~ 29; tongue of the ~ 28; tooth
 of the ~ 28; virtues of the Five ~s 69
Tathāgatoṣṇīṣa 23
Tathatā-dharma-vijaya 159
Taurus 92
ta yu 65
teeth 46
teeth of Gosanze/Trailokyavijaya 64
tei 93
Tejaprabha 428
Tejo-rāśy-uṣṇīṣa 151
temple, meditation of the ~=dō jō kaun
temple on Sumeru 75
ten=deva 22, 52, 91, 92, 94, 97
Tendai 1
teng ming 47, 109, 113
Teng phu-sa 79, 84
ten hō rin 4, 13, 20, 22, 54
ten powers of the Tathāgata 29, 30
ten quarters of the world 24, 29, 30, 39, 40 ,41, 42
ten worlds 12, 36, 52
thirteen sections 36
thirtytwo characteristics of the Buddha 17
thought of the Tathāgata 31
three groups of Buddha, lotus, vajra 76
three lives 32, 42
three lives, queen of unhindered power in ~ 32
three mysteries(san-mitsu) 1, 54
three powers 34, 104
three-pronged vajra=sankō
three things, purification of ~ *see* p.
three thousand worlds 74
three virtues 76
thu hiang 46, 108, 112
Thu hiang phu-sa 80, 84